For Mike and Esme, Karen and Shenell

Psycho-politics and Cultural Desires

Edited by Jan Campbell and Janet Harbord

© Jan Campbell, Janet Harbord and contributors, 1998

First published in 1998 by UCL Press

UCL Press Limited
1 Gunpowder Square
London EC4A 3DE
UK

and

1900 Frost Road, Suite 101
Bristol
Pennsylvania 19007-1598
USA

The name of University College London (UCL) is a registered
trade mark used by UCL Press with the consent of the owner.

British Library Cataloguing-in-Publication Data
A catalogue record for this book is available from the British Library.

Library of Congress Cataloging-in-Publication Data are available

ISBNS: 1–85728–806–8 HB
 1–85728–807–6 PB

Typeset in Garamond by Wilmaset Ltd., Birkenhead, Wirral, UK.
Printed and bound by T. J. International Ltd, Padstow, UK.

Contents

Part V: Corporeality 171

Part VI: Auto/biography 203

Notes on Contributors

Jan Campbell is working as a part-time lecturer in English and Cultural Studies at Sussex University. She also works as an analytical psychotherapist in Brighton. She has published on psychoanalysis and critical/cultural theory and is author of *Arguing with the Phallus: Feminist, Queer and Postcolonial Theory: a Psychoanalytic Contribution*. (Forthcoming from ZED Books).

Jo Croft completed a doctoral thesis on childhood and psychoanalysis at the University of Sussex, and is currently a lecturer in English at John Moore's University, Liverpool.

Gary Hall is a lecturer in cultural studies at Teesside University. He has published in cultural theory and cultural studies and is co-editor of a special edition in the journal *Authorising Culture*.

Janet Harbord is a senior lecturer in media and cultural studies at Middlesex University. She has published on queer theory and performativity, and is currently working on a book, *Regulating Tastes: Film, Space and the Body*.

Celia Hunt is organizing tutor of creative writing at the University of Sussex Centre for Continuing Education, where she teaches the certificate in creative writing and the postgraduate diploma in creative writing and personal development. She is engaged in doctoral research on "The use of fictionalized autobiography in personal development".

Vicky Lebeau is a lecturer in English at Sussex University. She is author of *Lost Angels: Psychoanalysis and Cinema*, London and New York, Routledge, 1995.

Stephen Maddison has just finished his doctoral thesis on gay desire and literature at the University of Sussex. He has published on cultural studies and gay desire.

David Marriott is a lecturer in English at Queen Mary and Westfield College, University of London, and has published on psychoanalysis and black representation.

Peter Nicholls is professor of American studies at Sussex University. He has numerous books and articles published, including his recent paper, "The

belated postmodern: history, phantams and Toni Morrison", in *Psychoanalytic Criticism: a Reader*, Polity Press, 1996.

Tina Papoulias is a doctoral candidate in the cultural studies department of the University of East London. She is currently researching the centrality of trauma for a theorization of memory and rememoration in relation to postcoloniality.

Jonathan Rutherford is a senior lecturer in media and cultural studies at Middlesex University. He is the author of numerous publications and books including his 1997 book *Forever England: Reflections on Race, Masculinity and Empire*, published by Lawrence and Wishart.

Andrew Samuels is professor of psychology at the University of Essex. He is also a Jungian analyst and author of numerous publications and books, including his recent book, *The Political Psyche*, London, Routledge (1993).

Introduction

Jan Campbell and Janet Harbord

Psychoanalysis is a contested terrain both within cultural theory and its own borders of clinical practice. The definitions of psychoanalysis proffered in this book offer a broad range of interpretations and positions that speak from either the clinical or the academic, but speak to a common concern. The objective here is not to select and prioritize some models over others for the project of cultural studies (a potentially explosive activity), but to argue for a continued dialogue between cultural theory and psychoanalysis. In some quarters even this has its risks. As Steve Pile remarks in arguing for a psycho-analytic geography, "any attempt to read the relationship between the subject, space and the social using psychoanalysis must be wary that the letter could be a bomb" (1996:8). Yet, without psychoanalysis, cultural theory has little to challenge the discourses of materiality and with it the rational, pursuing a path that cannot ultimately connect with contemporary experience of culture or the social. In the absence of a psychoanalytic framework, cultural theory lacks a model of subjectivity, a model crucial to the understand-ing of the way in which culture is produced and operates. How, for example, is it possible to understand the commercial success of fantasy texts such as films that reproduce the same narrative sequences over and again – that we pay to see not just *Nightmare on Elm Street,* but *Nightmare on Elm Street II* and *III*? What model of audience engagement informs the legislation of culture in the instance of censorship? Can we monitor and comprehend the way that an audience engages with culture by empirical measures alone? These questions are not just a matter of methodology within a discipline but are integral to the relationship between cultural theory and the social sphere, where the power of explication also has effects. They are questions brought abruptly and acutely into focus by instances such as the James Bulger case, where reason does not solve the murder, and culture, in the specific form of a film, becomes the prime suspect.

This is not the place, however to continue the discussion of the many differ-ent arguments for and applications of psychoanalysis and cultural theory, and

their ramifications; these occur later in the introduction. The interim sections offer first a context for these arguments by providing accounts of the two subject areas; initially cultural theory's relations with psychoanalysis, and reversing the perspective, psychoanalysis' relation with cultural theory. The interface this book presents between psychoanalysis and cultural theory has implications for the institution of cultural studies, especially because of the renewed interest in the relevance of psychoanalysis. Whereas cultural theory, in the guise of cultural studies, is the ascending star in international circles and institutions, psychoanalysis has in the recent past had a less up-beat reception. Conferences such as The End of Psychoanalysis?[1] (1995), signal at the very least a dissatisfaction with the subject, and have not always treated the question as rhetorical. Of course, psychoanalysis exists both clinically and academically. The latter has become grafted onto various disciplines in the humanities, not least cultural studies, but how this academic institutional history relates to practice and to the future of cultural studies is up for question. Charged with both a universalism and an ahistoricism, an insensitivity to questions of race and an ambivalence towards gay sexuality, the interface of psychoanalysis and cultural studies might be taken to be something of a glacial surface at present. Yet ironically, psychoanalysis provides us with many of the concepts that are key to understanding something as large as the present postmodern period. Take for example Jameson's deployment of schizophrenia to describe the temporal and spatial displacements that commodification has brought about, or Hebdige's contention that neurosis is being replaced by psychosis as "the dominant psychic norm" under late capitalism. Or more generally, the diagnostic critique of the contemporary as the "death" of the subject (Barthes), and the emergence of the "sensorium" (Lyotard) as a new mode of being whereby the ability to separate subject/object, mind/matter is erased. Not just the concepts of psychoanalysis but also the general psychic processes are relevant and necessary to an understanding of the present, and indeed to discourses about the present.

Cultural theory and psychoanalysis

Staging a dialogue between psychoanalysis and cultural theory presents us with the challenge and difficulty of definitions for both of these terms. Not only definitions, but questions of location. Where, in the disparate field of the humanities at the present moment, do we locate cultural theory? Like ubiquitous claims about ideology, cultural theory is at once everywhere and nowhere in particular, both the method (and increasingly the object) of study and also the absent centre. In order to stage this encounter, the discipline of cultural studies will be made representative of some of the major paradigms of theoretical thought and debate within cultural theory. Although this may seem to risk eliding the specificity of cultural theory as it exists in particular subject

areas, at worst to present cultural studies simply as the boiled down "essence of the humanities", we contend cultural studies is a useful threshold, or broker for the disparate strands of cultural theory. What is more, the current spotlight on cultural studies, as it becomes further institutionalized, has produced a sensitivity to questions of disciplinarity and has focused attention on theoretical relationships in a way that is timely for the project of this book. In addition, approaching cultural theory as cultural studies allows us to address the geographic and historical context of what would otherwise, at worst, appear an arbitrary configuration of theoretical braiding.

The question of whether psychoanalysis belongs in cultural studies has recently been raised within the broader concern of what cultural studies is as it comes of age (Oedipalizes even), and undergoes the process of institutionalization. Although it may be argued that the process of meta-disciplinarity, that self-conscious reflection on the boundaries and form of the discipline, is integral to any subject area, the designation of cultural studies as a new subject cut from the fabric of various disciplines suggests that this reflexivity will be particularly keen here. Indeed, on the eve of the bright new day of cultural studies, questions of method, coherence and integrity trouble the scene. What happens when subjects are taken across borders, into new areas, applied to new objects of study? Is this taking from other disciplines a form of appropriation with imperial overtones, or is this a necessarily partial movement that characterizes the fluidity of travelling theory? Certainly, the early Foucaultian "radicalness" of interdisciplinarity has given way to a concern over the effects of pillaging and plundering that some self-reputed pirates have enacted. The question has become one of how to signify the history of that discipline while also calling into question the rigidity of disciplinary boundaries. This is not a call to return to pure subject areas and discrete fields of study, placed within the aetiology of a discipline with its concomitant secured authority, but an enquiry into the related parts of any new field. This would include a necessary glance in the rearview mirror at the exclusions, what this leaves behind, as well as the journey into new territory.

Although it might appear that it is only now that the kaleidoscope that constitutes cultural studies is violently shaken and the parts thrown aside or into new formations, psychoanalysis has in fact never yet had a comfortable or secure footing within the field. Recognition of its presence is at best partial. In the various accounts of the history of cultural studies, psychoanalysis is cited as a fairly late, and troublesome, influence. For example, Stuart Hall, in an essay "Cultural studies and its theoretical legacies" (1992), cites psychoanalysis as part of the ruptual effects of feminism which impacted on and changed the field of cultural studies in the 1970s. Listing the ways in which feminism explicitly reorganized the field, fifth, and last on this list is a "new continent", " 'the re-opening' of the closed frontier between social theory and the theory of the unconscious – psychoanalysis". For Hall, this rupture, which was feminism explicitly and psychoanalysis as an implicit stage within

that, both broke, and broke into, cultural studies. In this description the difficulty and ambivalence towards such a rupture is expressed in the double play of broke/into, that which literally shattered an earlier project, and something which intruded and became part of it. What in Hall's account had been broken into was a cultural studies whose foundations were Marxist.

Reading into the histories, or more accurately the renarrativization of cultural studies, the explicit antagonism, which is also the iterative dynamic, emerges as one of founding fathers, patriarchal precedents if you like: the conflict between Marx and Freud. If for many commentators Marx is the overwhelming and explicit theoretical origin of cultural studies, Freud enters the field, via feminism, as a late usurper. Yet, the relationship of psychoanalysis and Marxist cultural theory is neither as linear nor as clean as this implies. This is on two fronts; first, that encounters between Marxist cultural theory and Freudian psychoanalysis have a lengthy history (for example, in the Frankfurt School) that later entanglements replay. But rather than seeking the origin of that encounter, it is more useful to think of the relationship as an ongoing dialogue that, while it repeats the historical dynamic of that encounter, repeats it differently each time. Second, the success of Marxism as a dominant explicatory model in cultural studies was, according to many commentators, in crisis from the beginning. Therefore the notion of psychoanalytic feminism erupting into, or being grafted onto, an established Marxist orthodoxy overemphasizes the presence and legitimacy of Marxist theory. In practice the markers in the debate were less fixed, more contingent and dynamic than is suggested.

But if the narrative of cultural studies (at Birmingham) represses a lengthier relationship of psychoanalysis and Marxism that predates its own existence, then surely the Marxism of that later moment had already been forged in relation to an earlier debate. Given this history it might be more accurate to suggest that if Marxism is the *explicit* foundation of cultural studies, certainly the discourse of psychoanalysis is the *implicit* undercurrent in the project that seeks to understand how subjects are reproduced. Without a notion of the unconscious processes through which the social contract is manufactured, Marxism threatens to collapse into dichotomy, differentiating false consciousness from "truth", where, at its crudest, ideology becomes simply determined by the economic base. The significance and difficulty of the concept of ideology is addressed by Althusser whose work, from the 1950s onwards, draws on concepts from psychoanalysis, but again sublimates the source. This is both implicit, for example in his thesis of interpellation, and also explicit, in his correspondence with Lacan and essays such as "Freud and Lacan" (Althusser 1970). The difficulty of extrapolating psychoanalytic concepts from Althusser's work is no easy task as they form in many ways the naturalized foundations of his thesis; as David Macey comments, "the reference to psychoanalysis, sometimes overt, sometimes covert, so imbues the Althusserian project of founding and elaborating a science of modes of production

and social formations that it appears almost natural" (Macey 1996:142). In Althusser then, the crossing and braiding of Marxism and psychoanalysis is present, if not always evident as such.

The important influences of psychoanalysis in the Althusserian project, which are also crucial to the development of the theory of ideology, can be seen in the famous essay, "Ideology and ideological state apparatuses: notes towards an investigation" (1970). Here, as Macey notes, the question of how ideology functions, the extent of its power and the concomitant problem of agency, are played out in two directions. The first is to draw on Gramsci's model of a distinction between state and civil society, which allows Althusser to argue that civil society is a more discursive forum than the authoritarian state, thereby refining the functionalist element in accounts of ideology. Second, Althusser, in his attempts to account for the way in which ideology is internalized, posits the emerging concept of subjectivity. This is an account influenced by psychoanalysis and Lacan in particular; not only the "imaginary relation" of individuals to the material base, but more pronouncedly the hailing of subjects. The significance of linguistics is reminiscent of Lacan's borrowing from Saussure, language being crucial to the positioning of the subject within the social structure; Althusser's example of hailing does not just appropriate subjects into its ranks, but is the process by which subjects are produced and come to know themselves. This shares with Lacan's mirror stage the notion of the subject drawn into the social contract through a misrecognition; the subjects' recognition of self in the mirror image (Lacan) or urban space (Althusser) is the image of the self as other. To put it differently, the image of self as constructed by the other, the crucial point at which ideology takes root.

The presence of psychoanalysis in cultural studies, and more generally its influence on cultural theory, long precedes the encounter through feminism mapped by Hall and others. Psychoanalysis offered, and offers, concepts for thinking interiority (including fantasy and irrationality) an area as crucial to the Marxist project as it was to become to feminism. In retrospective accounts, such as James Donald's, the Freudian inflection of the Marxist account serves to illustrate a belief in the powers of theory to provide the answers (Donald 1991). According to Donald, the combination of linguistics, psychoanalysis and Marxism almost offered the "complete picture" of the "complex unity" of social relations. The notion that it was possible to get the theory right provides, it seems, an imperative for interdisciplinary exchange during the early stages of the cultural studies project, becoming ossified into something approaching a methodology through the triple alliance of Althusser, Saussure and Lacan. Linguistics offered to hinge intra-psychic reality, constructed in and through language, and the socio-economic reality; the ahistoricism of linguistics was, however to evidence the weakness of this model for Marxism.

Before moving on to the later formalization of a Lacanian psychoanalysis

through feminism, it would be useful to pause to consider what sort of history of cultural studies is being drawn on, and drawn. Certainly Althusser and Gramsci, Foucault, Derrida and other familiar names in the cultural studies forum, raise serious questions concerning the national "origin" of theory in the present moment of reading history. That is, does the context in which theory is produced matter to its subsequent application? How far does theory travel, and how can we recognize its transportation? In many ways the history of cultural studies invoked so far is *the* conventional history, where difficult questions of contexts are subsumed under the personalized accounts of a subject area; like the personalization of politics, the central issues become displaced onto characters who have a challenge to resolve. The conceptual difficulties that arise in the process of meeting this challenge tend to iron out the interrogatives that arise along the way. Indeed, the story of the origins of cultural studies in Britain is so well documented elsewhere to merit only a brief mention here; that is, the evolution of a discipline from the working-class experience of Hoggart and Williams, later Hall, resulting in the establishment of the Birmingham School. Raymond Williams is key to an understanding of this field within a British context, bridging the distance between on the one hand, a working-class English culture traditionally excluded from educational institutions and discourses of culture as authority, and on the other, the cosmopolitan influences of theorists such as Althusser and Gramsci, imported into cultural studies to develop further a Marxist understanding of culture. The conceptual relevance, it might be argued, overrode the contextual questions of theoretical conjunctions.

Yet, this is something of a paradox given that the founding tenet of cultural studies was to make social and historical frameworks account for, or at least connect with, the object of study; so that analyses of texts, for example, could no longer float above in an abstract space of moral or aesthetic consideration, as the traditional mode of English literature was given to, but would be read within a paradigm of historical materiality. It is perhaps strange that the nationally eclectic "pick and mix" of theoretical influences has only recently drawn critical attention. But there is a second paradox that emerges in contemporary rereading of cultural studies. The process of historical narrativization raises a further set of questions asking whether the Hoggart-Williams narrative of the origins of cultural studies uncritically reinstates the notion of discrete national boundaries. This would be particularly ironic for a discipline that has been so keen to problematize concepts of "nation".

Certainly Paul Gilroy's work has problematized the complacency of this reading, and in his most recent work, *The Black Atlantic* (1993), the notion of an authentic intellectual inheritance grounded in English working-class traditions and practices becomes implicated in the erasure of race. "Any satisfaction to be experienced from the recent spectacular growth of cultural studies as an academic project", warns Gilroy, "should not obscure its conspicuous problems with ethnocentrism and nationalism" (1993:5). The ethno-historical

perspective necessitates constructing an account of cultural studies where the interconnections with European traditions are represented, but more importantly "at every stage examining the place which these cultural perspectives provide for the images of their racialised others as objects of knowledge, power, and cultural criticism". The narrative of cultural studies needs to pay attention to the histories that British culture has both relied on and marginalized and repressed. That is, cultural studies needs to write in the dependency of a national culture economically, psychologically and culturally on others with whom it has a long and complex relationship. The insularity of the "canonised" genealogy of cultural studies is also attacked by Stratton and Ang (1996) who seek to situate the cultural studies discourse internationally. Like Gilroy, they are critical of the notion of a British cultural studies as an origin, the preciousness of which has led to a national critical elitism rooted in an English working-class radicalness. This is particularly pronounced, according to Ang and Stratton, in relation to American cultural studies where the rapid institutionalization of the discipline has been regarded as a sort of vulgar commercialization of a "political" project[2]. For Stratton and Ang, the position from which this narrative of the discipline is articulated, while always having been parochial, is increasingly archaic as the centre of economic, cultural and intellectual power shifts towards the Pacific Rim. A proposed position or route is "that of the diasporic", a term that Gilroy employs to describe the fluidity of culture and theory, the suspension between "where you're from" and "where you're at" (Gilroy 1990).

This suspension, or reflexivity concerning the past and present contexts of both subjectivity (Gilroy) and theory (Stratton and Ang) effectively denaturalizes the notion of origins, of insularity and purity, while also insisting on the context of emergence and enunciation as one that counts and requires critical attention. The following section attempts to retain this critical sensitivity to the historical and geographical contexts within which psychoanalytic discourses emerged, while also tracing the threads of intersection, cross-fertilization and conflict which dispel notions of theoretical purity. The particular renarrativization of psychoanalysis here is framed by the project of the book, concerned to trace the imbrication of cultural theory and psychoanalytic discourse. In the process it will, of course, effect its own displacement and repression of other narratives.

Psychoanalysis and cultural theory

The received history of feminism and psychoanalysis as a late stage which broke into cultural studies is challenged by other histories of feminism and psychoanalysis, as well as Marxism and psychoanalysis, which can be traced back at least as far as the 1920s. In reinserting these narratives it is possible to tease out the circuit of tensions that exist historically between the sites of Marxism,

feminism and psychoanalysis, and the various demands for either a theory of social change or explanations for the status quo. Psychoanalytic feminism of the 1970s, exemplified by the work of Juliet Mitchell and Jacqueline Rose, can be seen as a discourse emerging out of and in dialogue with earlier debates that interlace psychoanalysis and materiality, Marxism and feminism. Hall's reference to feminist psychoanalysis as the thief in the night occludes the ruptures and disputes between those two discourses, ruptures that point to the difficulty of psychoanalysis for feminism and Marxism. In introducing *Feminine Sexuality: Jacques Lacan and the Ecole Freudienne* (1982), Mitchell and Rose return to the early debates within psychoanalysis in the 1920s and 1930s (the femininity debates) to map the paths of Freudian theory, to which Lacan vehemently objected. Predominantly a dialogue between London and Vienna, the femininity debates refer to a dispute conducted in relation to a question of the status of the phallus in Freud's work and a predecessor for the controversy of Lacanian theory. In Britain this can be traced through the work of Karen Horney, Melanie Klein and Ernest Jones (the Freud-Jones debate), where culturalism and essentialism are pitted against one another. Whereas on the one hand the British school objected to Freud's account of the centrality of the phallus, the neglect of femininity (both the unconscious knowledge of the female body, and the mother–daughter relationship), their critique of phallocentrism in fact reinforced it; what it set out to refute it subsequently confirmed. By presenting an account of subjecthood that posits a primary femininity in place of Freud's theory of castration, the femininity debate returned psychoanalysis to the biological explanations from which Freud's emphasis on psychic bisexuality had departed.

In other locations, Vienna and Berlin, the debate between Marxism and psychoanalysis, or the political import of psychoanalysis, was paramount. This is not to suggest that feminism is outside a political arena; indeed, both debates are evidence of a desire to use Freud's work on psychic processes for a radical social critique, and therefore the projects overlap and converge. But the focus of the debate and the ensuing trajectories of each present distinct pathways. In parallel to these early debates on femininity within psychoanalysis was an ongoing psycho-political debate centring around the Berlin Institute of Psychoanalysis. The three key political psychoanalysts associated with the Berlin group, Wilheim Reich, Erich Fromm and Otto Fenichel, each present differing arguments for a political, Marxist psychoanalysis; they were in the 1930s engaged in fruitful dialogue with one another. Reich's Marxism was forged for him in Vienna (after the First World War) and then in Berlin, where experiences of working-class misery and the impotence of the political left (both of them instrumental in the rise of the Nazi Party) led Reich to join both the German communist party and the political psychoanalytic Institute in Berlin. Reich saw the liberation of sexual instincts as revolutionary. His attack on society's repression of sexual instincts, via the family, combined Marx and Freud to condemn the conservative family repression of the Oedipal complex, and

call for a radical, instinctual dissolution of the family. Reich's compatriot, Erich Fromm, shared the former's commitment to psychoanalysis and Marxism, evidenced by his association with the Berlin Institute where he trained with Hans Sachs and Theodore Reik. In addition, Fromm was involved with the broader cultural debates that attempted to theorize the social and psychic effects of mass production and consumer culture, in dialogue with the Frankfurt School, particularly Herbert Marcuse and Max Horkheimer. Although Fromm's political psychoanalysis differed from Reich in the sense that Fromm maintained his position as an historical materialist, they shared an allegiance in the departure from more conservative and orthodox uses of Freud. Yet although the psychoanalytic left provided a challenge to the normative developmental theories that had ossified into certain institutionalized approaches, it was not without its own problems of reductiveness. The demands for a political psychoanalysis tend, as Jacqueline Rose points out, to form a binary of the internal and external spheres, where the external "social" imposes problems on the internal "subject". Therefore the psyche has no mechanism of its own, but is simply acted on; it then follows that the resolution of internal conflict is to change the social conditions, the external event, which in turn reconfigures the Freudian model of the unconscious from "the site of a division" to "the vision of an ideal unity to come" (Rose 1986:9).

A political psychoanalysis, then, tends to come at the cost of a loss of complexity as the fabric of psychoanalysis is cut according to the needs of political explanation. However, a contemporary of the psychoanalytic utopians, Otto Fenichel, was a key figure who put psychoanalysis and Marxism together, "without losing like Reich and the culturalists, the unconscious and sexuality" (Rose 1993:105). Fenichel, who went on to lead the political Freudians of the Berlin Institute, retained a classical, orthodox Freudian position. Although, initially in political and psychoanalytical allegiance with Reich and Fromm, Fenichel was eventually extremely critical of both men for what he saw as their distortion and reduction of Freud's psychic conflict between society and the unconscious drives of sexuality. Fiercely antagonistic to Reich's theoretical reduction of psychoanalysis to simple notions of libidinal repression and to Fromm's cultural revisionism, which stripped psychoanalysis of a radical, sexual unconscious, Fenichel's political adherence to a classical Freud wanted to retain the complexity of a Marxist analysis of society and a psychoanalytic exposition of the unconscious. Fenichel's work and his realization that ideology operates at the level of psychic identity and drives can be seen as a direct precursor to Juliet Mitchell's feminist intervention in the 70s. Mitchell was to argue that "where Marxist theory explains the historical and economic situation, psychoanalysis, in conjunction with notions of ideology ... is the way to understanding ideology and sexuality" (Mitchell 1974:xxii). The argument is reversed here by Mitchell; for it is not that sexuality is ideological (as opposed to biological) but that ideology is constituted in and through sexuality.

This early history of Marxism, psychoanalysis and feminism is a significant although unacknowledged dialogue for cultural studies whose theoretical concerns throughout the 1980s invoke the same problematics and at times replay many of these earlier exchanges. Again Rose comments on the 1920s–30s: "Looking back at this moment, it is rather as if the theoretical/clinical debate about female sexuality and the more explicitly Marxist debate about ideology and its forms were historically severed from each other – at least until feminism itself forged, or rather demonstrated, the links" (Rose 1986:8). Mitchell's defence of Freud has to be seen in terms of both the early femininity debates and the psycho-politics of Fenichel. In *Psychoanalysis and Feminism* Mitchell argued that Freud's phallic sexuality emphasized the psychic and cultural construction of sexual difference and was therefore more useful to feminism than the ultimately biologically determined debates on femininity that followed in his wake. Freud's belief in women's phallic sexuality was not sexist, but evidence of his understanding of the psychic difficulty of both masculinity and femininity. Mitchell's critique of the legacy of left politics and psychoanalysis for an exclusive reliance on the "reality principle" paralleled her critical response to a contemporary (1970s) feminist socio-political attack on Freud. *Psychoanalysis and Feminism* signalled a crucial turning away from an empirically based, political psychoanalysis, and the introduction of a Lacanian reworking of Freud's radical ideas about sexual difference and identity which was to become the central psychoanalytic paradigm through which culture could be studied.

The possibilities for a radical political project between Marxism and psychoanalysis were transformed by the Lacanian rereading of Freud. The difficulty at the heart of psychic identity, so insistently presented in Lacan's work, rules out the promise of a revolutionary (and holistic) transformation of the subject, a predication that both Marxism and feminism had within their philosophy. For Lacan, psychic health is not about the return to a humanist subject, but about the adaptation of the subject within the laws of the symbolic, an adaptation that is always, and at its best, a struggle for a fictional coherence of identity, a struggle that is neither complete nor fully achieved. Thus, a Lacanian psychoanalysis circumscribes, in a way that must at some level be viewed as devastating, the political possibilities of identity. Only in its affiliation with poststructuralism does the broader social effects of decentred subjectivity, as the demise of an historic period of imperialism based on enlightenment thinking, become evident.

Lacan's account of language provides the apparent fix for the project of bridging psychical and social reality, and psychoanalysis and Marxism. Harnessing a Saussurian linguistics to the Freudian model allowed Lacan to argue for language as the structure through which the imaginary is formed, thereby producing an account of subjectivity in which the subject is produced in and through language.[3] The problematic of a predestined nature and the extent to which instinctual drives exist, or an inscribing socio-culture presupposed

by earlier debates, appeared momentarily at least to evaporate under the weight of such an explicatory model. Certainly Lacanian psychoanalysis was quick to become appropriated within the disciplines of English, with its emphasis on textuality, and film studies, where a Lacanian emphasis on the visual produced a whole enterprise in film analysis around the mechanisms of voyeurism and scopophilia (the morbid urge to gaze). However, what promised to be a descriptive analytical model turned in time into its own prescriptive orthodoxy or even a theoretical stranglehold, as Valerie Walkerdine comments, "In Screen theory the grip appeared so tight there was little escape" (Walkerdine 1995:322). Although these discrete areas of application might be regarded as the moments closest to a coherent meeting of cultural and psychical models, there are questions that have come to unsettle this account, not least, the absence of historic and geographic limits in the Lacanian model. Following on the heels of this critique of ahistoricism is the more specific charge that the symbolic presents a structure in stasis; the (im)possibility of change promotes further questions of agency, deviation and non-conformity, culminating in the critique that it is psychoanalysis itself, rather than the social regulatory law, that refers "deviations" to the place of deviance and, rather more disturbingly, psychosis.

What then of the political project of psychoanalysis, and what of its impact on and dialogue with cultural studies? Certainly the presence of psychoanalysis in the discrete disciplinary niches of English and film studies represents a diminution of Juliet Mitchell's earlier project that placed psychoanalysis central to the understanding of ideology, and therefore the workings of culture. There may be a sense in which psychoanalysis is dispelled from the cultural studies project, even where feminism and Marxism have made alliances, cast aside as the despised "feminine" position along with the femininity that it seeks to describe.[4] Which raises another question about the presence or absence of psychoanalysis in disciplinary terms; does psychoanalysis appear only or predominantly where feminism is already established (for example, film studies and English)? Is it only feminism that is seen to have a stake in theories of the unconscious, sexuality and gender? We suggest that there are (at least) four pathways that lead from the Marxist/feminist-psychoanalytic break-in. The first is feminism's reworkings – mostly internal critiques – of the Freudian–Lacanian paradigm. Teresa Brennan usefully surveys the field of critical debate and the Lacanian influence from a perspective of feminism and psychoanalysis (noting along the way that politics and psychoanalysis have been "unproductively entangled") identifying key points that have become impasses for theory. These amount to four: the status of the Lacanian symbolic, sexual difference and knowledge, essentialism and feminist politics, and the relation between psychical reality and the social. Although Brennan introduces these areas as "stagnant" and "deadlocked", she also goes on to argue for the validity of re-examining old ideas and texts in new contexts, which, like the analytic interlocutor, is always in

the process of becoming, of reconfiguring itself. Thus for Brennan, new readings, if not new frameworks, are a valid project in themselves (Brennan 1989:1–23).

A second trajectory, which could be viewed as much as a displacement of psychoanalytic concepts as a furthering, is the invocation of psychoanalytic terms in the discourse of postmodernism (and its imbrication with post-structuralism). Terms such as schizophrenia (Jameson) and psychosis (Baudrillard) are used as tropes or metonyms, standing in for whole shifts in economic, representational and psychological structures. The efficacy of such usages or deployments is arguable. At one level, the generalized terms of the debate replay the grand gesture of critical authority prophesying from a distance, a position and an authority the end of which postmodernism initially sought to represent. The scale and measure of the discursive frame makes an interesting comparison with the detailed texts of the feminist discourses above. But viewed from another perspective, the conjunction of psychoanalytic concepts and postmodernism offers a bridge between the theoretical and the clinical, the abstract and the historical. The work of Stephen Frosh, for example, reads psychoanalysis through a postmodern frame to argue that historically the cases that present are no longer hysterics or neurotics, but psychotics. The inability to connect spatially and temporally is not just a trope but a material (and imaginary) effect.

The third path is in some senses a dead end, or an acknowledgement of the arrival in a cul-de-sac after what might be viewed either as a journey of learning or the tortuous meanderings of the garden path. Given the ferocity of recent critiques of psychoanalysis it is tempting to agree with Robert Young that psychoanalysis and Marxism have remained polarized, providing antithetical explanations of the psychic and the social because they are, indeed, incompatible. He points out with recourse to the story of Oedipus that psychoanalysis is in itself a theory of the incompatibility of the psyche and the social. The rejection of psychoanalysis by Marxist feminists such as Michelle Barratt, on the grounds that it is exclusively ideological and universal, ignoring specific material structures of women's oppression such as family and state, is used by Young to further emphasize the distinct and incommensurate relationship between psychoanalysis and Marxism. If it is true that psychoanalysis has been used to argue for a decentring of the old unified humanist subject, recent critics point out that a fractured and decentred identity refuses the agency needed for women to collectively organize within an historical and political agenda. The danger, according to Young, of a return to an unproblematic unified subject is the imperialist identity that is manufactured through a singular and deterministic politics; the importance of psychoanalysis is that "it questions all that" (Young, 1991:155). This is a valid and important defence of psychoanalysis, but it leaves unresolved the criticism levelled from gay identity politics, postcolonialism, and feminism; that psychoanalysis decentres the subject, but it does so in "the name of the father", producing

accounts of sexuality, femininity and racial identity that are either patholo-gized, excluded or given as a purely relational category.

Negotiating the real

This points the final direction to where psychoanalysis has taken root in cultural theories of identity, where the project is not to rehearse the model of the dominant psychic law and its regulatory apparatus, but rather to recover by means of interlocution the exceptions, exclusions and prohibitions of the symbolic. The various manifestations of this route are simultaneously reconfi-guring a material and psychic history, which leads us back to the place where Gilroy, for example, writes his way back into modernity, not as confirmation of black people simply as Other, but in restating the sublimated and complex subjectivities of black peoples. The project is made more complex by the fact that the concept of history as a discipline has undergone a radical transforma-tion, as part of what may be conceived of as a broader crisis of reason that has affected, and even infected, all knowledges. This crisis has been characterized by a metatheoretical excursion into the methodological, epistemological and political grounding of areas of knowledge. In what has been named the New Historicism, emerging in the early 1980s in the work of Hayden White and Aram Veeser, the dichotomy of materialism and psychic reality and the proble-matic notion of "truth" has led to a critical practice that deconstructs history. The notion of an authoritative and unified history has been challenged in two ways. First, post-structuralists assert that totality is not expressive. Therefore different narratives within history compete against each other, but do not make up the whole picture. Second, the always mediated textuality of history replaces the notion of the real as the object of study. Thus, notions of narrative, rhetoric, metaphor, trope and positionality, methodologies borrowed from post-structuralist literary criticism, become the tools of analysis in the disman-tling of the texts of history. This approach interrogates notions of truth, and suggestively offers up the interior personalized narratives of memory and auto-biography as accounts equivalent in their claim to knowledge. Although it effectively confounds the call to separate out fantasy from reality, it provides other problems. Most significantly, the notion of history as textuality simply returns to the dominant narratives that exist in the archives and museums, neglecting the material conditions of production and circulation that confer authority. Thus minority histories, never represented or circulated as heritage (the most recent pervasive call on historic truth), remain unrepresented because not narrativized in authoritative form.

This problematic has been played out in a number of ways within cultural studies. Cultural materialism represents one approach committed to the exca-vation of minority cultures, although its critics refer to its methodology as "committing naïve acts of interpretation". Identity politics has most recently

grappled with both the demand of political (and historical) representation, and the postmodern eclecticism of subjectivity. The double demand deserves a double insistence; to retain the opportunity for multiple identifications that are often contradictory, provisional and shifting (mitigating against any one political identification), while retaining the notion that historically it is important to be counted at moments of political and representational crisis. This produces an argument for the need to retain *both* a notion of decentred subjectivity and an historical framework within which (subjective) change is possible, even demonstrable.[5] Identity politics then begins to negotiate the double demand: to retain history and the specificity of identities, which are also the specific differences of bodies, as well as the complexity of psychic life.

What has psychoanalysis to offer this project in beginning to unravel further the intricacies of psychic life, history and bodies? In Lacan's account, like the poststructural, the "real" is unrepresentable. The narcissistic self-referentiality of the post-structural subject collapses the external event into a closed referential shop of the imaginary and symbolic. Without access to the external event and the real of the body, the imaginary becomes closeted within a universal theory, or history of signs, supported by a linguistics that traps the unconscious under a dominant history of ideological signifiers and signs. The Lacanian symbolic is, as its critics point out, devoid of materialism, body or affects. If, in the history of psychoanalytic debate, Reich has idealized the unconscious to an extreme degree by the exaggerated meeting place he gives it between the body and culture, then Lacan's work has gone too far the other way, by refusing the unconscious any material or bodily connection to the symbolic. Reich's idealization of the unconscious, and the Neo-Freudian collapse of the unconscious into a symmetrical mirroring of socio-cultural norms both lose the theoretical complexity of unconscious mental representation and psychic conflict, a complexity found in both Freudian and Lacanian frameworks. But Lacanian psychic complexity comes at the cost of an unconscious stripped of its materialist and bodily relations to culture.

In psychoanalytic terms the question of history is precisely a question of how to negotiate the real. Whether this real is viewed as the literal historical event, or as (the Lacanian) psychotic body, the unrepresentability of the real is key to the Oedipal assumption that psychoanalysis and Marxism, or psychoanalysis and history, are incompatible discourses. But the problems of how to negotiate the real, the unrepresentable traumas of history, are more urgently pressed outside psychoanalytic discourse, perhaps most insistently by the postcolonial. Like Gilroy's critique of a self-professed and crafted insular British cultural studies, the American fiction writer and critic Toni Morrison rewrites the postmodern. Morrison's work deals with narratives of memory and history and the centrality of slave experience, not just for Afro-American culture but for the historic understanding of modernity. Morrison has argued that the intensity of slave experience marks out blacks as the first truly modern people. For her, modern life begins with slavery and "from a woman's point of view, in

terms of confronting the problems of where the world is now, black women had to deal with 'postmodern' problems in the nineteenth century or earlier" (Morrison 1993:178). The First World War, according to Morrison, and the holocaust of the Second World War, are not intelligible unless slavery is placed as a primary and unacknowledged holocaust. Remembering this traumatically unspeakable space becomes a part of Morrison's narrative archaeology in re-creating a cultural representation of the lost real event. Fiction hovers in a space between the real event and fantasy; Morrison's narrative strategy in her novel *Beloved* becomes a political re-inscription of a more bodily imaginary or unconscious. But what is more, the ghosts of the text press the question of the status of truth, knowledge and belief, questions that psychoanalysis sets out to interrogate but not resolve.

Placing slavery as an origin of European modernity also places it as a founding origin to Freudian thinking, a point that French psychiatrist Frantz Fanon repeatedly made in arguing that the black man remains the unconscious other to a white and colonial imaginary. Fanon worked in the 1950s, as a colonial psychiatrist in French Algeria. The work of Homi Bhabha returns to Fanon, reading his texts through a Lacanian definition of the imaginary. Bhabha argues that it is the two forms of identification associated with the imaginary, aggressivity and narcissism that construct dominant colonial stereotypes of the other. The colonial stereotype provides a knowledge of difference, at the same time as it disavows it. This stereotype works through fetishistic tropes, where a metaphoric masking of metonymic lack shows how the stereotype is both fixed and a fantasy. In other words, the racist stereotype is fixed as "the same old stories", for instance the Negro's animality. But at the same time compulsive repetition of these tired and familiar caricatures brings the fantasy; these stories are always "differently gratifying and terrifying each time" (Bhabha 1994:77).

Bhabha's work adds a much needed politicism to the contemporary institutional Lacanianism, where theory renders history without context. However, Fanon quite clearly challenged the universality of Lacan's Oedipal and imaginary structures, pointing out that castration for the negro is not only imaginary, but real. Bhabha's rereading of Fanon is not uncritical, and can be seen, not unlike Fenichel's wariness of Reich, to promote the psychic complexity of the work over more reflective social significations. Bhabha then warns against the narratives of reductive Marxism and existential humanism, which undoubtedly operate within Fanon's text. For sociological psychiatry has a tendency to explain away the radical turnings and convolutions of colonial desire. Again, according to Bhabha, the demands for political truth threaten to repress the contradictions of psychic life, suggesting that Fanon's fear was that "the politics of race will *not* be entirely contained within the humanist myth of man or economic necessity or historical progress" (Bhabha 1994:61).

Bhabha's rereading of Fanon privileges a Freudian/Lacanian unconscious

over deterministic Marxist accounts, echoing both Mitchell's case for feminism and Fenichel's earlier response to the political Freudians. The foregrounding of race by both Fanon and Bhabha raises the question of historicizing psychoanalysis most forcefully. It is Fanon's notion of the real that marks out his distance from Lacan, by making it, not an unrepresentable relation to the body, but a cultural and political necessity. The problem, however, then becomes how to locate the real without losing it to an exclusively psychic dynamic, or a reductive cultural signification. Fanon's socio-psychiatry at its worst redeems romantic ideals of a transcendental subject. But his commitment to psychoanalysis as a clinical, empirical and therefore historical praxis provides a material context, at a local and historical level, so lacking in the contemporary post-structuralist universalizing of a linguistic unconscious.

The project of this book can be seen within this dynamic, a renegotiation of psychoanalysis that includes re-examining the relation to the real, and the distinction between so-called "internal" psychic fantasy: the unconscious world of narcissistic identifications, and more external emphasis of cultural fantasy. It is a project characterized by a history of collisions more than synthesis. If for Fanon cultural fantasy seems to collide with political reality, Homi Bhabha's critique of what he sees as a collapse between proper unconscious fantasy and more conscious racist phantoms of fear and hate refuses to acknowledge that such blurring can be seen not so much as a denial of more complex distinctions, but more a rethinking of so-called "proper" boundaries between waking and unconscious life. Recent influences on psychoanalytic thinking and practice that move this debate forward have come from the philosophical tradition of phenomenology. This tradition, traced back to philosophical thinkers such as Heidegger, Merleau-Ponty and Levinas, has many affinities with poststructuralism. Indeed, both phenomenology and poststructuralism influence Lacan's and Derrida's thinking. But there remain significant differences between these approaches, particularly with respect to psychoanalysis. One crucial difference is the representational status of the body. In poststructuralist psychoanalysis, the phallic linguistic subject represses the body as the unconscious, albeit that the bodily unconscious returns to destabilize the speaking subject. A phenomenological approach does not make this internal division between language and the body. Instead, the body is always already a discursive body, there is no pre-Oedipal position outside language and culture and no privileged moment of linguistic repression or castration mobilizing the speaking subject. Derrida criticizes Lacan for aligning psychoanalysis with the truth claim of castration, thereby subsuming the body under a linguistic phallic mastery (see Derrida 1987). The phallus reinscribes a Cartesian duality or ego of mastery because it relegates the body of the woman as unknowable and unrepresentable. Luce Irigaray repeats Derrida's challenge to Lacan, when she says that Lacan's phallus splits language from the female body. Phenomenological psychoanalysis thus disputes the more structural determinants of an Oedipal linguistic division, because such a

division constructs a culturally speaking subject, on the basis of some excluded, prediscursive and purely ontological body.

The spatial conceptualization is a significant point of focus for, it is argued, Lacan's narcissistic imaginary can *only* be understood within a symbolic intersubjective field of language, an "out there" where the unconscious resides, not located in an encapsulated self but as a language between people. This radical insight of the intersubjective nature of the unconscious is the phenomenological influence on Lacan's thinking, that seems to contest the more conservative, linguistic underpinning of his Oedipal structures. Fanon's work illustrates this difference between an intersubjective and an Oedipal unconscious. By taking the intersubjective concept of the unconscious, Fanon points out that the unconscious other for the white man is the negro, the Oedipal complex explains this projection in terms of the white subject, but it does not account for the subjectivity or the unconscious of the black man. Again this understanding of the unconscious residing out there, between people, rather than inside the individual, has interesting implications for the subjective status and the translation of knowledge.

If the unconscious is not inside ourselves, but is in a sense the unknowability of the other and the other's discourse, then what does this mean for the translation of knowledge and discourses across cultures and historical situations of space and place? Discourses of knowledge and theory produce differing histories, but they produce them differently. Western discourses of the white male decentred subject, cannot necessarily know or translate other subject discourses from an eastern or African culture. Such translation merely produces that discourse as universally unknowable or other, when in fact they are only unknowable to that colonial subject. The implications of theorizing psychoanalysis from more situated, cultural subject positions become an increasingly urgent agenda for the field of cultural theory. The radical implications of a phenomenological approach, informing the work of Irigaray and Fanon, have been lost within a linguistic psychoanalysis which forgets the origins of Lacan's own thinking – namely the intersubjective and bodily transference. Psychoanalysis offers a model of how cultural difference is produced, but it also immediately blocks that understanding if it refuses to acknowledge its own subjective speaking position. How and where you interpret or place the unconscious has led to very different ways of understanding the notion of transference in clinical practice.[6] Traditionally the British school of psychoanalysis has inherited a positivist Freud, where the unconscious and reality-bound ego are in Cartesian fashion clearly divided. At its most extreme this unconscious is a caricatured Kleinian toolbox, where delineated objects and processes are accordingly interpreted. Winnicott's work moves this emphasis on a definable unconscious much more into the necessarily unknowable and relating space, thereby, paradoxically challenging, in ways quite similar to Lacan, the enlightenment split between the mind and body.

But although a phenomenological clinical practice emphasizes a transference

where the unconscious resides in a cultural, discursive and intersubjective space, the post-structuralist theorizing of Lacan (institutionalized within the academy of cultural criticism) has often ignored clinical fluidity in favour of a rigid application of his concepts. This of course has to be understood within a criticism of Lacan's own work, but it is also an instance of the clinical providing insights for cultural theory. Where Lacan's symbolic, Oedipal law of language provides a model of cultural psychic norms acceptable to cultural theory, it also sets up a division between language and the (female, black, homosexual) body. This, as Irigaray points out, is just as essentialist as the Cartesian model that splits the mind from the body. Lacan's symbolic division is further elaborated within a post-structuralist criticism which then delineates between cultural fantasy (external or real) and the unconscious proper. Certainly this division accords with the Lacanian opposition between the real and the symbolic, and the subsequent gap between unconscious fantasy and the real event. But it also refuses the necessary clinical blurring of these boundaries within the transference. As Irigaray has noted, it is the clinical blurring of the relationship between the real and the imaginary which represents Lacan's radical insights of an intersubjective cultural unconscious and at the same time critiques the structuralist opposition of his terms. A counter argument may find a return to the real which posits a complex *interrelation* between culture and the psyche, rather than a complex *incompatibility*. This might seem a rather optimistic and utopian gesture which once again threatens to collapse the unconscious into determining essentialist notions of culture. However, the post-structural refusal to challenge Lacan's obsolete real, the success of those arguments that seemingly dispose of any representation of reality, can be countered by an equally urgent demand to combat the present apathy of any political change with a psychoanalysis which responds to the ethics of the real event.

If, at the beginning of this introductory passage, the struggle was presented in terms of Marxism and psychoanalysis, and subsequently feminism, a further series of oppositions surface as the account evolves. In addition to the iterative appeal to a political psychoanalysis versus the unconscious are theoretical complexity versus reductive accounts, decentred subjectivity versus essentialism, cultural theory versus clinical practice. Scratch deeper, and further oppositions reveal themselves, for example, populist psychoanalysis versus academic, European versus American. These different conceptualizations and applications of psychoanalysis can be traced back to the inconsistencies of Freud's own work which provide the opportunity to privilege either a realist ego or a more narcissistic one. Because Freud's realist ego has been used to bolster a conservative and normative status quo, the model of the narcissistic ego, via Lacan, has become an almost revolutionary, academic alternative. It allows subjectivity to be understood as culturally constructed, and an old biologically determined model to be overthrown in favour of post-structuralist ones. However, lurking behind such laudable and political theoretical

concerns is a more worrying elitism, dangerously entwined with national and geographical distinctions. For instance, the familiar caricature of American ego psychology, as a conspiratorial regulator of normative social roles, is the reading of psychoanalysis within a political context; the blossoming of psychoanalysis in the US alongside a fairly right wing agenda. In addition, ego psychology is not just criticized for being right wing, but also for being reductive. A literal, populist rendering of Freud's work in ego psychology becomes demonized as a vulgarized American interpretation, leaving the high moral, but also sophisticated, ground to European post-structuralist theories, a dubious reading of national differences that can be compared to the equally worrying trend in cultural studies.

The contemporary debate of psychoanalysis and cultural studies then has to take account of the way in which class, nationality and ethnicity, as well as sexual and gender differences, inflect the terms and outcomes of its discourse. These differences affect not only the present model, but determine and focus the spotlight on which history we choose to return to. Adam Phillips makes this point in relation to political psychoanalysts such as Erich Fromm who have been so hastily dismissed for adherence to reductive "common-sense" views of culture at the expense of a more sophisticated, theoretical unconscious. Phillips has recently drawn attention to the way Fromm's work has been forgotten by the "Owners of Culture" precisely because of its populist style and therefore its mode of circulation. The revolutionary nature of Fromm's life and work was informed by a questioning of the inward psychoanalytical institution through external political reality. Perhaps the most effective way to bury Fromm's political challenge has been to reduce his writings to definitions of popular banality, summoning those distinctions of class and taste which reverberate along the axes of national ownership and cultural knowledge. Adam Phillips notes how the accessibility of writers such as Erich Fromm have led to their exclusion from the canon of important cultural thinkers:

> Since the most exhilarating psychoanalytic theory now idealizes incoherence, the pleasures of common sense in psychoanalysis can be lost. The common-sense analyst – Anna Freud, Heinz Kohut, often Fromm himself – tends to be accessible and reassuring. Their virtue is that they are often comforting, which is their vice to the more inspired bizarre analyst like Bion and Lacan, who demand not that their patients get better but that they pursue Truth. The common sense analyst knows what it is to get better. For the bizarre analyst, the whole notion of getting better smacks of omniscience (Phillips 1994:136).

The low status of "common sense" analysts, who have also been most vocal in emphasizing external reality, creates a factor of taste that skews any consideration of "the real". It provokes a necessary distancing from former attempts

to negotiate a semi-permeable membrane between history and psychic complexity. In arguing for a return to the political issue of the real we are not suggesting that the unconscious world be subsumed under an all-knowing, determining view of culture. By stressing a more undecidable threshold between the social and the psyche, we argue for a discursive interrelation which does not set up the terms as incommensurable, but allows, like an intersubjective transference, a more fluid response between imaginary and cultural worlds.

The papers

The overall project of this book needs to be set within this history of what constitutes a political, accountable psychoanalysis and its uses for cultural studies. It is a project at least in dialogue with, if not reacting to, the institutionalization of Lacanian psychoanalysis within the humanities. This is not to deny the success and surmounted difficulties that Lacanianism has achieved in over-turning concepts of the humanist subject upon which the humanities had built its foundations over many centuries. Another of its achievements has been to provide a model of the ways in which sexual difference is so persistently reinscribed and reproduced in our culture, offering a foothold for feminist critique within what was in the past, and arguably still is, the dominant narratives of political transformation. But this book evolves out of another moment, where it is no longer appropriate to reiterate critiques of the dominant relations of power; rather, critical focus has turned to the spaces of marginalized experience, not as others locked within the timeless binary of difference, but as complex subjects. The implication of our argument is that the dominant does not articulate all that there is to say about its others, just as it can never sufficiently contain nor control them.

It is no accident then, that the sections of this book take up issues of institutionalization, experience, history, corporeality and writing. The first two chapters of the book address the "use" of psychoanalysis for cultural studies and its founding Marxist tenet. Gary Hall's chapter, "Beyond Marxism and psychoanalysis", introduces the question of the subject in relation to Robert Young's assertion that Marxism and psychoanalysis have competing theoretical claims. Robert Young's privileging of psychoanalysis over Marxism is based on the tension, or at its most extreme, the incommensurable relationship that psychoanalysis theorizes between psyche and social. Because Marxism fails to recognize this tension or difficulty, it simply repeats (rather than examines) the incompatible division, thereby reiterating the split between inside and outside that psychoanalysis so successfully challenges. This fixed incompatibility is, however, re-addressed by Hall through rethinking the inside/outside problematic between the psyche and the social in terms of psychoanalysis. Examining the terms introjection and projection, Hall

returns to the work of Ferenczi and Freud to show how the boundary between the ego and outside world is continually blurred. Hall then uses this argument to reflect on the relationship between Marxism and psychoanalysis.

Stephen Maddison's chapter, in contrast, draws the interaction of psychoanalysis and cultural studies in a less kindly light. The success of one particular strand of psychoanalytic theory within cultural studies, argues Maddison, the Lacanian model of decentred subjectivity, has fitted with the structural critique of culture to produce a composite picture of subjectivity and its reproduction linguistically. But the same Lacanian model also fits with a broader intellectual movement, "a late post-modern enthusiasm for an evacuation of identity politics". Paradoxically, this model of subjectivity mitigates against the modes of articulation that cultural studies initially enabled; those of marginalized positions. Whereas Maddison acknowledges the existence of a body of work that seeks to re-present psychoanalysis while displacing the Oedipal narrative, he goes on to develop a polemical argument against the incorporation of psychoanalytic concepts into mainstream criticism and culture. According to Maddison, two concepts from psychoanalysis emerge into the broader socio-cultural sphere and gain a purchase on popular thought during the 1950s: that of inversion and latency. In relation to Tennessee Williams' work, Maddison offers a revisionist reading of inversion which situates it clearly within a sub-cultural framework.

In the following section, "Between psychic processes and culture", Andrew Samuels explores change as negotiation in "A new deal for women and men". In Samuels' account, change occurs in the spheres of the institution and the individual. Critical of the institutions of psychoanalysis, Samuels shows how complex political issues become reduced through the demand for institutional coherence; the pursuit of the Truth through one psychoanalytic approach leads to the idealization of a singular definition of the unconscious at the expense of equally complex political and social relations. According to Samuels, mobilizing a two-way street between psychoanalysis and politics will lead to a more accessible and interdisciplinary theory and practice. Equally, in the sphere of individual relations, intermixing and hybridity offer new potential. Examining present gender relations within contemporary western society, Samuels concentrates on the conscious and unconscious aspects of gender certainty and gender confusion. Whereas gender confusion has often been viewed as a problem, Samuels argues that it reflects a psychological maturity and complexity.

The relationship between politics and psychoanalysis is also the subject of Jan Campbell's chapter, which maps a prospective interdisciplinary debate between practice/experience and theory. Using Luce Irigaray's challenge to the linguistic phallus in Lacan's thinking, Campbell argues for a more bodily imaginary, creatively accessed in the transference, through the image. Mapping Irigaray's imaginary with a Winnicottian notion of unconscious experience, Campbell argues for an historical rememorizing of the real through

a more bodily imaginary. Noting the difficulties of mapping the divide between object relations and post-structuralist psychoanalysis, Campbell, however, emphasizes the necessity of bridging these different camps of practice and theory, experience and epistemological representation. The advantage of such interdisciplinary crossings to the field of cultural studies lies in the possibility of rethinking psychoanalysis in more historical, experiential and ethnographic forms. Campbell's understanding of the imaginary as a primary bodily narrative able to connect the experiential, sensual real with the symbolic, brings together the writings of Irigaray, Toni Morrison and Franz Fanon in a concluding discussion of the importance of historically situating psychoanalysis in both time and place.

The relationship of psychoanalysis to race and ethnicity is addressed by both Vicky Lebeau and David Marriott. Lebeau reconsiders *Black Skin, White Masks* to unravel Fanon's analysis of the black man as a (phobic) fantasy, intricately tied up with his analysis of white female sexuality, which he sees as integral to that "phobic structure of racism". Fanon's radical theorization of race is mixed with a somewhat disturbing account of sexual difference. Lebeau's chapter, however, utilizes this debate, not so much to explore the feminist readings of Fanon, but to discuss the role of the real within his work, "his analysis of the pressure of the real world on unconscious fantasy itself". Starting with Homi Bhabha's distinction between the real and the imaginary, Lebeau points out that Bhabha's difficulty with the analysis Fanon provides is not the distinction between unconscious fantasy and colonial reality, but to one between unconscious and cultural fantasy; Fanon's analysis collapses the Freudian unconscious into more realist notions of cultural fantasy. Rather than seeing this as the point of Fanon's turning away from psychoanalysis, Lebeau reads Fanon as opening up new ways of reading the dream work in terms of the cultural real event: "if the dream-work can be found on the outside, then the outside may be there in the dream".

David Marriott uses a psychoanalytical critique to analyse the symbolic absence of black paternity and social spectatorship within 1990s Afro-American cinema. In an analysis of *Jungle Fever* and *Boyz N the Hood*, Marriott traces the stories of fathers and sons. In these family romances, an excessive need to remember absent fathers becomes a paternal fantasy of return which, for the sons, is predicated on the brother's death. In other words the fantasy of reunion between father and son is undercut by the symbolic death of the brother. Marriott's psychoanalytic reading of spectatorship in Afro-American cinema does not replace paternal absence through the mother's name. Instead he foregrounds a black Oedipal drama to explain the boundaries of a "black politics of kinship and race", thereby tracing a violently ambivalent identification with the father, understood within a "sphere of mourning, reparation and of love".

The problematic relation between history and the psyche, a problematic made more complex by the reconfiguration of history through postmodern-

ism, is the subject of the next section. Tina Papoulias' chapter opens with the current critique of the Freudian emphasis on Oedipal internal fantasy at the expense of real experienced trauma. Jeffrey Masson's *Assault on Truth* sets a scenario of whether reality or fantasy are causal which, in his view, is clear. Masson's view is that the Oedipal complex is a cover-up for the reality of initial sexual trauma or sexual abuse. Papoulias explores this mutually exclusive choice (of reality or fantasy) through an analysis of the fixed understanding of memory and history. Detailing current debates on sexual abuse and false memory syndrome, Papoulias argues that to conceive of traumatic memories as unproblematically recollected events leaves us with a dominant and linear account of history and subjectivity. Papoulias' rereading of Freud, focusing on his analysis of the wolfman and concepts of deferred action, provides a more complex temporal account of history where the past is always reconstructed as a narrative, a fiction or fantasy of the initial unavailable traumatic event. However, Papoulias does not see this account of reconstructed memory to be at odds with those who posit the reality of sexual abuse.

Peter Nicholls follows Papoulias' postmodern emphasis on psychoanalytic temporality with his own exploration of "belated" history in terms of a poetics of opacity and literary form. How does language articulate, but also deny, access to the referential real event? Linguistic opacity is not just a stylistic and universal condition of language, rather it signifies "the deforming effect of a specific historic event". For Nicholls the initial traumatic historical event "remains somehow encrypted within a language", a language distorted "by its apparent refusal to refer". Nicholls deploys Abraham and Toroks' concept of the crypt to explain how the traumatic real is always in excess of language. Incorporated but unassimilated this "encrypted" experiential event is opaque to language but, as Derrida notes, this opacity generates rather than halts the process of language – reading and writing. Nicholls' exploration of this "generative unreadability" focuses on the language poetry of the American writers Lyn Hejinian and Susan Howe. In differing ways these writers rework the boundaries between opacity and readability, producing a form of Derridean unreadability "which sets reading in motion". Nicholls' own reading of these poets constructs a psychoanalytic account of temporality and memory which radically unsettles any definitive limits between linguistic narratives and history.

The chapters in Section V explore corporeality as the material condition of subjectivity; that is, the body is not simply the concrete, physical matter where the psyche happens to be located, but is the condition that limits and disrupts the psyche, defying the strictures of inside/outside. The essays here are part of the recent intense speculation on corporeality which subverts both the Cartesian concept of a rational mind that adminstrates and controls the body, and the Foucaultian notion that bodies are docile with respect to power, the objects of surveillance and regulation. In the first essay Harbord argues that fantasy is delimited and disrupted through the dialogic relation

between the psyche and the body. It is not only sexual difference and its subsequent production of gender that positions subjects within a field of identification and desire, but also discourses of taste, class and ethnicity that are written through and across the body. Returning to Freud's *Interpretation of Dreams*, specifically the analysis of the butcher's wife's dream, it is argued that the body is neglected in the critical discourses that have ensued. Reading the dream through the particular historical discourses of a European modernity (itself a state of crisis), consumerism and class mobility, the body emerges as the site of intense anxiety about class and gender intermixing.

Jo Croft's chapter turns to the adolescent body, noting its neglect in the critical enquiry of both cultural studies and psychoanalysis, as a troubling moment for narratives of linear identity. Paradoxically, it is the marked staging of adolescence that enables the notion of linear development to retrospectively recuperate this troubled moment within a broader life history. Croft returns to the work of analyst Willie Hoffer who, in the post-war period, studied the diaries of adolescent schizophrenics to establish "a borderline within a borderline", or the point at which normal psychosis and psychic normality reside. The relationship between the textual and the corporeal, the diaries and bodies of the adolescent subject, are used by Hoffer to develop a normative account of the development of the psyche. However, Croft's analysis points to the inconsistencies in Hoffer's interpretation which confuses the temporal and spatial in recourse to the categories "inside" and "outside". Hoffer's reading refers all expression to these spheres to the model of object relations; what this neglects is the broader historical narrative within which the diaries are situated. Such narratives problematize any developmental, positivistic accounts of the borderline along with the normative inside/outside dichotomy.

The final section of the book addresses a problematic and a concern of both cultural studies and psychoanalysis, of the relation of ontology, or the subjective being in the world, to epistemology, the knowledge of ourselves. Both essays exploit the recent renaissance in autobiography and the return to writing as a performative practice rather than an expressive passtime. Jonathan Rutherford's "Backward glances" reviews the significance of the burgeoning genre of autobiography written by men; although these narratives represent a turn away from traditional public discourses of male heroics, common to each is a search for the father. Rutherford's essay explores the reasons for this search for the elusive father, and why men are, in some senses both in spite of *and* because of the Oedipal complex, emotionally connected to the figure of the mother, whereas the social demands are to imitate and emulate the father. Freud's case study of Little Hans is referenced as the model of Oedipalization that precludes and denigrates femininity, making the mother the token to be fought for between men. The work of Melanie Klein is offered to reinvoke the power of the mother in the making of subjectivity. But what is important to understand about masculi-

nity, and the genre of autobiography, is that the process of narrativization does not approach a truth but a fabrication; "story telling can only invent origins, never find them".

In a similar vein Celia Hunt addresses the issues and limits of self-knowledge and creativity through the process of writing. For Hunt, the process of writing proposes questions about our own identities; does writing fictionalize our own conflicts and experiential histories, or does it perform or bring into being new ways of knowing the self, in other words, fabricate coherent yet fictional identities? In some respects writing may be seen as a trope for a postmodern sense of self as discontinuous, contingent and always bordering on emergence. Hunt proposes for writing a therapeutic act of bringing out the conflicted aspects of subjectivity. Using Karen Horney's work to articulate a model of unconscious and divided aspects of self, Hunt argues that creative writing can provide a vector for the exploration of these disparate parts of identity. Thus, subjectivity bleeds into fiction as well as vice versa.

This collection draws together many of the areas where work on psychoanalysis and cultural desire is taking place, although not always or often under the title of psychoanalysis. In a sense, these essays indicate the manifest ways in which psychoanalytic concepts have permeated the field of the humanities, existing in various locations. In some instances psychoanalysis may be the recognizable set of theories and practices that connect to clinical work; in other places, the framework may be stretched to almost beyond the point of recognition. To represent these diverse courses, and to map the tensions between psychoanalysis and culture, is the objective of *Psycho-politics and Cultural Desires*, an insistent return to the troublesome relation between two terms, a relation that is neatly indexed and condensed by this hyphen.

Notes

1. Conference held at The Institute of Romance Studies, London University.
2. See for example Stuart Hall's "Cultural studies and its theoretical legacies" (Hall, 1992) which marks the differences between British and American cultural studies in a way that can only be described as lamentable: "I don't know what to say about American cultural studies. I am completely dumbfounded by it." Hall goes on to talk of the danger of the moment of institutionalization, ". . . there are ways of constituting power as an easy floating signifier which just leaves the crude exercise and connections of power and culture altogether emptied of any signification. That is what we take to be the moment of danger in the institutionalization of cultural studies in this highly rarified and enormously elaborated and well-funded world of American academic life." See also the essay by Stratton and Ang in the same collection which notes the shift in power networks away from Britain towards the Pacific Rim, symbolized by the absence of British speakers at a cultural studies conference held in Taiwan. The authors wryly note that the absence of British presence was not noticed: "This reflects the current intensifying

formation of an Asia–Pacific network of interconnections, where Britain – and more generally, Europe – are hardly relevant" (p. 386).
3. It is interesting to note that Saussure's model of language has long since ceased to be the dominant form of explication within linguistics.
4. Rachel Bowlby makes this argument in "Still crazy after all these years", in Brennan *Between Feminism and Psychoanalysis* (1989), London and New York, Routledge, pp. 40–60.
5. See Diana Fuss (1991) and Kobena Mercer and Isaac Julian, 1988.
6. Object relations practice locates the transference and the unconscious in a relation between inside and outside, for example, a projection of the analysand's internal world onto the analyst's external reality-bearing presence. However in phenomenological schools of practice such as the Philadelphia Association, the unconscious and the transference is located in an intersubjective language of desire between two people, the analysand and the analyst.

References

Althusser, L. 1970. In *Lenin and Philosophy and other Essays,* B. Brewer (trans.). London: New Left Books.

Barthes, R. 1977. *Image-music-text*, S. Heath (trans.). London, Fontana.

Brennan, T. 1989. Introduction, *Between Feminism and Psychoanalysis*, T. Brennan (ed.). London: Routledge.

Bhabha, H. 1994. "Interrogating identity and the other question", *The Location of Culture*. London: Routledge.

Brennan, T. 1989. *Between Feminism and Psychoanalysis*. London: Routledge, 40–60.

Derrida, J. 1987. *The Postcard from Socrates* and beyond. Chicago, Illinois: University of Chicago Press.

Donald, J. 1991. "On the threshold: psychoanalysis and cultural studies". In *Psychoanalysis and Cultural Theory*, J. Donald (ed.). Macmillan/ICA, 1–10.

Fuss, D. (ed.) 1991. *Inside/out*. London: Routledge.

Gilroy, P. 1990/1. It ain't where you're from, it's where you're at . . .:the dialectics of diasporic identification, *Third Text* **13**, Winter, 3–16.

Gilroy, P. 1993. *The black Atlantic: Modernity and Double Consciousness*. London and New York: Verso.

Hall, S. 1992. "Cultural studies and its theoretical legacies". In *Cultural studies*, L. Grosberg, C. Nelson, P. Treichler (eds). London: Routledge, 277–86.

Hebdige, D. 1986. Postmodernism and "the other side". *Journal of Communication Inquiry*, 10/2, 78–98.

Lyotard, J.F. 1984. *The Postmodern Condition: a Report on Knowledge*. G. Bennington and B. Massumi (trans.). Minneapolis Minnesota: University of Minnesota Press.

Macey, D. 1996. "Thinking with borrowed concepts: Althusser and Lacan". In *Althusser: A Critical Reader*, G. Elliott (ed.). Oxford: Blackwell, 142–58.

Mercer, K. and I. Julian 1988. "Race, sexual politics and black masculinity". In *Male Order*: unwrapping masculinity. R. Chapman and J. Rutherford (eds). London: Lawrence and Wishart.

Mitchell, J. 1974. *Psychoanalysis and Feminism*. London: Allen Lane.

Mitchell J. and R. Rose (eds) 1982. *Jacques Lacan and the Ecole Freudienne; Feminine Sexuality*. New York: Pantheon.

Morrison, T. 1993. "Living memory: a meeting with Toni Morrison". In *Small Acts*, P. Gilroy (ed.). London: Serpent's Tail, 178.

Phillips, A. 1994. Erich Fromm, *Flirtation*. London: Faber & Faber.

Pile, S. 1996. *The Body and the City: Psychoanalysis, Space and Subjectivity*. London: Routledge.

Rose, J. 1986. "Feminism and the psychic". *Sexuality in the Field of Vision*. London: Verso.

Rose, J. 1993. "Where does the misery come from". *Why War?* Oxford: Blackwell.

Stratton, J. and Ang, I. 1996. On the impossibility of a global cultural studies: "British" cultural studies in an "international" frame. In *Stuart Hall: Critical Dialogues in Cultural Studies*, D. Morley and K. H. Chen, (eds). London: Routledge, 361–91.

Young, R. 1991. "Psychoanalysis and political literary theories". *Psychoanalysis and Cultural Theory: Thresholds*. J. Donald, (ed.). London: Macmillan/ICA.

Walkerdine, V. 1995. In *Mapping the Subject: Geographies of Cultural Transformation*, S. Pile and N. Thrift, (eds). London: Routledge.

Part I

Politics and psychoanalysis

1

Beyond Marxism *and* psychoanalysis

Gary Hall

The question of the subject

The theoretical and political importance issues around both gender and sexuality and race and ethnicity have assumed in recent years has meant that the "question of the subject" has been put back on the agenda for many Marxists. For some, this has led to a turning toward psychoanalysis, in the hope that it will be able to supply Marxism with a fully fledged theory of subjectivity. For others, such attempts to bring psychoanalysis to bear on Marxism have raised more questions than they have answered. Indeed, for others again, the very idea that psychoanalysis is somehow able to add a "theory of subjectivity to the field of historical materialism" is a mistaken one, given that, as Ernesto Laclau observes, the "latter has been constituted, by and large, as a negation ... of subjectivity (although certainly not of the category of the subject)" (Laclau 1990:93). What, then, is the value of psychoanalysis for a historical materialist understanding of subjectivity? More to the point, do Marxism and psychoanalysis have competing claims to theories of the subject?

Robert Young provides an excellent starting point for addressing these questions in an essay on "Psychoanalysis and political literary theories" (Young 1991), which is part of a collection, *Psychoanalysis and Cultural Theory: Thresholds,* that arose out of a series of talks on the subject of psychoanalysis and culture held at the Institute of Contemporary Arts (ICA) in London during the first few months of 1987 – a period when positions on this issue "entrenched in the 1970s were becoming more fluid and self-critical", according to the volume's editor, James Donald (Donald 1991a:vii). Situated by Donald (alongside the rest of the collection) at "the intersections between psychoanalysis and cultural theory" (ibid.), Young's essay begins with a description of psychoanalysis as:

a theory of unhappy relationships which has itself a long history of unhappy relationships. In the first place there is the story of the tense relationships within psychoanalysis between analysts, the psychoanalytic politics that has been charted by Paul Rozen, Francois Roustang, Sherry Turkle and others. In the second place, psychoanalysis has a history of relationships with other disciplines (Young 1991:139).

Young proceeds to trace the history of "three of those relationships in the cultural sphere" – psychoanalysis' relationships "with literary criticism, with Marxism, and with feminism" (p. 139). In doing so, he draws attention to some of the difficulties involved in any attempt on the part of Marxism and feminism to utilize psychoanalysis to produce a theory that unites and synthesizes the individual psyche with the social.[1]

The way in which this relation is usually set up is that Marxism and feminism require a theory of the subject, while psychoanalysis, in turn, needs a theory of the social. The problem with such a pairing for Young is that:

psychoanalysis is already a theory of the articulation of the subject with the social: if desire, for instance, is the desire of the Other, this means that desire is a social phenomenon. Furthermore, as the concept of desire itself suggests, psychoanalytic theory amounts to the argument that the structure of the relation of the psyche to the social is one of incommensurability – which does not mean that they do not interact, only that they do so unhappily. When social analysis has tried to link itself with psychoanalysis, it seems often not to have noticed this aspect of psychoanalytic theory, with the result that those marriages between forms of social explanation and psycho-analysis, far from being able to exploit psychoanalytic theory, merely repeat the narrative of incompatibility that it theorizes (Young 1991:140–1).

Moreover, Marxist theories, in particular, have, as Young observes:

always tended to restrict [their] use of psychoanalysis to the occasional im-portation of one or two concepts in order to construct a model; [they have] never allowed it to affect the terms of [their] own theory substantially. Psychoanalysis always remain marginal ... [they have] rarely attempted to rethink the Cartesian inside/outside dichotomy on which this division is based and which psychoanalysis challenges. A reworking of that dualism would also have to include a rethinking of the exclusive claims of the forms of rational logic on which is predicated (Young 1991:149).

The "lesson of psychoanalysis" is that the psychic and the social have to be "lived simultaneously as two irreconcilable positions" (1991:142). Young privileges psychoanalysis for "producing a theory of that incompatibility", rather than getting "caught up in acting out the conflict between the psychic

and the social", as Marxism and feminism tend to do (1991:142). Or rather, as Marxism and socialist feminism tend to do – for while alliances between Marxism and feminism "have tended to be predicated on the exclusion of psychoanalysis" (1991:150), other forms of feminism, Young insists, have found psychoanalysis "critical for [their] redefinitions, critiques and explorations of questions of sexuality and identity" (1991:153).

Feminism, then (and especially what Young refers to variously as "Derridean feminism" or "deconstructive feminism"), like psychoanalysis – indeed precisely because of the very closeness of its relationship to psychoanalysis – contains at least the possibility of theorizing the psyche's "incommensurable" relation to the social. By contrast, those theories associated with Marxism (including Marxist feminism) are presented as admitting few such possibilities – in no small part because psychoanalysis has been far less important to Marxism, serving merely as "a worry at its margins" (1991:153). But can psychoanalysis really be prioritized over Marxist theories of culture on the basis that the "living through of this incompatibility between the individual and the social is the subject . . . of psychoanalysis", whereas this incompatibility is not the subject of Marxism (1991:142)? Even if it is not achieved by means of a close relationship with psychoanalysis, does Marxism offer so few opportunities for theorizing the individual's "incompatibility" with the social? What is more, is this placing of Marxism in what appears to all intents and purposes to be an oppositional relationship with psychoanalysis not a little curious, given the vigour with which Young, both here and elsewhere, has defended the emphasis placed by both psychoanalysis and deconstruction on the instability of such polarities?[2] In particular, is Young's positioning of Marxism as the subordinate term in this relationship not somewhat at odds with his insistence in an earlier essay on "The politics of 'The politics of literary theory'", that "as deconstruction has shown, there is no text so politically determined that a clever reading cannot show how it simultaneously undermines its own strategy, thus allowing the text to be claimed for an opposing point of view" (Young 1988:133).

Certainly, there may be strategic reasons for situating psychoanalysis in a hierarchical relationship to Marxism. Marxism and psychoanalysis might have competing claims to theories of the subject, but it is Marxism that has tended to dominate the realm of cultural theory. Is privileging psychoanalysis over and in opposition to Marxism therefore a strategic move on Young's part, designed to participate in the dislodging and overturning of Marxist discourse from its traditional position of theoretical dominance? (As feminism has never been quite so powerful, it is presumably less of a threat.) Even if it is acknowledged that, in arguing against the institutional validation of Marxist theories of the subject, the emphasis Young places on psychoanalysis may have a certain strategic effectiveness, a number of questions remain. For while Marxism may still cast a large shadow over the sphere of cultural analysis (as Campbell and Harbord observe in their introduction to this

volume, a cultural study which has Marxism as its "explicit foundation" is the "ascending star in international [academic] circles and institutions" (this book, Chapter 1)), its degree of influence in the public arena, in Europe at least, has declined rapidly in the face of the new dominant consensus which, following the collapse of the Soviet Union, regards Marxism, more often than not, as a rather uninteresting discourse that has long since been outmoded. Seen from this point of view, does Young's subordination of Marxism to psychoanalysis in "Psychoanalysis and political literary theories", while offering a challenge to Marxism's "success" within the realm of cultural theory, not at the same time risk participating in the anti-Marxist discourse that is currently holding sway in the capitalist economies of the West?

Ironically, it is precisely the prevailing common sense tendency to dismiss Marxism as a discourse relevant only to a superseded age, that has prompted a recent "deconstructive" intervention into the texts of Marx by Jacques Derrida. Prior to *Specters of Marx* (Derrida 1994), the Marxist text had constituted merely a series of "lacunae" in Derrida's work, "explicitly calculated to mark the sites of a theoretical elaboration ... *still to come*" (Derrida 1981:62). But the consensus around the death of Marxism and the triumph of capitalism's free-market economy has become so unbearably dominant in the late 1980s and early 1990s that, for Derrida at least, there is an urgent need to reawaken the spirit of Marx's critique of capitalism via a "radical critique" of Marx's critique. The "radical critique" Derrida invokes in *Specters of Marx* is not to be confused with the previous sort of dogmatic Marxism with which Marxism is often associated. Indeed, it was the wish to reject this dominant, oversimplified interpretation of Marxism that for a long time made producing a "transformational" reading of Marxism difficult for Derrida. Instead, he takes his:

> inspiration from a certain spirit of Marxism [that] ... has always made of Marxism in principle and first of all a *radical* critique, namely a procedure ready to undertake its self-critique. This critique *wants itself* to be in principle and explicitly open to its own transformation, re-evaluation, self-interpretation (Derrida 1994:88).

So if one problem with Young's subordination of Marxism to psychoanalysis in "Psychoanalysis and political literary theories" concerns doubts about the strategic effectiveness of such a manoeuvre, another relates to the way in which Young's presentation of Marxism tends to underestimate the extent to which, as deconstruction implicitly, and Derrida explicitly, suggest, Marxism contains within itself the possibility of its own self-critique, its own "transformation, re-evaluation, self-interpretation". Given sufficient time and space, it would be possible to demonstrate how Derrida's turning to the ghosts in Marx's text – not only the ghost of Marx, but the function of the ghost in Marx's text – and his following through of this thread in *Specters of Marx*

to produce a rereading of Marxism which is neither simply for Marxism, nor simply against it, enables a theory of the "incommensurable" relation of the subject to the social to be located within the Marxist text itself. For the moment, such an analysis seems superfluous, given that Young himself, in an essay on "The dialectics of cultural criticism" published only five years after "Psychoanalysis and political literary theories" (1991), insists that the "incompatibility of the inside and the outside" psychoanalysis theorizes is also the subject of a "particularly acute and productive" Marxist analysis (Young, 1996:12,17).

The paradoxes of cultural criticism

In "The dialectics of cultural criticism" Young described how the dilemmas and paradoxes of the "inside/outside dichotomy" have found themselves "endlessly perpetuated" in cultural criticism: from Burke, Coleridge and Arnold's embodiment of the concepts of culture in cultural institutions; through the attempt to shift the proper subject of cultural criticism's attention outside such institutions and onto history, in the case of New Historicism, and culture, in that of Cultural Materialism; to Fredric Jameson's "celebrated use of the The Bonaventure Hotel as a metaphor of the post-modern condition" (Young 1996:16) of cultural criticism, in which the intellectual is trapped on the inside of the institution, unable to get out. Indeed, Young observes that:

> the very project of cultural criticism involves an impossible contradiction in which the critic places him or himself simultaneously inside and outside the culture. Here we find the basis for the interminable dialectic between inside and outside so characteristic of critical thinking. In general, individuals are inclined to endorse either one side or the other . . . The result is that the options remain entirely within the culture's own terms, and thus either repeat it uncritically . . . or take up a transcendent position outside it and dismiss it in its entirety with the critic implicitly claiming that he or she possess the true knowledge (or the culture) which the culture itself lacks (Young 1996:18).

This tendency is particularly apparent in critical attitudes toward popular culture. As I have demonstrated elsewhere in an analysis of some of the irreducible paradoxes that produce cultural studies (Hall 1996, from where the remainder of this paragraph has been taken), the criticism of popular culture is often set up very much in this way: as a struggle between two opposing forces – "cultural critique and critical distance versus a populist celebration of the popular" (Webster 1990:85). What is more, it is a struggle neither side seems able to win. What one side sees as assuring victory, the other regards simply as a product of the same old problem; one that it is all the more

dangerous for being held up as some sort of solution. Cultural criticism conse-
quently appears trapped in a struggle in which the representation of popular
culture is restricted to a choice between what appear to be two equally unaccep-
table positions – between a traditional intellectual position of critical difference
and distance on the one hand, and a populist denial of any such difference on
the other – with each side charging the other with adhering to the very
system of rules and values it should be questioning. For traditional critics,
what cultural studies needs is a supply of the sort of critical weaponry only
they can deliver. From this point of view, cultural studies is not nearly objec-
tive, critical or political enough. Meanwhile, cultural studies argues in turn
that, far from offering any sort of solution, such critical weapons are in fact pre-
cisely the problem. As far as cultural studies is concerned, the only thing it
would be making if it were to join forces with a criticism already weakened
by elitist, masculine norms, is the sort of strategic mistake that has already
cost cultural criticism too dear.[3]

An answer to the "quandary of the choice between" these two positions,
Young argues, can be found in a "short but difficult" early essay by the
Marxist cultural critic Theodore W. Adorno entitled "Cultural criticism and
society" (Young 1996:18). According to Young:

> . . . the deficiencies readily apparent in both methods led Adorno to propose
> that the practice of criticism must sustain an antinomy between them, a
> critical dissonant doubling which parallels the fissure within the individual
> work of art or in culture itself. He argues that cultural criticism must
> operate through an incompatible logic of transcendent and immanent
> critique, even if that removes the finality associated with either and substi-
> tutes unresolved contradiction. Dialectical criticism must sustain a duality,
> which means a continuous mobility between contesting positions (19:21).

The point, then, for the Adorno of "Cultural criticism and society" (in marked
contrast to the emphasis on reproducing this interminable dialectic usually
identifiable and identified in the work of the coauthor of "The culture
industry")[4] is "not to choose between the two at all, but to practice both at
the same time dialectically" (p. 18): "The dialectical critique of culture must
both participate in culture and not participate. Only then does [the cultural
critic] do justice to his object and to himself" (Adorno 1973:12; 1981:33; cited
in Young 1996:21,23).

For Young, Adorno's analysis thus indicates the "need to utilise the more
complex antinomies that deploy in a productive way the paradoxical, impossi-
ble position of the cultural critic in society" (p. 23). But what interests me
here is not so much the possibilities Adorno's essay contains for "coming to
terms" with the paradoxical doubleness of the cultural critics' situation both
"inside" and "outside" culture at once, but rather the consequences of
Young's reading of this essay for his own earlier representation of Marxism

in "Psychoanalysis and political literary theories" (Young 1991). What Young's account of Adorno's Marxist cultural criticism seems to suggest is that, although psychoanalysis may, indeed, be itself a theory of the individual's "incommensurable" relation to the social, it is not the only discourse capable of theorizing this relation. Marxism also appears to contain the possibility of producing a theory of the incompatibility of the subject with the social. Like feminism, Marxism is apparently capable of that "different kind of thinking and different kind of logic [that is] necessary to think them both together at the same time" (Young 1991:151–2). The question, then, as Young observes, is "to what extent such thinking would still be Marxist, or even perhaps feminist" (1996:152)? Or psychoanalytic, I might add? For surely a reworking of the "inside/outside dichotomy" on which Marxism bases its relationship to psychoanalysis calls for a rethinking, not just of Marxism's relation to psychoanalysis, or even of the identity of Marxism, but of the very institution of psychoanalysis itself.

Subject boundaries

Simply following one attempt on the part of psychoanalysis to theorize the relation between the subject and the social is enough to suggest that the challenge psychoanalysis represents to the "Cartesian inside/outside dichotomy" has implications more profound than even those Young suggests. One way in which psychoanalysis has sought to address the issue of the individual's relation to the outside world is by means of its examination of that mode of object relationship Sandor Ferenczi termed "introjection". A complete history of a psychoanalytical account of "introjection" – which can be traced through the work of Sigmund and Anna Freud, Melanie Klein, and, more recently, through that of Nicholas Abraham and Maria Torok, and Jacques Derrida – is unnecessary at this point. Suffice it to say that, for psychoanalysis, the identity of the subject is based precisely around its ability to distinguish itself from those objects that lie outside it. Taking up Ferenczi's term for use in his own work, Freud perceives the relation between subject (ego) and object (external world) as having its origin in the link between this opposition and the pleasure principle: "In so far as the objects which are presented to it are sources of pleasure, [the ego] takes them into itself, 'introjects' them (to use Ferenczi's 1909 term); and, on the other hand, it expels whatever within itself becomes a cause of unpleasure (the mechanism of projection)" (Freud 1915:133). This antagonism between projection is first expressed, for Freud, in the language of the "oldest" instinctual impulses – the oral – through the contrast between digesting and expelling. Here the ego's ability to judge has its basis in the desire to "introject into itself everything that is good and to eject from itself everything that is bad" (Freud 1925:439). ". . . the judgement is: 'I should like to eat this', or 'I should like to spit it out'; and, put more

generally: 'I should like to take this into myself and to keep that out' " (ibid.). In this way, by constantly testing and measuring itself against external objects, the ego is able to determine the boundary limits of its identity.

Psychoanalysis, and in particular Freud, thus utilizes the antagonism between introjection and projection to provide an answer to the question of the ego's relation to the outside world. What remains unexplained is the nature of this process' role in doing so. As Laplanche and Pontalis point out, the question still needs to be answered is does the operation of introjection and projection *presuppose* a distinction between ego and object (inside and outside), or does it actually *constitute* it (Laplanche and Pontalis 1973:353)? In *The Language of Psychoanalysis,* Laplanche and Pontalis present Anna Freud as having taken the first view. For her, ". . . we might suppose that projection and introjection were methods which depend on the differentiation of the ego from the outside world" (quoted in Laplanche and Pontalis, 1973:353). By contrast, the "Kleinian school . . . has brought to the fore the dialectic of the introjection/projection of 'good' and 'bad' objects, and . . . treats this dialectic as the actual basis of discrimination between inside and outside" (Laplanche and Pontalis, 1973:355). It seems to me, however, that despite their respective differences, both accounts of the process of introjection and projection take for granted the idea that such a distinction *can* be achieved. Both therefore assume, rather than question, the nature of the ego's relation to the external world, and as a result, far from explaining this relation, continue to obscure it.

To use the contrast between introjection and projection as a means of explaining the ego's relationship to the outside world, then, is to presuppose the very point at issue. If it is the boundary that governs and separates the ego from the object that is in question, employing the antagonism between introjection and projection to describe or account for this boundary suggests that this problem has already been settled. The contrast between introjection and projection thus acts as a means of obscuring, rather than explaining, this relationship, all the more so given that it is this very boundary which actually defines the antithesis between introjection and projection; and which, moreover, provides a means of distinguishing between these two concepts. The question of the relation between the ego and the object is not resolved by the antagonism between introjection and projection, for the simple reason that introjection and projection are themselves entirely dependent on this relation. To raise the question of the ego's relationship to the outside world, the concepts of introjection and projection must themselves be put in question. We need to ask what exactly is meant by the terms "introjection" and "projection"?

A return to Ferenczi quickly reveals that providing an answer to this question is not a simple task. In his essay on "Introjection and transference" Ferenczi employs the term "introjection" to refer to a process of enlargement of the ego. According to Ferenczi, it is "a kind of diluting process, by means

of which [the neurotic subject] tries to mitigate the poignancy of free-floating, unsatisfied, and unsatisfiable, unconscious wish impulses" (Ferenczi 1909:40). This process he places in diametrical contrast to projection.

> Whereas the paranoiac expels from his ego the impulses that have become unpleasant, the neurotic helps himself by taking into the ego as large as possible a part of the outer world, making it the object of unconscious phantasies ... One might give to this process, in contrast to projection, the name of *Introjection* (Ferenczi 1909:40).

Ferenczi thus uses the distinction between the inside and the outside of the ego to both define introjection and projection, and to distinguish between them. Introjection takes external objects and their inherent qualities into the inside; while projection reverses this process, expelling objects from the inside to the outside. But it is the very boundary between the ego and the external world that Ferenczi's analysis of the concepts of introjection and projection also seems to bring into question and blur.

Immediately after drawing the above dividing line between introjection and projection, Ferenczi observes that "... the neurotic is constantly seeking for objects with whom he can identify himself, to whom he can transfer feelings, whom he can thus draw into his circle of interest, i.e. introject" (1909:40–1). Ferenczi's neurotic, then, wants to bring "inside" only that part of the external world with which he can identity. But does this very identification of the neurotic with these external objects put the absolute exteriority of these objects in question? Are these objects straightforwardly outside? Is it a part of the outside world that the neurotic wishes to introject, or is it merely a part of himself;[5] a part of himself, moreover, which has to be projected outside onto the external world *before* it can be introjected inside?[6]

The boundary between the ego and the external world is further complicated by Ferenczi's account of projection. "We see the paranoiac on a similar search for objects who might be suitable for the projection of 'sexual hunger' that is creating unpleasant feeling", he writes in "Introjection and transference" (1909:41). The first part of each process is thus "similar", according to Ferenczi: both the paranoiac and the neurotic are looking for objects onto which they can transfer their feelings. The difference between introjection and projection appears to rest with the final destination of those feelings. Whereas those of the neurotic are drawn back "into his circle of interest, i.e. introject[ed]", those of the paranoiac are attached to an external object and left there. As a result, "the psychoneurotic suffers from a widening, the paranoiac from a shrinking of his ego" (1909:41). But given that a question mark has already been placed against the apparent externality of the objects introjected by the neurotic, should the externality of the objects onto which those impulses that have become a "burden" (p. 40) to the paranoiac are projected not come under similar suspicion?

Freud's account of the origin of projection in "Beyond the pleasure principle" (Freud 1920) suggests that the answer to this question is a positive one. Speculating on the relationship between consciousness and mental process, Freud presents a picture of a living organism that is susceptible to two types of stimulation: those excitations which emanate from the external world and which would kill the organism if it were not "provided with a protective shield" against such stimuli (1920:300); and those excitations the organism receives from within and against which there is no such shield. Lacking the protective barrier which safeguards it from external stimuli, Freud describes how, in order to defend itself from "any internal excitations which produce too great an increase of unpleasure", the "living vesicle" resorts to projecting them outside itself: "there is a tendency to treat them as though they were acting, not from the inside, but from the outside, so that it may be possible to bring the shield against stimuli into operation as a means of defence against them. This is the origin of *projection*", Freud states (1920:301). Henceforward, the unpleasurable internal excitations are perceived as stimuli emanating from, and belonging entirely to, the outside of the organism. But this outside, as Freud suggests, is not expelled to some absolute exteriority. On the contrary, it is forged and maintained at the heart of the inside, and is kept outside by the very living organism from which it is supposed to be separated.

As this point, a question mark can be placed against the respective abilities of both introjection *and* projection to distinguish between the inside and the outside of the ego. While they maintain a distinction between the inside and the outside of the ego, both of these processes also work to problematize any such distinction. For both introjection and projection, the inside is also on the outside, while the outside is both inside and outside too.

This inability to distinguish once and for all between the inside and the outside of the ego creates a problem for the identity of both introjection and projection – based, as both of these concepts are, precisely on this distinction. Introjection cannot be placed in a relationship of "diametrical contrast" to projection. On the contrary, introjection and projection are mutually interdependent, one upon the other, both inside and outside each other at the same time. And this in turn has profound implications for the way in which psychoanalysis understands the ego's relation to the outside world.

Initially, the boundary of the ego – the place where it comes into contact with the outside world – appears to have two related functions. First, this boundary acts as a container or body bag for the identity of the ego. Secondly, it acts as a protective apparatus or shield, in order to defend and separate the contents of this bag from the outside. By passing objects through this boundary, either by introjection or projection, the ego maintains its relation to the external world. However, this boundary also has a third function. At the same time as maintaining a distinction between the inside

and the outside of the ego, it also acts as a point of communication and exchange between the contents of this bag and the outside. Writing on the "skin" of the ego, first in an article and later in his book *Skin Ego*, Didier Anzieu puts it as follows:

> The primary function of the skin is as the sac which contains and retains inside it the goodness and fullness accumulating there through feeding, care, the bathing in words. Its second function is as the interface which marks the boundary with the outside and keeps that outside out; it is the barrier which protects against penetration by the aggression and greed emanating from others, whether people or objects. Finally, the third function – which *the skin shares with the mouth and which it performs at least as often* – is as a site a primary means of communicating with others ... (Anzieu 1989:40, my emphasis; see also Anzieu 1980:30).

The boundary between subject (ego) and object (external world) is thus complex and paradoxical: it still divides the ego from the object, from the external world; but at the same time the boundary between the ego and the external world joins them together, too. It is not only that which helps establish and define the identity of the ego; it is also that which puts that identity at risk, by opening the ego toward others.[7] Indeed, it is only by means of this relationship with outside others that the ego is formed.

We have already seen how, for Freud, the infant's capacity to establish the limits of its identity has its basis in the ability to take some objects into itself and to keep others out. For Ferenczi, too: "We may suppose that to the new-born child everything perceived by the senses appears unitary, so to speak monistic. Only later does he learn to distinguish from his ego the malicious things, forming an outer world, that do not obey his will". This is what Ferenczi calls "the first projection process, the primordial projection" (Ferenczi 1909:41). However, it is not just the way in which the ego introjects into itself everything that is good and ejects from itself everything that is bad that is of interest here. More interesting still is what this process says about the formation of the ego. For the ego here does not constitute a datum point from which self-awareness is built. Rather, its existence is linked to the existence of external objects. The ego is inconceivable without primary experience of the existence of external objects. It is the existence of these external objects (the outside world), after all, which provides the ego with an awareness of its own self. The ego is thus born out of its relationship to the external world; the latter is a constituent part of the ego. The ego is formed precisely by means of this pressure from outside: it is only by defending the ego as an ego that the ego can be constructed as an ego. The boundaries that enclose the ego thus need to be crossed *before* they can be established. Ego and object are both inside and outside each other at the same time.

The end of analysis

This reformulation of the "inside/outside dichotomy" has profound implications, not just for the identity of the concepts of introjection and projection, nor even that of the subject, but for the very identity and institution of psychoanalysis, despite (or precisely because of) the fact that these questions occur in, and arise out of, psychoanalysis. Before developing psychoanalysis, Freud had tried to "cure" hysterical symptoms by means of hypnosis. The intention was to use hypnosis to introduce the idea of going to sleep to the patient. A further idea would then be introduced, suggesting to the patient that the symptom or its cause should be relieved. However, in 1896 Freud abandoned hypnosis and began to concentrate exclusively on analysing the discourse of the hysterical patient. It was with this abandonment of hypnosis – and with it Freud's rejection of those practices that depend on the analyst influencing the patient in some way (advice, manipulation, suggestion, hypnosis, etc.) – that the "science" of psychoanalysis was established.

The difference and identity of psychoanalysis is thus founded on the distinction it draws between the knowledge and information emanating from the analyst, and that which originates with the patient. Whereas the hypnotist makes direct suggestions to the patient, the psychoanalyst concentrates simply on listening to, and interpreting, the patient's account of his or her own life story. Of course, it would be too simplistic to suggest that psychoanalysis is able to maintain such a distinction between the analyst and the patient. As we have seen, it is difficult to conceive of a boundary or dividing line that is not already a form of joining. Nor can psychoanalysis itself be said to believe in any simple way that it has achieved such a division. It quickly became clear to Freud that the analyst could still sometimes have an influence on the autobiographical story told by the patient – not least through the tendency of patients to *transfer* unconscious ideas onto the person of the analyst; that is, to play out, as Ferenczi puts it, "long forgotten psychological experiences" in their current relationship with the analyst (Ferenczi 1909:31).[8] Nevertheless, working in accordance with the idea that the "proper", or at any rate "ideal", psychoanalytic experience is one where the analyst does not intervene in the patient's story, but is merely an aid to the patient's own self-analysis, Freud aimed to maintain the distinction between the analyst and patient, and in this way retain control over the analysis, by means of the dissolution of the subjective elements of the analysis: what he literally called the transference. It was through the analysis of the transference that Freud attempted to identify what belonged to whom in the analysis. Hence the importance he placed on analysts themselves undergoing analysis, so that they could be aware of their own involvement in the analysis, their own transference onto the patient, the process he termed counter-transference. As Freud observes in "Analysis terminable and interminable":

Among the factors which influence the prospects of analytic treatment and add to its difficulties in the same manner as the resistances, must be reckoned not only the nature of the patient's ego, but the individuality of the analyst . . . It almost looks as if analysis were the third of those "impossible" professions in which one can be sure beforehand of achieving unsatisfying results. The other two, which have been known much longer, are education and government. Obviously we cannot demand that the prospective analyst should be perfect before he takes up analysis, in other words that only persons of such high and rare perfection should enter the profession. But where is the poor wretch to acquire the ideal qualifications which he will need in his profession? The answer is, in analysis of himself, with which his preparation for this future activity begins (Freud 1937:247–8).

The analysis of the transference is therefore crucial to the identity of psychoanalysis. And indeed, it is the lengths psychoanalysis has gone to to investigate this relation – and thus, in a sense, question its own analytical activity – that makes it so interesting. But in an extraordinary essay which returns to psychoanalysis' founding split from hypnosis, Mikkel Borch-Jacobsen has demonstrated that it is:

> . . . difficult, at least, to maintain the thesis (authorized by Freud himself) of a pure and simple break between psychoanalysis, on the one hand, and hypnosis and suggestion, on the other. Psychoanalysis no doubt did found itself on the abandonment of hypnosis – but only, it must be recognized, to see hypnosis reappear, sometimes under other names or in other forms, at the cross-roads of all questions; hence the importance of reconsidering this so-called abandonment, not so much to initiate a "return to hypnosis" as to examine, in light of the questions Freud was asking himself in his last phase, the reasons why in his first phase he had believed, rather too quickly, that these issues were settled. In other words, what is important is to reconsider what Freud called the "prehistory" of psychoanalysis, to return to it with the suspicion that this "prehistory" belongs to a certain future of psychoanalysis rather than to a long-dead past (Borch-Jacobsen 1993:43–4).

Returning to that part of the history of psychoanalysis that extends from the rejection of hypnosis to the identification of transference as a "distinct problem", Borch-Jacobsen shows how Freud finds it "more and more difficult, even impossible, to distinguish between the mechanics of analysis and those of hypnosis, even though hypnosis was supposed to have been discarded once and for all" (1993:54), precisely because it is the relation between the ego and the object that produces the ego. As Borch-Jacobsen emphasizes, the "ego forms itself or *is born*" (1993:60) out of its relationships with the object:

> Thus there is no ego, no subject to form an idea of the object and/or of the identificatory model, since it is precisely in the singular "event" of the appropriation ... that the ego as such emerges ...
>
> This first "emotional tie" to another, which is also the unrepresentable event of my "own" birth, can never be remembered, never to recalled to memory. This is also why it can never be "dissolved", as Freud would have it (1993:60–1).

This creates problems for any notion of an irreducible distinction between hypnosis and psychoanalysis. The rigorous, "proper", "true" analysis is supposed to begin where hypnosis ends – but it is now through the analysis of the relation between the ego and the object, through hypnosis, the transference. However, this relation cannot be dissolved, as it is constitutive of the ego; it is precisely the relation between the ego and the object that produces the ego. Far from being a clear difference between them, the distinction between psychoanalysis and hypnosis is blurred:

> Thus one issue – the beginning of "true" analysis – now becomes another, distressing one: the end of analysis. The end of analysis becomes the end of analysis. Is there an end to analysis, after all? Is analysis "terminable"? Can hypnotic transference be "dissolved"? Or is it instead the part of analysis that cannot be analyzed, of which the patient cannot be cured ... ? (1993:57).

This question is of vital importance to psychoanalysis, since it is upon this issue that the identity of psychoanalysis rests. Yet it is a question that psychoanalysis has never really been able to answer. "In the end", Borch-Jacobsen asks, "is psychoanalysis, to use Francois Roustang's expression, 'long drawn out suggestion'?"

> There is certainly no way to decide on the basis of the facts. Indeed, can we ever determine whether an analysis is really over, whether the transference is really gone? It is more useful to ask what the transference *is* – that is, to ask ... what *hypnosis* is – if we want to know whether the transference can truly be eliminated. This last question rapidly brings us back to the original "enigma", that of the ... "emotional tie", the "rapport *sans* rapport" with another. For it is this rapport that Freud found in the transference, and perhaps it was simply pointless to try to dissolve it. It is constituent of the "subject" and, as such, unrecollectable, untellable, unrepresentable – indissoluble (1993:57).

Beyond psychoanalysis

The attempt in psychoanalysis to theorize the subject's relation to society by means of introjection thus points not only to that which exists "beyond"

Marxism and feminism, but "beyond" psychoanalysis, too.[9] The implications of psychoanalytical rethinking of the "inside/outside dichotomy" are consequently more profound than even those suggested by Young in "Psychoanalysis and political literary theories".

To bring psychoanalysis to bear on Marxism in order to provide Marxism with a fully developed theory of the subject may be, as Young insists, to overlook the extent to which psychoanalysis is already a theory of the *impossibility* – and yet at the same time, I would stress, also the *possibility* – of the subject's relation to the social. But even so, the last word on this subject cannot be left with psychoanalysis. Not only is such a manoeuvre questionable on strategic grounds, it also risks underestimating the extent to which Marxism is capable of providing a productive theory of the subject's incompatible relation to the social – as Young himself demonstrates with his analysis of Adorno's cultural criticism.

Accordingly, it might be thought that the solution is not to choose between the competing claims to theories of the subject of Marxism and psychoanalysis at all, but to utilize both paradoxically at the same time. In his introductory chapter to the collection in which "Psychoanalysis and political literary theories" appears, James Donald, emphasizing that a boundary is a point of separation as well as exchange, reminds us "of the impossibility of any easy synthesis between [psychoanalysis and cultural theory], or of any final answers to the enigmatic transactions between subject and culture, between the psychic and the social" (Donald 1991b). "Any attempt to merge the two bodies of theory blunts [the] specific insights" of each, according to Donald, while at the same time ignoring their "incompatibilities and contradictions". Refusing to collapse psychoanalysis and cultural theory into each other, Donald argues that "[w]hat seems potentially more fruitful is the dialogue in which, although the two discourses remain distinct – they are always to some extent talking past each other – the questions untranslatably specific to each can provide new thinking and insights in the other" (1991b:3). But what tends to be overlooked in such a conception of the threshold or boundary between Marxism and psychoanalysis, the subject and social, is the way in which these two discourses are not merely placed in a state of unresolvable tension by the "different kind of logic and different kind of thinking [that] would be necessary to think them both together at the same time" (to, in Donald's words, "hang onto to (sic) both the operations of the unconscious and the opacity of the social at the same time" (1991b:8)), the very identities of Marxism and psychoanalysis are brought into question.

As Young insists in "Psychoanalysis and political literary theories", if Marxist theorists want to add a psychoanalytical ready-made theory of the subject to their thinking (and not just restrict their use of psychoanalysis to the occasional importation of "one or two concepts"), they need to rethink the "Cartesian inside/outside dichotomy" on which Marxism's relationship to psychoanalysis is based and which psychoanalysis challenges. The question

then is to what extent such theory would still be Marxist? "[I]f Marxism did re-examine its relation to psychoanalysis", Young asks, "would it end up in the dreaded position of being post-Marxist?" (1991:149)[10] But the challenge psychoanalysis presents to the "inside/outside dichotomy" has implications not just for the identity of Marxism. In rethinking this dichotomy, psycho-analysis also draws attention to a series of ambiguities and paradoxes that both radically disrupt psychoanalysis, and expose it to modes of knowledge and analysis it can comprehend only by rethinking its own identity. Psychoanalysis' "rethinking of the exclusive claims of the forms of rational logic" on which both the "inside/outside dichotomy" and the relation between Marxism and psychoanalysis are "predicated" thus risks going beyond itself. Beyond psycho-analysis, as it were. Providing a theory of the relation between Marxism and psychoanalysis, the subject and the social, is therefore not a matter of somehow negotiating the "intersections" or "threshold" between Marxism and psychoanalysis. The question of the subject rather opens up both Marxism and psychoanalysis to the possibility of discovering new forms of knowledge in the margins of, and spaces between, Marxism *and* psychoanalysis.

Notes

1. Young notes that ". . . in so far as it implies bringing a body of knowledge, psycho-analysis, to bear on a body of unselfconscious experience, literature", psycho-analytic criticism no longer exists. The reason for this is that Lacan's emphasis on the role of language in psychoanalysis has meant that the "knowledge of psycho-analysis is at least partly grounded in literature", and therefore cannot at the same time provide a "grounding for literature" (Young 1991:143).
2. See, for example, "The same difference" (Young 1987) where, referring to the dualisms through which the politics of sexual difference are often thought, Young concludes that "the trick . . . is not to get caught within the binary terms of an either/or choice" (p. 91). While such a strategy "remains unthinkable accord-ing to the normal procedures of logic", Young invokes Derrida's reading of Freud in "Difference" (Derrida 1973; Derrida 1982) to demonstrate that "it is pre-cisely the moves of such procedures that deconstruction, and indeed psycho-analysis, trace" (p. 90).
3. For more recent contributions to this debate, which appeared too late to be included in my earlier essay, see Grossberg 1995; McRobbie 1996a; McRobbie 1996b.
4. For a reading which locates, albeit very briefly, some of the impossible contradic-tions Young ascribes here to cultural criticism in Adorno and Horkheimer's cele-brated essay "The cultural industry: enlightenment as mass deception" (Adorno and Horkheimer 1979), see my "It's a thin line between love and hate": why cultural studies is so "naff" (Hall 1996:31–2).
5. Hence also the distinction Abraham and Torok are able to establish between incor-poration and introjection. For Abraham and Torok, incorporation is "to refuse

to take within oneself *the part of oneself contained in what has been lost* ... in short, it is to refuse introjection" (Abraham and Torok 1980:5, my emphasis).

6. An obvious objection can be raised against this notion of introjection as somehow already involving projection. As we have seen, for Freud, the opposition between introjection and projection is closely related to that between pleasure and unpleasure. Introjection is the process whereby the ego takes inside itself those objects which are a source of pleasure, while projection enables the ego to expel that part of itself that has become a source of unpleasure. How, then, can the ego's identification with these external objects be ambivalently inhabited by projection, if it is only the unpleasurable that is projected?

One answer to this question can be found in Jacques Lacan's account, in "The mirror stage as formative of the function of the I as revealed in psychoanalytic experience" (Lacan, 1977), of how the moment when a child recognizes its own image in the mirror is crucial for the construction of the ego. As Laura Mulvey so succinctly puts in her highly influential analysis of "Visual pleasure in narrative cinema":

> The mirror phase occurs at a time when children's physical ambitions outstrip their motor capacity, with the result that their recognition of themselves is joyous in that they imagine their mirror image to be more complete, more perfect than they experience in their own body. Recognition is thus overlaid with misrecognition: the image recognised is conceived as the reflected body of the self, but its misrecognition as superior projects this body outside itself, as an ideal ego, the alienated subject which, reintrojected as an ego ideal, prepares the way for identification with others in the future (Mulvey 1975:9–10).

7. As Anzieu suggests, the ego's boundary limits take on a similar form to the mouth. Like the mouth (which is also a point of digesting/taking in), this boundary is not just a system of edges that divides inside from outside; it is also and equally a blurring of edges.

In view of this, the location "precisely in the mouth" (Abraham and Torok 1980:6) of both Freud's boundary between introjection and projection, and Abraham and Torok's boundary between introjection and incorporation, takes on an added significance. We have already seen how this is expressed for Freud "in the language of the oldest – the oral – instinctual impulses". And for Abraham and Torok, too:

> It is because the mouth cannot articulate certain words, cannot utter certain phrases ... that in fantasy one will take into the mouth the unspeakable, the thing itself. The empty mouth, calling in vain to be filled with introjective words, again becomes the mouth greedy for food over speech: unable to obtain nourishment from words exchanged with others, it will take within itself, in fantasy, all or part of a person, the only depository for that which is nameless. When introjection proves impossible, then, the mouth's empty *words* do not succeed in filling up the subject's emptiness, so he fills it instead with an imaginary thing (1980:6).

Although it is outside the scope of the present essay, it would be interesting to examine the consequences of this reading of the relation between the ego and the outside world for the rigorous distinction that is traced between introjection and

incorporation by Abraham and Torok (Abraham and Torok 1980); and also for their related notion of the "crypt" (Abraham and Torok 1986). For one such analysis of the "problematic border between incorporation and introjection", and of what he refers to in *Specters of Marx* as the "effective but limited pertinence of this conceptual opposition" (Derrida 1994:178, n.3), see Derrida's "Fors" (Derrida 1986).

8. Significantly, transference lies at the origin of introjection, for Ferenczi. "The first loving and hating is a transference of auto-erotic pleasant and unpleasant feelings on to the objects that evoke those feelings. The first 'object-love' and the first 'object-hate' are, so to speak, the primordial transferences, the roots of every future introjection" (Ferenczi 1909:42).

9. I am here following Homi Bhabha's use of the term "beyond" in "The postcolonial and the postmodern: The question of agency". The phrase "beyond theory" is employed by Bhabha in this essay to suggest "that beyond theory you do not simply encounter its opposition, theory/practice, but an 'outside' that places the articulation of the two – theory and practice, language and politics – in a productive relation similar to Derrida's notion of supplementarity" (Bhabha 1994:179).

10. As Young indicates, the challenge psychoanalysis presents to the "Cartesian inside/outside dichotomy" and the "exclusive claims of the forms of rational logic on which it is predicated" (Young 1991:149) also has implications for conceptions of politics based on traditional notions of agency and identity. At the end of "Psychoanalysis and political literary theories", Young acknowledges that for some Marxist feminists, by deconstructing the identity of the subject, psychoanalysis has undermined those coherent notions of agency and self that are needed if women are to organize themselves politically around their identities as women. But the problem with the call for a return to the old, totally unified and unproblematic notion of the subject, Young suggests, is that it presupposes, among other things, "a kind of imperialism of identity, so that we are only allowed one, and our politics then has to have a single meaning too". "The point about the challenge of psychoanalysis", Young concludes, "is that it questions all that" (1991:155). But for Jan Campbell and Janet Harbord, in their introduction to this collection, Young's privileging of psychoanalysis:

> leaves unresolved the criticism levelled at psychoanalysis from gay identity politics, postcolonialism and feminism; that psychoanalysis decentres the subject, but it does so in "the name of the father" producing accounts of sexuality, femininity and racial identity that are either pathologized, excluded or given as a purely relational category (pp. 12–13).

And yet I would argue in turn that psychoanalysis' *rethinking* of the subject does not disavow the possibility of political change. What it does suggest is that the relation between the subject and the social needs to be rethought, so as not to exclude other forms of identity and agency operating beyond the patriarchal, rational and Cartesian inside/outside models. This would apply not just to Marxist feminist notions of political agency, but to the forms of gay identity politics and theories of race to which Campbell and Harbord refer. Once again, the problem would then be to what extent such thinking would still be political? What is it to be political? Is the political a genre, or, as Lyotard suggests in *The Differend*, a name for the heterogeneity of regimes and incommensurability of genres which resists any such totalization? (Lyotard 1988:138, n.190).

References

Abraham, N. & M. Torok 1980. "Introjection – incorporation: mourning and melancholia". In *Psychoanalysis in France*, S. Lebovici and D. Widlocher (eds). New York: International University Press.

Abraham, N. & M. Torok 1986. *The Wolf Man's Magic Word: a cryptonymy*. Trans. N. Rand. Minneapolis, Minnesota: University of Minnesota Press.

Adorno, T. 1973. *Negative Dialectics*. Trans. E.B. Ashton. London: Routledge & Kegan Paul.

Adorno, T. 1981. "Cultural criticism and society", *Prisms*. Trans. S. & S. Weber. Cambridge, Massachusetts: MIT Press.

Adorno, T.W. and Horkheimer, M. 1979. *Dialectic of Enlightenment*. Trans. J. Cumming. London: Verso.

Anzieu, D. 1980. "Skin ego". In *Psychoanalysis in France*, S. Lebovici & D. Widlocher (eds). New York: International University Press.

Anzieu, D. 1989. *Skin Ego*. New Haven, Connecticut: Yale University.

Bhabha, H.K. 1994. *The Location of Culture*. London: Routledge.

Borch-Jacobsen, M. 1993. "Hypnosis in psychoanalysis". In *The Emotional Tie: Psychoanalysis, Mimesis and Affect*. Trans. A. Brewer and X.P. Callahan. Stanford, California: Stanford University Press.

Derrida, J. 1973. "Difference". In *Speech and Phenomena and other Essays on Husserl's Theory of Signs*. Evanston, Illinois: Northwestern University Press.

Derrida, J. 1981. Positions: interview with Jean-Louis Houdebine and Guy Scarpetta, *Positions*. Trans. and annotated by A. Bass, Chicago. Illinois: University of Chicago Press.

Derrida, J. 1982. "Difference". *Margins of Philosophy*. Trans. A. Bass, Chicago, Illinois: University of Chicago Press.

Derrida, J. 1986. Fors: the anglish words of Nicholas Abraham and Maria Torok, B. Johnson (trans.). In *The Wolf Man's Magic Word: a Cryptonymy*, N. Abraham & M. Torok, N. Rand (trans.). Minneapolis, Minnesota: University of Minneapolis Press, xi–xlviii.

Derrida, J. 1994. *Specters of Marx: the State of the Debt, the Work of Mourning, and the New International*. Trans. P. Kamuf. London: Routledge.

Donald, J. 1991a. Preface. In *Psychoanalysis and Cultural Theory: Thresholds*, J. Donald (ed.). London: MacMillan.

Donald, J. 1991b. "On the threshold: psychoanalysis and cultural studies". In *Psychoanalysis and Cultural Theory: Thresholds*, J. Donald (ed.). London: MacMillan.

Ferenczi, S. 1909. "Introjection and transference"*Contributions to Psycho-analysis*. Trans. E. Jones. London: Stanley Phillips.

Freud, S. 1915. Instincts and their vicissitudes. *PFL* **11**, Harmondsworth: Penguin, 133–8.

Freud, S. 1920. Beyond the pleasure principle. *PFL* **11**, Harmondsworth: Penguin, 275–338.

Freud, S. 1925. Negation. *PFL* **11**, Harmondsworth: Penguin, 437–42.

Freud, S. 1937. Analysis terminable and interminable. *S.E.* **XXIII**, 216–53.

Grossberg, L. 1995. "Cultural studies vs. political economy: is anyone else bored with this debate?" *Critical Studies in Mass Communications* **12** (1), 72–81.

Hall, G. 1996. It's a thin line between love and hate: why cultural studies is so "naff". In *Authorizing culture, Angelaki*, G. Hall & S. Wortham, (eds), **2** (2), 25–46.

Lacan, J. 1977. "The mirror stage as formative of the function of the I as revealed in psychoanalytic experience". *Ecrits*. Trans. A. Sheridan, London: Tavistock.

Laclau, E. 1990. "Psychoanalysis and Marxism". *New Reflections on the Revolution of our Time*. London: Verso, 93–6.

Laplanche, J. & J. B. Pontalis 1973. *The Language of Psychoanalysis*. London: Hogarth.

Lyotard, J.-F. 1988. *The Differend: Phrases in Dispute*. Trans. G. Van Den Abbeele, Manchester: Manchester University Press.

McRobbie, A. 1996a. "Looking back at new times and its critics". In *Stuart Hall: Critical Dialogues in Cultural Studies*, D. Morley and K.H. Chen (eds), London: Routledge, 238–61.

McRobbie, A. 1996b. All the world's a stage, screen or magazine: when culture is the logic of late capitalism, *Media, Culture and Society*, **18**, 335–42.

Mulvey, L. 1975. Visual pleasure and narrative cinema, *Screen*, **16** (3), 6–18.

Webster, D. 1990. Pessimism, optimism, pleasure: the future of culture studies. *News From Nowhere* **8**, Autumn, 81–103. An edited version of this essay appears in *Cultural Theory and Popular Culture: a Reader*, J. Storey (ed.) 1994. London: Harvester Wheatsheaf, 531–46.

Young, R. 1987. The same difference. *Screen* **28** (3), Summer, 84–91.

Young, R. 1988. The politics of "The politics of literary theory". *The Oxford Literary Review* **10**, nos. 1–2.

Young, R. 1991. "Psychoanalysis and political literary theories". In *Psychoanalysis and Cultural Theory: Thresholds*. J. Donald (ed.), London: MacMillan, 139–57.

Young, R. J.C. 1996. The dialectics of cultural criticism. In *Authorizing Culture, Angelaki* G. Hall and S. Wortham (eds), **2** (2), 9–24; also in Young, R. J.C. (1996), *Torn Halves*, Manchester: Manchester University Press. [Unfortunately, *Torn Halves* appeared too late to be considered here.]

2

Gay men and female identification: pathology or cultural dissent?

Stephen Maddison

Lesbian and gay scholars have good reason for their investments in cultural studies, a relatively new paradigm that we have had a significant hand in propagating. A small personal anecdote may illuminate the needs that have led to such investment. In my final year as an undergraduate on an English literature degree at a reasonably well respected red brick university I took a course on philosophy in literature. At this time I was enjoying my new political life as an out gay man. I had entered higher education so that I could be gay by escaping the small and deeply provincial town in which I grew up. In 1988, just after Clause 28, gay politics on campus was thriving, and I threw myself into it with an enthusiasm that slaked the frustrations of small town narrow-mindedness. By my final year I had also begun to be fired up by my course, while still whirling and shrieking round campus, caught up in fights for lesbian and gay officers on the Union Executive, campaigns for AIDS and HIV welfare policy, etc. The point is, I was not politically timid about my sexuality: indeed, you could say that I was striving to become a human pink triangle. One of the set books on this philosophy and literature course was *Death in Venice*, and I remember the professor in charge of the teaching starting his lecture by instructing us that Mann's novel had nothing whatsoever to do with homosexuality, but was instead concerned with more substantial issues of an ethical and artistic nature. What is striking about my recollection is that even though I instinctively knew this professor was wrong and deeply prejudiced, anxious even, I did not challenge him. Moreover, I did not think to challenge him because his was the intellectual authority; I had no access to dissident rhetorical strategies with which to engage him on an appropriate footing. Naturally I bitched and carped about him with an outlandish relish in the bar after seminars, but taking on this brown acrylic clad harbinger of open-mindedness was beyond the scope of my newly hatched and brashly affected gay pride.

Cultural studies and psychoanalysis

Respectable canonical literary criticism, enshrined in institutions of higher education, preserves and naturalizes a very specific view of the world. That is, it takes an upper middle-class, white, heterosexual and male anxiety about the manliness of sitting around and gossiping about books and fashions it into a discrete and manly search for truth. Reading becomes not so much the indulgence of fantasies and desires, but the search for the one true meaning: a meaning which authenticates the particular arrangement of contingent identities I have just specified. Readings which have the audacity to diverge from this one true meaning are wrong. That is of course, if such readings ever find articulacy, given that the framework of literary criticism lacks the tools for such transgression, and given the institutional power of this ideology (once you know that certain kinds of arguments get your essays failed, your theses unpublished, you learn to ventriloquize the appropriate discourse). Similar kinds of ideological activity have defined all the traditional arts disciplines, as well as subject paradigms within psychology, geography, anthropology and sociology, although each has its own particular history and set of circumstances through which such authorities become instated.

These intellectual orthodoxies have been variously eroded, moderated, mediated and emboldened by the growing popularity of the critical apparatus provided by cultural studies. The history of British cultural studies is liberally covered elsewhere, through its development in the work of Richard Hoggart and later the Marxists, Raymond Williams and E. P. Thompson, and later still through the interventions of the members of Birmingham University's Centre for Contemporary Cultural Studies (CCCS), notably Stuart Hall (see During 1993; Franklin, Lury and Stacey 1992; McGuigan 1992; Sinfield 1994 and Sparks 1996). These developments leave us with a rough date for the emergence of cultural studies around the earlier years of the 1970s. Once this kind of work became disseminated, scholars in other fields, who had not necessarily been encouraged to think culturally within the frameworks of their subject paradigm, but whose own political affiliations had been suppressed by the terms of these paradigms, began to incorporate the materialist discourse cultural studies offered into their own work. Subsequently we could suggest that it has become fairly unthinkable to teach media studies and film studies (both disciplines which developed out of cultural studies initiatives), and geography, sociology and anthropology without substantial coverage of a range of English, American and European cultural theory. It should be unthinkable to teach literary criticism without an engagement with the discourses of cultural studies, but many lovers of brown acrylic and their like still persist in their reactionary ways.

Presenting cultural studies in such unified terms is a little fallacious; currently there are diverse kinds of intellectual practice engaged under its rubric. Developments in cultural studies have reflected those in the socialist politics of

which it is a product, and have given rise to recognizable and distinct black and post-colonial studies, and lesbian and gay studies, which have emerged as responses to the economic determinism of cultural studies and the heterosexism and ethnocentrism of many of its practitioners. One particularly powerful strain within cultural studies develops Levi-Strauss' work on linguistic practices with Lacanian notions of the decentred subject and Freudian notions of the subconscious, and has posed a significant challenge to the stress placed upon the subjective experience of structural power in cultural criticism, and its analysis of historical materialism (see Hall 1986:46). This kind of psychoanalytic theory has become incredibly popular, I would suggest, as part of a late postmodern enthusiasm for an evacuation of identity politics, which has represented a backlash against the kinds of articulation cultural studies enables for those of us usually silenced by mandarin academicism. Many denser-than-tough theorists shrug off the messy intricacies of identities and materially lived power relations, dissipating them with an insistence upon our instability and incoherence as refracted effects of signification. Heterosexuality is not just some postmodern ironic effect, a performance to be parodied or deconstructed; it is an institution with complex material, ideological and representational structures. Insisting on the continuing importance of the category of identity is *not* some naïve attempt to return to the apparently bad old days of structuralism, humanism or Hegel. I know how complex and mediated my identity is, and because of that complexity, I would rather it was not swept away by the broom of assimilationism, thank you very much. I would like to spend a little more time attempting to understand the material and discursive terrain upon which the components of my social reality intersect with those of other aligned, hostile or competitive formations of identity before I have to give myself over to an orgy of hegemonic recuperation masquerading as postmodern fragmentation.

Clearly many concepts and terminologies of cultural criticism are dependent on Freudian or Lacanian insights – it would be highly disingenuous to suggest otherwise. Clearly also, the realm of the subconscious has been a richly mined resource for women's studies, and lesbian and gay studies; particularly in terms of opening up a space for conceptualizing desire and fantasy. Yet the self-perpetuating and seductive referentiality of the psychoanalytic narrative has lured many otherwise astute commentators into a position where they are no longer taking part in a process of questioning the material world in which they live, or even the deep-seated desires and damages that secure the plausibility of that world, but where they are pursuing some rarefied search for a missing fraction by which the Oedipal narrative can be resolved. The inevitability of that narrative, with its endless refractions of contradiction, irresolution, transference and symbolism seems to draw many into an entrancing master-narrative determined by articles of faith, principally that of the ludicrously arbitrary Oedipus myth. In *Male Impersonators*, gay critic Mark Simpson uses Freud to attempt to illuminate the instability of masculinity

exhibited in the air-brushed and monochromatic virility of Calvin Klein and other adverts (Simpson 1994). Simpson's argument and subject matter is appealing; he suggests that, in its infatuation with connoted signs of masculinity, the narcissism fostered by the new man of the early 1990s represents a Freudian repression/expression of homosexuality. But in the process of tying himself in knots of Freudian complexity and transference, Simpson misses the point entirely. Of course masculinity is unstable, of course the embodiment of virility is elusive, but such efforts are the catalytic linchpin of patriarchal authority. In constantly doubting and in striving to attain a reflection of symbolic masculine power, men *maintain* rather than dissipate the authority of masculinity and male interests. Similarly, in Lorraine Gamman and Merja Makinen's *Female fetishism* a desire to gain the heavy duty intellectual credibility of psychoanalysis fashions an argument in which a political context is lost. Rather than question the principles of psychoanalysis through which the fetishistic practices of assorted divas, perverts and mistresses are overlooked in theory and in clinical analysis, Gamman and Makinen claim their right to understand such flagrancy as pathological behaviour – an as yet uncovered feminine variation in the Freudian super-narrative. In effect these queer and feminist interventions serve as recuperative enhancements to the psychoanalytic faith, reshaping and regurgitating its narrative to accommodate and assimilate contemporary and radical interventions.

However, it should be clear that my criticisms are substantial, polemical generalizations; there are branches of psychoanalytic criticism which pursue a displacement of the Oedipal narrative as opposed to its recuperative enhancement. Obviously there is the work of French feminist Luce Irigaray, whose work powerfully suggests the contingency of the Freudian orthodoxy (Irigaray 1985). But there's also the extraordinary work of Mario Mieli (1980) which nonchalantly integrates the work of Freud and Marx into a wilfully partisan celebration of subcultural queerness. More structurally prestigious however, is the work of Kaja Silverman, which maintains the centrality of Oedipus, but considerably enlarges the wayward and dissident potential in theories of the subconscious (Silverman 1992). Then there is a considerable body of work which utilizes psychoanalytic concepts but succeeds in maintaining the specificity of its own project; a particularly exciting example of this resistance of psychoanalysis as a package deal is Chris Straayer's audacious "The she-man: postmodern bi-sexed performance in film and video" (Straayer 1990).

Ideally, a critical apparatus should be a questioning tool with which to reveal layers of meaning. Conventional psychoanalytic criticism seems to produce meaning from within an exploration of the tool itself, yet often with a striking lack of reflexivity about the limitations or effectiveness of that tool. Psychoanalysis often functions as a master narrative, in relation to which all acolytes must pay deference, or become understood as theoretically naïve (and here I am perhaps anticipating my own critics). Academic criticism

should not be justifying its privileged status in the world with endless dissections of the fluff in its belly button. I do not want to engage with theory as an intellectual exercise in itself, I want to use theory as a means through which I can understand the cultural processes that form me, and with which I must engage. Writing about issues of sexuality, class, disability, gender or ethnicity should be a political process, and I always want to be able to insist on the contingency of frameworks within which power is reproduced. It is therefore essential not only to resist the embroiling intricacies of psychoanalysis as a means of enlightenment, a tool, but it is essential that the very edifice of psychoanalysis itself as a body of intellectual and social authority is questioned, resisted and situated.

Tennessee Williams and gay subculture

In 1994 the National Theatre in London staged the most prestigious revival of a Tennessee Williams play in some time. The sumptuous production of *Sweet Bird of Youth* was the occasion for the resuscitation in the British broadsheet press of a discourse about the particular importance of Williams' female characterization. *The Independent*, which ran a full page feature headlined, "Tennessee Williams and His Women", suggested that: "Williams' women, more than those of any other 20th-century dramatist, only truly exist in performance. That they are merely feminised men has been disproved time and again" (Benedict 1994:23). That such disproving needs to be stated, again, might indicate either that the *Independent* was uncertain how conclusive that disproving has been, or that they felt that such was the currency of the proposition that its readers might need to be reminded that they no longer invested in such a notion. Regardless, in her *From Reverence to Rape* Molly Haskell offers an incisive account of the apparently disproved notion:

> In the case of Tennessee Williams' women, there is little confusion. His hothouse, hot-blooded "earth mothers" and drag queens – Blanche DuBois, Serafina, Maggie, and Alexandra Del Lago – are as unmistakably a product of the fifties as they are of his own baroquely transvestised (Haskell 1987:248).

This is a particularly clear example of what David Savran has called the "virtual ubiquity" of Stanley Edgar Hyman's notion of the "Albertine strategy", which refers to Proust's Albert-made-Albertine transposition, and describes the transvestism of the authorial position (Hyman in Savran 1982:116). This transaction has come to exemplify a preponderant strain through which homosexuality is understood, and I will come to a discussion of the political effects of this knowledge shortly. Tennessee Williams is important not only for being a particularly visible and contentious homosexual

man who seemed to enjoy his homosexuality (and the pills and the booze), but because his visibility is partly intelligible through an identification with women. Film spectatorship and star adoration are particularly highly determined practices in gay male culture. One of the things that has made Williams so compelling and accessible are the potent cinematic adaptations of his work; in these films, and in a series of famous stage performances, actresses such as Elizabeth Taylor, Vivien Leigh, Ann-Margaret, Geraldine Page, Tallulah Bankhead, Bette Davis, Anna Magnani, Ava Gardner and Lauren Bacall, have structured an iconography of femininity that for dominant critics and gay culture alike has become distinctively associated with homosexuality. At the National Theatre in 1994 Alexandra del Lago was played by Clare Higgins, whose performance so accurately pastiched the voice and mannerism of Lauren Bacall that it verged on becoming an impersonation, and showed how far the intelligibility of Williams' women characters rests on a stylized iconography of female stardom.

The way in which mainstream America theatre criticism, and indeed the US cultural establishment generally, has handled Tennessee Williams shows us that he has been a source of considerable anxiety. On the one hand his works were showered with acclaim and awards: when *A Streetcar Named Desire* opened on Broadway in 1947 it won the New York Drama Critics' Circle Award and the Pulitzer Prize, and in 1952 Elia Kazan's film version won the New York Film Critics' Circle Award; in 1955 *Cat on a Hot Tin Roof* ran for 694 performances, winning the Pulitzer Prize, the Drama Critics' Circle, and Donaldson Awards. In the West the emergence of cold-war ideology in the early 1950s insisted on the moral, spiritual and cultural superiority of American way of life over communism. Williams' popularity, both at home and abroad, made it necessary for him to be embraced as emblematic of that American superiority. Yet on the other hand, by the 1960s, critics such as Howard Taubman and Stanley Kauffman began to question the way in which understandings of American culture were being handled by Williams; they also challenged the work of Edward Albee and William Inge, hugely popular and successful dramatists who were also homosexual. In 1963, a couple of months after the Broadway debut of Albee's *Who's Afraid of Virginia Woolf?*, Taubman wrote a piece for the *New York Times* in which he claimed to want to help the people of America recover their "lost innocence". He entreated them to:

By the Look out for the baneful female who is a libel on womanhood.
Look out for the hideous wife who makes a horror of the marriage relationship.
Be suspicious of the compulsive slut ... who represents a total disenchantment with the possibility of a fulfilled relationship between man and woman (Taubman 1963:1).

In the 1970s, Stanley Kauffman was more explicit:

> we have all had much more than enough of the materials so often presented by the three writers in question [Williams, Albee, Inge]: the viciousness towards women, the lurid violence that seems a sublimation of social hatreds, the transvestite sexual exhibitionism that has the same sneering exploitation of its audience that every club stripper has behind her smile (Kaufman 1976).

The difficulty Taubman and Kauffman are negotiating resides in Williams' homosexuality being so proximate to understandings of him as a great American playwright. Cold war ideology rested on the virility of the imperialist nation state, that is, on the naturalized integrity of the heterosexual patriarchal subject. The rise of psychoanalysis as popular discourse through the 1950s in America all too clearly manifested homosexuality as tangible and unsettling to the internal confidence of that subjectivity. As Alan Sinfield has shown, Freud's reference to the notion of bisexual latency "meant that *anyone* might be subject to deep-set homosexual inclinations. This was convenient for witchhunters". (Sinfield 1992:42). The idea of latency provided ample opportunity for the exploitation of anxiety in potential subjects, for it implied that the unspeakable homosexual urge may possibly reside deep in the subconscious of even the most manly American; certainly the more anxious that subject the more he would attract an aura of paranoia and guilt. Yet, as Sinfield suggests, "latency was too good; once you started looking, no one was exempt", and this could explain the gradual turn from an opportunistic celebration of Williams as a great American artist to a systematic demonization of him that Taubman and Kauffman exemplify. It became necessary to turn the anxiety from the threat within to the threat without; hence Kauffman's instructive guidelines: "look out for the baneful female" for she is a sign of homosexuality, of un-Americanism (Bronski 1984:126).

In the logic of their paranoia these critics subscribe to a prevailing psychoanalytic construction of homosexuality as an inversion of physical and psychic sex identity: Williams' female characters express his morbid (and un-American) homosexuality which is a pathological inversion of normal masculinity and femininity. However, the pathological and heterosexist notion of inversion made popular through psychoanalytic discourse in the 1950s was itself an appropriation of models of inversion or of a third sex separately proposed by Krafft-Ebing, Karl Heinrich Ulrichs and Havelock Ellis at the turn of the century, who were attempting to make sense of their desires (see Chauncey 1983; Edwards 1994:19; Hekma 1994). Indeed in his first of the famous *Three Essays on the Theory of Sexuality* of 1905, "The sexual aberrations", Freud himself acknowledges the debt to Krafft-Ebing, Havelock Ellis, Hirschfeld, and others, adding a footnote in 1910 to indicate that the non-psychoanalyticallyconstituted notion of inversion had become certified in

psychoanalytic clinical practice. Thus Freud bought into a narrative of homo-sexuality, produced by homosexuals, to enable the constitution of a specific conceptual space in history within which to image same-sex desire as rational, and fitted it into what become a trans-historical and essentializing discourse that institutionally enshrined the pathologizing of homosexual women and men. Radclyffe Hall's *The Well of Loneliness* and E.M. Forster's *Maurice* remain as literary testimonies to the attempts made by homosexual writers to assemble a matrix of plausible homosexual identities through models of inver-sion in a period which predates the mass cultural circulation of psychoanalytic concepts, although Freud's *Three Essays on the Theory of Sexuality* had been pub-lished and would have been available to both writers through their intellectual milieu.[1] Kenneth Lewes, in his authoritative study *The Psychoanalytic Theory of Male Homosexuality*, suggests that Freud himself never quite decided whether gay men exhibited pathological perversion, or inversion. It is interesting to note that for Lewes, the non-pathological status of invert is the most favour-able, or liberal of Freud's vicissitudes on the status of gay men (Lewes 1989:29). Certainly Freud seems to use the term inversion to stand in for homo-sexuality, and in doing so throughout his huge and often contradictory body of work stabilises an *a priori* understanding of homosexuality in this way. Later Freudians, as Lewes points out and cultural history and experience confirm, collapsed The Father's distinction between perversion and inversion, daubing homosexuality as clinically exhibiting both.

As a specific, political intervention into an evolving historical narrative, gay criticism has been concerned with repelling the inversionist propositions about Williams and situating him in the context of post-Stonewall thinking, as a way of remodelling homosexuality as something other than heterosexuality gone treacherously wrong. What we now understand to be gay politics emerged in the liberationary aftermath of the Stonewall riots of June 1969 in Greenwich Village in New York. The riots, led largely by Latino and black drag queens, acted as a catalyst for burgeoning political awareness and anger amongst homosexuals that had gained a new context in the heightened social unrest that characterized 1960s radical politics in America, with the anti-Vietnam war movement, Black Power and Feminism. In America and in Britain, the politics of the Gay Liberation Front fashioned a radical refusal of state toleration of homosexuality in private that had enabled considerable sur-veillance, control and intimidation, in both specific and federal terms. In Britain we had just had the 1967 Sexual Offences Act, which instated contain-ing and liberally tolerant notions of public and private, and had opened but a small window of legal acceptability for certain male homosexual practices in private. In America an uneasy combination of post-1950s national hysteria about manliness, homosexuality and communism (which, as we have seen, was deployed through psychoanalytic notions) and the principal of the venera-tion of individual liberty and citizenship in the ideology of the constitution brought considerable pressure to bear upon homosexual life as a source of

anxiety for state authorities. Under these political conditions, and following the example of the Black Power movement, gay liberation emphasized public de-claration, coming out of the closet – a refusal of dominant narratives of your identity, as a way of confounding the covert control of private toleration.

Thus we can see that for gay theatrical critic John Clum, the principal concern in the work of Tennessee Williams is the extent of his closetedness; this is a marker of the degree to which he is useful to the agendas of Gay Libera-tion in speaking openly about homosexuality. Clum writes that the playwright "was much more successful at dramatizing the closet than at presenting a coherent, affirming view of gayness" (Clum 1994:149). For Clum, the closet is an intrinsically problematic realm that it is the project of Gay Liberation to dissipate; yet his model of the closet itself perhaps bears an unfortunate resem-blance to a psychoanalytically constituted concept of latency not dissimilar to that operative in American nationalistic paranoia: *"A Streetcar Named Desire, though without a living homosexual character or overt gay theme*, depicts in a codified fashion a paradigmatic homosexual experience" (Clum 1989:150, my emphasis). Even apparently radical critical manoeuvres do not necessarily escape the entrapment of dominant and heterosexist ideologies. So, *Streetcar* may not realize any homosexual representation or characterization, but holds an inherent, and latent, form of homosexuality. For Clum, as with other gay critics, the homosexualness of characters like Blanche DuBois is an effect of the operations of the closet and not of a psychoanalytically ascribed pathology of inversion.[2] The knowing, falaciously feminine disposition of Blanche then becomes a cloaking of the playwright's homosexual expression, hidden "within the actions of a heterosexual female character" and this is a function of historical conditions (rather than psychic ones) which censored the open representation of coherent homosexuality (Clum 1994:150).

Gay criticism, like Clum's, maintains a precarious balance between repudiat-ing the pathological and heterosexist aspects of inversion, which work to cul-turally authenticate gender roles produced by capitalist patriarchies, while maintaining an investment in the queerness of Blanche, Alexandra del Lago and company. Underneath a political rhetoric which attempts to moderate the more rabid effects of certain powerful ideological uses of psychoanalysis and put distance between homosexuality and Blanche and her colleagues, we can however see that gay subculture remains suffused with cross-gender identi-fications. Metropolitan, urban gay male centres in America, Britain and Austra-lia have lapped up the *Absolutely Fabulous* goings-on of Patsy and Edina and offered a whole new vocabulary for the trichological excesses of drag-queens, whereas the divine megalomania of Streisand, Maclaine, Dietrich, Madonna, Midler, Bassey, Davis and the rest continues to hold diverse kinds of queens the world over in papal thrall. Despite a call to historical circumstance, Clum seems to infer that homosexuality becomes textually coded through women because they expresses our gay sensibility; that is how he attempts to elude the inversionist trap. Yet gay subcultural activity itself may suggest a more fun-

damental preoccupation with women, and with gender itself, which speaks more proximately to the conditions which underwrite inversion theories.

It is not politically desirable to turn explanations of gay subcultural activity on the axis of psychoanalysis, where female identification becomes the collective manifestation of pathological neuroses, infantilism or some such pejorative perversion. Not only do these explanations exhibit heterosexism to an extraordinarily arrogant degree, they give us little substance with which to fashion any political dissent, and thus they may represent a limit case in entrapment. Even more fundamentally, such psychoanalytic explanations individualize and de-historicize practices which are meaningful only to gay men in collective and historical terms.

If it were appropriate to compile a canon of cultural studies, then Dick Hebdige's work on youth subcultures (Hebdige, 1979) and Angela McRobbie's feminist enhancement of subcultural theory (McRobbie 1991) would surely be included.[3] The maps of subcultural dynamics that these writers have laid down are particularly useful in understanding gay culture. Subcultures are necessarily resistant and marginal in attitude, but they retain a symbiotic relationship to wider cultures and the dominant powers that produce them. Subcultures fashion new meanings from objects and representations that circulate in mainstream cultures, but these appropriations are often quickly recuperated through processes of commodification and ideological reworking. Thus, although the notion of subculture allows us to constitute alternative spaces for social and political articulation, such activity always takes place under conditions of contest. Defining the mannerisms and materials produced by gay men through the terms of subculture allows us to constitute them in terms that side-step critical approaches that endlessly see marginal behaviours as functions of powerlessness that only ever manifest our subordination. Raymond Williams and Stuart Hall both work with three kinds of decoding systems that may help us to narrativize the fluctuations that mark subcultural activity: dominant, negotiated and radical. The dominant claims normative status, negotiated readings adapt to dominant systems or make room for them without directly aligning with or repudiating them, and radical readings take up direct opposition to dominant ones. We know how difficult it is to sustain radicalism, for dominant authorities continue to claim normative status, but if we are to escape entrapment, or the endless mediation and compromise of a negotiated decoding position where we accept a dominant view of ourselves and work round it, then we need to be able to envisage dissent.

Hegemony and homosocial masculinity

Raymond Williams' version of Gramscian hegemony (1981), which he presents in "Base and superstructure in Marxist cultural theory", enables us to understand the scope and power of dominant authorities, but also their contingency,

formed through a continuous process of adjustment, reinterpretation, incorporation and dilution, conducted in response to alternative, oppositional, residual and emergent cultural formations. Alan Sinfield has suggested that "the dominant may tolerate, repress, or incorporate these other formations, but that will be a continuous, urgent and often strenuous project" (Sinfield 1994:25). There is no single location which dominance inhabits, power is not monolithic, but disparately spread through a complex of material and ideological institutions; what we understand as dominant authority expresses a coalition of interests shared by these institutions or locations of power, but these coalitions are shifting, compromised and conflicted. Heterosexual capitalist patriarchy is a macro-political example of such a coalition, which manifests complex requirements concerned with maintaining gender power for men, control over property and succession, and the integrity of capital. The needs of this system are diverse and create anomalous circumstances. Eve Sedgwick has described one ideological system which works to police and organize one such set of anomalies, which she calls homosocial bonds (Sedgwick 1985).

Sedgwick argues that the most celebrated and important relationships in our society are between men, and that many of our most valorized cultural representations celebrate shared interests and intimacy amongst men, and an exchange of women between these men, as tokens of masculinity. We can see the plausibility of her thesis in the buddy movies Hollywood produces: a fairly recent and extraordinarily potent example is Tarantino's film, *Pulp Fiction*, where women exist merely as the opportunities for masculine exhibitionism and bonding between men, and homosexuality exists in visible and threatening proximity to such masculinity. Sedgwick suggests that male homosocial bonds maintain a functional relationship with homosexuality which is actively connotated as a policing mechanism, "the result has been a structural residue of terrorist potential, of *blackmailability*, of Western maleness through the leverage of homophobia" (Sedgwick 1985:89). The content of homosocial narratives, like that represented in *Pulp Fiction*, show us that this leverage rests on a misogynistic horror of the feminine and an understanding of homosexuality as men's potential to perversely manifest that femininity. Even if aspirational patriarchal subjects appropriately vilify women as representations of femininity, and signal their distance from abjection with constant invocations of homophobia, they remain caught in what Sedgwick characterizes as a "double bind". "For a man to be a man's man is separated only by an invisible, carefully blurred, always-already-crossed line from being 'interested in men'" (1985:89).

This strenuous ideological framing and the anxiety it produces across the board of all male behaviour expresses a perfect example of the kinds of hegemonic reformation which Raymond Williams has proposed, which work to absorb and reshape diverse cultural narratives and representations. The constitution of homosocial masculinity, a cultural and historical formation, rests on the authority of many psychoanalytic propositions: we can see how functional

both the ideas of homosexual latency and of inversion are in regimenting appropriate male behaviour and identity. Resisting the authenticity of psycho-analytic notions as clinical fact, and placing them in a cultural and historical context enables us to understand the ideologies through which they gain cred-ibility as markers of apparently personal pathology. At moments of particular stress and tension, such as shifts in the organization of labour and gender roles in post-war America, psychoanalysis has provided useful narratives with which to re-stabilize male authority. Raymond Williams' notion of hegemony allows us to see how institutions like that of patriarchal masculinity retain their dominance by powerfully repressing the instabilities necessarily inherent in such complex manifestations of power. This acknowledgement of contin-gency in powerful formations enables us to see much more potential in our transgressive activities: "Social orders and cultural orders must be seen as being actively made: actively and continuously, or they may quite quickly break down." (Williams 1981:201). Yet we must also be cautious about this optimism Williams fosters. Clearly dominant power does not necessarily break down under the weight of such incoherence and ideological production: indeed, it seems to thrive on it. If hegemony is the process through which powerful constituencies attempt to instate their concerns as those of the majority, then that process will necessarily be a difficult one – manipulating what have been described as faultline possibilities that are thrown up by the abrasions between different sets of ideological and institutional needs so as to restore apparent equilibrium.[4] Yet this constant attention required to reorga-nize areas of instability back into efficacy keeps capital and patriarchy agile and constantly on the move. The possibilities for radicalism and dissent are great, but the demands such dissident activity may place on the resources of the marginal are enormous.

Homosocial narratives of masculinity produce a sexualized abjection of homosexuality for functional purposes within the formation of gender roles; far from being personally disgusted phobic responses (as in homophobia) most prejudice against homosexual people is institutionalized and ideologically validated. Yet the particularly striking notions of women offered by Tennessee Williams, and the popularity and importance of female identification that Clum evades in his post-Stonewall notion of the playwright, would suggest that gay men have formed subcultures which attempt to resist the homosocial mechanism through its production of gender. Diverse kinds of gay men clearly have a number of ways of decoding the culturally powerful narrative homosociality offers. To follow Raymond Williams and Stuart Hall, we could suggest that one way would entail an alignment by some gay men with the practice of exchanging women and suppressing the realm of the feminine – a position which ventriloquizes dominant decoding. John Clum would identify this strategy as closetedness, and thankfully the consolidation of gay political articulation has made this an often unnecessary option; although residual traces of the kind of misogyny such exchange produces do remain in

lots of gay culture. However, the naturalization of gay male abjection often means that many gay men take up negotiated positions of self-oppression and humility: accepting the psychoanalytic pathologization of queer practices. Dominant sponsorship of narratives like that of inversion show us how unstable the organization of gender roles remains, and the fearsome punishment of those who blur the distinctions between them. Gay male–female identification is a dissident activity that attempts to intersect with these dominant faultlines, by fracturing the integrity of the homosocial negation of the feminine, and by attempting to overcome the structural obstacle masculinity represents in potential alignments between marginalized homosexuality and women oppressed through homosocial exchange. However, one of the most important features of gay male identification with women is the sense of historical continuity it offers, a shared vernacular that Tennessee Williams has been crucial in establishing. Although we may not relish the hostile attentions of dominant critics of Williams' work, we have exploited the faultlines such accounts represent, and bought into a practice that has become emblematic of gay male refusals of homosocial subjectivity. In the process we have also fashioned subcultural dissent against those dominant accounts of Tennessee Williams which would have him as a great national playwright, representative of American imperial superiority. The continuity of critical unease about Tennessee Williams and his women, from the 1960s to the more recent revivals, illustrates the unresolved faultline nature of his representations. Williams has remained important for stabilising gay practices and in this we have managed to keep him as both a subcultural and a homosexual playwright.

Acknowledgement

For patience beyond the call of duty, thanks to Jan Campbell and Janet Harbord. For countless formative conversations, hugs and kisses to Paula Graham, Ben Gove, Andy Medhurst and of course, Alan Sinfield. Particularly sloppy kisses for Andrew Hutton.

Notes

1. *The Well of Loneliness* (London: Virago, 1982) was first published in 1928. *Maurice* (London: Penguin 1972) was first published in 1970, after Forster's death and in accordance with his instructions; it had been finished in July 1914 and was circulated amongst the author's friends. Freud's *Three Essays on the Theory of Sexuality* was first published in 1905 and is printed in volume seven of the Pelican Freud Library, *On Sexuality: Three Essays on the Theory of Sexuality and other Works*, (London: Penguin, 1977).
2. For example, Mark Lilly, *Gay Men's Literature in the Twentieth Century* 105–15 (London: Macmillan, 1983), discusses how Williams' homosexuality is metaphorically refracted through, amongst others, Laura's lameness in *The Glass Menagerie*.

3. In 1976 the Birmingham CCCS published *Resistance Through Rituals: Youth Subcultures in Postwar Britain*, edited by Stuart Hall and Tony Jefferson which contained the essay, "Subcultures, cultures and class" by John Clarke, Stuart Hall, Tony Jefferson and Brian Roberts. This work was the first to introduce the idea of subculture as a critical concept.

4. The term *faultline* is used by Alan Sinfield to describe those occasions facilitated by incoherences, contradictions and tensions between often competing sets of powerful ideological formations which best enable our dissident exploitations. Faultline stories are those that have required the most assiduous and anxious reworking in order to cohere within dominant ideological formations. See Sinfield 1992.

References

Benedict, D. 1994. Tennessee Williams and His Women, the *Independent*, June 15, section 2, p. 23.

Bronski, M. 1984. *Culture Clash: the Making of Gay Sensibility*. Boston, Massachusetts: South End Press.

Chauncey, G. 1983. From sexual inversion to homosexuality: medicine and the changing conceptualisation of female deviance, *Salmagundi* **58–9**, Fall 1982–Winter.

Clum, J.M. 1989. " 'Something cloudy, something clear': Homophobic discourse in Tennessee Williams". In *Displacing Homophobia*, R.R. Butters, J.M. Clum & M. Moon (eds). Durham, NC: Duke University Press.

Clum, J.M. 1994. *Acting Gay: Male Homosexuality in Modern Drama*. New York: Columbia University Press.

During, S. (ed.) 1993. *The Cultural Studies Reader*. London: Routledge.

Edwards, T. 1994. *Erotics and Politics: Gay Male Sexuality, Masculinity and Feminism*. London: Routledge.

Franklin, S., C. Lury & J. Stacey 1992. "Feminism and cultural studies". In *Culture and Power: a Media, Culture and Society Reader*. P. Scannell, P. Schlesinger & C. Sparks (eds). London: Sage.

Freud, S. 1905. "Three essays on the theory of sexuality". In *On Sexuality: Three Essays on the Theory of Sexuality and other Works, The Pelican Freud Library*, (1977) **7**. London: Penguin.

Gammon, L. & M. Makinnen 1994. *Female Fetishism: a New Look*. London: Lawrence & Wishart.

Hall, S. 1986. "Cultural studies: two paradigms". In *Media, Culture and Society: a Critical Reader*. Collins London: Sage.

Hall, S. & T. Jefferson 1976. *Resistance Through Rituals: Youth Subcultures in Postwar Britain*. Birmingham: CCCS.

Haskell, M. 1987. *From Reverence to Rape: the Treatment of Women in the Movies*. 2nd Edition, Chicago, Illinois: University of Chicago Press.

Hebdige, D. 1979. *Subculture: the Meaning of Style*. London: Methuen.

Hekma, G. 1994. "A female soul in a male body": sexual inversion as gender inversion in nineteenth century sexology. In *Third Sex, Third Gender: Beyond Sexual Dimorphism in Culture and History*, G. Herdt (ed.). New York: Zone Books.

Irigaray, L. 1985. *This Sex Which is Not One*. Trans. C. Porter and C. Burke. New York: Cornell University Press.

Irigary, L. 1985b. *Speculum of the Other Woman*. Trans. G. Gill. New York: Cornell University Press.

Lewes, K. 1989. *The Psychoanalytic Theory of Male Homosexuality*. London: Quartet.

Lilly, M. 1993. *Gay Men's Literature in the Twentieth Century*. London: Macmillan.

Kauffman, S. 1976. *Persons of the Drama: Theater Criticism and Comment*. New York: Harper and Row.

Mieli, M. 1980. *Homosexuality and Liberation: Elements of a Gay Critique*. London: Gay Men's Press.

McGuigan, J. 1992. *Cultural Populism*. London: Routledge.

McRobbie, A. 1991. *Feminism and Youth Culture*. Basingstoke: Macmillan.

Savran, D. 1982. *Communists, Cowboys and Queers: the Politics of Masculinity in the Work of Arthur Miller and Tennessee Williams*. Minneapolis, Minnesota: University of Minnesota Press.

Sedgwick, E.K. 1985. *Between Men: English Literature and Male Homosocial Desire*. New York: Columbia University Press.

Silverman, K. 1992. *Male Subjectivity at the Margins*. London: Routledge.

Simpson, M. 1994. *Male Impersonators: Men Performing Masculinity*. London: Cassell.

Sinfield, A. 1992. *Faultlines: Cultural Materialism and the Politics of Dissident Reading*. Oxford: Clarendon Press.

Sinfield, A. 1994. *Cultural Politics – Queer Reading*. London: Routledge.

Sparks, C. 1996. "Stuart Hall, cultural studies and Marxism". In *Stuart Hall: Critical Dialogues in Cultural Studies*, D. Morley, K.-H. Chen (eds). London: Routledge.

Straayer, C. 1990. The she-man: postmodern bi-sexed performance in film and video, *Screen* **31** (3), Autumn.

Taubman, H. 1963. Modern primer: helpful hints to tell appearances from truth, *New York Times*, April 28.

Williams, R. 1981. *Culture*. Glasgow: Fontana.

Part II

Between psychic processes and culture

3

Politics and psychotherapy

Andrew Samuels

Politics in the West is experiencing a paradigm shift in which old definitions, assumptions and values are being transformed. While politics will always be about struggles for power and the control of resources, a new understanding of all that is political has evolved since feminism introduced the phrase "the personal is political". This new kind of politics often gives pride of place to the feeling level and could be said to be a politics of subjectivity, that encompasses a key interplay between the public and private dimensions of power. The discovery of the past 25 years is that political power is also manifested in family organization, gender and race relations, connections between wealth and health, control of information, and religion and art.

Few would disagree that politics in western countries is in a mess. We urgently need new ideas and approaches. The political parties and the old, formal political system have lost political energy. By political energy I mean the capacity to bring imagination, creativity and effort to bear on seemingly intractable problems to try and solve them in ways that reflect concern for social justice. Clearly, formal politics has still got the resources, and most of the decisions will in the future still be taken via the electoral system. But political energy has moved on into a plethora of seemingly unconnected social movements: environmentalism, consumerism, ethnopolitics, human rights movements, liberation theology, feminism and so on. The growth of these social and cultural movements has been a striking feature of the past 20 years in modern societies like Britain and the United States. More and more people are involved in such networks – increasingly aware that what they are doing may be regarded as political. The elasticity in our idea of politics is not something done to it by intellectuals. It is rather something politics seems actively to embrace. These new social movements operate in isolation from each other, seeming to have quite different agendas and programmes. Yet their collective impact, if it could be garnered without damaging the spontaneity and creativity of what is going on, may be just what western societies, starved of

these features in their politics, crave and need as we stumble towards the end of the century.

But these disparate social movements *do* have something in common, something psychological in common. They share in an emotional rejection of "big" politics, its pomposity and self-interest, its mendacity and complacency. They share a common philosophy or broad set of values based on ideas of living an intelligible and purposeful life in spite of the massive social forces that mitigate against intelligibility and purpose. They share a disgust with present politics and politicians – sometimes people report a quite physical disgust, the gagging reflex, an ancient part of the nervous system, absolutely necessary for survival in a world full of literal and metaphorical toxins.

What may be going on in this paradigm shift is the frank pursuit of a transformation of the political process itself involving what I call a resacralization of it. The attempt is to get a sense of purpose, decency, aspiration and even holiness back into the political process and value system. Even if such a state of affairs never really existed, many behave as though it did – hence resacralization. A key problematic in politics these days is how to translate our emotional, bodily and imaginative responses to Bosnia, ecological disaster, unemployment, poverty worldwide, into action. Can we begin to make political use of our private reactions to public events? There is a sense in which this is a core political problem of our times: how we might convert passionately held political convictions – shall we call them political dreams – into practical realities.

In order to move things along, we need to begin to think again about what to expect a citizen to be, shifting our assumptions in the direction of the "psychological citizen". This citizen is a "politically self-aware" citizen, knowing *already* that the personal, inner and private levels of life connect up with the political, outer and public levels. But the culture in which he or she lives is very reluctant to make this connection. In a way, this reluctance is surprising because people have always spoken about politics and politicians in emotional terms such as "character". Similarly, a good deal of political debate boils down to disagreement about what is human nature (what, if anything, lies beyond self interest, to give an example).

If new connections could be made, then we will get more used to talking a mixed language of psychology and politics. In this new, hybrid language for a new political paradigm, we will want to know not only what is being said, but who is saying it – and maybe which part of a person is talking. As therapists know, everyone teems with inner people ("sub-personalities" or "complexes") and this is always a difficult thing to acknowledge. In the same way, we could develop an approach to politics that understands that no society has a single, unified identity. In our world, politics and questions of psychological identity are linked as never before. This is because of myriad other interminglings: ethnic, socio-economic, national. The whole mongrel picture is made more dense by the rapid course of events in the realms of gender and sexuality.

How does the psychological citizen grow and develop? An individual person

lives not only his or her life but also the life of the times. Jung told his students that "when you treat the individual you treat the culture". Persons cannot be seen in isolation from the society and culture that has played a part in forming them. Once we see that there is a political person who has developed over time, we can start to track the political history of that person – the way the political events of a lifetime have impacted on the forming of his or her personality. So we have to consider the politics a person has, so to speak, inherited from their family, class, ethnic, religious and national background – not forgetting the crucial questions of their sex and sexual orientation. Sometimes people take on their parents' politics; equally often, people reject what their parents stand for.

As far as socio-economic background is concerned, there is an interesting relationship of class and the inner world. Many people in western countries since the war have achieved a higher socio-economic status than that of their parents. Yet, in the inner world, the social class wherein they function is often the social class into which they were born. There is a staggering psychological tension that exists within the socially and economically mobile citizen between what he or she is and what he or she was. I think this tendency brings with it an optimistic message for a progressive political and social project. To the extent that the typical move is from working to middle class, and to the extent that a passion (and need) for social and economic justice exists in the working class, it is possible to access within middle-class clients concerns for economic and social justice appropriate to their inner world location of themselves as working class.

But even this is perhaps a bit too rational. If there is something inherently political about humans – and most people think there is – then maybe the politics a person has cannot only be explained by social inheritance. Maybe there is an accidental, constitutional, fateful and inexplicable element to think about. Maybe people are just born with different amounts and types of political energy in them. If that is so, then there would be big implications both for individuals and for our approach to politics. What will happen if a person with a high level of political energy is born to parents with a low level of it (or vice versa)? What if the two parents have vastly different levels from each other? What is the fate of a person with a high level of political energy born into an age and a culture which does not value such a high level, preferring to reward lower levels of political energy? The answers to such questions shape not only the political person but the shape and flavour of the political scene in their times. The questions can get much more intimate. Did your parents foster or hinder the flowering of your political energy and your political potential? How did you develop the politics you have at the moment? In which direction are your politics moving, and why? I do not think these questions are presently on either a mainstream or an alternative political agenda.

My interest is not in what might be called political maturity. No such universal exists as evaluations by different commentators of the same groups as terror-

ists or freedom fighters show. My interest is in how people got to where they are politically and, above all, in how they themselves think, feel, explain and communicate about how they got to where they are politically – hence I refer to the political *myth* of the person. From a psychological angle, it often turns out that people are not actually where they thought they were politically, or that they got there by a route they did not recognize.

An awareness that politics is psychological is also the theme that links all engaged in the discussions about the loss of meaning, purpose and certainty in communal and personal life. Yet such is the western fear of the inner world that its implications are barely recognized, let alone discussed or used. It is tragic how little discussion there has been about the socialized, transpersonal psychology that will be needed to make the ambiguous visions current on both sides of the Atlantic of community and communitarian politics viable. But there are established psychological theories in existence (for example, Jungian and post-Jungian approaches to the social) that focus on the transpersonal ways in which people are already linked and attuned to one another, living in connection in a social ether. In this vision of humanity, it is possible to experience that we were never as separate from each other as so-called free market, neo-liberal politics – which had its own tame psychological theory in there somewhere – claimed us to be. These kinds of pre-existing connections are between people who are already linked and attuned to one another, living in connection in a social ether. They may be largely non-verbal, working on a psyche-to-psyche level. We are stalks – growing, feeding, flowering from the same rhizome. Unfortunately, psychoanalysis has never been comfortable with shared psychological states, quite missing the radical potential of a socialized, transpersonal psychology when such states are castigated as mystical or ecstatic (with nothing favourable being meant by either term).

Many previous attempts to link psychology and politics have often been academic, involving empirical work on such things as voting patterns or the birth order of political leaders. Then there have been rather mechanical, from on-high applications of psychoanalytic and Jungian ideas which end up providing us with simplistic solutions to very complicated political problems. In fact, the hidden agenda of many of these psychoanalytic and Jungian explorations of politics has perhaps been to prove the psychological theories of the thinker right and this may be a reason for the lack of acceptance by political theorists and activists. I would not always except myself from this tendency.

Without resorting to empirical research or to the route that displays the maddening rectitude of psychoanalysts and Jungians, I have been trying for some time to present an approach to modern politics that makes use of what we learn about politics in the outer world from ordinary clinical practice in psychotherapy (Samuels 1993). These explorations of our hidden politics may start with the ideas and methods of therapy but take them away from the clinical office, out into the streets and cities, the mountains and forests, the

families and organizations, the world of economics and finance whose politics have become dulled and monochrome.

What might the role of psychology and the psychotherapies be in a transformed politics based on a search for intelligibility and purpose in social life, a search that is implicitly and sometimes explicitly transpersonal and spiritual in tone? We must acknowledge the limitations of a psychological approach to politics. Freud, Jung and the founders of humanistic psychology like Maslow had ambitions to be of use in the political world. But that world never showed up for its first therapy session with them. I do not think this reluctance by twentieth century politics to undergo psychological treatment of itself can all be put down to resistance to therapists. There is something offensive and ridiculous about the mechanical psychological reductionism that has been produced from time to time. I recall an article by a psychoanalyst in a newspaper about the phallic symbolism of cruise missiles going down ventilator shafts in Baghdad, or a statement by another analyst that students protesting in Paris in 1968 were functioning as a "regressive" group. Jungians are just as bad; it doesn't help to be told that the military-industrial complex is all due to the Greek god Hephaestus. So-called archetypal themes and images can get used just as reductively as any Freudian idea that childhood is decisive. Both are equally problematic in politics. Both schools have as a major goal this attempt to prove their theories right. Similarly, arguments that all will be well were we to access a wholly different dimension of life ("soul") will justifiably be dismissed by politicians and social scientists alike as simplistic and one-dimensional.

A multi-disciplinary approach is crucial as we face up to the possibility that we might lose the political altogether if we do not ourselves reclaim it from the media and the pundits. It is not that the media and their star columnists or presenters ignore psychology altogether. They certainly use a form of psychology. My concern is that a false dialogue has been started between psychology and the politicians in which we all join in a wild analysis of our politicians in a desperate search for the one with personal stability and integrity. It is a search that usually ends up with the provision of a single strand nostrum for political ills – *integrity* gets misused like this. The professional psychotherapists are often little better. In the 1920s it was *genitality*; in the 1950s *identity*; in the 1990s, *soul*, or *meaning* or *virtue*.

I am not completely uninterested in the psychological motivations of politicians, but I am much more interested in considering what could happen to the political system were *citizens* to work on their political self-awareness. Then there would be a different and more self-referential basis from which to interrogate the motivations of the politicians. It is not at all easy to make a psychological analysis of politics because every element in our culture is undergoing fragmentation and Balkanization. Still, people have risen to the challenge. Our sense of fragmentation and complexity seems to be *healing* as well as wounding to the possibilities of political and social empowerment.

For, in the midst of the tragic anomie and baffling atomization, the dreadful conformism of "international" architecture, telecommunications and cuisine, the sense of oppression and fear of a horrific future, in the midst of war itself, there is this strange, equally complex attempt at transformation of politics going on.

Therapists are aware of this from what their clients tell them. Alongside the expectable problems – relationship difficulties, early traumas, feelings of emptiness – we see the ecological and other crises presented as sources of symptoms and of unhappiness in individuals. From a psychological point of view the world is making people unwell and it follows that, for people to feel better, the world's situation needs to change. Perhaps this is too passive; for people to feel better, maybe they have to recognize that the human psyche is a political psyche and do something about the state the world is in.

I sent a questionnaire to 2000 analysts and therapists worldwide in which I asked them what political issues their clients mentioned in therapy, how they reacted, and what their own political views were (see Samuels 1993:209–66). Aside from the revelation that the therapy profession is far more politically sensitive than one would think and that politics is a welcome theme in quite a few clinical offices, it was clear that clients are bringing economic, environmental and gender political issues to their therapy sessions much more than they used to. I think this development in the therapy world justifies my wider claim that, in our age, we are witnessing the emergence of a new kind of politics.

One role for the psychotherapies would be to mount a challenge to accepted ideas of what constitutes "human nature". At the moment, when idealistic or even utopian political thinking gets a bit threatening to the old order and to established ways of doing things, someone usually says "But what you're proposing goes against human nature!" What the speaker often means is that human nature is violent, greedy, involves hostility to other people, and inevitably leads to a pecking order and social hierarchy. If such speakers are psychotherapists, then it is usually assumed that they are experts in human nature.

However, I am not sure there really are experts in human nature. Most statements about human nature reflect the social circumstances, ideological prejudices and even the personality of the writer – not to mention his or her purpose in writing. Here the tag "his or her" is very relevant because males and females are usually portrayed differently by writers on human nature. What they say varies over time. For example, according to novels and letters of this period, men in Europe stopped crying at the end of the eighteenth century. Up to then, it was perfectly manly to cry. Similarly, some ancient Greek philosophers said that women do not have souls.

In spite of these arguments, many people continue to assert conservatively that human nature is one thing that does not change over time. However, the fact that people may always have had similar emotional and physical experiences does not mean that they experienced these experiences in the same way.

For the means they have to tell us about it are totally embedded in the worlds in which they lived. One follow-on from this is that it is possible to speak in terms of human nature changing, making it very difficult to say that something is politically impossible because of human nature. What psychotherapists can contribute is an explanation of why more positive aspects of human nature have such a struggle to emerge.

Psychotherapists can join academic critics in pointing out that the depressing definitions of human nature that are around are not neutral – someone benefits from them: big business, conventional politicians, reactionary males, anyone with a stake in the system has an interest in preserving the system's conception of human nature. For example, who benefits when we are told that environmentalism and all kinds of new ideas for economic policy are unrealistic or too idealistic because of human nature being so greedy and selfish? Some might object that this is a New Age point of view. Well, Oscar Wilde was not exactly New Age, and he said that "The only thing we know about human nature is that it changes. Change is the one quality we can predict of it ... The systems that fail are those that rely on the permanency of human nature, and not on its growth and development" (Wilde 1978).

It seems to me that self-exploration, self-development, self-expression – the whole interior thing that therapy does reasonably well – and political activity, conceived of rather broadly, are part of the same process. This realization is part of the big change in politics that I have mentioned. In the United States in the 1990s, Clinton (Democrat) and Bush (Republican) won their various elections by intuiting that for many millions of people in the United States, politics and political choices, as expressed in the crudity of voting, had become matters of self-exploration and then self-expression. When we look at our lives from the point of view of political ideas and commitments, what we see is an unfolding of the personality in political terms. I am concerned about the fantasy that many engaged in an attempted transformation of politics still have that politics is only a dirty business, that getting involved in politics somehow sullies one, leading inevitably to a loss of self-respect. I challenge the divide that has arisen between what we ordinarily conceive of as creativity, self-respect and a productive inner life on the one hand and the political life on the other.

Politicizing therapy thinking and practice

When attempting to link psychoanalysis or psychotherapy with political and social issues, we need to establish a two-way street. In one direction travel men and women of the psyche bringing what they know of human psychology to bear on the crucial political and social issues of the day, such as leadership, the market economy, nationalism, racial prejudice and environmentalism. Going the other way down this street, we try to get at the hidden politics of

personal life broadly conceived and understood: the politics of early experience in the family, gender politics and the politics of internal imagery, usually regarded as private. The dynamic that feminism worked upon between the personal and the political is also a dynamic between the psychological and the social. It is so complicated that to reduce it in either one direction (all psyche) or the other direction (all socio-political), or to assert a banal, holistic synthesis that denies difference between these realms is massively unsatisfactory. There is a very complicated interplay, and this chapter trades off the energy in that interplay. As I mentioned, the hope is to develop a new, hybrid language of psychology and politics that will help us to contest conventional notions of what *politics* is and what *the political* might be. The aspirations of so many disparate groups of people world-wide – environmentalists, human rights activists, liberation theologians, feminists, pacifists and peacemakers, ethnopoliticians – for a reinvented and resacralized politics would gain the support of the psychological community.

It is worthwhile focusing on therapy and on clinical work for two main reasons. First, because the results of the survey show that this is a hot issue for practitioners. Second, because exploring the politicization of practice might help to answer the awkward question: Why has the political world not responded to the analysts and first session with the therapists who are so keen to treat it? Would it be different if clinical experience were factored in? At the very least, there would be a rhetorical utility. For, without their connection to the clinic and to therapy, why should anyone in the world of politics listen to the psychotherapeutic people at all? What do we have to offer if it does not include something from our therapy work? Therapy is certainly not all that we have to offer, but it is the base.

The professional stakes are very high. In certain sectors of humanistic and transpersonal psychology clinical work is becoming more overtly politicized so that the whole client may be involved. But this is still very much a minority view in the psychodynamic and psychoanalytical sectors of psychotherapy. Politically speaking, most clinical practice constitutes virgin territory. The stakes are so high because what is being attempted is a change in the nature of the field, a change the nature of the profession – that which analysts and therapists profess, believe and do. As the survey showed, this attempt is part of a worldwide movement in which the general tendency is to extend the nature of the psychotherapy field so as to embrace the social and political dimensions of experience.

If we do want to treat the whole person, then we have to find detailed ways of making sure that the social and political dimensions of experience are included in the therapy process regularly, reliably and as a matter of course. We must try and achieve a situation in which the work is political always. Not unusually, not exceptionally, not only when it is done by mavericks, but when it is done in an everyday way by *every* therapist.

The detailed work is not easy to do. About seven years ago an interesting

book appeared entitled *Psychoanalysis and the Nuclear Threat: Clinical and Theoretical Studies* (Levine et al 1988). All the editors and all the contributors were the most *echt* (real), kosher psychoanalysts one could find, and they were all members of the American Psychoanalytic Association. In the editorial introduction the following passage appears:

> In the best of circumstances analysts may assume that considerations of politics are irrelevant to the analytic space. We raise the possibility here that the potential of nuclear weapons for destroying the world intrudes into the safety of that space. We no longer live in the best of circumstances. Thus, the construct of a socially, culturally, and politically neutral analytic setting may be a fantasy, one that embodies the wish that the outside can be ignored, denied, or wished away (1988:vii).

In a basically favourable review of this book, the psychoanalyst and social critic Alexander Gralnick stated that:

> Unfortunately, few of the contributors to the theoretical part of the book deal with the many important assumptions and unsettled issues in psycho-analytic thought and clinical practice that the editors hoped consideration of the nuclear threat would prompt them to discuss ... Though bound by traditional concepts, some authors seemed to recognise that psychoanalysts may not be as neutral as they believe themselves to be ... These psycho-analysts are plagued by their own resistances and anxieties about the further changes they face and how creative they dare be; they are naturally limited by being at the *earliest stages* of changes we all face, and, like the rest of us, are *handicapped by lack of a needed new language* (emphases added) (Gralnick 1990 p. 96).

All of us are at the earliest stages of this project, we are handicapped by the lack of a much-needed new language. These thoughts and speculations on politics and the internal family are my best shot.

A new deal for women and men?

The New Deal was the name given to the wide range of programmes, agencies and economic laws and institutions brought in by President Franklin Delano Roosevelt in the United States between 1933 and 1938. The new deal discussed in this chapter is primarily, but by no means exclusively, a psychological new deal between the sexes. I have chosen the term because of the cluster of associations connecting it to economic and social reform. Roosevelt and his advisers were responding to the Great Depression. Who would disagree that there has

been a traumatic situation for women and men and the relations between them in most western countries since the end of the war?

How universally relevant all the ideas will be, one cannot say. Cultural and ethnic differences obviously exist. My arguments are as vulnerable to a blanket relativist rejection along the lines of "Oh, that may be true for white, middle-class Britain or the United States today, but it is simply not the position for everyone everywhere". This criticism will from time to time be justified but I hope it will not be deployed in a defensive way. My angle of entry into the problematic of masculinity and femininity is very much concerned with today's women and men in the here and now. Deprived of academic, philosophical or even mythological distancing devices, I am sure I will say a few things that strike the reader as inappropriate.

Gender has come to mean the arrangements by which the biological raw material of sex and procreation is shaped by human and social intervention. Gender and the politics it spawns has passionately divided our world – and this is now true of West, East, South and North. But the very idea of gender also has a hidden bridge-building function because gender is a liminal concept. That means it sits on a threshold half way between the inner world and the outer world. This is why gender issues get political so readily, because gender is already half-way out into the world of politics. Gender is partly a very private, secret, sacred, mysterious story that we tell ourselves and are told by others about who we are. It is also a set of experiences deeply implicated in and irradiated by political and socio-economic realities stemming from the outer world. The reason gender turns us on is not only its link to sexuality but also because it marries the inner and the outer worlds, even disputing the validity of the division.

The problem of men

I want to focus on men because, as many have said, it is timely to do so. Men are the object of scrutiny in the West these days and are often seen as the problem. It is ironic because, for millennia, men have scrutinized and made other groups problematic: women, children, blacks, the fauna and flora of the natural world. Men were a sort of Papal balcony from which we surveyed the universe. But in our age, a huge shift in cultural consciousness has taken place.

The underlying questions seem to me to be: (1) Can men change? (2) Are men powerful? and (3) Do men hate women? Today's heroines and heroes would probably want to answer all three of those questions: "yes and no". It is not a high-octane or passionate position to say "yes and no" but I suggest that it may be the only reasonable, viable, pragmatically effective and imaginative position to take. Can men change? Men *can* change, of course, and yet the statistics about who takes care of children or does the washing-up show that they have not changed their behaviour very much. Why not? In the past years, I

have spent far too much time on philosophical, metaphysical and quasi-scientific discussions about the relative importance of nature and nurture in the formation of gender identity and performance. I certainly do not want to spend so much time on it in the chapter. But there may well be something to get hold of in that debate that does suggest the existence of serious limitations on men's capacity to change. Not so much due to biological hard-wiring, but rather to depth psychological factors, what has been called internalization, a kind of psychological inheritance, not a physiological inheritance.

Are men powerful? They certainly have economic power, but it is difficult to balance that power with an acknowledgement of the existence of pockets of real world vulnerability that men experience: black men, homeless men, men in prisons, young men forced or tricked into the Army, disabled men and gay men. We have serious problems in holding male economic power and male economic vulnerability in the same frame. We know, too, that men are scared of women. Never mind their fear of "the feminine", what scares men is *women*. How can a man be said to be powerful if he is scared of women? Men are also frightened of other men. Male economic power could have progressive uses. If men and their formal institutions put just a tiny proportion of their economic power to benevolent uses, it would make an enormous difference. Whatever changes might be taking place in the world of men could have immense political and social effects in the not too distant future.

Do men hate women? Here, the word ambivalence comes to mind and, as I shall return to the concept later, let me give its history. In 1910, when Jung's superior, Eugene Bleuler, coined the word ambivalence, he meant it to be a very serious symptom that was part of schizophrenia. By the 1930s and '40s, it was *the sign* of psychological maturity according to psychoanalysis. Ambivalence means the capacity to have at one and the same time hating and loving feelings towards what the jargon calls the same object. (For *object*, here read *person*.) Ambivalence is therefore *not* only a problem. Ambivalence is an extremely hard-to-achieve aspect of psychological maturity. Therefore, later in this chapter, when I propose that we think about creating temporary deals and alliances of a political nature between men and women on the basis of their ambivalent feelings towards each other, I am proposing something elevated, difficult to achieve, and worthwhile, and not something tawdry and short-term.

In praise of gender confusion

Having briefly discussed these three key questions, I want now to turn to what I call *gender confusion* and say a few words in praise of gender confusion in modern societies. Most people are wary now of anyone who seems too settled and sure in his or her gender identity and gender role. Think of the tycoon – so capable and dynamic, such a marvellous self-starter. Don't we know that, secretly, he is a sobbing little boy, dependent on others, maybe

mainly female, for all his feelings of safeness and security? Or the Don Juan, talking incessantly of the women he has seduced, who (as we know) turns out to have fantasies of being female himself and yearns to be seduced by another man? Or the woman many write about who seems so fulfilled as a mother yet privately desires to express herself in ways other than maternity, to come into another kind of power, to protest at her cultural castration?

We have come to accept that behind excessive gender certainty lurk gender confusions like these. Yet many will probably consider that, as well as being suspicious of too much gender certainty, it is basically a good thing for everyone to be pretty certain about their gender, to know for sure that, in spite of all the problems with being a man or a woman, one is indeed a man or a woman. As an analyst, I have come to see that quite another idea is needed to make sense of what people are experiencing in the muddled and mysterious world of late twentieth century gender relations and gender politics. Many of the people who come to see me for therapy are indeed manifestly and magnificently confused about their gender identity. Not only are they not at all sure how a man or a woman is supposed to behave but they are not sure that, given what they know about their internal lives, a person who is truly a man or a woman could possibly feel or fantasize what it is that they themselves are feeling and fantasizing.

I noticed that, for these profound feelings of gender confusion to exist, there had to be an equally profound feeling of gender certainty in operation at some level, maybe unconsciously. You cannot know the detail of your confusion without having an inkling about the certitude against which you are measuring your confusion. The client sobbing his little boy heart out knows very well that tycoons exist and evaluates himself negatively as a result. Indeed, we could even say: no gender certainty, no gender confusion! What this means is that, to a very great degree, gender confusion is created in people by the operations of gender certainty. If we agree that these certainties are part of socialization, then it is hard to deny that the parallel confusions are equally artificial constructions and not deeply personal wounds, failures or pathologies.

Let me underscore the radical implications of what I am saying. We need to extend the by-now conventional insight that gender confusion lies behind gender certainty to see that *gender certainty also lies behind gender confusion*. However, this gender confusion is usually taken as the mental health problem, so I think we have made a colossal mistake here. We may even be playing a most destructive confidence trick on those supposedly suffering from gender confusion. The problem is, in fact, gender certainty.

Let us look at how this works out specifically for men in western countries today. The turgid idea that many men living in a feminism-affected culture feel confused about who they are *as men* takes on a rather different cast when looked at in the light of what I have been saying about gender confusion. Behind the apparent confusion and the pain that many modern men certainly feel lies the kind of unconscious gender certainty that we import from the

culture by internalization. From this angle, modern men are not at all confused – or, rather, feeling confused is simply not the main problem at depth. Their problem is being afflicted with a gender certainty that is no use to them, and maybe is actually harmful to their social potential. When men's movement leaders such as Robert Bly or Robert Moore offer a certainty that seems to have been missing from the lives of men, they are unwittingly doing nothing more than bringing the unconscious gender certainty that was always there to the surface. As that certainty came from the culture in the first place, there's nothing radical or scene-shifting about it at all. The really interesting question is what to do with the feelings of gender confusion from which everyone suffers these days. On a personal level, we need to measure the confusion against the certainty. If we do this, we may find we are not as badly confused as we thought we were. It is not necessary to be confused about being gender-confused. You can evaluate your confusion and decide what to do with it. If we stop seeing gender confusion as a wound, a failure or a pathology, then I think there is a lot we can do with gender confusion. I can see that it all becomes easier to do in words if you replace *confusion* with something that sounds a lot more positive like *fluidity*, *flexibility*, or even (hateful word) by supporting *androgyny*. But, although I realize it is a hard sell and will not win votes, I want to stick up for the word *confusion* because it is an experience-near word, capturing what I do indeed often feel about my gender identity and what many clients I see in analysis feel about theirs.

The internal family and a new deal

What can be done with gender confusion? I think such confusion can actually contribute something to a new deal for everyone, that is to social and political reform and change. As I said earlier, gender is a key element in modern politics because it sits halfway between the inner and the outer worlds. Politics comes in because gender is something upon which most cultures have erected a welter of oppressive practices and regulations, mostly favouring men.

But many men want to make a progressive contribution to gender politics and hence (as men) to the wider political scene. Perhaps they could do it in part on the basis of a frank reframing of how we evaluate the confusion-certainty spectrum in relation to being a man. It is not necessary to refuse to be a man, or enter into spurious socio-political alliances with women that deny the existence of differing political agendas for the sexes. All that may be required in the first instance is a celebration of not knowing too well about who we are in terms of gender and gender identity, not knowing too well what we are supposed to know very well indeed. Then the scene is set for a linking of destabilizing and reform of gender politics with destabilizing and reform of politics in general.

My main goal in this discussion is to contemplate how good-enough temporary new deals might be established, leading to alliances between women and men, based on acceptance of ambivalent feelings between them and a positive estimation of gender confusion. I want to do this by turning to what I call the *internal family* as a source of psychological inspiration and models. I do not want to turn to other cultures or other times in our own history as sources of inspiration. Plenty of people are doing that work. I want to turn to the internal family as it functions in each of us *now*. I do not mean the internal family to be taken as a universal or constant form or organization. The family in social reality has a social history. But there is in everyone living in a given culture a family inside one's head and that subjective, imaginal family is what I am referring to.

I will try to let the psyche speak its politics by looking at the four heterosexual relationships of the internal family, to see what new thinking about these might suggest to us in terms of templates, models or frameworks for the kind of progressive political alliances between women and men that are worth aiming at. So I shall look in turn at the mother–father relationship, the mother–son relationship, the daughter–father relationship, and the sister–brother relationship. I am focusing on heterosexuality because of the limitations of space in this chapter. It is actually quite a change for me to be talking about heterosexuality. I have been very active in the last few years in a campaign to rid British psychoanalysis of its homophobic tendencies and theories, forcing an end to scandalous practices which bar lesbians and gay men from training to be psychoanalysts. Therefore, I have to write and speak a lot about homosexuality. Writing about heterosexuality does not feel like coming home, in fact it feels a bit strange.

The secret politics of the parents in bed

I want, now, to look at the mother–father relationship as a template, as a base, as a source of inspiration for thinking about the politics of women and men. If, as feminism asserted, the personal is political, then what I am trying to do is to develop ways of taking the personal private stuff and actually moulding, massaging, shaping it into something that has a political form.

Depth psychology refers to the relationship in one's mind between father and mother, between the man and the woman that created each of us: "the primal scene". The primal scene is a mixture of memory and fantasy that is elaborated over a lifetime. Thinking about the sex act that creates each of us, the intimate relationship of our parents, or the sexual life of the parent we grew up with in a lone parent family makes us consider. What are its characteristics? What are the images that come to mind? What are the emotional themes of each individual primal scene? Is it harmonious? Is it vigorous? Is there a sharing of power, or is there an imbalance? Is the bedroom door closed? The

primal scene themes are the most political themes in the internal family that one can imagine. Contemplation of the child's sense of exclusion makes us also reflect on political discourse about marginal, dispossessed and excluded groups in society. Children are usually extremely curious about the sexual life of their parents – it is the first investigative journalism or even detective work any of us do. Then there is the question of who initiates and who is setting the sexual behaviour agenda – who is writing the manifesto and policy documents.

The Midrash tells us that before Eve was created there was Lilith. God created Adam and Lilith from the same dust, and on their first night in the garden, Adam mounts her, to have sex with her. She says "Get off me. Because why should you lie on top of me in the superior position when we were made at the same time, from the same stuff?" He rapes her. She cries out God's name, is drawn up into the stratosphere, and then enjoys a subsequent career as the stereotypical she-demon, responsible for stillbirths on the one hand, and wet dreams on the other hand, thereby becoming an emblem of that which most destabilizes traditional images of women (stillbirth) and traditional images of men (wet dreams, when the man loses control of his sexuality). But I do not want to focus on Lilith herself. What I want to focus on is the fact that this is the truly politicized version of the primal scene. Not Adam, Eve and a snake but Adam, Lilith and the politics of marital rape.

What I suggest is that the imagery within each reader of her or his parents' intimate life and sexual relationship is an extremely useful indicator of the reader's politicality, political values, desire and capacity to do politics. The primal scene moves between conflict and harmony, harmony and conflict. In particular, is it not about enjoying enough conflict, enough sense of vigorous movement, to achieve a harmonious result, such as a mutual sexual satisfaction or a baby? This can be taken as an analogy for the political process itself.

The imagery people have in their hearts and in their mind's eye of their parents' sexual relationship tells them quite a lot about their political selfhood, provided they decode it that way. It is a self-administered diagnostic test of a person's political *Weltanschauung* to dwell on this most intimate and sacred image that actually is responsible for his or her creation. I have begun my survey of the heterosexual politics of the internal family with that account of the primal scene because of the way it demonstrates how sexuality and politics symbolize each other.

Earthing the mother–son relationship

The second relationship I want to discuss is the mother–son relationship. Most conventional psychological books stress that he has to escape her. When we talk about "the feminine" as a threat to men, when Julia Kristeva talks about "the abject", the feminine swamp, it is probably mother that we all have in

mind. With the father's help or without the father's help, so the mainstream psychodynamic textbooks tell us, he must escape her. This means that, in effect, he has to harden his body against softness, that he has to replace playful relatedness by goal orientated activity, he has to strike a bargain with society that will reward him for doing these things by giving all its material good things. This is what I call "the male deal". The male deal involves the kind of separation and differentiation from the feminine represented by the mother that I have been describing. The reward, the pay-off, the bottom line for the male is: all the women you can eat! All the children you can control!

Is this really the only way to envisage the son–mother mother–son relationship? James Hillman (1973) told us years ago about the problem of heroism, and this is truly the problem of an excess of objectivity and a striving for hyper-consciousness. It is the problem of the over-analytical attitude that cuts things up so as to control them and understand them. All these things have been attributed by feminist commentators, quite rightly in my view, to the rule in western culture that says sons must escape mothers. But it is an outrageous insult to mothers and to sons, this conventional account, because it overlooks the fact that both of them, not just the son, need to separate from the other. Here we must return to ambivalence and, in particular, to maternal ambivalence. As Roszika Parker (1995) has argued, maternal ambivalence towards her children fosters a mother's capacity to take responsibility and make use of her *own* desire to separate for her *own* reasons. Women need and want to be more than mothers. Obviously, sons also somehow have to become who they are, but the politics of it, never mind the psychology, need not be violent, bloody and demeaning of women once we build into our picture of the mother–son relationship that she too, mother too, wants to separate. It is incredibly boring being a mother all your life.

This leaves room for a new kind of relationship between men and their (literal or metaphorical) mothers. A new picture of the mother emerges, perhaps as a way of grounding "eco-masculinism", a much better relationship between men and the environment and a way of bringing realism to bear on the idealism of many "New Men". One might think about achieving this via a kind of maternal politics, meaning a maternal politics capable of being done by both sexes. Maternal politics (cf. Ruddick, 1989) would highlight issues of care, nurture and containment, and get to grips with the secret politics that lie behind questions of self-esteem and self-respect.

Let me explain what I mean. If one reads a standard text in social theory such as John Rawls *A Theory of Justice* (1971), one finds much about self-respect and self-esteem as kinds of commodities or goods that have somehow to be distributed in society. I agree with that formulation. We talk about money being distributed, water being distributed, power being distributed or motor cars being distributed. But there is a sense in which we also need to start to think in psychological detail about self-esteem and self-respect being distributed in a society. In organizing a society along lines that are informed by maternal

politics, things like self-esteem and self-respect get talked about and valued in the same way as things like food, water and transport, which mainstream politicians tend to see as far more important.

Another aspect of maternal politics would be to completely reverse the theoretical trend that nearly all psychological approaches to politics have taken, which is to see the citizen primarily as a child and even, if it is a psychoanalytic critique, as a baby. Then the child citizen is up against parental society. In British terms, this is seeing Mrs Thatcher as our mother, as the hated yet restorative container of our infantile greed (to give a highly tendentious example of the genre). These positionings of the citizen as a child are extremely significant. They represent the collusion of depth psychology and psychoanalysis with the interests of the powerful who have an investment in keeping citizens as children. What I have been suggesting is that we can start to think about the citizen as an adult, and even as a mother. A maternal politics would make use of this idea that each citizen can take a maternal attitude towards the social issues and social problems in the culture that she or he inhabits.

One last feature of maternal politics to mention returns us to the theme of economics. I think there are emotional and aesthetic factors that need to be introduced, via maternal politics, to economic thinking. Economists talk about exchange value. That means the money/price value of things. I am wondering if there is not also *emotional value* to consider here. What are the emotional consequences of such and such an economic decision – to build a motorway, to build a nuclear submarine, to raise or lower income tax? What are the consequences for the emotional life of the nation? There is also an *aesthetic value* to consider, as well as exchange value. What are the aesthetic consequences of policy decisions? Do they add to or subtract from the store of beauty in a society?

Pulling it all together, if we start to think again about the mother–son relationship and stop seeing these two as lifelong enemies, it is possible to see the emergence of a maternal approach to politics that stresses self-esteem and self-respect as distributable goods that can be fought over and contested in a society. Without idealization, based on maternal ambivalence, nurture, containment and care become the highest political values. We stop seeing citizens only as children of a parent state. We add emotional and aesthetic value to exchange value in the field of economics.

The father's body

Now for the father–daughter relationship. This section of the chapter is about paternal erotics and the secret politics of the father's body. Something has gone very wrong with the western world's response to the father's body. Actually, the problem concerns the male body generally, but is highlighted

by the father's body. In all the quite justifiable legitimate and factually correct concern over child sexual abuse, we have forgotten that there are benevolent uses, psychologically benevolent uses, of the father's body in the emotional development of children of both sexes. (I am going to continue writing about heterosexuality but I would like once again to assure the reader that I have published at least as much work on the father–son relationship as on the father–daughter relationship (Samuels 1993, 1995).)

We cannot just get rid of the cultural equations between father and sex and father and aggression. We cannot simply start again. We have to stay with sex and aggression. As far as sex is concerned, what I call "erotic playback" from father to daughter communicates to her that she is something other than a person restricted to the role of mother. The physical warmth of erotic playback involves a communication of the daughter's sexual viability but not any kind of physical enactment. Clinicians will know how often they hear in our consulting rooms about fathers who have failed to deliver erotic playback to their daughters – a sense of admiration, a message initiated by the erotic that she is something other than a maternal person and hence not necessarily a highly related creature who puts the needs of others first. Deficits in erotic playback lead to serious psychological problems. While these are not the same as the problems caused by physical incest and child sexual abuse, there are very significant issues here which have been overlooked by many clinicians. But it is extremely difficult to get this discussed without being accused of advocating incest.

Erotic playback leads to a kind of psychological pluralism. Breaking up the equation "woman equals mother" leads to the possibility of other pathways for female development opening up. For example, a pathway of spiritual development, self-assertion, vocation, or sex and lust, absolutely unrelated sex as a pathway of development for women. This is something men know more about, and men like it, and I think women probably like it too. It is not the only way to relate and certainly not the most elevated way, but it is one way to relate. Not relating is one way of relating. Then there is a pathway that has nothing to do with men at all. A pathway of community and solidarity with other women, that may or may not involve lesbianism or celibacy. What happens once a rigid equation that has too much gender certainty is broken is that doorways open up to other possible kinds of relationship. It may be very hard to accept that paternal sexuality has this door-opening function. To reiterate this point: alongside the problems of child sexual abuse that we now know a lot about, let us recognize the opposite problem and speak out against the daughter–father relationship remaining stunted, inhibited and cool. In particular, we need testimonies, books and texts about the benevolence of the father's body and paternal erotics which are missing at the moment.

There is a very important contribution to be made here to what is called "the politics of time": how a woman organizes her life, how she copes with the balancing act or juggling act between the various selves that she inhabits. I

suggest that erotic playback, although not solving the problem of the politics of time, plays a part in contributing to a woman's pluralistic capacity to think about it. I mentioned aggressive playback and that this, too, involves the father; the way he deploys, uses and inhabits his own body serves to communicate to his daughter that it is all right to be angry. The way I see it is that the father's body is a kind of forum, a place in which father and daughter can practise and experiment with different styles of aggression. For instance, *mouth aggression* – verbal aggression; *leg and foot aggression* – when each walks away from the other; *genital aggression* – a disparaging of the beauty of the other; *anal aggression* – a smearing, envious, mocking kind of attack. It is important not to get stuck in one style or mode of aggression and to become competent at rotating through a plurality of aggressions.

Everything I have been writing about has been markedly social, markedly political; I need to conclude this particular section with a remark about why my ideas do not apply only to male fathers. I have invented the phrase "the good-enough father of whatever sex" (Samuels, 1995). Succinctly, my research work with lone-parent families has shown me that, although women parenting alone or together with other women may not do these things in quite the same way that men do them, it does not mean that there is therefore an inevitable psychological deficit. It is about time that therapists and analysts spoke out about the fact that in our practices we encounter numerous people who have had two parents, grew up in a conventional family, whose parents might very well be alive – and yet the individual is extremely disturbed and unhappy. Similarly, the psychoanalytic and political panics over the absent father may be a cover-up for how little we know about what fathers who are present do – or could do.

Sibling justice

Finally, we come to the brother–sister relationship. If you read the conventional psychoanalytic or psychodynamic texts about sisters and brothers, you will see that that an almost exclusively negative orientation is taken. There is rivalry, or there is the way in which the siblings receive different projections from the parents. There is jealousy and over-involvement, with physical incest hovering around as a threatening presence in all these discussions as well. Sometimes, the sibling relationship receives what is effectively a put down because somebody says in their book that sibling-style marriage is a bad thing. "This marriage went wrong because there was too much of a brother–sister tone to it."

I certainly think that the brother–sister relationship is different from romantic love, or marriage, and that is *precisely why* I want to celebrate it as the repository of a great deal of secret political energy. We can think, for example, of myths like Antigone or of discussions about why Jesus does not

seem to have had a sister and the significance of that. The point about the sister–brother relationship I want to make is that it is an extremely useful image with which to address a key political problem in so-called liberal societies. We are all *supposed* to be equal, but in fact we are not. Similarly, the brother–sister relationship in modern western societies is supposed to be a relationship of equals. It can be, but it still often is not. Hence it is absolutely full of the kind of politically useful ambivalence that I have been describing. How do brothers and sisters relate politically? What do they do that we could get some political juice out of it? To begin with, they exchange information. They are the Interneters of the internal family.

When the first sibling reaches the age of 11 or 12, something tragic, something awful, something repressive happens to the sister–brother connection. They stop talking. They start mocking, or getting into a silent and withdrawn stand-off with each other. The conventional explanation of this is that it has to do with sex. Clearly puberty is relevant. But there is something else. At 11 or 12 a child is a real threat to parental authority. To the degree that parental authority carries the state's authority, it is absolutely crucial for the preservation of the state's authority that the sister–brother relationship remain politically depotentiated. This happens at the point when it might actually achieve something.

I realize that what I am writing here may strike the reader as a horrendous melange of psychology and politics. To some extent it is meant to be. What I am saying is that, when a person stops having the close playful relationship with your brother or sister that most of us in some sense have stopped having, he or she has to consider himself or herself a *politically depotentiated and repressed individual*. I want to restore the brother–sister relationship as a key template or model for progressive political action and relationship between the sexes. Most western societies have failed to achieve the full benefits of the sibling of horizontal dimension of culture. Incredibly then, we hear many calls these days for the restoration of the socially vertical dimension. Horizontal politics – sibling politics leading to sibling justice, new deals between women and men that come into being and then fall apart – for me, that is the way to go. There will be interesting pay-offs for both sexes. For example, in terms of sibling politics, men may get women to listen better to some of the concerns and worries they have. What do we make of the enormous explosion of interest in western countries in men's health? For instance, the worldwide panic about declining sperm counts or other men's health issues: stress, coronary disease, etc. Can women take those things seriously? I believe, within a sibling mode of politics, they can.

But what about the other way? What could sisters say that might get heard by brothers? I think that women have been done a huge disservice by much of the essentialist literature (a lot of it Jungian) that insists that they are true, deep, pure, integrated, related, containing, nourishing, wild earthy goddesses. Instead, I would be interested to see it valued when women start to lie openly, to be ingenious and improvise, to deny reality, to move more

confidently in public, urban places at all hours of the day and night, to mock the rules that contain them, to play power games, to succeed in sport. There is a prison of depth, purity and integrity in which women have been placed by much of the literature on female psychology. True, it has liberated some women to some extent and goddesses have been an incredibly useful resource, for many women in their individuation.

The politics of transformation

Finally, a few words about transformational politics and the politics of transformation. Here is a crisis in western politics that I cannot pretend (for one minute) will be completely solved by the kinds of ideas I am putting forward. I would like the reader to respond to the need I mentioned earlier, to evolve a new hybrid language of politics and psychology that will also involve spiritual values. What I have been trying to do in this short guided tour through the social, political and psychological dynamics of the internal family is to reveal the deep connections and links between people that precede the social order and are not only created by it. Western philosophy and western psychology have positioned people as atomized individuals with empty space between them. This is far too limited a view because it misses out on the primary connectedness of persons, the new deal that was hidden in the open. If we think in terms of the internal family and its dynamics, then we start to see, or allow to shimmer into being these pre-existing links between people, an imaginal solidity in which citizens move, that rhizome, the collective nutrient tube below the surface, which sends up what look like individual stalks or sprouts. What is most transpersonal and spiritual about human life is its sociality and its primary connectedness. The French theologian Charles Peguy said that "everything starts in mysticism and ends in politics". Although it cannot succeed as planned, new deals between women and men need to happen soon, and so I will conclude with the words of Hillel, the first-century Jewish sage: "If I am not for myself, who is for me? If I am only for myself, what am I? And if not now, when?"

Appendix: recent developments in this field

The roots of this chapter lie in a number of recent political developments with which I have been closely involved. I have carried out a number of consultations with politicians in Britain and the United States designed to explore how useful and effective perspectives derived from psychoanalysis might be in the formation of policy and in new thinking about the political process. It is difficult to present psychotherapeutic and psychoanalytic thinking about politics so that mainstream politicians – for example, a Democratic senator or

a Labour party committee – will take it seriously. I have found that issues of gender and sexuality are particularly effective in this regard. Partly this is due to the perennial fascination and excitement carried out by such topics, partly it is due to the feminist politicization of such issues over the past 30 years which has gradually led to their presence on the agenda of mainstream politics. Partly it is because, as discussed in this chapter, gender is itself a hybrid notion from a political point of view.

I have also been involved in the formation of three organizations whose objectives are relevant to the content of this chapter. Psychotherapists and Counsellors for Social Responsibility is a professional organization, intended to facilitate the desire of many psychotherapists, analysts and counsellors to intervene as professionals in social and political matters making appropriate use of their knowledge and, it must be admitted, whatever cultural authority they possess. The second organization is a psychotherapy-based think tank, Antidote. Here, the strategy has been to limit the numbers of mental health professionals involved so as to reduce the chances of psychotherapy reductionism and foster multidisciplinary work in the social policy field. Antidote has undertaken research work in connection with psychological attitudes to money and economic issues generally and is also involved in work of emotional literacy but expanding the usual remit from personal relationships and family matters to include issues in the public domain. The third organization is a broad front based at St. James Church in London. The St. James's Alliance consists of individuals from diverse fields such as politics, economics, ethics, religion, non-governmental organizations, single issue groups and progressively political organizations. It is an experiment in gathering political energy that is split up and dissipated under current arrangements.

References:

Gralnick, A. 1990. Review of Levine, Howard et al (eds), *Psychoanalysis and the Nuclear Threat: Clinical and Theoretical Studies*. In *International Journal of Mental Health* **20**:1.

Hillman, J. 1973. "The great mother, her son, her hero, and the puer". In *Fathers and Mothers*. Berry, P., Zurich: Spring Publications.

Levine, H. et al (eds) 1988. *Psychoanlysis and the Nuclear Threat: Clinical and Theoretical Studies*. Hillsdale, NJ: Analytic Press.

Parker, R. 1995. *Torn in Two: the Experience of Maternal Ambivalence*. London: Virago.

Rawls, J. 1971. *A Theory of Justice*. Cambridge, Massachusetts: Belknap Press of Harvard University.

Ruddick, S. 1989. *Maternal Thinking: Towards a Politics of Peace*. New York: Ballentine Books.

Samuels, A. 1993. *The Political Psyche*. London: Routledge.

Samuels, A. 1995. The good-enough father of whatever sex. *Feminism and Psychology* **5**:4.

Wilde, O. 1978. "The soul of man under socialism". *Complete Works of Oscar Wilde*. London: Book Club Associates.

4

For Esmé with love and squalor

Jan Campbell

The birth of my daughter coincided with the beginning of my doctoral studies in psychoanalysis. At the time, I was studying Lacan, having therapy with a Winnicottian therapist and struggling to survive in a housing co-operative. Idealistic visions of bringing up a baby communally were eventually forced to confront the chaotic, unsupportive reality of my situation and I moved out. My daughter was named after J.D. Salinger's novel, *For Esmé with Love and Squalor*, because the title summed up so aptly the love and passion I felt for my child and my hatred and feelings of obliteration towards the harsh realities of having to cope with single motherhood in an unconventional, non-nuclear family set-up.

Unlike me, Esme thrived on communal living, which extended from the co-op to the crèche and nursery at the university which she attended for four days a week, from the age of 4 months, until she was five. As a baby Esme had contact with various men including her natural father, who became involved in childcare, but the bulk of this, which supported me outside of crèche hours, was carried out by lesbian and feminist friends of mine who quite happily incorporated Esme into their political and social activities.

Now for those who equate traditional family constellations with healthy child development, Esme's seemingly happy and humorous personality is probably viewed as a consequence of nature not nurture; a sceptical view of my conviction that her varied cultural and communal influences as a small child were so good for her. The conservative opinion, and one that owes much to the traditional institution of psychoanalysis, is not just that babies need fathers, but that the father is the necessary psychic and social separator, who will rescue the child from the overpowering, ultimately deathly imaginary of the mother. Freud's Oedipal complex states that in order to grow up and enter society the little girl must turn her back on her mother (hating and rejecting her), in order to take her father as her new heterosexual love object. Luce Irigaray argues that this is the masquerade of femininity which is enforced on women, leading them to self destructively hate and reject themselves.

Freud's Oedipal complex is a phallic hegemonic narrative, where the father's law represses the world of desires and drives in relation to the mother's body, enabling the child to separate and gain access to the symbolic, civil institutions of culture. Jacques Lacan returns to this Oedipal formation in Freud's thinking, making the triangular constellation explicit at the level of language. For Freud, the Oedipal is the literal law of the father: his physical body and presence. But for Lacan, this Oedipal law is symbolic, a naming of the father which announces his absence in reality. The symbolic phallus is a fraud, a transcendental signifier which veils or covers over the loss or lack intrinsic to sexual desire and identity. But the phallus remains hegemonic in repressing the maternal body and excluding it from the symbolic (language and representation). Irigaray criticizes Lacan for essentializing Freud's Oedipal father at the level of language; privileging the symbolic and linguistic Oedipal father (Irigaray 1985:87). For although the symbolic father makes his literal presence redundant, it also absolutely divides the mother's body from language, providing the hysterical dilemma for women. Either they accede to a cultural identity, inscribed within a phallic linguistic symbolic, providing them with a sublimated and speaking position, or they align themselves in relation to their mother's and their own bodies, an abjection designating them to an unmediated, ultimately psychotic position outside the cultural norms of sanity and identity. In this scenario, phallic identity and the mother's body become mutually exclusive terms, and the woman is forced to relinquish her loving relationship to the women's body (her mother's body and hers) in order to enter our designated cultural symbolic.

For Irigaray the mother–daughter relationship is emblematic of a new ethics of subjectivity, which can acknowledge both identity and difference. This embodied subjectivity does not repress the woman's body beneath the phallus or outside language. Instead it mediates the woman's body or translates it within a cultural configuration which privileges neither sameness nor difference, but underscores an ethical relation between two (Irigaray, 1993). Irigaray has famously called this liminal and embodied subjectivity, "neither one nor two". The difficulty of Irigaray's vision of an alternative subjectivity not based on the phallus, is that within a Lacanian framework it is impossible. Rejection of the phallus and of symbolic castration leaves you outside culture and sanity, in the realms of madness and fragmentation.

This chapter addresses this impossibility. For the purposes of mapping a certain field of debate, my text sometimes follows through arguments schematically which I have made in depth elsewhere. My defence of this is quite simply wanting to put forward a new approach to psychoanalysis and cultural studies which does not assume an incompatibility between the psyche and the social, but argues for a complex interrelationship between them. My initial studies into Lacan and Irigaray were at the height of enthusiasm for poststructuralism in the academy, particularly in English and cultural studies. "Psychoanalysis" meant Lacan and Freud read through

Lacan. Developmental and clinical issues in psychoanalysis, the experiential and empirical material, were dropped as irrelevant to the linguistic arguments of subjectivity, which focused on questions of mental representation and language rather than lived reality. My doctoral thesis was informed from the start by my experiences of having therapy and giving birth and bringing up Esme. These experiences convinced me, rightly or wrongly, that separation between daughter and mother, rather than being dependent on the phallus or the father, has much more to do with the symbolic and cultural recognition of the mother.[1] However, the Oedipal complex does not explain symbolic mediation *between* mother and daughter, either at a developmental or poststructuralist level, and my subjective experiences could not help with a doctoral thesis whose theoretical field rejected empirical methodology, however objective I could have tried to make it. Studying poststructuralist psychoanalysis and the debates on the phallus which centered around Irigaray and Lacan were complicated for me by my own experiences of having Winnicottian therapy. My own personal therapy, therefore, fueled my interest in object relation theory, especially because of its focus on the mother. In Britain, clinical practice is largely maternalistic, drawing mainly on the object relations schools such as Winnicott and Klein. Academically, in cultural studies, the paternalism of Freud and Lacan have been paramount, principly because there is no explanation within object relations theory of the construction of identity in relation to language and culture. Where critical development of Winnicott's ideas has occurred, it has been hampered by a sociological bracketing of his ideas on subjectivity, reading them as evidence of some kind of core or true gender identity which has completely obfuscated Winnicott's understanding of self-experience as a more unconscious fluidity.

I lived out this split between practice/experience and theory during my postdoctoral studies. In trying to theorize an alternative to the Oedipal using Irigaray, I turned to the feminist debates with psychoanalysis which have been polarized oppositionally between object relations and Lacan, between an idealization of either the mother or the father. Linking Irigaray with object relations theory, I attempted to theorize an alternative to the Oedipal or a female symbolic which would not repeat or substitute for the masterful metaphors of the phallus. My problem with feminist object relations theory was the absence, within it, of a theorization of language or the symbolic. Chodorow's influential writing has been discredited because of her failure to theorize such a relationship between the unconscious and the symbolic and her consequent inability to account for the postmodern decentered nature of the subject.[2] But if Chodorow's writing remained too entrenched within positivist notions of an essential social identity, Irigaray's ran the risk of refusing the social entirely and becoming mired within what became, in the 1980s, a fairly wholesale rejection of her work as biologically essentialist.[3] Irigaray's alternative to the Oedipal in terms of the mother–daughter relationship was seen to collapse women's identity back into the

pre-Oedipal drives of the maternal body, as an unmediated, biological function, outside culture.

Feminism and psychoanalysis have historically been uneasy occupants of a territory which has sought to explore and understand the origins and meanings of sexual difference. In cultural studies, the Lacanian analysis of the correspondence between language, subjectivity and the phallus have proved indispensable to poststructuralist theories of the subject and indeed to a whole range of critical schools which interface feminism, literary theory, film studies and postmodernism. The historical, somewhat arbitary, split between structuralism and culturalism in British cultural studies, assigns Lacanian psychoanalysis to the realm of high theories of subjectivity, dividing it from questions of lived experience and culture, and therefore leaving it open to criticisms of ahistoricism and universalism.[4] Stuart Hall's famous essay "Cultural studies: two paradigms" tries to hang on to the equally crucial, but incompatible, narratives of structuralism and culturalism. His attempt "to map the experiential emphasis of Raymond William's cultural expression with structuralism's emphasis of meaning as a set of imposed meanings or texts", is ultimately unsuccessful; the problem of historicizing a Lacanian phallic subject remains. How can this dominant narrative of history (however decentred) account for minority histories, the cultural stories that a dominant and imperial phallic text, forgets and actively represses?[5] Especially when the methodology for recovering such minority histories refuses, as Lacanianism does, the more experiential stories of life that do not qualify as either knowledge or history, because they are not situated at the level of linguistic mental representation or the text.

Robert Young points out that Marxism and psychoanalysis are incompatible: the Oedipal text documents this incommensurability between the social and the psyche, and the danger of refusing the Oedipal dictate is a return to the old imperialist and unproblematical, unified subject.[6] My argument in this chapter is that, whereas I agree with Young that psychoanalysis is important as a narrative which can challenge such singular and imperialistic politics, it cannot do so at the level of the Oedipal phallus, because the phallus is implicitly a master discourse of the subject. Even when it is deconstructed in the eloquent language of Lacan, it still remains a colonizing narrative because it splits and represses the more experiential and bodily stories of class, sexuality and ethnicity. This mastery exists at the symbolic level of language, where the "phallic subject" exists only because the more experiential and bodily relation to the maternal body is castrated, abjected and excluded from representation and culture.

As Juliet Mitchell has recently suggested, there are at least two very different readings of Freud: a classical Freud and a more deconstructionist one. For Mitchell, the classical Freud is one who looks backwards, towards the past, "towards the Enlightenment, modernism and ethics" (Mitchell 1995:127). This is the Freud who conceptualized the Oedipal and the castration

complex. The other Freud is a postmodern Freud, a deconstructionist whose concepts such as "deferred action" (analysed in *The Wolfman*) bear witness to all the complex temporality and ontological insecurity of our postmodern world. If modernism can be characterized crudely as a crisis in epistemology and knowledge, a crisis of man's rationality and the imperial narrative of totality and mastery that goes with it, then postmodernism is the logical extension following this, namely, a crisis and breakdown in the ontological self. Now, as Mitchell so rightly points out, there *is* a modern and postmodern Freud, but there is also a modern and postmodern Lacan. Mitchell acknowledges that her reading of Lacan in *Psychoanalysis and Feminism* was a modernist reading which looked backwards at a more classical Freud:

> My own distortions of Lacan for that book, for a political purpose and through ignorance as well, looked towards the classical Freud, the Freud who was looking backwards, saying something about sexual difference as it has been established (Mitchell 1995:127).

Although Lacan can be read in the most playful and deconstructive postmodern way, his argument for the symbolic phallus (and the feminist readings which support it), collude in a discourse of mastery. They assume that a symbolic phallus, or a symbolic Oedipal complex can be situated as a deconstruction of the original and literal Oedipal father, or phallus in Freud's text. As Luce Irigaray shows us in her essay "Cosi Fan Tutti" (1985), Lacan's symbolic phallus does not displace the mastery of the Oedipal complex; it merely essentializes it at a linguistic level. So although supporters of Lacan would argue that the symbolic phallus is a masquerade, a sham which reveals the mastery of the Oedipal father as illusionary, Irigaray explains how the symbolic phallus represses the female body more totally than Freud's anatomical model. It is in this sense that Lacan's symbolic phallus is classical; a hegemonic metaphor of mastery which divides language from the female body, making women's bodily experience abject and external to representation and culture. Irigaray sums this up when she says:

> Female sexualisation is thus the effect of a logical requirement, of the existence of language that is transcendent with respect to bodies. Take that to mean that woman does not exist, but that language exists. That woman does not exist owing to the fact that language–a language–rules as master, and that she threatens – as a sort of "prediscursive reality" – to disrupt its order (Irigaray 1985:89).

This well known quote has been interpreted in various ways by feminist critics. If the master rule of the phallus splits language from the female body, then for Irigaray there must be "some other logic and one that upsets his own. That is, a logic that challenges mastery" (Irigaray 1985:90). Lacan decon-

structs the phallic presence of the Oedipal father only to reinscribe its law at a universal symbolic level.[7] To move beyond the phallus entails another logic. For the Lacanian critic Jacqueline Rose, bypassing the phallus means moving outside the order of symbolization, into a world governed by the unmediated drives of the maternal body. Margaret Whitford, who has done much to translate and reintroduce Irigaray's work in Britain, has claimed that Irigaray is not actually rejecting symbolic castration, but trying to bring women as female subjects into our current symbolic. I have argued elsewhere that this is a contradiction in terms; for Irigaray the phallus and the inclusion of a female symbolic subject are mutually exclusive, because the phallus occupies a space of linguistic mastery.[8] You cannot theorize an alternative female symbolic on the basis of phallic castration, because that linguistic law refuses any possible language of the female body. Both Margaret Whitford and Kaja Silverman try to distinguish between Lacan's symbolic castration and the anatomical "reality" of Freud's castration complex, because they want to incorporate Irigaray's thinking within a Lacanian system of representation. But Irigaray quite clearly tells us you cannot separate the literal from the metaphorical phallus. We have to question the phallic laws of language because they are based on the Oedipal, anatomical organ:

> Going back to historically dated anatomico-physiological arguments is obviously out of the question, but we do have to question the empire of a *morpho-logic,* or the imposition of formations which correspond to the requirements of desires of one sex as the norms of discourse and, in more general terms, of language (*langue*) (Irigaray 1991:96).

What does it mean in psychoanalytic terms, not to repress the female body under the phallus? Not to repress the experience of the body, but to listen and find a way of translating it. For Irigaray, a language or theory of the phallus, which represses female bodily experience becomes a "technocratic" process which impoverishes the analytic experience; she asks, "How does a psychoanalyst look at, conceive of or listen to the body?" (Irigaray 1991:95).

I want to suggest that the psychoanalytic practice of conceiving of and listening to the body – the experiential bodily stories that occupy the clinical space – are the postmodern histories of individuals that do not translate so easily into a classical, Oedipal system of representation. Lacan's reading of Freud privileges a linguistic reading which censors the old empirical understanding of Freud as a clinician who recounted and interpreted stories of people's lives. The empirical has always been there in psychoanalysis, since Freud, in the presence of case histories. But with the advent of Lacanian psychoanalysis, the empirical component of psychoanalysis – its clinical setting – has become repressed in favour of a model which is linked with language and representation. Psychoanalytic theory in the academy has, through its Lacanian and post-structuralist travels, become associated with the area of unconscious and

linguistic representation which is almost exclusively linked to mental representation, rather than lived experience. Of course, Lacanian psychoanalysis exists and is applied in relation to a clinical setting, but the divide between psychoanalytic theory and practice in Britain has led to a split situation. Where, as I have acknowledged, object relations maternalism seems to reign supreme in a clinical arena, however the academic inclusion and theorization of psychoanalysis in such disciplines as cultural studies remains phallic-centred, untrammelled by the more experiential and bodily associations with the mother. Theories of subjectivity in cultural studies have relied on a Lacanian psychoanalytic account, positing cultural representations of the self through the symbolic name of the father. These accounts of sexual difference and subjectivity privilege the phallic mental representation associated with the symbolic over the more bodily experiential debt to the mother. Psychoanalytic accounts of the symbolic have, therefore, been criticized, particularly from an ethnographic perspective in cultural studies, for providing a universal, immutable meaning of culture which gives little room for resistance or change. Object relations psychoanalysis has been largely avoided in cultural studies because of its inability to theorize or explain how sexual difference and subjectivity are historically and symbolically reproduced.[9]

In another article entitled "Ethics and Sexual Difference", I have used Irigaray to argue for a more bodily imaginary.[10] This bodily imaginary is not governed by Lacan's narcissistic phallic castration and does not set up a division or split between the mind/language and the body. A Lacanian mental imaginary opposes the symbolic and the real; thus excluding the real as an impossible, non-signifying relation to the body of the mother. My theorization of a more bodily imaginary using Irigaray, re-evaluates the real in relation to an imaginary which integrates the body within culture and the symbolic. The bodily imaginary therefore forms a threshold, rather than a split, between the real and the symbolic, and between the female *experiential* body and language. Such a threshold cannot be conceptualized solely with respect to language, theory or mental representation, but needs to be understood within the experiential, clinical space. Understanding the imaginary in terms of the clinical space, means that it has to be explained not just in terms of a mental secondary unconscious but also in terms of a more primary, experiential unconscious. Now of course both Oedipal and a more primary pre-Oedipal unconscious are theorized by Freud, but it is the early object relation to the mother, not the Oedipal complex, which has been foregrounded in psychoanalytic practice in Britain over the last half century. Klein and Winnicott rule the roost in clinical practice and although there are various explanations as to why this is so, there is a lot of clinical evidence to suggest that whereas in Freud's time the more repressive Oedipal neuroses were more common, in these postmodern days it is the ontological breakdown of the self with which the clinician is confronted.[11] Clients increasingly present with narcissistic disturbance. Identity is experienced as fragmentary, there is a

problem in articulating and representing the self that cannot be explained in terms of Oedipal conflicts, but is linked to an earlier, more primary, unconscious experience.

Juliet Mitchell wrote *Psychoanalysis and Feminism* from an academic perspective of Lacanian theory (1974), but now 20 years on, she writes as a clinician trained in object relations psychoanalysis. Acknowledging this difference, Mitchell reflects that: "During those twenty years of training and becoming an analyst the change for me has been to move from thinking with my mind to thinking with my body" (Mitchell 1995:126). For Mitchell, this means utilizing thought processes that "actually feel as if they come from inside the body, rather than inside the mind, as one tries to see and hear what the patient is saying" (Mitchell 1995:126). Juliet Mitchell's move from academic and Lacanian feminist, to clinical analyst within the object relations tradition, signifies a move from theory to practice, although she herself remains very wary of translating the question of sexual difference to clinical practice. "Can we actually address the question of what sexual difference is, and within that, what is a woman, to psychoanalysis, if we are thinking as clinicians? Can we address it to our practice?" (Mitchell 1985:127).

Lucy Irigaray, however, trained clinically under Lacan and was thrown out of his institution for disagreeing with his ideas. Her subsequent clinical work as an analyst has been central, not just to her theorization of sexual difference, but to her conviction that there is a beyond to the phallus in Lacan's theory, and that beyond entails understanding a more bodily imaginary, within a more empirical, clinical space. This bodily imaginary entails a structure of a "pre-Oedipal" experiential unconscious, rather than Oedipal configurations of mental representation, and therefore implicitly links Irigaray's work with object relation theorists such as Winnicott.[12] However, putting Winnicott and Irigaray into dialogue raises all sorts of difficulties because of the crossover entailed between developmental and poststructuralist frames. But as I have argued elsewhere, the potential possibilities in bridging this gap between these differing frameworks which seem to emphasize either theory or practice cannot be underestimated.[13]

I am not suggesting that object relations theory has never been theorized in terms of post-structuralist thinking and postmodernism, but it remains problematic. Without the Oedipal configuration, object relations theory on its own cannot account for the symbolic historical reproduction of subjectivity, or the temporal relationship between the body, unconscious fantasy and society, which the triadic structure of the symbolic, imaginary and real explicitly addresses. So although Julia Kristeva's poststructuralist theories owe a huge debt to Kleinian object relations thinking (through the influence of the French psychoanalyst Andre Green), they are dominantly framed by the necessity of the Lacanian symbolic and the phallus. Alternatively Jane Flax is a leading feminist theorist, following in a Chodoverian tradition, who has based her accounts of the postmodern condition on a Winnicottian transitional

subjectivity. Flax avoids the pitfalls of Chodorow's sociological determinism, showing the complex construction of the individual through a transitional space, which engages inner and outer worlds.[14] For Flax, culture arises out of this third transitional space, and although this neatly does away with the need to tie down social augmentation or separation to fundamental signifiers or figures such as the phallus or the father, Winnicott's theory does not explain the historical and unconscious reproduction of subjectivity or the symbolic representation of desire.

This then is the difficulty I confronted in my thesis. Although Winnicott and Klein presented me with the experiential relation to the maternal body, and to an implicit lived experience and history within the clinician's consulting room, it was Oedipal psychoanalysis which explained the symbolic and cultural translation of the mother's body. Without this Oedipal explanation of the negotiation between the psyche and culture, feminist object relations theory ended up idealizing and essentializing female identity and the mother/ daughter relationship within universalistic or naturalistic accounts. It thereby bypasses both tenets of history and decentred subjectivity, concepts and trajectories that have been crucial in the constitution of British cultural studies.

The Oedipal configuration is a crucial stumbling block: in Lacanian frameworks, the Oedipal signifies language, culture and linguistic mental representation, and although the culturalist and Marxist perspective in cultural studies would view Oedipal theorizations of culture as universalizing and ahistorical, the object relations dyad seems even more oblivious to the lived forms of history, shored up (without the Oedipal) in a nursery land of psychic or social determinism. Irigaray's work, alone, stands out in its attempts to translate the daughter's relationship to the mother's body, to chart its connection and difference, within an historical and psychoanalytic framework of a female symbolic. The problems with arguing for a substitute maternal language or metaphor are manifold and have been documented elsewhere. But if Irigaray's concept of a female symbolic can be understood more in terms of a cultural and discursive sublimation of women's desire for each other, which does not have to set itself up as universal linguistic law, then a Lacanian reading equating symbolic linguistic law with the acquisition of a cultural, discursive identity will have to be rethought.

In other words, if language can exist outside of symbolic linguistic law (the phallus), but not outside culture, then the symbolic is not a predetermining, universal origin of identity (castration), but a more hermeneutic and narrative reconfiguration of the subject's temporality. If Irigaray's female symbolic is understood in this narrative phenomenological way, then it cannot be aligned with a Lacanian linguistic symbolic. However, such a narrative reading also poses the question, what exactly is meant by the symbolic? We might, for instance, agree that the symbolic coincides with language but is not simultaneous with it, i.e. the symbolic does not act as an inclusive regulatory law. Therefore, it is not a case of the body coming before the law, or the law

coming before the body, but how the body is reconfigured and transformed into a language which can symbolically recognize and represent it. The symbolic does not have to substitute the real, but can reconfigure it within a different space–time, translating the bodily encounter with the mother. If the Lacanian symbolic is an example of a male imaginary, made law, then for Irigaray, "We have to discover a language which does not replace the bodily encounter, as paternal language attempts to do, but which can go along with it, words which do not bar the corporeal, but which speak the corporeal (Irigaray 1991:43).

For Irigaray, the symbolic order is simply the "victorious imaginary system" which "wins out over another one". She insists that the female imaginary is a utopian place because it still awaits that acknowledgement as symbolic law. However, it *does exist*. She writes:

If to be utopian is to want a place that does not exist yet in some of its modalities, I am utopian. That said I only speak of this place from the sensory and corporeal experience that I have of it. Therefore it is not a simple projection of, I don't know what kind of dream; it is a place that already exists and that I wish could be developed, culturally, socially, amorously (Irigaray 1988:164).

This seems to suggest that the female imaginary has a narrative potential that is not dependent on a universal phallic symbolic for its cultural augmentation. If the female imaginary is utopian, because it has been historically obscured by a dominant, linguistic framework, then the question is not how can it exist, but how can it be imaginatively translated through cultural narratives which do not bar the body? Again, the symbolic as some universal and regulatory law is displaced here. But if, as Irigaray seems to be saying the female imaginary is sensed and *experienced* through the body, then what does this mean in terms of a Lacanian Oedipal model of the unconscious?[15]

Christopher Bollas, a Winnicottian analyst, has recently marked out a difference between early, maternal, unconscious experience and a secondary unconscious of mental representation which is governed by the repressive Oedipal phallus. Now, this of course can be traced back (as Bollas acknowledges) to Freud's primary and secondary unconscious. But the problem of trying to link the pre-Oedipal early maternal world with the symbolic or history is that Winnicott's transitional space between mother and child, and Klein's depressive position are two-body relationships which do not theorize the movement between bodily desire and language or representation. This would then leave mediation between the psyche and the social solely within the territory of the phallus. However, Bollas' work does move the debate forward significantly with his account of a generative, experiential unconscious.

In his recent essay, "The Functions of History", Bollas describes how the traumatic real can be generatively transformed into imaginary and symbolic

registers. Although the "fact" of the real might be unavailable to mental representation, because we cannot think or narrate it, the traumatic event of the real can be revisited within the clinical encounter and re-constructed or created, as traumatically destroyed self states are brought back to life. For Bollas, the historian's text and the psychoanalyst's reconstructions can both be understood as a psychic function, where the imaginary and symbolic work upon the real, "creating a space in the mind that gives special significance to the real" (Bollas 1995:143). In his view "psychoanalysis errs if it turns away permanently from the presentation of the real, taking refuge either in a theory of narrative or in a misplaced empiricism" (Bollas 1995:113).

Distinguishing between a Freudian, phallic repression of desire (where desire is repressed and preserved) and a traumatic amnesia which is the result of intrapsychic destruction, Bollas suggests that the latter explains deathwork in the psyche. So whereas a phallic account of repressed desire means it has been hidden somewhere in the unconscious, the amnesia that Bollas speaks of signifies psychic self-destruction. However, traumatic deaths of early, unconscious experience, can be generatively reconstructed within the analytic space. This generative work, which recreates a lost maternal (internal) object relation can transform parts of the real into imaginary and symbolic registers. Transformation of the deathly real is achieved through the representative function of the image. Bollas uses Freud's concept of the screen memory: a seemingly inconsequential or trivial detail remembered, that is deeply significant, covering powerful desires and anxieties. Linking the screen memory with his own analysis of unconscious experience, Bollas suggests that "Screen memories are condensations of psychically intense experience in a simple object" (Bollas 1995:135). Unconscious material which has been lost through trauma, can be liberated through tapping screen memories which are captured by the aesthetic image. Free association of the screen memory yields inner images, between analyst and client, which can convert the destruction of the past into new stories of meaning.

Transformation of the real into imaginary and symbolic registers, within the clinical space, is Irigaray's answer and challenge to the universal theory of castration and to a Lacanian phallic symbolic. In "The poverty of psychoanalysis", Irigaray criticizes the automatic repression and equation of the real of the maternal body with castration and death and suggests that the real might be a "forgotten thing to do with the body" (Irigaray 1991:86). In another essay "Flesh Colours", Irigaray distinguishes between a mental imaginary at war with the real, and an unconscious, accessed by the image, which is more connected with the bodily senses and can imaginatively express them. For Irigaray, this imaginary space is represented through the image and painting, and utilizes the senses of the real, providing the analytic encounter with a "power of imagination", an imagination necessary for completion of analysis (Irigaray 1987:161). Transference, in other words, cannot be resolved simply by deconstructing the analysand, through a linguistic, mental framework

which analyses, but leaves no room to recreate. The difference between a mental and bodily imaginary is that with the first, the real returns as a threatening and destructive death-drive, but in the second the real becomes liberated within an imaginative recreation of the self.

Irigaray does not refer to object relations theory, although I suggest there is an unacknowledged debt to it in her work. There are obvious links between Irigaray's conceptualization of an imaginal imaginary and Bollas', but the question remains; how does this bodily imaginary translate into our cultural symbolic? Irigaray's refusal to separate concepts of the symbolic or culture from a question of the bodily real is maintained in the connective relationship she envisages between a female imaginary and symbolic. The female imaginary evolves in her work within different images which are all connected to one another, as the threshold, the beloved, the angel and the placenta. As these terms connect between the imaginary and symbolic, so they are also figurative representations of the bodily real, connecting, in Irigaray's words, the carnal and the transcendental. This intertwining of the literal with the metaphorical is implicit in Irigaray's understanding of the relationship between the body and the symbolic; it is there in her refusal to separate questions of literal and symbolic castration and in her explanation of how Lacan's morpho-logic is ultimately based on a male body and imaginary – the literal Oedipal complex.

But what does it mean to talk about the imaginary and symbolic as connective registers which can transform and represent the real? We are clearly moving outside Lacan's tripartite, but oppositional, structure which is governed and organized by the phallus. For Lacan, the real is a traumatic and psychotic space, unrepresentable and impossible. Envisaged as a black hole in the narrative fabric of the symbolic, the real is that unthinkable space that the psychotic falls into foreclosing the name of the father or the metaphoric phallus. But this psychotic relation to the maternal body, which in Lacan's world always remains external to the symbolic and to culture, can be seen as an unspeakable historical place, not just a psychic space, occupied by those suffering from madness, or psychoses. For Lacan, the aim of analysis is to introduce or re-establish the patient's place within language; patching the hole in the symbolic order by providing the Oedipal and paternal metaphor, which has been refused. Irigaray's understanding of the imaginary, symbolic and real as mediating between literal and metaphoric, challenges this phallic opposition between the female body and language and provides a more representative, imaginal imaginary. In a similar move to Bollas', Irigaray proposes a transformative real which can be ultimately realized within symbolic and imaginary registers. But this passage from unconscious experience to mental representation, or should I say between, only makes sense *if you perceive the imaginary* (as well as the symbolic) *as a primary form of stories or narrative*.

Other psychoanalytic critics have argued for the notion of psychoanalysis as narrative and for the unconscious as representative. Cornelius Castoriadis argues for a radical, creative unconscious which is essentially self-transforma-

tive and representative. For Castoriadis, the imaginary is not, as Lacan would have it, a mirrored image of the self; instead it is a socio-historical and psychical "creation of figures/forms/images". Anthony Elliott has developed Castoriadis' concept, seeing the unconscious as a constant "intertwining of representational wrapping, imaginary and socio-symbolic forms" which explains the interdependent construction of our psychical selves, relations to others and the internalization of social and cultural meaning. According to Elliot's theory, relationships between the imaginary and cultural are not cemented into a "fixed reality" by the symbolic phallus (Elliot 1995:50).

These arguments implicitly critique an Oedipal split, or incompatibility between the psyche and culture, and argue instead for their complex interrelation. If, as I propose, the imaginary and symbolic are to be understood as narrative forms, then it is not just a case of marking out differences in the imaginary, mental, bodily, representative and so on, it is also the case that we begin to mark out historical differences in the symbolic. If the symbolic is understood as a structural regulatory power and an ideal limit to desire, it is also a cultural narrative which is situated in terms of time and place. The symbolic is not therefore just white, male and phallic. Instead of the paternal metaphor, there is an implicit potential naming (even if this remains in some cultures on an imaginary level) of the symbolic as female, as black, as male and gay, as lesbian, etc. Moreover, historicization of a universal phallic symbolic entails an understanding of the movement between the experiential, bodily stories of the analytic encounter and the contextual narratives of culture. This means using practice to historicize theory; the Lacanian discourse of a de-centred subject must negotiate with its unacknowledged experiential imaginary. But it also means using theories such as post-structuralist ones to critique the apolitical stance of our current institutions of clinical practice. Object relations theory cannot be understood within a psychic vacuum, or left to stand unashamedly as a back to basics, conservative script for the "right" maternal practice within a traditional family. As dominant discourses within clinical institutions, Winnicott's and Klein's theories need contextualization within a postmodern analysis of culture and society.

I want to end this chapter with a discussion of the historical challenge to psychoanalysis through the question of race, and to a residual problem with Irigaray's *naming* of a female symbolic. Thinking through a non-essentialist symbolic figuration of women's desire entails theorizing a non-hierarchical relation to the masculine. As Elizabeth Grosz points out, Irigaray is not backing ontological truths about female desire, but is concerned with desire between women and within a radical heterosexual relationship. This then begs a question addressed to me by my doctoral examiners; why call it the female symbolic? Surely the naming of a female symbolic, at its worst, revives the female body as an essentialist truth claim, at best it returns as a master metaphor substituting the phallus, pulling images of a terrifying female super-ego in its wake. My thesis re-conceptualized the imaginary and

symbolic as narrative terms; the female symbolic therefore becoming a narrative alternative to the phallus. But even if the female symbolic is understood as a narrative, why should a narrative of sexual difference be accorded primacy over other narratives such as race? Doesn't the female symbolic as a counternarrative to the phallus become an umbrella term, signing an appropriation of all differences to the phallus under a generalized feminine "other"? My doctoral research confronted this issue by arguing for a dialogue between Luce Irigaray's notion of an embodied subjectivity as the beloved or threshold and Toni Morrison's novel *Beloved*. Conceptualizing the female imaginary and symbolic as anti-Oedipal narratives which connect with the masculine and with the otherness of race, I explored how a narrative of the black female symbolic automatically entailed differing narratives of masculinity. The narrative journey of the Paul D character in *Beloved* moves him from identification with a white, phallic masculinity to another *more embodied* naming of masculinity embedded within a symbolically maternal community.[16]

Toni Morrison's novel offers a literary example of how the narratives of the female imaginary and symbolic can be historically and culturally situated as a remembering/reclaiming of the African-American woman's sexed subjectivity and bodily desire. Now obviously the female imaginary and female symbolic would signify different statuses as narrative, but if the symbolic is understood as language, or a secondary level of meaning and discourse, then the representative imaginary can perhaps be seen as more bodily, unconscious stories that are hermenuetically linked to language as a pre-narrative structure. Paul Ricoeur views these stories as a prenarrative structure of experience where life "constitutes a genuine demand for narrative". Stories are not just recounted, they are also "lived in the mode of the imaginary" (Ricoeur 1991:432). For Ricoeur, these stories are also poetry, the projection through art of the world in which we dwell.

The "real" in Toni Morrison's text *Beloved*, is both the forgotten relation to the mother's body and the traumatic facts of slavery which no-one wants to remember. Psychic destruction of the "beloved", internal/maternal object within the self, is intrinsically connected with a communal history which has been destroyed and forgotten. This historical amnesia or forgetting is confronted by Morrison's narrative strategy of remembering, which moves from "image to text". Morrison uses the image of the veil drawn over the events of slavery "too terrible to relate". A colonial veil of castration, both literal and symbolic that can only be ripped aside with the act of the "imagination". Morrison's "literary archaeology" relies on the work of the imagination. Her reliance on the "image – on the remains – in addition to recollection", can also be seen as a return to the disconnected fragmented events, or "screen memories", as the poetic image liberates lost experience and history into the realm of language (Morrison 1987:112,113).

As Bollas and Morrison show us, the aesthetic image mediates between the unspeakable real and the symbolic place of narrative, connecting the body to

language. This bodily threshold appears in Irigaray's rereading of Levinas, as an ethical immanence. Homi Bhabha's reading of Toni Morrison's novel *Beloved*, cites Levinas' understanding of how the poetic image brackets or holds the real, to demonstrate an "ethical time of narration" (Bhabha 1994:16). The poetic image holds or brackets the real, providing an ethical alterity with the other, a relation between the internal self and the external community that does not split repressively under a colonial phallus, but provides a view of the internal psyche from the outside. For Bhabha, Morrison who undertakes the ethical and aesthetic project of "seeing inwardness from the outside, furthest and deepest" (Bhabha 1994:16). Morrison's writing transforms the lived representation of space, experience and the body into a narrative and discourse of time and postmodernity. Luce Irigaray also underlines how the poetic image, within the analytic transference can re-establish a necessary balance for the patient within his or her space–time. Painting the body or the painterly image can correct an overemphasis on analytic deconstruction of mental representation and is crucial for the resolution of the transference, which needs to be worked out on both sides of the imaginary, in relation to the body and the mind. This recognition of an embodied subject involves not just a linguistic relation to the other but the projection, within an intersubjective space, of the *sense* of self. Christopher Bollas elaborates on this sense of self as a "spirit of place". Although Freud analysed the unconscious mental processes that psychically constructed the "self", he did not, according to Bollas:

> address this specific atmosphere of place which prevails in any person's life – its aesthetic intelligence and structure. Not just the unconscious but its, "endopsychic derivative", a spiritual sense of place within the person, which is felt when it is there and terrifyingly missed when it seems to have departed (Bollas 1995:165).

This dwelling within the self becomes translated in Morrison's text to the intertwined question of naming and place. Recognition of Sethe's (the slave mother's) sexed and embodied subjectivity, in *Beloved*, involves the becoming movement of the real experiential body into language. But that narrative of recognition and history as a black female symbolic is finally only located within the novel as a community. A dwelling within the self, in relation to a naming of place. When we talk about a psychoanalytic concept of the symbolic, it is ahistorical, not to say politically irresponsible, to allow the naming of either an Oedipal, phallic or female symbolic to stand as a universal location of culture.

In *Black Skin, White Masks*, Fanon reminds us that the psychoanalytic dream must be returned to "its proper time" and "its proper place" (Fanon 1967:104). Arguing against Freud's universal prescription of Oedipal neurosis, where the psyche and the social are in conflict, Fanon's view simply states: "It is too often forgotten that neurosis is not a basic element of human

reality. Like it, or not, the Oedipus complex is far from coming into being among Negroes". Fanon references the disagreement that this establishes between him and Lacan: "On this point psychoanalysts will be reluctant to share my view. Dr. Lacan, for instance, talks of the 'abundance' of the Oedipal complex" (Fanon 1967:152). Like Fanon's, Toni Morrison's text stands alongside other such writings, as a narrative which challenges the universality of the Oedipal complex. According to Hortense Spillers the Freudian and Lacanian text cannot be translated into Afro-American experience, because under the law of the Northern American slave code the African father is banished. The "master" slave owner and his class cannot be said to father either; owning the slaves as human property denies kinship bonds and the children follow the condition of the mother.[17]

My thesis reached a conclusion with a rereading of the Lacanian concepts of the symbolic and imaginary, through Morrison's text *Beloved*, as narrative terms. In these narratives, the symbolic is historicized through a community of place, the imaginary is figured both consciously and unconsciously as a poetic act of imagination and imaginal painting of the body. The real, as the unspeakable traumatized events of slavery becomes re-memorable and transformable, through these historicized registers of the imaginary and symbolic. Just as the real events of slavery have caused a historical amnesia wiping out memory, so the traumatic real takes over and destroys the internal world of the psychotic. But, as Morrison has shown us, this historical and psychic real does not have to eternally haunt or live on as a dead incorporated m(other). In *Beloved* the real is moved and moves us as readers to understand it as a space and a place, a dwelling within the self that needs mediation through narrative. Does the fictional writing of Morrison, as a text of psychic and communal healing for her community and people, help us to begin to read and deconstruct our psychic, "universal whiteness", whether that mastery is played out as the Oedipal phallus in Freudian and Lacanian theory or the all-powerful mother in object relations practice? Paul Gilroy's conceptualization of the black Atlantic has made us confront the central relevance of unspeakable histories such as slavery, to the construction of discourses of modernity, such as Freudian psychoanalysis. As a fictional text, Morrison's work cannot be reduced to a theoretical polemic, or forced into theoretical parameters as an alternative anti-Oedipal psychoanalysis. But if psychoanalytic concepts can be read as narrative terms which are culturally situated in time and place, then such fiction can read and historicize the universal splitting of psychoanalysis, which seeks to distance theory from practice, theory from history, language from the body and the symbolic from the real.

Franz Fanon shares with Toni Morrison an understanding of the colonizing practice of the Oedipal, both literal and metaphoric. In the same way Irigaray understands in Lacan's work the exclusionary politics of the phallic metaphor, which refuses the affectual place of the mother's body thus relegating women's experience as abject and unspeakable. Irigaray's *and* Fanon's

critiques of Lacan arise from their refusal to separate psychoanalytic theory and practice, a refusal to separate thinking with the mind, from thinking with the body. Fanon explicitly spells this out, referring to Lacan's mirror stage, when he says, "the real Other for the white man is and will continue to be the black man". No impossible real here, but the real bodily castration of the negro, a colonial and phallic castration, not simply located at the level of language, but also at the level of his experiential, corporeal self. "But it is in his corporeality that the Negro is attacked. It is as a concrete personality that he is lynched. It is as an actual being that he is a threat" (Fanon 1967:63).

This connection between symbolic and literal castration, so reminiscent of Irigaray, opens up an interesting debate on the relationship between theory and practice. Fanon, like Irigaray, refuses to make absolute distinctions between the real and the imaginary, and both Irigaray and Fanon make it clear that this more fluid relation between the imaginary and the real is linked to the clinical transference. Attempts to read Irigaray and Fanon from within a poststructuralist tradition have missed the phenomenological understanding that informs their work. Traced back to such figures as Merleau Ponty, Heidegger and Husserl, phenomenology insists that the subject is always an embodied subject. Such notions of embodied subjectivity seriously question the divisory, linguistic phallus that splits and abjects the mother's body outside language. It is perhaps particularly ironic that Irigaray and Fanon have been so misread, in relation to Lacanian psychoanalysis.[18] Irigaray refuses, on phenomenological grounds, the Lacanian split between language and the female body. Similarly Fanon (who is influenced far more by Sartre's existentialism than by Lacan) critiques the Lacanian phallus as part of a white male imaginary which relegates the black man to an abject bodily other.

Paradoxically, Lacan's most radical insight of transference, namely that the unconscious exists as an inter-subjective discourse between subjects, undercuts the more absolute theoretical distinctions he makes between the imaginary, real and symbolic. As Irigaray points out, the clinical transference is not just made up of linguistic deconstruction (people are not texts) and the transference also implies a language of bodies. This is perhaps hard to assimilate within a linguistic poststructuralist tradition where the divide between a linguistic symbolic and the body seems integral. Phenomenologically, however, no such division exists. The body, for Irigaray, is always a culturally lived body, whether or not it is represented within our linguistic symbolic. Similarly, application of Lacanian ideas within phenomenological, clinical practice cannot avoid the bodily affectual aspects of the transference, thus opening out the more rigid linguistic categories of the theory.

Certainly, such rereading of theory through practice, raises important questions of methodology with respect to the academic institution. Academically, Lacanian psychoanalysis operates most smoothly within the theoretical parameters of poststructuralist thinking, where, for instance, the language of the phallus remains relatively unchallenged by the cultural implications of the

real, or its experiential effects within the clinical encounter. Within the realm of the social sciences, psychoanalysis generally has been given short shrift, because it cannot be validated on the basis of a positivist empirical model. Cultural studies is significant as an arena in which, historically, the theoretical and the empirical have, albeit unhappily, lived with each other. A political psychoanalysis, which situates the self culturally, and represents the lived body in time and place, can only be understood as an *historical threshold* between cultural theory and the experience of location. This threshold has been sadly eroded in British cultural studies where, on the one hand, an adherence to Lacanian theory (ignoring practice) relegates the diverse cultural experience of sexuality, race and class to the position of a generalized phallic other. On the other hand, however, a wholesale rejection of Lacanian theory (as the whole of psychoanalysis) has thrown the psychoanalytic baby out with the Oedipal bathwater. This has impoverished those more ethnographic accounts and cultural experiential stories that fail to take account of psychoanalysis and the political significance of the real as it resides inside, outside and connected with cultural narratives of the symbolic.

Acknowledgements

I would like to acknowledge my group at the Philadelphia Association (1996–97), for their contribution and recognition of difference. Thanks to Kaushika, Adam, Leon, Mike, Penny, Trish, Ben, Roy and Maureen.

Notes

1. Lacanian critics would argue that the phallus is the mother's cultural desire, i.e. her job, her social desires and relationships. But the phallus cannot sublimate or translate the mother's desire, in terms of her body, because the phallic law of castration represses the maternal body. This exclusion of the maternal body from cultural representation applies to both Freud and Lacan, although in Freud's case the repression is literal and for Lacan it remains metaphorical.
2. For feminist accounts which critique Chodorow for sociological determinacy see Parveen Adams (1983), Jacqueline Rose (1986), Janet Sayers (1986).
3. For early feminist criticism of Irigaray for essentialism, see, Jacqueline Rose (1986); Janet Sayers (1982), (1986). For a defence against these essentialist charges see Margaret Whitford (1991). More recently Tina Chanter (1993) has successfully argued that Irigaray's displacement of the sex/gender distinction, (through questioning sexual difference) makes the charge of essentialism untenable.
4. This split in cultural and media studies can be seen most clearly between the Lacanian, theoretical and textual focus of film studies and more empirically based audience research.
5. See Introduction.
6. See Robert Young, (1991:139–55).

7. Derrida also criticizes Lacan for phallocentric linguistic mastery. By figuring woman as the truth of castration, within the oppositional structures of the imaginary, real and symbolic, Lacan, in Derrida's view, re-inscribes the very cartesian metaphysics or presence he is trying to displace. See Derrida (1987).

8. See Jan Campbell (May 1997).

9. See Jackie Stacey (1994) and her argument for a more ethnographic approach to the study of film.

10. See Jan Campbell (Spring 1997).

11. See Stephen Frosh (1991).

12. The problem with locating the bodily imaginary within a pre-Oedipal space is that it seems to suggest some pre-ontological or pre-discursive state. Irigaray's phenomenological stance would not agree with this developmental position, but interestingly her challenge to the post-structuralist Oedipal position, (Lacan, Kristeva) is also based on her perception of how it situates the female body, as the abject maternal, in this same ontological, pre-discursive state.

13. See my article "Imaging and imagining a different imaginary" (Spring 1997).

14. See Jane Flax (1990) (1993).

15. As part of Irigaray's project is to connect the female body with language and the realm of the empirical with the discursive/symbolic, then the female imaginary occupies a different space to the pre-Oedipal narcissism of Lacan. Irigaray has begun to talk explicitly about different conceptualizations of narcissism. See Irigaray (1993).

16. See Jan Campbell (1993).

17. See Hortense J. Spillers (1989).

18. Some of the most impressive and scholarly poststructuralist readings of Lacanian psychoanalysis have ignored the phenomenological critique implicit in Irigaray's and Fanon's work. Consequently, Jacqueline Rose argues that Irigaray's challenge to the Lacanian phallus is essentialist and Homi Bhabha aligns Fanon with a Lacanian reading, thereby subsuming Fanon's roots in existential phenomenology and his criticism of Lacan with regard to the Oedipal complex. See Jacqueline Rose (1986) and Homi K. Bhabha (1994).

References

Adams, P. 1983. Mothering. *M/F* **8**.

Bhabha, H.K. 1994. "Interrogating identity" and "The other question". In *The Location of Culture*. London: Routledge.

Bollas, C. 1995. "The functions of history". *Cracking Up*. London: Routledge.

Campbell, J. 1993. *The Mother as a Subject, within the Writings of Psychoanalysis and Women's Literature*. PhD thesis, Sussex University.

Campbell, J. 1997. Mediations of a female imaginary and symbolic. *Journal Of Human Sciences*, May, **10**, 2.

Campbell, J. 1998. Ethics and sexual difference: imaging and imagining a different imaginary. *Journal Free Associations* **43**.

Chanter, T. 1993. *Ethics of Eros: Irigaray's Re-writing of the Philosophers*. London: Routledge.

Derrida, J. 1987. *The Postcard from Socrates and Beyond*. Trans. A. Bass. Chicago and London: University of Chicago Press.

Elliot, A. 1995. "Affirmation of primary repression rethought". *Psychoanalysis in Contexts: Paths between Theory and Modern Culture*, A. Elliot and S. Frosh (ed.). London: Routledge.

Fanon, F. 1967. *Black Skin, White Masks*. C.L. Markmann (trans.). New York: Grove Press.

Fanon, F. 1986. "The so-called dependency complex of colonised people". *Black Skin, White Masks*. Trans by C.L. Markmann. London: Pluto Press.

Fanon, F. 1986. "The Negro and psychopathology". *Black Skin, White Masks*. London: Pluto Press.

Flax, J. 1990. *Thinking Fragments*. Oxford: University of California Press.

Flax, J. 1993. *Disputed Subjects*. London: Routledge.

Frosh, S. 1991. *Identity Crisis: Modernity, Psychoanalysis and the Self*. Basingstoke: Macmillan.

Hall, S. 1980. "Cultural studies two paradigm". In *Media, Culture and Society: a cultural reader*, R. Collins, 33–48. London: Sage.

Irigaray L. 1985. "Cosi Fan Tutti". *This Sex Which is Not One*. Trans. C. Porter and C. Burke. Ithica, New York: Cornell University Press.

Irigaray L. 1987. "Flesh Colours". *Sexes and Genealogies*. Trans. G.C. Gill. New York: Columbia University Press.

Irigaray, L. 1988. *Women Analyse Women*. E.H. Baruch and L.J. Serrano (eds). New York: New York University Press.

Irigaray L. 1991. "The bodily encounter with the mother" and "The poverty of psycho-analysis". *The Irigaray Reader*. M. Whitford (ed.). Oxford: Basil Blackwell.

Irigaray, L. 1993. *Ethics of Sexual Difference*. Trans. C. Burke and G.C. Gill. London: Athlone Press.

Mitchell, J. 1974. *Psychoanalysis and Feminism*. London: Alan Lane.

Mitchell, J. 1995. Twenty years on in psychoanalysis and culture, *New Formations: A Journal of Culture Theory Politics*, Autumn **26**, 123–29.

Morrison, T. 1987. "Site of memory". In *Inventing the Truth: the Art and Craft of Memoir*, W. Zinsser (ed.). Boston, MA: Houghton-Mifflin.

Ricoeur, P. 1991. *A Ricoeur Reader: Reflection and Imagination*, M.J. Valdes (ed.). London: Harvester Wheatsheaf.

Rose, J. 1986. *Sexuality in the Field of Vision*. London: Verso.

Sayers, J. 1982. *Biological Politics: Feminist and Anti-feminist Perspectives*. London: Tavistock.

Sayers, J. 1986. *Sexual Contradictions: Psychology, Psychoanalysis and Feminism*. London: Tavistock.

Spillers, H.J. 1989. "The permanent obliquity of an in(pha)llibly straight": In the time of the daughters and the fathers. *Changing Our Own Words*. C.A. Wall (ed.). New Brunswick, New Jersey & London: Rutgers.

Stacey, J. 1994. "From the male gaze to the female spectator", *Star Gazing: Hollywood Cinema and Female Spectatorship*. London: Routledge.

Young, R. 1991. "Psychoanalysis and political literary theories". In *Psychoanalysis and Cultural Theory: Thresholds*. J. Donald (ed.). Basingstoke: Macmillan.

Whitford, M. 1991. *Luce Irigaray: Philosophy in the Feminine*. London: Routledge.

Part III

Race, ethnicity and fantasy

5

Psycho-politics: Frantz Fanon's *Black Skin, White Masks*

Vicky Lebeau

Il s'agit de replacer ce rêve en son temps. . .et dans son lieu, Où qu'il aille, un nègre demeure un nègre [We must put this dream back in its time ... and its place; Wherever he goes, a negro remains a negro] (Fanon 1952).

Thus Frantz Fanon, refusing to give way on two key elements of the psycho-analysis of racist culture put forward through *Peau Noire, Masques Blancs*: the cultural formation of dreams and the imago of the black man as the dream of European culture.[1] First published in French in 1952, translated into English in 1967, *Black Skin, White Masks* brings together with his analysis of race politics both Fanon's experiences of colonial psychiatry and his reflective appropriation of a range of different psychoanalytic and philosophical traditions. As such, the book remains central to what Homi Bhabha has described as Fanon's "mythical" reputation as "the prophetic spirit of Third World Liberation ... the inspiration to violence in the Black Power movement" (Bhabha 1986:viii). It is also, I think, essential to the development of what can appear in cultural studies as the wish for, or the lure of, a psychopolitics of culture, a wish that has made itself felt through psychoanalysis at least since the publication of Freud's studies in the origins and discontents of "civilization". It is there, too, and agitating, from beginning to end of *Black Skin, White Masks* in so far as Fanon turns to psychoanalysis for a way of thinking about what could be described as the veridical dimensions of culture: provisionally, those aspects of cultural life which, going beyond what Jacques Lacan refers to as the "two terms of reason and need", appear to be dominated by the pressures of fantasy, of the dream-work, on that life itself (Lacan 1992:209). "But when we say, 'Fanon insists in "The negro and psychopathology", that European culture possesses an *imago* of the negro responsible for all the conflicts that may arise', we do not go beyond the real [*le réel*]" (Fanon 1952:136–7; 1986:169; t.m.).

To say this is not only to stake a claim to the truth-value of his analysis; Fanon is also uncovering a fantasmatic image of the black man structuring the *reality* – the real conflict, the racist violence – of European culture. Part of the difficulty, the challenge, of *Black Skin, White Masks* derives from that doubling of its critical focus: this is an analysis of the black man, of blackness, as a (phobic) fantasy, certainly, but it is also a reading of the psychoanalytic concept of fantasy as a "real event", a presence, or a pressure, within and on the real. More specifically, Fanon makes a demand on the psychoanalytic concept of phobia to think the origins and effects of racial hatred – hatred and phobia at the heart, then, of what Fanon analyses as "culture". At the same time, as is by now well-established in the critical responses to *Black Skin, White Masks*,[2] the pressure of that hatred, of the black imago, is closely bound up with Fanon's investment in the sexuality of white women as central to the phobic structure of racism. At least since Homi Bhabha's Foreword to the new edition of *Black Skin, White Masks* in 1986, Fanon's working through of a psychoanalytic concept of fantasy has become inseparable from what Diana Fuss has recently described as Fanon's "disquieting discussions" of sexuality and sexual difference (Fuss 1994:30). But, felt as urgent to a feminist reading of Fanon, and one of the starting-points for this chapter, these discussions seem to have passed over what Fanon has to say elsewhere concerning the *réalisation*, the production, the making real, of unconscious fantasy through the formations of racist culture; or, more precisely – and to anticipate the argument of this chapter – to have occluded his analysis of the pressure of the real world on unconscious fantasy itself.

It is in Chapter 6 of *Black Skin, White Masks*, "The negro and psychopathology", that Fanon sets out most clearly, perhaps, the terms of his engagement with psychoanalysis. (Or, with psychoanalyses since the book is eclectic in its yoking together of diverse thinkers in psychoanalysis, some at serious odds with one another. Fanon turns to Freud, obviously, but also to Carl Jung and Alfred Adler; "The negro and psychopathology" includes what must be one of the earliest commentaries on Jacques Lacan's "mirror stage" while Lacan's rival for possession of "French Freud", Marie Bonaparte, provides the basis for Fanon's analysis of the psychosexuality of white women in the same chapter. There is mention, too, of Anna Freud and Helene Deutsch, to name the most familiar.) Confronting himself with two questions – Why does the "normal" black child become "abnormal" [*s'anormalisera*] "on the slightest contact with the white world?" and "What is phobia?" (1952:117,125; 1986:143,154), Fanon turns first to Freud and Breuer's studies of the role played by a real trauma in the development of neurosis and then to the mismatch between those studies and the experience of the black subject:

Frequently, the negro who becomes abnormal [*s'anormalise*] has never had any relations with the White man. Has there been an ancient experience and repression in the unconscious? [*Y a-t-il eu expérience ancienne et refoulement*

dans l'inconscient?] Has the young black child seen his father beaten or lynched by the White man? Has there been a real traumatism [*traumatisme effectif*]? To all this we have to answer: *no*. Well then? (Fanon 1952:118; 1986:145; t.m.)

The inadequacy of an explanation which finds the cause of the symptom in the repressed memory of a real event then leads Fanon into his analysis of the role of cultural representation in the formation of the black child's subjectivity. Throughout his childhood and adolescence, Fanon suggests, the black man has "devoured" [*dévoré*] and so identified with a culture put together by white men for little white men in all its diverse forms: its systems of education, books, films, comics (Fanon 1952:119; 1986:146). Insofar as he does not think of himself as black, then, insofar as he thinks and acts subjectively "like a white man", the black man who encounters himself as a phobic object within white culture encounters the dereliction of his *own* self-representation through that culture: dereliction as one of the effects of a hatred coming now from both inside and outside, which Fanon tracks throughout *Black skin, white masks* (Fanon 1952:120; 1986:148).

At the same time, commenting on a passage from Michel Cournot's *Martinique* (1948) – a passage which starts, notably, "The black man's sword is a sword. When he has thrust it into your wife, she has really felt something . . .' – Fanon shows up the gradual condensation, the reduction, of the black man to a black penis: "When one reads this passage a dozen times and lets oneself go, that is, when one abandons oneself to the movement of images, one no longer perceives the negro, but a member: the negro is eclipsed. He is made a member. He *is* a penis" (1952:137; 1986:169–70; t.m.). In one of the more unmanageable aspects of that dreaming, the black man becomes nothing more than a violating penis: "The negro is fixed firmly at the genital; or at least he has been fixed there . . . He is the specialist in this issue: whoever says rape says negro" [*Le nègre, lui, est fixé au génital; ou du moins on l'y a fixé . . . C'est le spécialiste de la question: qui dit viol dit nègre.*] (1952:134; 1986:165–66; t.m.). Further, while he appeals to two figures to stand as privileged examples of white phobic subjectivity – the sado-masochistic white woman and the repressed homosexual white man – Fanon is operating with a model of white female sexuality which provides the standard for the negrophobic subjectivity he detects in both repressed white male homosexuals and black women insofar as they think of themselves as "all-but-white":

The negrophobic woman is in fact nothing but a putative sexual partner – just as the negrophobic man is a repressed homosexual; . . . Basically, does this *fear* of rape not itself cry out for rape . . . can one not speak of women who ask to be raped?" [*Au fond, cette peur du viol n'appelle-t-elle pas, justement, le viol? . . . ne pourrait-on pas décrire des femmes à viol?*]; "What I can offer, at the very least, is that for many women in the Antilles – the type I shall call the all-but-whites [*les juxta-Blanches*] – the aggressor is symbolized by the

Senegalese type, or in any event by an inferior (who is so considered)" (Fanon 1952:127,145; 1986:156,180).

That identification between the black man and the act of rape shows up the tautology – "a rape/rapist is raping me" – supporting the fantasy that Fanon ascribes to white femininity: "a negro is raping me" (Fanon 1952:145; 1986:178). By reading fear of rape as a desire for rape, by pitting the truthful rhetoric of unconscious fantasy against the delusory literalism of what is consciously avowed, Fanon *both* interrupts the cultural logic which interpellates the black man as always and only ever a rapist *and* reproduces what he has just identified as a key element of the rape fantasy itself: reversal, inversion, *transitivisme intégral* (1952:145; 1986:156). Thus Fanon's account of white femininity derives, at least in part, from one of the most controversial – and caricatural – strategies of psychoanalytic reading: crudely, the translation of a conscious and symbolized "no" into an unconscious and unsymbolized "yes".[3] Thus the strategy of psychoanalytic interpretation used by Fanon – negate whatever the white woman is saying to you – mirrors the inversion that, he says, has already taken place between the woman's conscious and unconscious processes of symbolization. Or, as Lacan might put it, analysing from *"ego* to *ego"*, Fanon's interpretation cannot be distinguished from the mechanism of projection – reversal and transference of affect – that it is supposed to explain (Lacan 1988:32).

One of the effects of that indistinction is to unleash the aggression, the paranoia, that (as Fanon knew) Lacan makes so central to "mirroring" between subjects, a paranoia which could be said to enter into the relation between *Black Skin, White Masks* and its feminist readers in so far as Fanon offers the book as a "mirror" (Fanon 1952:148; 1986:184). The challenge for psychoanalytically-oriented feminist critics has been to find a way of reading Fanon which takes account of the political and historical context in which he was writing while preserving the psychoanalytic concepts of fantasy and identification on which so much of Fanon's analysis depends. On the one hand, for example, Diana Fuss recalls that "Fanon elaborates his reading of this particular fantasy ['A negro is raping me'] during a period when fabricated charges of rape were used as powerful colonial instruments of fear and intimidation against black men" (Fuss 1994:30). On the other hand, both Fuss and Mary Ann Doane have drawn attention to what Fanon does not say about the black woman's experience of interracial rape: "Ultimately what may be most worrisome about the treatment of interracial rape in *Black Skin, White Masks* is not what Fanon says about white women and black men but what he does *not say* about black women and white men" (ibid.); "Fanon asks few (if any) questions about the white man's psychosexuality in his violent confrontation with the black woman – fewer still about how one might describe black female subjectivity in the face of such violence" (Doane 1991:211). "History" and the experience of the black woman, then, appear to provide

something like a defence both *against and on behalf of* what Fanon is saying: *against* what, in a different context, Jacqueline Rose has described as "an anxiety that the text might be speaking with a hostile voice, one which is alien to *me*" and *on behalf of* a Fanon who deserves something more than what, in a Note to the Foreword of a new edition of *Black Skin, White Masks* in 1986, Homi Bhabha anticipates as a "facile" charge of sexism (Rose 1994:403–4; Bhabha 1986:xxvi).

Drawing our attention so forcefully to the difficulty of knowing what, if anything, to say about the sexual politics of *Black Skin, White Masks*, Bhabha was perhaps the first reader of Fanon to make the crucial link between Fanon's cultural stereotyping of white femininity and the clichéd version of psychoanalysis which emerges at this point in his text: the reduction of sexuality to sex and of racial violence to a naturalized psychic aggression. Thus Bhabha concludes:

> In Chapter 6 he attempts a somewhat more complex reading of masochism but in making the Negro the "*predestined* depository of this aggression" (my [Bhabha's] emphasis) he again pre-empts a fuller psychoanalytic discussion of the production of psychic aggressivity in identification and its relation to cultural difference by citing the cultural stereotype as the predestined aim of the sexual drive. Of the woman of colour he has very little to say. "I know nothing about her," he writes in *Black Skin, White Masks*. This crucial issue requires an order of psychoanalytic argument that goes well beyond my foreword. I have therefore chosen to note the importance of the problem rather than to elide it in a facile charge of "sexism". (Bhabha 1986:xxvi).

As Bhabha makes clear throughout his Foreword, he wants to caution against what he sees as Fanon's tendency to find "too close a correspondence between the *mise-en-scène* of unconscious fantasy and the phantoms of racist fear and hate that stalk the colonial scene", against the too "hasty" turns "from the ambivalences of identification to the antagonistic identities of political alienation" (Bhabha 1986:xix). In this sense, Bhabha's unease with Fanon's attempt to put the fantasmatic structures of racism back into their time and place refers not to a distinction between unconscious *fantasy* and colonial *reality*, between psychical and real processes, but to one between unconscious and cultural fantasy: the phantoms and stereotypes of the colonial *mise-en-scène* that Bhabha wants to distinguish from the moving images and identifications proper to the unconscious. In this sense again, it is as if Fanon's insistence on a congruence between aggression at the level of the white woman's sexual drive and the cultural stereotype – the black man legitimated as object of phobic rage – risks collapsing the distinction between unconscious and cultural formations of fantasy.

To say this is to suggest that what Fanon does, or starts to do, in *Black Skin, White Masks* is to recast the perennial problem for psychoanalysis of how to

tell the difference between fantasy and the real event[4] as the difficulty of how to distinguish between unconscious and cultural forms of fantasy – and, by extension, between dreams and daydreams, daydreams and other forms of culturally-sanctioned activity, whether aesthetic or political in the main text. It is also to suggest that the critical purchase of the feminist turn to history and to the black woman has interrupted or, more strongly, defended against both what Fanon is writing into white femininity and the development of the psychoanalytic framework that is necessary if we are to engage further with his analysis of the articulation between psychical and cultural forms of violence. In this context, what is most suggestive in Bhabha's Note to *Black Skin, White Masks* – or, its feminist readers – is its identification between the work of the stereotype and an interruption of the psychoanalysis taking place through *Black Skin, White Mask*: it is as if psychoanalysis cannot tolerate, or cannot resist, the introduction of a stereotype which "pre-empts" it, which comes to substitute for and so to occupy the place of the properly psycho-analytic discussion initiated through Fanon's work. Thus the problem brought into focus through Fanon's work – and, in particular, through Bhabha's reading of Fanon – is that of the *cultural stereotype* as such: how are we to understand a form of fantasy that we are invited to think of as already there – where? – to be refound and reused?

In the first place, perhaps, by looking at what Fanon himself has to say about a form of stereotype that, far from interrupting the work of psychoanalysis, puts us on back on the right track. We must not, Fanon insists in the opening lines of "The so-called dependency complex of the colonized", lose sight of the real (1952:65; 1986:83). It is his insistence on the real – the real as violence – which governs his critique of Octave Mannoni's *Psychologie de la Colonisation*, first published in French in 1950, translated into English as *Prospero and Caliban* in 1956 and published in 1964. What first struck me on reading Fanon reading Mannoni through this chapter was his, albeit tantalizingly brief, reference to the apparently oxymoronic idea of "real fantasies" [*phantasmes réels*] (1952:86; 1986:106). At issue is Mannoni's interpretation of a selection of Malagasy dreams included as an Epilogue to the first section of *Prospero and Caliban*. These dreams, Mannoni suggests, are "typical of the dreams of thousands of Malagasies" and they reflect the "dependency complex" that, for Mannoni, is central to the fantasy-structure supporting the psychology of colonialism (Mannoni 1964:89). A detailed reading of Fanon's response to Mannoni on this point goes well beyond the boundaries of this chapter. What is essential here, however, is Fanon's turn away from psychoanalysis – from Freud – when faced with Mannoni's almost parodic attachment to a psychoanalytic hermeneutic in which diverse historical and cultural material is drawn back within the frame of the Oedipus, or familial, complex. "Malagasies's dreams", Mannoni assures us, "faithfully reflect their overriding need for security and protection. All the dreams quoted below were, it is true, recorded at a time of public disturbance, but their authors had seen nothing

of the disorders and knew about them only from hearsay" (ibid.). The "public disturbance" in question, or what Mannoni refers to elsewhere as a "theatrical kind of violence", included the deaths of 80,000 inhabitants of Madagascar; that is, one person in every 50 on an island of 4 million people (Mannoni, cited in McCulloch 1995:101; Fanon 1952:84; 1986:104). It is Fanon who recalls this; Mannoni says no more, but continues his analysis of the "typical" Malagasy dreams. The first dream – Fanon includes seven of them in *Black Skin, White Masks* – reads as follows:

> *The cook's dream.* I was being chased by an angry black bull. Terrified, I climbed up into a tree and stayed there till the danger was past. I came down again, trembling all over. (Mannoni 1964:89).

And Mannoni's interpretation follows immediately:

> The bull stands for the Senegalese soldier. It was not possible to push the analysis any farther in this instance, but other dreams, set forth below, leave no doubt as to the correct interpretation ... [B]ehind the figure of the Senegalese (the bull), who represents external danger, there undoubtedly lurks the psychologically deeper image of the father, as will be shown by other dreams of the same type. (ibid.)

It is perhaps because he assumes something like a collective Malagasy unconscious, that Mannoni is prepared to find the meaning of one man's dream through the dream material presented by others[5] – dream material that he refers first to the outside world (the bull is a Senegalese soldier) and then back into a more "primal" unconscious (the Senegalese is a representative of a furious paternal imago). Thus Mannoni screens the possibility that blackness has taken on the function of an imago at the same time as he passes over the torture and murder of Malagasies by the Senegalese. By contrast, citing the cook's dream, Fanon will emphasize (though without further comment) the *black* bull, just as, describing the dreams of a 13-year-old boy, Rahevi, and of a 14-year-old girl, Elphine, he will stress the dream presence of two *black* men and a *black* ox (Fanon 1952:81,82; 1986:101,102). He will reject, absolutely, Mannoni's attempt to interpret the figure of the Senegalese in terms of an Oedipal drama. "We know", Fanon reminds us again, "that one of the torturers in the Tananarive police headquarters was a Senegalese":

> So, knowing all that, knowing what the archetype of the Senegalese can be for a Malagasy, Freud's discoveries are of no use to us [*les découverts de Freud ne nous sont d'aucune utilité*]. The thing to do is to put this dream back *in its time*, and that time is the period during which eighty thousand locals were killed, that is, one inhabitant in fifty; and *in its place*, and that place is an island of four million inhabitants, at the heart of which no true relation can

be instituted, where dissensions break out from all sides, where lies and demagogy are the only masters (Fanon 1952:84; 1986:104; t.m.).

Cast here as a form of archetypal family romance, psychoanalysis becomes suddenly useless when confronted with a dreaming that has been overwhelmed by its time and place: by a history, a culture dominated by war, by murder, that brings the work of a dreaming itself to a halt. That is, Freud is no use when we want to discuss not the pressure of unconscious fantasy on the "real world" but the imposition of that world on fantasy, on dreaming, itself. "The raging black bull", Fanon insists, "is not the phallus"; or, referring to the appearance of armed Senegalese soldiers in the dreams of 14-year-old, Razafi:

The Senegalese soldier's rifle is not a penis but really a rifle, model Lebel 1916. The black bull and the bandit are not *lolos* – "reincarnated souls" – but actually the irruption, during sleep, of real fantasies. What does this stereotype, this central theme of the dreams, represent if not a return to the right road? (Fanon 1952:86; 1986:106; t.m.).

At this point of his revision of Mannoni's interpretation of the Malagasy dreams, Fanon is preoccupied both with the racist dimensions of Mannoni's psychoanalysis itself – "Here is what an extensive analysis could have found," he tells us, that is, an analysis not blinded by its assumption of Malagasy dependency – and with what looks like a sudden collusion between unconscious and cultural representations of violence: crudely, sometimes a rifle is a rifle on both sides of the dream-work. Or, sometimes what we dream is real; there is no work of transformation between culture and dream. In effect, this is to call into question one of the founding tenets of Freud's theory of dream-interpretation: namely, that the work of dreaming is there to effect the transformation of one thing into another through the mechanisms of condensation, distortion, displacement – mechanisms which, for Freud, are the mark of the primary process as such and which cast the dream as the royal road to the unconscious.[6] By contrast, Fanon is giving us an account of the dream as something more like the royal road to cultural trauma, or, perhaps, to a culturalization, a traumatization, of the unconscious – to a kind of dreaming in which the world seems to be already there, waiting, for the dreamer to refind it in the (so-called) intimacy of unconscious life. Thus Fanon cites and endorses Pierre Naville's comment on dreams in *Psychologie, Marxisme, Matérialisme* (1948): "[T]he content of a human being's dreams depends also, in the last analysis, on the general conditions of the culture [*la civilisation*] in which he lives" (Fanon 1952:86; 1986:106).

For Fanon, at least, this is not Freud's kind of dreaming. While psychoanalysis can be used to think racism as a form of dreaming, as a hallucinatory imaging of blackness in a foundational conformity with the processes of the dream-work, it appears to miss the logic of what it is uncovering: crudely, if

the dream-work can be found on the outside, then the outside may be there in the dream – both in terms of a mirroring between unconscious and cultural processes (the more familiar point) and of a culturalization of the dream (Fanon's less familiar insight) which brings the *process*, the *work* to a halt. The rifle is a rifle is a rifle ... Once again – though, this time, with Fanon's approval – the stereotype is invoked as that which brings psychoanalysis to a halt. Fanon uses the *imago* – the stereotype – to put us on the track of an unconscious and a dreaming possessed not, or not only, by the subject's own wishful-shameful fantasies but by the real; or, more precisely, by the fantasies which make up the real, including those racial and sexual phantoms which Bhabha locates on the cultural scene. Is this really an interruption of psychoanalysis, or is it to move psychoanalysis along a new track, towards the real fantasies which erupt in sleep to mirror the world in which they find their time and place? If so, then what Fanon is uncovering through *Black Skin, White Masks* – what he uncovers as he transforms the psychoanalysis he reads – is not so much the limit of psychoanalysis but the need for a sociology of the dream-work and for a psychoanalysis that might start to chart the emergence of both a veridical culture and a cultural unconscious.[7]

Acknowledgements

Thanks to the Women's Research Centre Seminar at the University of Sussex and to the Theory Cross Disciplines Seminar at the University of Lancaster for responses to very early versions of this paper. My thanks too, to Rachel Bowlby, David Marriott and John Shire for discussions and comments.

Notes

1. Frantz Fanon *Peau Noire, Masques Blancs* (1952:84,140), translated by Charles Lam Markmann as *Black Skin, White Masks* for Grove Press in 1967, reissued by Pluto Press in 1986 (1986:104,173; translation modified). Further references to the French and English editions of the book will be given in the text. t.m. indicates a slight modification of the available English translation. For ease of reading, I have included the French only where it seemed necessary to suggest the ambiguity, or resonance, of Fanon's text.
2. See Mary Ann Doane (1991), Diana Fuss (1994) and Jean Walton (1995). Both Fuss and Lee Edelman (1994) include a commentary on the homophobia structuring Fanon's analysis.
3. Freud's claim to such an interpretive liberty appears in the opening few lines of his essay on "Negation", first published in 1925. Giving the example of a patient who responds to the analyst's question concerning the identity of a figure in his dream with an energetic denial – "You ask who this person in the dream can be. It's *not* my mother" – Freud acknowledges that "[w]e amend this to: 'So it *is* his mother.' In our interpretation, we take the liberty of disregarding the negation,

of picking out the subject-matter alone of the association ... [T]he content of a repressed image or idea can make its way into consciousness, on condition that it is *negated*" (Freud *Pelican Freud* **11**:437–8). Or, as Freud himself puts it elsewhere: "Heads I win, tails you lose" (Freud, *Standard Edition* **23**:257).

4. That problem has emerged most publicly in the recent debates concerning "false memory syndrome". Jeffrey Masson's *Freud: The Assault on Truth* (1984) is probably the most famous attack on psychoanalysis as a theory and institution which uncovered, and then worked to conceal, "the sexual, physical and emotional violence that is a real and tragic part of the lives of many children" (Masson 1984:189). For a balanced response to Masson – and his reduction of the psycho-analytic theory of fantasy – see Jacqueline Rose's "Where does the misery come from?" in Rose (1993).

5. This recalls Freud's response to the fantasy lives of servant girls. For a discussion of his letters to Jung on this topic, see Lebeau (1995).

6. In 1925, in a footnote added to the section on "The dream-work" in *The interpreta-tion of dreams*, first published in 1900, Freud noted, or complained:

> I used at one time to find it extraordinarily difficult to accustom readers to the distinction between the manifest content of dreams and the latent dream-thoughts ... But now that analysts at least have become reconciled to replacing the manifest dream by the meaning revealed by its interpretation, many of them have become guilty of falling into another confusion which they cling to with equal obstinacy. They seek to find the essence of dreams in their latent content and in so doing they overlook the distinction between the latent dream-thoughts and the dream-work. At bottom, dreams are nothing other than a particular *form* of thinking, made possible by the conditions of the state of sleep. It is the *dream-work* which creates that form, and it alone is the essence of dreaming – the explanation of its peculiar nature (Freud 1900:650).

7. This is to argue for Fanon as a reader of psychoanalysis. After completing this chapter, I came across Françoise Vergès' powerful description of Fanon's writing and practice as a *psychiatrist*, Françoise Vergès signals Fanon's attention to alienation as something like the limit-point of his interest in psychoanalysis: "Freud, then Lacan, had posited a fundamental alienation of the subject (Lacan's *méconnaissance*). But to Fanon, alienation was entirely the result of social, cultural and political conditions. Social and cultural emancipation meant as well psycho-logical emancipation" (Vergès 1996:95). Fanon's "ambivalence" towards psycho-analysis, in Vergès' view, derives in part from his desire to "act decisively on the structure of the individual's personality" and so to reject a psychoanalytic approach which says "that one's structure cannot be changed, that one can only learn to accommodate the world" (ibid.). Insofar as Fanon was in dialogue with an American "ego psychology", this assessment of his approach to psychoanalysis as a discourse of accommodation may well be correct. (For a fuller discussion of Fanon and ego psychology, see Marriott, forthcoming 1998) It is less convincing, for me, if Fanon is considered as a reader of Lacan – *Black skin, white masks* includes a lengthy footnote on *Les complexes familiaux* – or, more important here, as a psychoanalytic thinker in his own right (a thinking which does not, I think, depend on whether or not Fanon trained as a psychoanalyst or used psychoanalytic techniques in his practice). Crucially, as a thinker of psychoanalysis Fanon

problematizes the distinction between social and individual alienation at the same time as he complicates the relations between culture, unconscious and dream. In other words, the division between individual and collective, psychological and political, is precisely what is put at issue in *Black skin, white masks* – so much so that even if alienation were to come at the subject solely from the outside, that outside is itself the site of the "psychological", of the fantasies structuring the "real conflicts" of European culture.

References

Bhabha, H. 1986. Foreword to Fanon 1986.

Doane, M.A. 1991. "Dark continents: epistemologies of racial and sexual difference in psychoanalysis and the cinema". In *Femmes Fatales: Feminism, Film Theory, Psychoanalysis*, M. A. Doane (ed.). New York: Routledge.

Edelman, L. 1994. *Homographesis: Essays in Gay Literary and Cultural Theory*. London: Routledge.

Fanon, F. 1952. *Peau Noire, Masques Blancs*. Paris: *Éditions du Seuil*.

Fanon, F. 1986. *Black Skin, White Masks*. Trans. by C.L. Markmann. London: Pluto Press.

Freud, S. 1900. *The Interpretation of Dreams, The Pelican Freud Library*. **4**, Harmondsworth: Penguin.

Fuss, D. 1994. Interior colonies: Frantz Fanon and the politics of identification. *Diacritics* **24** (2–3), 20–42.

Lacan J. 1988. *The Seminar of Jacques Lacan. Book I. Freud's Papers on Technique 1953–1954*. Trans. by J. Forrester; first published as *Le Séminaire I* by Les Éditions du Seuil, Paris, 1975. Cambridge: Cambridge University Press.

Lacan, J. 1992. *The Ethics of Psychoanalysis*. Trans. by D. Porter; first published as *Le Séminaire, Livre VII. L'ethique de la psychanalyse, 1959–60* by Les Éditions du Seuil, Paris, 1986. London: Routledge.

Mannoni, O. 1964. *Prospero and Caliban: the Psychology of Colonization*. Trans. by P. Powesland; first published as *Psychologie de la Colonisation* by Les Éditions du Seuil, Paris, 1950. New York: Frederick A. Praeger.

Marriott, D. 1998. "Bonding over phobia". In *Psychoanalysis and Race*. C. Lane (ed.), (forthcoming Columbia University Press).

Masson, J.M. 1984. *Freud: the Assault on Truth*. London: Faber & Faber.

Rose, J. 1993. *Why War?* Oxford: Blackwell.

Rose, J. 1994. On the "universality" of madness: Bessie Head's *A question of power*, *Critical Inquiry*, **20**, 401–18.

Vergès, F. 1996. "To cure and to free: the Fanonian project of 'decolonized psychiatry'". In *Fanon: a Critical Reader*, R. Lewis, T. Gordon, D. Sharpley-Whiting, R.T. White (eds). Oxford: Blackwell Publishers.

Walton, J. 1995. Re-placing race in (white) psychoanalytic discourse: founding narratives of feminism, *Critical Inquiry* **21**, 775–804.

6

In memory of absent fathers: black paternity and social spectatorship

David Marriott

> The story goes sons kill fathers to become men, assume their rightful place in society. The king is dead. Long live the king. Isn't the other story also always true? Fathers slay sons (Wideman 1994:141).

> Dr. Lacan, for instance, talks of the "abundance" of the Oedipus complex. But even if the young boy has to kill his father, it is still necessary for the father to accept being killed (Fanon 1967:152).

I would like to begin with the absent black father and the work of mourning that marks his memory in African American culture. Inasmuch as this legacy recalls a pact and performs the role of memory for the abandoned son, one of the questions which will concern me in this chapter is the role paternal abandonment and departure plays in the formation of the son. Since the story of this absence is also the story of racism, to better introduce the disinheritance of the black father I will begin with the son's own desire to reclaim the father, and thereby himself, from America's racial past.

First of all, this desire to repeat and recollect the past is not straightforward by any means, for the son's desire to remember and to mourn the father is always interdicted by the latter's own aporetic legacy. From the moment he desires paternal restitution the son is already engaged in an attempt to rid himself of the absent black father's historic and symbolic dispossession. In order to remember the father the son must therefore, paradoxically, learn to forget the pain and trauma associated with the father's memory. This strange command to forget is at once a desire to unlink himself from the cycle of violence and debt and to affirm himself through forgetting. Unfortunately, one of the consequences of this command is to unleash an aggressivity

against the self which makes memory itself the symptom of an anxiety. For example, how is the son to remember the father if, implicitly, there is nothing left to remember about him? How is he to desire forgetting if the paternal memory is already dispossessed?

All of these themes or motifs are at work, more or less visibly, in 1990s African American cinema, the main subject of this chapter. In 1991 two black American film directors, Spike Lee and John Singleton, each released a major Hollywood film, *Jungle Fever* and *Boyz N the Hood*, which had, as its nexus, the twinned themes of race and family romance. I shall be arguing, with particular reference to these two films, that African American cinema is caught up in a double bind or double obligation *vis-à-vis* the absent black father and his fraternal disinheritance. These films, announcing as they do the trauma of identifying with black paternal memory, and the guilt of becoming, in turn, a place where the absent father cannot be forgotten or disowned, are marked by a wish to remember and an inability to forget that seems excessive. Before describing how this excess appears as a fantasy of the paternal, as a dreamwork of the father's desires and demands, I would like to stay a moment longer on that double bind or stricture of the absent father so as to describe how both these films – marked as they are by moments of interruption, repetition, and a need to return, compulsively, to the black father in dream and/or in memory – are also films determined by a paternal filiation which can neither be avoided, nor foretold. Insofar as these films perform an interrupted recollection of the father, a performance inscribed, as parentheses, in the lives of the son (and these films are, if anything, representations of the son's adestination, territorial displacement, his struggles over hierarchies of meaning, institutional constraints and closure), they also show the demand that the son places on the father, and vice versa. Finally, since I am saying with such insistence that these films are essentially stories of fathers and sons, I would like to point out that these stories are also inseparable from the place and name of the brother, more precisely, the brother as dead. Let us notice first of all, in passing, that fantasies of a return to the father perhaps represent, in these films, a defense against a sense of the brother as already dead, given the overdetermined references in both films to the genocidal crisis of young African American men.[1] In other words, insofar as both of these films present an odyssey of the son as a return to the father, the son's rite of passage is invariably contrasted with the rites of fraternal brotherhood and rivalry. The meaning of *brother* here is to be defined as he who fails to return to the father; a failure to return which must be mourned, because lacking the father the brother is, in an important sense, already dead.

To substantiate these remarks, it is necessary to ask the question. "Why has the place and name of the brother become a symbol of the father's own symbolic death?" Why has African American cinema in the 1990s, assuming the role of a loving and vengeful father, sought to represent the inheritance of the brother's name as the privileged work of mourning and social

rememory for African American men? Could it be that this consensus on the basis of which a recollection and memorial to the brother is performed allows us to understand the trace of another racialized memory; namely, the historic and symbolic absence of the black father? This alternative, let us note before turning to both films, would in both cases concern an inescapable destiny or inheritance passed on from black fathers to brothers and sons: an inherited assurance that there are certain lives already dead to the future; lives, in other words, whose promise is inextricable from the most deadly psychic and social fantasies; lives for whom paternal abandonment is only one part of the necessary violence of the life as lived.

The screen as mirror

How is one, then, meant to read these memories of the father in the specular dreamwork of two Hollywood films? How is one meant to explain these paternal fantasies inscribed, as they are, with change, loss and regret, if not via a recourse to the demands and desires of the son? All of these questions concern the nature of black social spectatorship, which is first of all a question of fantasy and affect in the black public sphere. In the first viewings of *Jungle Fever* and *Boyz N the Hood*, it was claimed that black America had seen, for the first time, its own Oedipal drama reflected back to itself in a mirror image. Michelle Wallace, recounts how, on first seeing *Boyz N the Hood*, she left the theater, "crying for all the dead men in my family" (Wallace 1992:123). In this translation of cinematic screen into cultural and psychic mirror it was felt that both films offered black Americans an image of themselves which they had not previously seen. Hence, Nelson George, writing in *Blackface* (1994), argued that "Most black Americans could see themselves somewhere in this [*Boyz*] film" (George 1994:119); and Lisa Kennedy, accounting for the impact and importance of Spike Lee's films on black America in her seminal essay, "The body in question", suggested that:

> If in the recent past, Spike Lee's films have been treated as something of a hand-held mirror by the collective body – many of us drawn to his images less like Narcissus than like people who have seldom seen themselves – the cinema has now become a house of mirrors. *New Jack City*, *Chameleon Street*, *Jungle Fever*, *Boyz N the Hood*, and *True Identity* all speak of, to, and/or for the collective body. With every viewing, the black community gets an inkling of its shape, its texture, even its age and gender (mostly young, mostly male these days) (Kennedy 1992:109).

According to these two accounts, the pleasure of the cinema is that it allows black America to dream, fantasize and look at itself for the first time. The cinematic screen has become a mirror for things seldom seen, a mirror signalling

an important shift in the historical nature of mass black spectatorship. This spectatorship has changed from being that of a naïve spectator seduced by the novelty of its own mirror image, to that of a knowing audience obsessed with an identificatory, narcissistic restitution of itself in a "house of mirrors". This account of black cinematic spectatorship equates identification with a narcissistic recognition of the collective body in images on the screen.[2] Further, for Kennedy, the obsession of these films with black male youth also reinflects the black family romance in terms of a male and adolescent imaginary, and one with dangerous connotations insofar as this imaginary racial community come together through love and desire for a black patriarchal father, also reflects a disturbing convergence between the cinematic screen and the social. In this paternal fantasy, Kennedy perceives a desire to resuscitate and mourn an image of the black father as the lost head of family and home; a dream of restoration fundamentally exclusive of the black mother and daughter:

> From *House Party* to *To Sleep with the Enemy* to *Mo' Better Blues* to *Boyz N the Hood*, the sons are working overtime to secure the place of the father, and in doing so, themselves. If ever there was a symbolic effort to counteract a sociological assertion – that of paternal abandonment – it has been these films, which depict a world of fathers and sons (Kennedy 1992:110).

In other words, *whose* imagined racial community are these films representing? Why have these cinematic fantasies of the father proved so seductive to a mass black (and white) spectatorship? The importance of these questions goes to the heart of current debates concerning the place of the black father in American culture, and whether or not the fantasy of his redemption in the black public sphere nevertheless remains an overwhelmingly *male* question of law, narcissism and authoritarian seduction? The question is, if the indebtedness of these films to a fantasy of the father represents a way of the sons securing themselves, what is the precise law and meaning of the father's gift? In order not to answer this question too precipitately we must first understand the nature of that father's own exemplary love, the return to which forms the main drama of John Singleton's *Boyz N the Hood*.

Death of the brother, rebirth of the son

At the very end of *Boyz N the Hood*, an exchange takes place between the leading character Tre (Cuba Golding Jr.) and his lifelong friend, Doughboy (Ice Cube). In response to Doughboy's "I ain't got no brother, got no mother neither", Tre replies: "You still got one brother left, man." To grasp the significance of this exchange in the symbolic logic of the film, dominated as it is by the question of masculinity and of kinship, it is necessary to return to this

naming of the brother, granted and confirmed by another "brother", and marked by the death and rebirth of a fraternal bond.

Immediately after this exchange the film ends with a caption detailing Doughboy's death two weeks later at the hands of other "brothers" in a gangland shooting. Throughout the film the meaning and direction of Doughboy's life has been presaged by the horizon of his family and its crucial dispossession of the father. The primary connection between Doughboy's death, which concludes the film, and the absent father turns upon the status of the father's law: who has the rights to confer it and pass it on. For reasons to which I shall return, the name and death of the brother in Singleton's film is intimately linked to that of a loving and theatening paternity whose absence, in turn, reveals itself as an unbearable loss for those sons who, having had no father in the first place, also have nothing to lose in a cycle of violence and death in inner-city "hoods". The loss of the father as an ego ideal is thus inextricably linked to the failure, shame and death associated with the dispossessed son. The love offered Tre by his father, Furious Styles (Larry Fishburne), is represented in the film as an idealized demand for a manhood worthy of respect and amounting to something more than survival in the oppositional cultures of street and hood. It is this demand which confers the rights to a socially responsible masculinity; by binding the son to the symbolic father as the representative of familial law, this demand removes the son from the fatal violence of fraternal rivalry and its cycle of melancholic need, reparation and social death. On the other hand, the fatal consequence of being excluded from this paternal law, of being denied this demanding love, is also explored throughout the film in terms of an anomic masculinity based entirely on fraternal rivalry and violent fraternal retribution.

It is almost as if the demand for love made by a brother can only be an illegitimate and degraded form of the paternal demand and one which leaves the brother, very precisely, in a state of lost symbolization. The film's main representative of this paternal loss is, as mentioned previously, the figure of Doughboy, whose family has been abandoned by the (absent) father. Earlier on in the film, Doughboy's mother (Tyra Ferrell) addresses him with the accusation: "You ain't shit. Just like your Daddy." The violence of this logic — absent black fathers and their present sons equal shit — constitutes the measure by which other brothers and sons in *Boyz* judge themselves. Such melancholic failure to incorporate the black self-brother as an object worthy of love leads, in turn, to an externalization of aggressivity towards that selfsame persecutory object as a way of evacuating persecutory feelings within. The violent sociality on display throughout the film is literalized in the degraded fraternal identifications of murdered black men with fecal objects. *Boyz* presents such degradation in two or three crucial scenes depicting the trauma of looking on the murdered body of "brothers", the victims of drive-by shootings and/or gangland deaths.

In other words, having a father is counterposed throughout the film to what

it means to be both a brother and son. The idealized and idealizing demand of the father is, simply enough, manifested through the son's abeyance to the father's desire; a filial bonding which occurs through the marginalization and death of the brother and of the fraternal bond. Throughout *Boyz N the Hood*, the countless references to "killing another brother" and "trying to act like brothers", are not simply indicative of a failure to secure paternal identification, but also represent the specific destinies awaiting the rebirth of Tre the son. If the sovereignty of the father is circulated through repetition – love me, be like me, but remain my son – insofar as this aporetic difference confers onto the son the possibilities of life and "normal" sexual maturity, it also offers the son liberation from the death and abjection of the brother. In other words, Tre is saved from the risk of disintegration and ritual executions which the regime of the brother brings forth because he willingly submits to the name and law of the father as ego ideal. It is precisely this theme of renunciation which integrates the otherwise competing demands of the father and son in the film: the reason why Tre does not kill or get killed is because he recognizes the prohibition, laid down by the father, against murdering other brothers, whereas the other brothers – Doughboy and Ricky (Morris Chestnut) – are doomed to die because such law does not intervene to save them; their fathers are absent.

This radical ungrounding of both the brother and son, at the heart of the film, thus has, as its opposite, an identification of the father as foundation. The question is: does this notion of the father as foundation offer any meaningful liberation for Tre the son? Both the relation between fraternity and paternity in *Boyz in the Hood* and the double configuration of law and murder are connections which the film fails to think other than through the foundational knowledge of Furious and his unifying symbols of racial authenticity. As a result a central aporia of the film goes missing: namely, the father's right to murder a brother because of his avowable right to protect the son. If Tre's right to survival is based on a founding of himself in the name of Furious, this foundation is only explicable on the basis of the paternal right to murder in the name of the son's defense, as represented in an early scene from the film.

Having returned to live with his father after an extensive sojourn with his mother, Tre's first night is disturbed by sounds of his father's gunshots aimed at a retreating burglar, who escapes. Furious says to the young Tre: "I aimed right for his head"; to which Tre responds, "You should've blown it off." Furious, angered by this display of maschismo at the level of the word, replies: "Don't say that. It'd just be killing another brother." In what sense is the word "brother" being used here, especially given Furious' later irony in calling a sadistic black policeman, "brother"? In the address to the son, the father's appeal to the name of the brother carries the imprint and recollection of moral law. In the naming of the policeman as brother, as perverse representative of state law, the word seems to suggest a marked failure to maintain

racial and ethical respect other than through an institutionalized racial violence, a role which the police come to represent in the film.

Here it becomes clear how close and yet diametrically opposed to one another are these two appeals to the name of the brother as foundation. For Furious, the state's right to murder another brother is the logical consequence of a violence institutionalized without any respect for ethics; whereas the father's right to murder the brother in order to protect the son overcomes violence because it *founds* an ethical relationship. Here, in this distinction between a legitimated paternal law and sadistic state violence (from which the son must be protected), lies the central double bind of the film. The father's right to shoot a brother cannot and must not be passed on to the son, if the son is to receive the prestigious love of the father as against the degraded form of black fraternity and the state's violent failure to protect, without murdering, young black men. A notable consequence of this "foundational" thinking is that the father comes to represent an ethics secured through legitimate or rightful violence, and the state an illegitimate or excessive violence without ethics. What dominates in this speculation therefore is the father as the embodiment of moral law *qua* legitimated violence. The question is, is the father who murders out of love any different from the fatal violence of the social? It is quite clear that legalized state violence against young black men reenacts fantasies of black masculinity as identical to the threat and fear of an aberrational violence from which the symbolic (white) majority must be protected. It is also quite clear that Furious' contemptuous dismissal of the black state trooper makes its appeal against the pathologies of racist state violence. However, both forms of violence instance an aggression internal to paternal identification and one which threatens to spill over and overwhelm the social here coded as paternal law. Thus the notion of a responsible black father as representative of a moral law grounded in violence, can be seen to unravel not only itself but a paternal fantasy at the heart of the social. Both become, instead, a paternity instituting itself through violence, or through a lawful claim to embody such violence legitimately. In Spike Lee's *Jungle Fever* the perversity and violence of the father as well as the social and racial identifications secured through him are also shown to be inextricable, but in ways minus the idealization of the father in Singleton's film.

In other words, in *Boyz N the Hood*, the authority of the father's loving gift is one to which the son cannot accede without risking the brother's dereliction. This ideal and yet cruel love, posed in the film as the moral, ethical and political rule of an authentic black manhood, is an imperative one; it is what initiates the son into the moral anxiety of responsible citizenship. Yet the authority of this paternal love, its origin or its history, remains ultimately veiled in mystery. The question is: does the film actively reproduce this paternal charismatic authority or does it unveil it by exposing its claim to exemplarity?

Perhaps one of the most trenchant critiques of this problematic is Paul Gilroy's "It's a family affair" (1993). The question of black paternity is impor-

tant for Gilroy, because it does not concern cinema alone, but the whole meta-physical tradition of black ethnic absolutism that reaches its culmination in the symbolic projection or fantasy of a loving and authoritarian black father come back to redeem a racial community grounded in the family. For Gilroy, the whole history of black political and cultural life in the postnationalist epoch, which he counterposes to the interrupted and mediated figure of the "black atlantic", is characterized by a singular forgetting of the lessons of history in its search for the father as racial foundation and moral law:

> [The] discourse of race as community, as family, has been born again in con-temporary attempts to interpret the crisis of black politics and social life as a crisis of black masculinity alone. The family is not just the site of cultural reproduction; it is also identified as the mechanism for reproducing the cultural disfunction [sic] that disables the race as a whole. The race is nothing more than the accumulation of families. The crisis of black masculi-nity can therefore be fixed. It is to be repaired by intervening in the family to compensate and rebuild the race by instituting appropriate forms of mas-culinity and male authority (Gilroy 1993:204).

This representation of race *as* family or kinship in African American cinema involves a reinflection of recent black postnationalist calls for the state both to recognize the moral authority of black paternity and, in so doing, to reaffirm the history of the black subject as the history of a return to the father's law. Ethnic absolutism, especially in its postnationalist guise, is a thinking that corresponds to a refounding of the black nuclear family and male, or to use the language of crisis, of saving and liberating the race in an identification of authentic racial being with the patriarchal family as moral law.

For Gilroy, recent African American cinema may be defined as the perfect realization of this real and imaginary foundationalism in terms of the demands it places on black social spectatorship. Because the cinema is under-stood as a mass cultural phenomenon as well as an instrument of mass influ-ence, the worry is that such cinema will offer an "authoritarian, pastoral patriarchy" as the solution to the perceived crisis in black masculinity and the black public sphere, thereby displacing the public nature of political life with the fantasy of the black father as an ideal to be interiorized, and consumed by black spectators seduced by the cinematic screen (Gilroy 1993:197). Gilroy's unease with black cinema, like Kennedy's, may be characterized as a sense that, unless questioned, such cinema will offer the seduction of an authoritarian cultural nationalism to replace the agonistics of civic struggle and campaigns for individual rights for both men and women.

Yet there appears to be something radically missing from both Kennedy's and Gilroy's accounts despite the pertinence of their critiques. There seems to be an absence of any awareness of the *ambivalence* of identification in relation to the African American father, as well as a failure to analyse the guilty anxieties

and repetitions concerned with his historical degradation. If there is an attempt, in these films, to counteract sociological interpretations of black familial relations in inner city urban areas, amid members of the black underclass, can we understand that effort as ultimately "narcissistic", as Kennedy argues, without reference to the complex ways in which racist fantasies are experienced by black men in a racist symbolic?

Insofar as these critiques both draw upon an unproblematized notion of narcissism to define the relation between cinema and the social, their arguments tend to lose sight of a more complex interaction between desire, fantasy and identification in African American cinema and the public sphere. I would suggest, in a very preliminary way, that the loss of a secure paternal authority so central, as a site of memory, to the political aesthetics of these films, cannot be dissociated from this wider question concerning the place of black men in American culture generally or the place of racist fantasies in cinema. The black father in these films, as a source of knowledge and identification for the dispossessed son, must be secured precisely because he remains missing from the cinematic screen and the real. In other words, rather than occupying the point of a narcissistic identification between young black male spectators and filmic image, the black father, as the trace of the non-place in American racial memory, as this alterity haunting the filmic image, can never be simply "in place", and it is this symbolic disappearance which is anxiously repeated and resisted by African American cinema. It is precisely what is missing from the black paternal image which generates the idealized representation of Furious Styles in *Boyz N the Hood*, and the anxious guilt and hatred directed to the (black and white) father in Spike Lee's *Jungle Fever*.

Before turning explicitly to *Jungle Fever* and the racial histories with which it is engaged, allow me to briefly summarize the argument so far. If the black father, at the level of fantasy, is defined by his symbolic absence, this absence goes to the heart of an Oedipal anxiety – identified by Gilroy – currently infecting black political and cultural life; namely, a perceived crisis in black masculinity which has, as its focal point, a crisis of social authority going hand-in-hand with the desire, in fantasy, for a return to the father as symbol of racial authenticity, cultural identity and black nationhood. However, the symbolic restitution of the father – as we have just seen in *Boyz N the Hood* – is not simply about narcissistic (mis)recognition, nor is it simply representative of a regressive, authoritarian demand for ethnic absolutism, as Gilroy and Kennedy contend. Despite the importance of their stress on how familial ties link kinship with ideas of racial community, these interpretations present too easy a separation between psyche and the political, fantasy and the public sphere, thereby failing to understand the extent to which the fantasy of a return to paternal name and law is, essentially, at the heart of a wider conflict concerning paternal legitimacy and legitimation and one that informs the violence of American social ties. In fact, both readings fail to present the *passage* from family to cultural fantasy, paternal ideal to cinematic screen,

because they already assume that looking and identification are the same thing. In this rationalist approach to fantasy, the relation between cinematic representation and social spectatorship is reduced to a form of mass misrecognition or mass regressive fantasy. If the black father is symbolically defined by his absence, however, a return to him at the end of the postnationalist journey amounts to no more than an unveiling of the mirage of his disappearance or of his claims to legitimacy. Indeed, it is hard to see how the crisis in black family life can be repaired via the paternal return – allegorically read as the return of law and of inalienable rights to an assertive manhood – if one is not to forget the complex history of black filial and fraternal ties in American racial history. The fantasy which Furious Styles represents – as the primal father who guards the rights of exchange to kill and the ethics of bearing witness to the brother's unlawful or irresponsible death – is implicit to this history. Gilroy's reading of the paternal fantasy of the father *qua* law in black American cinema and political culture, which he contrasts to parental responsibility (as if the latter were somehow free of cultural fantasy), does indeed forget the affective ambivalence of emotional and political ties to this father and what have sustained these ties in their history. Rather than simply being rooted in patriarchal law and prohibition, as Gilroy believes, this father also has his source in homosocial love and fraternal guilt which undermines, in turn, the sons' own desire for freedom (as we have just seen in the relation between Tre and Furious). The ambivalence of such ties derives from a notable instancing of racial family romance in American history, and one which I believe is central to the representations of the father in recent black American cinema, the legacy of which continues to impact upon current cultural anxieties concerning black parentage, parental abandonment and paternal legitimacy, to which I now turn.

The father as failed mirror

In an important analysis of the symbolic death of the black father in "Mama's baby, papa's maybe" (1987), Hortense Spillers identifies two fantasmatic and real scenes, two phylogenetic myths and fantasies of origin, underlying the repetition and recollection of racial and familial relations in American culture.[3] In restoring a certain *historicity* to these racial and sexual relations, Spillers, in this essay, also reveals their psychoanalytic complexity. For her, the present situation of thinking about the black family in terms of trauma, mourning and rememory points to what is most irreducible about these scenes of racial memory in America: namely, the epoch of slavery and its catastrophic affects on black kinship ties between black mothers and daughters as well as between black fathers and sons. Under slaveholding forms of white paternity, the black male was subject to a paternal law which effectively removed him from paternal rights and filial ties as well as excluding him from interracial

fraternal alliance. This removal led to a corresponding *displacement* of the name of the father onto white fathers, brothers and sons: "legal enslavement removed the African-American male not so much from sight as from *mimetic* view as a partner in the prevailing fiction of the Father's name, the Father's law" (Spillers 1987:80). The black father cannot act out this "prevailing fiction" of law and symbolic paternity precisely because his social usurpation by legal paternity removed him from the "mimesis" of his children's filial identifications. The "official" version of the Oedipus complex (in its simplest form) through which the son's rivalry through mimetic identification with the father and incestuous desire for the mother becomes, in turn, transformed into a superegoic, respectful identification for that same father, despite the obvious aporia between these two identifications, cannot explain the dislocations named above. Black paternity, in its movement of disappearance at the level of identification and of mimesis, cannot introduce into repression a superegoic or promissory ideal for the black child. Instead, the cut of social authority and racial articulation of kinship, constitutes him as a paternity without social foundation, as the trace of the non-place. Thus the shadow of racial stigma disrupts and bars any paternal identification other than that of the white master who is also owner, eradicating in the process any symbolic resolution to Oedipal rivalry and reversal of fraternal rivalry which is not mediated by the threat of dispropriation attaching to racial simulcra and images of paternity. For the black boy, such racism intrudes in terms of an inequality of fathering, whose symptom is that of the black father's social and symbolic destitution, and whose trauma is the breach of black male narcissism by racialized cultural fantasy and white paternal ownership. In such quasi-foundational moments the black father is an object to be mourned and guiltily disavowed precisely because his destitution represents the son's own self-injury.

This act of symbolic displacement under legal slavery in effect condemned the black father to an *antimimetic* position of paternity, a non-place in a fractured family structure, to which no reconciliation is possible and whose insuperable traces continue to infect American culture with a delerium of symbolic unnaming and unmanning. The desire to be named as a father has been violently instituted as a solely white male desire, whose historical and hegemonic legitimation was reinforced by the legalized and ritualistic lynching castration of black men. Such violence was essentially about the status of paternity as racial simulacrum – who could be properly named and represented as such – and was articulated through the spectacle of dispropriation of the black male. This means, in effect, that the black son (and daughter) is presented with a paternity unnameable as such and one mediated by the history of a white paternal injunction; the aporia of whose identification – "be like me and do not be like me" – becomes transformed into "be lynched and do not be lynched". Thus the black boy must learn that, for him, white paternity is the only legitimate paternal ego ideal the transgression of which will result in literal castration. Although the societal taboos surrounding interracial

difference worked through the repetition of such dispropriation and its histor-
ical foundation, the value of Spillers' arguments lie in showing how that repeti-
tion continues to name the epoch of slavery as the moment in which black
fathers became symbolically dead or absent. That said, what her arguments
perhaps leave uninterrogated is precisely this question of the legacy of the
violated black father for those sons and daughters who could not help but
identify with him as the necessary condition of their own social identities.
What could it have meant for those children to identify with a black paternity
constituted through its absence from both the symbolic and the paternal simu-
lacrum; an absence or gap from which they could not free themselves, and to
which they remain enslaved? What could it mean to identify with a father
who is socially degraded? In other words, even though Spillers shows how
the foundation of paternity as racial simulcra works through the anxious
policing of differences between white and black men, white and black fathers
(a difference which also demands delerious repetition), she seems, at times, to
assume that certain identifications are chosen rather than forced.

Or, to put this slightly differently: Spillers fails to clarify the precise link
between the black father's symbolic death and his loss from "mimesis". I must
confess to being troubled by the irruption of the word "mimesis" in Spillers'
account, for does not mimesis imply a double relation between original and
copy, an inference which goes against Spillers' later use – in the same
sentence – of the word "fictions" to describe the lure and masquerade of all
forms of paternity? If mimesis is the point of paternal identification for black
(and white) children then, according to Spillers, black fathers, although
visible, were not available to such identificatory mimesis precisely because
they were socially degraded. Yet this moves identification (in a way which
both recalls and refuses Kennedy's and Gilroy's use of narcissistic recognition
to trace the affects of the social on cinematic fantasy) out of visibility; namely,
these children cannot identify with what they see, nor can they recognize them-
selves in the social imagoes of black paternity – whether as screen or mirror.
In this displacement and rejection of the specular, there is thus a complication
or undermining of a film theory model of black spectatorship which, as we
saw earlier, equates visibility and/or recognition with identification; or, what
one sees up there on the screen is what one identifies with. But, on the other
hand, is Spillers, in her account of black filial identification, assuming that iden-
tification with the father only takes place if it is with a positive image of pater-
nity? In which case is she not overlooking a more psychoanalytic notion of
mimesis defined as a "primordial tendency" to identification, a drive towards
identity which brings, in turn, the desiring subject into being, and not the
other way around in the form of a psychic voluntarism (Borch-Jacobsen
1989:47)? If so, and despite her complication of a naïve account of looking as
identification, of visibility as recognition, Spillers use of the word "mimesis"
appears to restrict it to an equally problematic voluntaristic account of social
identification.

In order to explore this issue of voluntarism (and it is perhaps significant that Spillers suspends the question at this point in her essay in order to return to the legacy of the black mother, an omission and return whose occurrence we will presently see is not fortuitous), I will try and show why this question or issue allows us, in turn, to read the place of the mother in Spike Lee's *Jungle Fever*, in the fourth and final section of this chapter.

Return to the dead mother

The symbolically dead black father, as we have already witnessed, does not become more powerful for being dead, unlike Freud's account of the son's affective remorse for the primal father in *Totem and Taboo* (1913). Freud's account of a murder at the origin of the social tie and moral law, beginning as it does with the necessary loss which founds paternal power through the father's totemic and symbolic rebirth in filial and fraternal ties, and institution of moral laws prohibiting murder and incest, cannot account for the specific death of the black fraternal bond, nor the historical transferral of hostile, destructive elements of the primal father onto black men (a destructiveness linked, according to Freud, to an original cannibalistic murder and incorporation). For Freud, the murder of the father (who is thereby always necessarily dead) leads to the authority of paternal law being sustained by the son's remorse and guilt, and the mournful fantasy of the dead father's love. Under racial slavery, the black father was systematically removed from the archival fantasy of paternal law and love. Accordingly, because the black father is already socially dead he cannot be murdered or agree to be killed, his absence is mythic because it founds what is absolutely lacking, the trace of a murderous identificatory rivalry or default passed on from generation to generation of black brothers and sons.

By contrast, can black mothers dispel rather than affirm this melancholic fantasy of the father's absence or loss? I think it is significant that in the two films I discuss, there is an almost obsessive concern with the failure of the mother and its effects on a fraternal demand for love. I will return to this obsession and the violence that grounds it in my reading of *Jungle Fever*. Although acknowledging the prevalence of this theme, Spillers is also at pains to bring back to recollection the black mother's own loss of kin and family under racial slavery. What can it mean – for the history and repetition of a certain black fraternal anxiety – to reinsert the mother's difference as difference in this account of America's racial past? For Spillers, the mother's loss is not a loss black men can afford to forget without doing themselves irreparable narcissistic injury. If black men have *forgotten* the mother as a "holding" place in their murderous identifications and negative self-love where can they go to reclaim her? Recalling the removal of black fathers from a mimetic identification with the name and law of the father under slavery, Spillers argues that the trace of

mimesis can and should be understood differently – as a return to the name of the mother. This is so because "the black American male embodies the *only* American community of males which has had the specific occasion to learn *who* the female is within itself..." (Spillers 1987:80). Whether one agrees or disagrees with this historical claim, what has therefore been given the black American male in his *specificity*, in his "kinless, semi-orphan state", according to Spillers, is the maternal as an historically constituted horizon of a touch, as the trace of a promise he cannot escape: "[...t]he African-American male has been touched ... by the *mother, handed* by her in ways that he cannot escape" (ibid.).

In locating the touch and hands of the mother as the place where the kinless can re-imagine the promise of an authentic future, Spillers is giving a clear indication as to why a pathologization of the black mother in American culture is misplaced. These pathological narratives lay the blame of black male anomie on the dominance of matrilineal ties in underclass black families, forgetting the black mother's own symbolic inheritance of racial violence. Such blaming forgets the promise of her memory and the founding moment of her touch and the inextricability of violence which institutes her future and her past. However, can the name of the mother replace the name of the father for black men? In Lacanian psychoanalysis (to which Spillers alludes), for example, the name of the father is what necessarily interrupts the maternal dyad by introducing into the place already occupied by maternal desire a lack into the child's imaginary, a lack which allows symbolization to occur. The symbolic function of the name of the father is, then, to introduce this gap or absence thus preventing the child from remaining trapped in the maternal real, the overproximity of which can result in psychosis (Lacan 1977). Yet for Spillers, in her advocacy of a return to the name of the mother, this "fatherly reprieve" (1987:80) is always already shadowed by the violated black father's castrated body. But why assume that the black child has a choice between paternal mutilation and maternal abjection, why assume that such a choice is not, itself, a form of foreclosure? Does not such thinking of the mother as a determinate presence itself forget the fantasies and identifications underlying the fraternal alliances of young black men, and the rivalries and hateful identifications between black mothers and absent fathers which can, in turn, sanction a mother's violence against the sons – "You ain't shit. Just like your Daddy" (George 1992:265)?[4] And why should the choice for the son be either the ineluctable touch of the mother or the inherited absence of the father and not the brother's (or sister's) name and bond? Perhaps at this point, and in honour of my earlier agreement, it may be pertinent to turn to *Jungle Fever*.

In *Jungle Fever*, released in the same year as Singleton's *Boyz N the Hood*, Spike Lee depicts three intertwined stories which have, as their central focus, the identificatory aporias of being emotionally tied to three perverse fathers whose paternity represents itself as grounded in the memory of maternal

love. One (Frank Vincent) brutally beats up his daughter for dating a black man; one (Antony Quinn) turns his son into a substitute wife; and the third (Ossie Davis), murders his beloved, eldest son out of perverse love. In *Jungle Fever*, emotional ties to these fathers are damaging not only because of the fatal violence of these retributions, but because such violence masquerades as paternal love. In *Jungle Fever*, unlike *Boyz N the Hood*, such paternity can only ever be, therefore, an unethical and violent paternal "seduction" of the daughter and son, a seduction which suggests a displaced anxiety about its own authority.[5] This seduction results from the threat of racial intrusion, represented by the black and white other, and the anxieties unleashed in relation to this intruding other. The subsequent unleashing of violence against the son or daughter, an unleashing which the father reserves to himself, is thus deeply implicated in a violence underpinning the paternal as such and one in which racism is implicit.

There are three main families in *Jungle Fever* – two Italian, and one African American. The two Italian fathers in the film both head families in which the mother has died but whose death remains forever preserved in the family memory. More powerful dead than alive the memory of the dead mother is used by the father to inaugurate a bond between himself and his daughter and sons, a bond based on an effective and painful guilt. These fathers remain foreclosed by their own memories of the dead mother. They display a mourning which goes beyond simple devotion in its obsession with an absence halfway between intrusion and loss. The incorporation of the dead wife's memory (which consequently remains forever alive) is used to institute and legitimate violence against the son and daughter in response to a fear of abandonment by the latter to a black lover. Such violence manifests itself as an appeal, designed to induce guilt, to the memory of the dead mother's love. Mike Tucci (Frank Vincent) violently assaults his daughter, Angie (Annabella Sciora), upon learning of her affair with a black architect, Flipper Purify (Wesley Snipes). He addresses her with the following demand and accusation: "Your mother's turning over in her grave. Is this how you respect her memory?" The degradation and shame associated with interracial intimacy is thus articulated through an aporetics of guilt and memory: for the daughter to live, the imago of the dead mother (as a symbol of paternal repression) must die. Tucci's refusal to give up on that love to a "black nigger" (a double emphasis which signals the racist overdetermination of such love) presents itself as an impossible possibility of demand which annuls the daughter's own desires and demands. Similarly, Lou Carbone (Anthony Quinn) responds to his only son, Paulie's (John Turturro) dating of a black woman, Orin Goode (Tyra Ferrell), with the aporetic accusation and demand: "You don't bring no black sugar home to *this* house. God, if your momma was alive she'd turn over in her grave." In other words, the mother will die for a second time if the unruly son pursues his transgressive love; her memory will be engulfed by sorrow and disgust. An appeal to which Paulie responds, "I'm not your fucking *wife*, I'm your *son*."

In these scenes of paternal retribution – articulated through an aporia of demand and guilt – the father's appeal to the dead mother is necessarily violent. The daughter and son must be restored to the dead mother in order to be retained by the father at whatever cost including the psychic death of the child. There is no escape from this claim. The question of memory and unconscious ownership here come together in the father's right to confer this aporia onto the daughter and son. In this context interracial love can only represent a loss or fate worse than death. Love of the black murders the daughter's and son's ties to a death that never dies and yet for them to refuse such love is to accept another death, that of themselves. On the other hand, for the son and daughter to take on the shame and death associated with blackness is to become literally dead in the eyes of the father. Yet this death is paradoxical, for it is precisely the child's unconscious identification with the dead mother which allows the desire for black love to be articulated in the first place. The imago of the black lover is a socially dead representative chosen by the child to represent on the outside his or her own feeling of psychic death. The only difference between the child and the father is that he has spent his life nourishing the dead image of the mother, preserving her memory in the hope that it may not perish and him with it, whereas the child has violently evacuated itself in an attempt to preserve this death by becoming dead: both identify blackness with the state of being symbolically dead and the black lover as an unintrojectable object (cf. Green 1986:153–4).[6]

The strength of *Jungle Fever* lies in its refusal to ever present the negativity of these identifications as rational or self-affirming. Hence, at the film's close, Angie returns to the perverse father having been rejected by the equally perverse black family of Flipper Purify; whereas Paulie chooses to offend the father by dating Orin Goode. Either choice cannot escape the guilt induced by the claims of the father. But this father, unlike the loving paternity on display in *Boyz N the Hood*, is himself founded upon the violence of such guilt. If this is the case what does the brother have to lose from such a father's loss? The black father in *Jungle Fever* murders Gator (Samuel Jackson), his drug addict son. He shoots him because he has already mourned the son he once loved and because what Gator has become is, for him, a state worse than being dead. But by murdering the son he also murders himself as the father in a way which inverts the exchange of violence and death between fathers and sons in *Boyz N the Hood*. The problems raised by that mutual loss in an economy of violence, remain, in various ways, considerable.[7]

Even so, this fratricide is not presented as a lesser violence than crack cocaine through which the racial violence of the social expresses itself in terms of federal incarceration or judiciary surveillance. This explicit connection between a "just" paternal law and black self-murder complicates the issue of paternal guilt and moral responsibility. Lee's film, unlike Singleton's, does not offer the image of a loving paternity as a counter to the violence of the

social bond. In *Boyz N the Hood*, the archival presence of the absent father, the traces he leaves, the mourning and memory he comes to represent, seem to infest the regimes of truth in which each of the sons in the film struggle to locate themselves – whether as brother, lover, son or man. These father stories are riven by a necessary guilt and a bond formed through violence and social death. By engaging with the *effectivity* of the paternity on display in both of these films, with the repertoire of positions of responsibility and emasculation, of law and spectatorial pleasure and identification the imago of the father demands from spectators looking at the screen, only then does it become possible to understand the ambivalence of the father's role in black American cinema and American culture culture generally. That ambivalent identification is at once an object of desire and compulsion, an articulation of an impossible homosocial love and a narrative of inalienable, but denied rights to manhood and masculinity. Over the years we have come to know that people do not die in the same way at the level of identification and of affect, a distinction which nonetheless disavows the extent to which the social is founded on the violent sacrifice of those deemed unworthy of what may be termed a "proper life or death". The truth of this inheritance is the dereliction of the black brother and the gift, through challenge, of the rights to sociality passed on from white fathers to sons. The absence of the black father is the non-place in relation to which this gift takes on meaning. This means, finally, that certain deaths are irrecoverable; being irrecoverable, these deaths cannot be witnessed or spectated, but remain traces of a promise that was. What such a reading reveals are the boundaries of a black politics of kinship and of race as it enables an explication of these limits from the sphere of mourning, reparation and of love. The black father, despite his symbolic absence, cannot not be remembered, for he has a claim that goes beyond, and is other than, the individual needs and wishes of the son. Yet the ambivalence of that claim, in all of the aporetic debt owed to the memory and death of the father, remains as originary and fraught for the son anxiously looking on as it does for the brother awaiting that father's redemptive return.

Notes

1. The opening still frame dedications to murdered black men in both *Jungle Fever* and *Boyz N the Hood*, are just one example of the real intruding in upon the cinematic screen. This pressure of the real prevails both inside and outside the space of cinema because the anxious repetitions of an absent paternity on display in both films cannot be separated from the real deaths of black brothers, fathers and sons occuring in American cities, the staggering statistics of which we are asked to bear witness to on and off the screen. The dedication of *Jungle Fever* to the memory of Yosef Hawkins, a young African American, killed under suspicion of dating an Italian girl in the Italian neighbourhood of Bensonhurst – where the Italian sections of the film are set – also introduces another aspect of the real – the

extent to which racial tensions between Italians and black Americans, the main subject of the film, vividly illustrate the close connection between racial aggression and fraternal rivalry.

2. For a fuller account of the use of narcissism in film theory see Copjec (1989) and Lebeau (1995).

3. The phrase "symbolic death" is being used in two senses here: because the black father has been systematically barred from being a representative of paternal law in America's racial history, he cannot be symbolically dead in the Lacanian or Freudian sense; i.e. his death is not linked to the establishment of the paternal as such, nor has a totem or veiled fantasy of the phallus been put in his place. Rather, his symbolic function has been replaced by a white ideological fantasy of why he had to die; namely, because he represented a degradation of the paternal.

4. Whilst recognizing the note of persecutory triumph and malice contained in this negative judgment, it would be naïve to disregard the tone of misfortune, grief and self-reproach also informing the mother's complex response to the loss of the father as mediated through the son. Cf. Klein (1940) for an articulation of the relationship between triumph, mourning and lost objects.

5. In Freud's letters to Fleiss, paternal perversity is seen as a defense against madness. The pervert transfers his neurosis to the object of his perversity in order to so defend himself while interfering with his child.

6. Fantasy, transposes objects and their inherent qualities from the outside to the inside of himself. Cf. Laplanche and Pontalis entry on "Introjection" in *The Language of Pyschoanalysis*.

7. As evidenced in a spate of recent African American autobiographies written by men. Cf. Wideman (1994), Staples (1994) and McCall (1994). Staples's *Parallel Time* begins, literally, with the body of the dead brother lying naked and dead on a mortuary stainless steel slab, an horrendous wound running the length of his abdomen from sternum to pubic mound. The trauma of that death is explored throughout the book in terms of an inability to mourn and one connected to fears over the loss of memory (Cf. Staples 1994:3–8; and passim).

References

Borsch-Jacobsen, M. 1989. *The Freudian Subject*. Trans. C. Porter. London: Macmillan.

Copjec, J. 1989. The orthopsychic subject: film theory and the reception of Lacan. In *October* **49**.

Fanon, F. 1967. *Black Skin, White Masks*. Trans. C.L. Markmann. New York: Grove Press.

Freud, S. 1913. Totem and taboo. *The Pelican Freud Library* **13**, Harmondsworth: Penguin.

George, N. 1992. *Buppies, B-boys, Baps and Bohos: Notes on Post-soul Black Culture*. New York: Harper Perennial.

George, N. 1994. *Blackface: Reflections on African-Americans and the Movies*. New York: HarperCollins.

Gilroy, P. 1993. "It's a family affair". In *Small Acts: Thoughts on the Politics of Black Cultures*. London: Serpent's Tail.

Green, A. 1986. "The dead mother". In *On Private Madness*. London: Hogarth Press.

Kennedy, L. 1992. "The body in question", In *Black Popular Culture*, G. Dent (ed.). Seattle, Washington: Bay Press.

Klein, M. 1940. "Mourning and its relation to manic-depressive states". In *The Selected Melanie Klein* 1986, J. Mitchell (ed.). London: Penguin Books.

Lacan, J. 1977. *Ecrits: a Selection*. Trans. A. Sheridan. London: Tavistock.

Lebeau, V. 1995. *Lost Angels: Psychoanalysis and Cinema*. London and New York: Routledge.

McCall, N. 1994. *Makes Me Wanna Holler*. New York: Vintage Books.

Spillers, H. 1987. Mama's baby, papa's maybe: an American grammar book, in *Diacritics* **17** (2), 65–81.

Staples, B. 1994. *Parallel Time: Growing Up in Black and White*. New York: Avon Books.

Wallace, M. 1992. "Boyz N the Hood and Jungle Fever". In *Black Popular Culture*, G. Dent (ed.). Seattle, Washington: Bay Press.

Wideman, J.E. 1994. *Fatheralong: a Meditation on Fathers and Sons, Race and Society*. New York: Pantheon Books.

Part IV

History and postmodernism

7

Out of the past: psychoanalysis, trauma and the limits to recollection

Tina Papoulias

> Out of the ruins of the traumatic theory of hysteria, Freud created psycho-analysis. The dominant psychological theory of the next century was founded in the denial of women's reality ... Psychoanalysis became a study of the vicissitudes of fantasy and desire, dissociated from the reality of experience (Herman 1992:14)

This argument, and the set of assumptions it rests on concerning the ethics and ideological underpinnings of the psychoanalytic project are both familiar. Powered by the insights of feminist interpretations concerning the structure of women's exploitation, Judith Herman, in her recent book *Trauma and Recovery* (Herman 1992) denounces the Freudian tradition of prior-itizing the internal world of impulses, desires and fantasy, to turn her atten-tion to the actual events and experiences that shape women's lives. Herman's stance emerges in the context of a broader critique of psychoanaly-sis on the grounds of its indifference to history in favour of an already given psychic structure, operating under the aegis of the Oedipus complex. In the terms of this critique, the usefulness of psychoanalysis for the study of sociocultural formations is easily cancelled the moment the negotiation between the psychic and the social is translated as an ethical choice between fantasy and experience. The further translation of experience as endurance of atrocity and systematic sexual abuse confirms the alleged indifference of psychoanalysis – as a set of knowledges about the self – to the role of history in the production of that self. Psychoanalysis neglects the unspeakable horror of specific experiences, not simply as a result of individual analysts' bad faith, but rather as a structural occultation, necessary for the operation

of its principles in the first place. Such neglect finds its (dis)reputable origin in Freud's early dismissal of his theory on the traumatic aetiology of the neuroses, marked in the famous 1897 letter to his friend Wilhelm Fliess, in which he confesses that he no longer believes that hysteria can be traced back to an actual traumatic occurrence.

Herman's critique of psychoanalysis however, does not amount to an unqualified rejection. As a practising psychotherapist who is also a feminist, Herman attempts to renegotiate the psychic through the social: this negotiation is enabled through her reading of experience as trauma in the sense of a psychic wound, a breach in the fabric of the self. This reading is effected in Herman's reconstruction of a "ruined" Freud, an early disavowed body of writings on trauma, which could have led to another psychoanalysis, one which was allegedly "repressed" in the construction of a psychoanalytic orthodoxy. In the first chapter of her book – tellingly entitled "A forgotten history" – Herman goes on to link the early Freud with W.H. Rivers' study of shell shock in the trenches of the First World War, Abram Kardiner's work on traumatic neuroses and the more recent feminist foregrounding of rape and child sexual abuse. She thus provides a connecting narrative, which moves from Freud to the official recognition of trauma as productive of a distinct pathology, signalled by the appearance of the term "Post Traumatic Stress Disorder" in the 1980 Diagnostic and Statistical Manual published by the American Psychiatric Association (DSM-III). Herman's re-evaluation of Freud's traumatic aetiology of the neuroses then doubles up as a certain kind of historical project, which explicitly mirrors her clinical work of reassembling the untold stories of her patients.

> The study of psychological trauma has an "underground" history. Like traumatised people, we have been cut off from the knowledge of our past. Like traumatised people, we need to understand the past in order to reclaim the present and the future. Therefore, an understanding of psychological trauma begins with rediscovering history (Herman 1992:2).

A therapy-assisted remembering of such experiences can here stand for an acquisition of knowledge about the past; a coming to terms with the past. Not only is history then what is absent in orthodox psychoanalytic practices, but also the recovery of history is expressed as a recovery of (and from) trauma. This equation between trauma and experience (in the sense of the lived event) is not without consequence, not only for an evaluation of the psychoanalytic project but also for an understanding of history as a relation to the past.

Herman's project finds a strong application in the current focus on memory recovery which has characterized a number of heterogeneous therapeutic practices in the United States since the mid-eighties. Memory recovery is the process by which traumatic material usually associated with an experience of child sexual abuse can return to light after an interval of several years, even

decades. It is the use of therapy to restore knowledge of the past, but this knowledge refers to an atrocity experienced by the patient. Contrary to the assertions made by their opponents, these practices do not constitute a movement and operate on different and rather eclectic models of the psyche. However, they share a belief in the curative function of memory recovery and an understanding that the forgotten past can be accurately reproduced through associations that may act as cues or through the use of therapeutic props such as hypnosis or the administration of sodium (Terr 1994). In a sense, such therapeutic practices concur with orthodox psychoanalysis that what matters is what we cannot remember. However, while psychoanalysis is indifferent to the external verifiability of the unremembered material, these newer practices set up this verifiability precisely as the index of memory. If the question of trauma, as the unspeakable experience, is central to current Anglo American therapeutic practices, this focus coincides, more often than not, with a restoration "out of the ruins" of an original Freud who believed in the reality of his patients' testimonies. This restoration has led to a redefinition of repression in which the object of repression is a memory of an event rather than the contents of a wish. The choice of the real against fantasy posits memory *per se* as a privileged conduit to the past, a conduit through which the past can be owned. This manoeuvre relegates fantasy to a position of unreality, and translates the problematic notion of historical experience to that of the real event. This translation is most evident in the appearance of therapists as expert witnesses in courts. For the purposes of establishing evidence in cases of alleged sexual abuse, it is only the notion of memory as accurate inscription of a real event that counts.

It is precisely from the launchpad of such juridical definitions of memory as truth, that the concept of False Memory Syndrome (FMS) has proceeded to gain unprecedented popularity in the last few years. Clinical and research psychologists initially in the United States and later in Britain have been at pains to demonstrate that memory is a transformative process open to falsification *vis-à-vis* the givens of the actual past and that therefore, what is forgotten cannot be restored (Loftus & Ketcham 1994). But even within the concept of false memory, the distinction between fantasy and real events is firmly in place: what is different here is that memory is relocated on the side of fantasy. If fantasy can be shown to be inseparable from the act of remembrance, then historical reality must lie elsewhere: a notion that assumes that historical reality translates as a series of verifiable events. In this context, reversible, pathogenic gaps in memory become meaningless. The notion of repression as an unconscious process is rejected and replaced with conscious mechanisms (avoidance) or neurological damage (amnesia) (Ofshe & Watters 1994:34). For FMS supporters, psychoanalysis is seen as the source of the most pernicious "myth of memory": namely that "the forgotten is the formative" (Hacking 1996). In Frederick Crews' virulent attack on both memory recovery and Freud, the latter is presented as a self-aggrandizing quack,

claiming to have discovered fragments of a buried past, while irresponsibly planting his own fantasies into his patients' suggestible minds:

> by virtue of his prodding both before and after he devised psychoanalytic theory, to get his patients to "recall" non existent sexual events, Freud is the true historical sponsor of "false memory syndrome" (Crews 1993:66).

The FMS supporters' allegations posit a serious challenge to psychoanalysis because they foreclose the notion of the unremembered as foundational to personal history. In so doing however, they do not simply oppose the direction taken by the supporters of recovered memory. Rather they also collude with them in silencing the difficult relation between trauma and the emergence of repression and between psychic structures and historical reality. In the remainder of this paper, I propose to open up the relation between trauma and history, through looking at the particular constellation that links trauma with child abuse and pushing for an alternative understanding of trauma as it emerges in a close reading of Freud's work. In other words, while I would agree with Herman that the understanding of trauma means the rediscovery of history, I would suggest that Herman's approach does not examine how the notion of history is troubled by the temporality that trauma lays open.

Child abuse and Masson's Freud

In starting her book on trauma with Freud's abandonment of the seduction theory, Herman follows the line on Freud most famously established in Jeffrey Masson's 1984 best seller *The assault on truth*. Although Masson's book did not inaugurate suspicion against psychoanalysis, it nevertheless operated as a catalyst, placing child abuse as the repressed past of psychoanalysis. Masson's argument was supported by his meticulous restoration of an original Freud through his investigations of the Freud Archives in London between 1970 and 1983. These investigations led to a discovery of the censored parts of Freud's correspondence. As Masson proclaims in his introduction, a reading of these censored parts reveals Freud's doubts concerning the abandonment of the seduction theory, *because* they demonstrate his belief in the reality of some of his patients' stories of rape. According to Masson, this uncomfortable truth continued to haunt Freud and eventually led to his severing of links with his disciple Sandor Ferenczi when the latter returned to the prioritization of sexual abuse over fantasy. The excision of such passages from his correspondence becomes a foundational act when one considers that Freud's alleged abandonment of the seduction theory is reiterated as the origin of psychoanalysis proper and is taught as such in the training of young analysts. It is only after moving away from a belief in patients' testimonies that Freud "could discover the more basic truth of the power of internal

fantasy and of spontaneous childhood sexuality" (Masson 1992:xxxiv). Masson's case that this prioritization of fantasy represents "a travesty of the truth" however, is based on several elisions which continue to persist in the work of Judith Herman as well as in the more recent controversy surrounding the False Memory Syndrome.

First, fantasy has to be defined as a function of masking and deception operating to disqualify the existence of actual unwanted experiences such as rape. In Masson's words fantasy is "the notion that women invent allegations of sexual abuse because they desire sex" (Masson 1992:xxiii). This definition disables the notion of fantasy as a process of reworking and interpretation through which memories acquire retrospective meaning and cancels the possibility that an experience of rape can be both unwanted *and* remodelled within a landscape of fantasy. Indeed, the problem of the event in psychoanalysis is not one of contestation (it never happened) but rather one of inattention (what must be analysed is not the actuality of the event, but the actuality of the analysand's interpretations). As some psychoanalysts have argued in the wake of Masson's accusations, it is this inattention that has to be redressed, but this problem in no way disqualifies the presence of fantasy as such (Bennett 1992).

Secondly, Masson aligns the seduction theory with a prioritization of sexual abuse (Laplanche 1989). This allows him to substitute the theoretical questions involved in the abandonment of the seduction theory with ethical questions associated with children's welfare. Indeed, Masson's lack of interest in the vicissitudes of Freudian theory is made explicit in his change of the book's subtitle for the 1992 edition from "The abandonment of the seduction theory" to the much more marketable "Freud and child sexual abuse".

Thirdly, Masson also aligns sexual abuse with trauma. This enables him to present Freud's haunting by "trauma" in his later writings as a result of a guilty conscience. He thereby occludes the problems that trauma and the repetition compulsion introduce for the termination of analysis, problems specifically related to the idea of memory recovery.

Recollection vs construction

Already in his 1896 paper "On the aetiology of hysteria" (Masson 1992), Freud is eager to point out that although a traumatic seduction may be seen to lie at the origin of hysteria, his patients do not strictly speaking suffer from the experience itself, but from unconscious memories of the experience. In the papers on hysteria co-authored with Breuer, he uses the notorious phrase "hysterics suffer mainly from reminiscences" (S.E. 2) It is precisely these unconscious memories, unlike conscious ones, which are pathogenic.

In his letters to Fliess, Freud expands further on the process by which the original traumatic experience may come to light. This is a process of substitu-

tion, in which the memories are represented by fantasies. The term "fantasies" here points to the psychic work of distortion to which certain pathogenic memories are subject. More specifically, the production of a fantasy is understood as "a falsification of memory by fragmentation in which it is precisely the chronological relations that are neglected", followed by a recombination of the fragments to form new images to the extent that "an original connection has become untraceable" (Freud 1985:247). But if this is the understanding of a distorting force resulting from the repression of a pathogenic memory, the normal process of memory formation in itself is no less fragmentary. In an earlier letter to Fliess, Freud had attempted to sketch out the topography of the memory system in which memory traces are not unique but already multiply inscribed:

> ... I am working on the assumption that our psychic mechanism has come into being by a process of stratification: the material present in the form of memory traces being subjected from time to time to a *rearrangement* in accordance with fresh circumstances – to a *retranscription*. Thus what is essentially new about my theory is the thesis that memory is present not once but several times over, that it is laid down in various kinds of indications (Freud 1985:207).

These indications (psychic systems) are at least three, corresponding to the psychic stratification Conscious-Preconscious-Unconscious that Freud was using at the time. It is precisely this multiple inscription of memory that will soon emerge as a problem in theorization of an aetiology of hysteria.

Indeed, this problem surfaces in Freud's 1897 crucial letter to Fliess. There, Freud clearly does offer as one of the reasons for his change his reluctance to believe that all of his patients had been abused. But this reluctance is by no means presented as the decisive factor for his abandonment of what he calls his "neurotica" that is the seduction theory. Rather this abandonment is motivated by Freud's problem with the notion of recollection. Freud admits that his attempts to make the patients recall what had been forgotten have not brought "a single analysis to a real conclusion" (Freud 1985:264). Furthermore, Freud has found it impossible to distinguish between "truth and fiction that has been cathected with affect" (ibid), and finally he has found instances where the secret of childhood has not been brought to light, even at the point of the most unrestrained delirium, and therefore it would be difficult to assume that the therapeutic session will inevitably lead to the return of memory.

These problems suggest not Freud's indifference to the traumatic experiences of his patients but rather the complication of the aetiology of the neuroses. It is the restoration of memory which constitutes the difficulty, and for reasons that go beyond the resistance posed by the patient. Contrary to his earlier assertions that the presence of affect (feeling) allows the therapist to

distinguish between truth and fiction, Freud remarks now that affect offers no such guarantee. This however does not mean that the patient is lying but rather that the patient's real may not coincide with a notion of historical reality as the reality of an *event*. It is because of this consideration that Freud posits the concept of psychic reality. If hysterics suffer from memories, these are always in the plural not because of repeated trauma but rather because of a delay in the transcription of the experience as traumatic. This delay constitutes the fundamental dimension of trauma: it makes the interpretation of the event, as opposed to the event in itself, pathogenic. An experience will become traumatic only through what Freud will later call "deferred action".

Perhaps the most scandalous reworking of Freud's thinking on the relationship between memory, fantasy and historical reality occurs in his analysis of Sergei Pankeyef, the Wolf-Man (S.E. 17). The scandal erupts as a result of a disagreement between Freud and his patient over the origin of the latter's neurosis. Pankeyef, the child of a very wealthy Russian family had been brought to Freud with a severe case of what had been diagnosed as manic depression, a condition which had incapacitated him for a number of years. The patient as a child had also suffered from a phobia of animals, especially wolves, which he tried to counter by way of obsessive religious rituals. In the course of the treatment, Pankeyef had a spontaneous recollection: "when he was still very small ... his sister had seduced him into sexual practices" (S.E. 17:20). The scene came filled with vivid detail as to the setting and the particulars of the seduction. Freud seized upon the recovered scene as the conduit to the patient's illness and claimed that "his seduction by his sister was certainly not a fantasy" (S.E. 17:21). Freud however went on to affirm that this seduction, although real, was in itself not sufficient to produce the neurosis. The emergence of the latter is rather linked to a haunting dream that Pankeyef had at the age of four. This is, of course, the dream that gives the patient his nickname: a child looking upon a scene in a winter garden is petrified to discover six white wolves sitting still on a tree, staring at him. Through the analysis of the famous wolf-dream, Freud comes to construct an unremembered "primal scene" as the traumatic origin of his patient's neurosis. Significantly, this construction was never owned by the patient. Indeed in his memoirs Pankeyef – who outlived Freud by 40 years – always maintained that no memory – that is to say no recollection – ever came to replace Freud's construction (Obholzer 1982:36). The analytical manoeuvres surrounding the case of the Wolf-Man are well rehearsed in psychoanalytic literature but for the sake of my argument I will underline some of their import.

The wolf dream was analysed as a remodelling of an early infantile memory. This hidden memory, Freud surmised, must have been the decisive element which, interpreted in the light of the seduction by the sister, triggered the later phobia. In the course of Freud's careful archaeological endeavours on the dream, nothing conclusive appears, until his patient produces a further series of fragments:

What sprang into activity that night out of the chaos of the dreamer's uncon-
scious memory-traces was the picture of copulation between his parents,
copulation in circumstances which were not entirely usual and were
especially favourable for observation (S.E. 17: 36).

It is from this hazy picture that Freud will resurrect the origin of the patient's
long-term suffering. He will posit a scene of parental sex witnessed by an 18-
month-old child, a scene which will only become traumatic later, through his
sister's seduction, according to the principle of deferred action. This witnessed
moment of intercourse Freud will term "the primal scene", to indicate that it
is a foundational scene not only with respect to Pankeyef's mental world but
in relation to the psychic as such. It is precisely this foundational scene which
cannot become the object of recollection: "these scenes from infancy are not re-
produced during the treatment as recollections, they are the products of con-
struction" (S.E. 17:50). Indeed, the scene will only live on in Pankeyef's
memory as the dream of the wolves. The dream, Freud underlines, is an "acti-
vation of this scene", a mnemonic operation which he is careful to distinguish
from its "recollection" (S.E. 17:44). This activation then stands as "another
kind of remembering" which is *equivalent but not identical* to recollection and
which emerges in the absence or impossibility of the latter. The notion of the
primal scene then operates as the place of origin for the neurosis and comes
to answer the problem that Freud had expressed in his 1897 letter to Fliess:
namely the problem arising when, in certain cases, the secret of childhood is
never revealed by the patient. The decisive factor for traumatization must be
that scene which is not recollected but is nevertheless presented as active in
memory. It is at this much contested point, that Freud's theory of memory
has to acknowledge a limit to recollection; *but that limit does not also constitute a
limit to memory as such.*

The positing of a primal scene does not cancel the notion of an event or deed
which intrudes in the psychic space. Not only does Freud insist on the reality
of seduction by the patient's sister, he further insists that the primal scene is
connected to an element of reality. The haunting dream which activates it is
imbued with "a sense of reality", it "relates to an occurrence that really took
place and was not merely imagined" (S.E. 17:33) – although Freud cannot de-
termine whether what really took place was parental or animal intercourse, or
something else altogether. The primal scene is the hypothesis put forward in
order to fill the inadequacy of *any* remembered scene to act as the origin of
psychic suffering. What is to be found at the origin is a gap, a limit of recollec-
tion. This is a gap that therapy cannot fill except through construction.
Furthermore, it is a gap that points to the direction of another temporality, in
which the real also plays a part.

In his technical paper, "Remembering, repeating and working through"
(S.E. 12), written at the same time as the case history mentioned above, Freud
elaborates further on the distinction between memory and recollection. As he

points out, memory manifests itself in the course of the analytic treatment as both recollection and "acting out". The patient performs in actions and words, fragments of the past that cannot be positioned as recollections. Acting out constitutes the performance of what is not yet recollection, of something that cannot be owned by the patient and yet determines his or her mental life: the patient repeats, acts out, past conflicts as if they referred to a present situation. This living under the spell of the past, the performance of the past as present, is what Freud calls "the compulsion to repeat" (S.E. 12:150). The aim of treatment is then to convert this pathological kind of memory into normative memory, so that the material which is repeated can be recognized as belonging to the past and can therefore cease to interfere with the present life of the patient. In other words, the aim of treatment is to restore a temporal order, so that the patient is no longer possessed by his or her past. By providing an artificial field for repetition to thrive, the therapeutic intervention constrains the compulsion within the context of the transference: it restricts it to the analytic dyad. In this way, repetition may be studied in isolation, until the patient starts recognizing the patterns thus materializing, thereby becoming able to relegate them to some past experience or conflict. The analytic experience becomes one of conversion from one type of mnemonic activity to another, from performative to cognitive and the transference becomes the controlling device through which such a conversion is made possible. However, this restoration of temporality becomes problematic when we begin to take on board some of the implications of the analysis of The Wolf-Man. The past contained in the Wolf-Man's "primal scene" is not strictly speaking one. That is to say, not only did it acquire meaning retroactively (this, Freud posits, is typical of all memory) but also, it was never experienced as such, it had never been conscious. Rather, the "primal scene" points to the direction of a *virtual*, not an actual past, something that emerges at the earliest moment of childhood only to be activated through ensuing contingencies. If the compulsion to repeat is installed not only as a pathological but in addition, as an originary type of operation, its excision through the course of analysis becomes highly problematic.

This problem came to the surface in Freud's 1920 study, "Beyond the pleasure principle" (S.E. 18). There Freud begins by discussing the pathology of shell shock victims, that is to say soldiers who had become ill as a result of traumatic experiences suffered in the trenches of the First World War. These soldiers were individuals possessed by their experience, returning to its horror nightly in their dreams. This compulsive restaging led Freud to hypothesize that an overwhelming experience may damage the individual's capacity to register and become conscious of the external world. For Freud, the system of perception and consciousness works as a shield against stimuli from the outside world, a shield whose function is to ensure that only a certain amount of excitation (an amount that can be mastered without difficulty) may be admitted at any time. What shell shock does in this account is

to break through the shield and produce a traumatic effect precisely because the registration of experience has been temporarily inactivated. In Freud's words, trauma arises when the individual cannot anticipate the experience, is helpless in the face of it. The compulsion to repeat then arises as a reflex generated in the absence of the possibility of recollection. In this, the traumatized soldier resembles the small child who activates through dreams and enactments what cannot arise as recollection. The kind of memory played out in shell shock touches upon the foundational structure of memory insofar as the latter refers to an intrusion taking place in the absence of consciousness.

Trauma and the return of memory

Current therapeutic work on trauma takes up the Freudian distinction between repetition and recollection. But in this very act of fidelity to Freud's work, psychoanalytic psychotherapists have translated "repetition compulsion" into "traumatic memory" and have therefore externalized the work of repetition and determined its origin as the traumatic event in itself. The category of traumatic memory is not Freud's own but has recently been reactivated from the writings of Freud's lesser known contemporary and rival, Pierre Janet. Janet distinguished between narrative memory, or memory proper and traumatic or pathological memory. Narrative memory involves the integration of new information (perceptions, emotions, etc.) into pre-existing narrative schemata; in other words it is the process of telling one's own story. Traumatic memory by contrast, arises in the disabling of such narrative schemata under conditions of duress. Unable to become integrated, memories of trauma are frozen in time and stand apart, developing a parallel existence to that of the individual's personal history (van der Kolk and van der Hart 1995). This parallel existence erupts because traumatic memories do not undergo repression – they are not pushed away – but arise through a dissociation of consciousness at the moment of the traumatic event; the traumatized person splits in two, with one part functioning normally, the other stunned and overwhelmed by the experience.

The concept of traumatic memory, although providing an important tool for conceptualizing the aftermath of trauma, leaves out of consideration that aspect of repetition compulsion that has to do with the limit to recollection which is constitutive of the work of memory. In other words, "not knowing" becomes an aberration of knowing, arising through the effect of massive psychic trauma and is no longer considered a condition for the emergence of memory as such. In the context of therapy addressed to trauma survivors, a model of memory is set up which consists in aiming at ownership of the experience. In the continuum between not knowing and knowing proposed by Dori Laub in a recent paper, the ideal state is one in which memory is owned, experiencing that I can also be present as a witness, and finally the distinction

between present and past holds fast. In this framework, Freud's repetition compulsion is interpreted as the desire to master the unknown, to integrate and finally own it. In this formulation the scandalous aspect of psychoanalysis, the hypothesis of a disturbance in memory which is seen to work within memory itself, is removed. Herman too eloquently explains this removal by pointing out that unlike Freud who failed to find an "adaptive, life affirming explanation" for the repetition compulsion, subsequent therapists "speculate that the repetitive reliving of the traumatic experience must represent a spontaneous, unsuccessful attempt at healing" by means of "integrat[ing] the traumatic event" (Herman 1992:41). In the end, the compulsion is seen to serve the ego's pre-existing cognitive function.

Just as the repetition compulsion is marshalled in the service of recovery, so too the distinction between recollection and construction is erased. Significantly Herman discusses not construction but *re*construction as a process undertaken by both the therapist and the patient/survivor with the aim of establishing the latters" memory, conceived here after Janet as a narrative function:

> The next step is to reconstruct the traumatic event as a recitation of fact. Out of the fragmented components of frozen imagery and sensation, patient and therapist slowly reassemble an organised, detailed, verbal account, oriented in time and historical context . . . the patient must reconstruct not only what happened but also what she felt ... The therapist must help the patient move back and forth in time ... so that she can simultaneously *reexperience* the feelings in all their intensity (Herman 1992:177–8) (my emphasis).

What Herman adds to the Freudian account of construction is not only an emphasis on the historical actuality of the traumatic event. More importantly, she posits that event as an experience endured by the patient who now has to reendure it during treatment. Reconstruction figures here as the return of memory, as recollection. This is precisely what construction is *not* in Freud's writing. The gap at the foundation of memory continually begs for a retrospective reading, but this reading can only work as an actualization of the virtual past, an actualization which is not equivalent to an elimination of its virtuality.

Conclusion: Laplanche and the temporality of trauma

The reality of sexual abuse and of repeated atrocities inflicted upon children and adults, possesses a gravity and horror which blocks the consideration of the double temporality of trauma, as located both in an experience and an outside of experience which I have termed the virtual past. However, in the recent work of psychoanalyst Jean Laplanche, the temporality of the virtual past is taken on board, precisely through a return and a reworking of the

seduction theory, that is to say with an emphasis on the importance of the real. It is therefore with this work that I will conclude.

In *New Foundations for Psychoanalysis* (Laplanche 1989), Laplanche returns to Freud's early postulation of memory as a multiple inscription, a process of translation from one psychic system to another. In this postulation, repression is "a failure of translation", a blocking and fragmentation of memories (Freud 1985:208). But at this point, Laplanche observes, Freud does not speak of how an initial inscription, which would be an inscription prior to re-pression, might arise except through an occurrence of seduction. This occur-rence is specific and can only come to pass under certain circumstances (eg. not all children are abused). Therefore, seduction is not a necessary condition for the emergence of memory. This contingency of seduction is one of the reasons Freud abandons the seduction theory. In its place, the primal scene will later emerge as the example par excellence of an originary entry into sexu-ality, an entry which may or may not become traumatic. Laplanche takes on this hypothesis of a scene emerging at the limit of recollection, and like Freud, underlines that this scene touches upon the real. However, he moves away from Freud's overwhelming focus on parental intercourse. He posits instead that in establishing a relation with the adult, the child inevitably becomes subject to a transmission of adult fantasy, in the form of a message that is indecipherable, and which constitutes a "primal seduction" in its very in-decipherability. The term describes

> . . . a fundamental situation in which an adult proffers to a child verbal, non-verbal and even behavioural signifiers which are pregnant with unconscious sexual significations (Laplanche 1989:126).

These messages constitute what Laplanche terms "enigmatic signifiers". They are incomprehensible to the child and will later enter a process of continuous re-translation. Seduction is not therefore an event, but a transmission of a message. Although the message will be subject to translation, as such it can be neither recollected nor explained away: it is not a message owned by or emanat-ing from the child. I would suggest that the content of the message remains virtual, while being real at the same time. We can revisit here Herman's distinc-tion between the vicissitudes of the internal world and the reality of experience. In Laplanche's formulation, the enigma of the experience-as-transmission con-stitutes the internal world: the experience is real but its reality surpasses the child: it is in a sense the reality of the adult's secret. The adult implants the message as a foreign object around which the sexuality of the child will develop. Primal seduction "is intended to found the structure of the psychical or soul apparatus in general" (Laplanche 1989:129). But this structure does not emerge in the transmission of the unconscious in general: the material constitut-ing the enigma is stamped by the specificity of the individual unconscious. In other words, what is transmitted is the history of the other.

To recapitulate, Laplanche's work offers a return to a seduction theory which can no longer be positioned in the external objectivity of an event such as rape, but which nevertheless suggests that the internal world is constituted through historical reality or rather through the virtuality of historical reality. This positing of a primal seduction allows that the relation to the other opens up the temporality of trauma in so far as it operates as a virtual, enigmatic transmission, an infection with history.

References

References to Freud's writing are from the *Standard Edition of the Complete Psychological Works of Sigmund Freud*, 1953–74. (ed. and trans.) J. Strachey, London: Hogarth Press. (Marked in the text as S.E.)

Bennett, S. 1992. Incest – see under Oedipus complex: the history of an error in psychoanalysis. *Journal of the American Psychoanalytic Association* **40**:955–88.

Crews, F. 1993. The unknown Freud. *New York Review of Books,* November 18.

Freud, S. 1985. *The Complete Letters of Sigmund Freud to Wilhelm Fliess,* J. Masson, (ed. and trans.). Cambridge, Massachusetts: Bellknap Harvard.

Hacking, I. 1996. "Memory sciences, memory politics". In *Tense Past: Cultural Essays in Trauma and Memory.* P. Antze and M. Lambek (eds). London: Routledge.

Herman, J.L. 1992. *Trauma and Recovery.* New York: Basic Books.

Laplanche, J. 1989. *New Foundations for Psychoanalysis.* Oxford: Basil Blackwell.

Loftus, E. and Ketcham K. 1994. *The Myth of Repressed Memory: False Memories and Allegations of Sexual Abuse.* New York: St Martin's Press.

Masson, J. 1992. *The Assault on Truth: Freud and Child Sexual Abuse,* (1st edn 1984). London: HarperCollins.

Obholzer, K. 1982. *The Wolf-man: Conversations with Freud's Patient – Sixty Years Later.* New York: Continuum Books.

Ofshe, R. and Watters E. 1995. *Making Monsters: False Memories Psychotherapy and Sexual Hysteria.* London: Andre Deutsch.

Terr L. 1994. *Unchained Memories: True Stories of Traumatic Memories, Lost and Found.* New York: Basic Books.

Van der Kolk, B. & Van der Hart, O. 1995. "The intrusive past: the flexibility of memory and the engraving of trauma". In *Trauma: Explorations in Memory.* C. Caruth (ed.). Baltimore, Maryland: Johns Hopkins University Press.

8

The poetics of opacity: readability and literary form

Peter Nicholls

Common to post-Saussurean accounts of language is the assumption that where the signified once stood, the signifier now stands, and that furthermore it is signifiers all the way down. The systematic assumption that language operates in the absence of an available signified has tended to produce practices of reading for which a certain dematerialization and abstraction are the inevitable concomitants of language's actual incapacity to refer. Yet it is arguable that where the absence of the referent is an easy assumption, too little concern may be shown for the residual vehemence with which signs attend to the world. To explore what may be in effect a turn towards reference by devious paths we must attend to opacities, since it is in moments when meanings fail that, as psychoanalysis has insisted, the painful origin of that failure may be intimated. Of particular relevance here is the work of Nicholas Abraham and Maria Torok who have focused on language as a barrier or obstacle to understanding within which what is being obstructed is a situation "whose interpretation consists entirely in evaluating its resistance to meaning" (Rand 1986:lx). The words in which the event resides, if only as the pressure points left by its refusal of expression, are "defunct", words "relieved of their communicative function" (Derrida 1986:xxxv–xxxvi), but not, paradoxically, of their force.

Abraham and Torok describe a situation in which the effect of some traumatic event is such as to block the symbolic operation and to locate linguistic resistance to communication in phonic and graphic effects. Such effects obstruct direct articulation of the event, with heightened non-semantic features operating in the service of the need to conceal. One example chosen by Abraham and Torok in their exploration of Freud's Wolf-Man case may serve to make the point: *tieret* (Russian, to rub) is taken to crystallize a 4-year-old boy's trauma over witnessing his father fondling or rubbing his

6-year-old sister.[1] At 16 the sister committed suicide by swallowing mercury (Russian *rtut*). Abraham and Torok noting two shared consonants, "r" and "t", and "the glottal pronunciation *t.r.t.*" hear *rtut* as an oblique enunciation of *tieret* (Abraham and Torok 1994:133). The girl swallows the word, objectified as mercury, and the boy disguises the word *tieret* in a visual image of a nurse-maid scrubbing a floor (*natieret*, to rub down, to scrub, wax, to scrape, wound oneself). The word, with its freight of occluded events, silent within the image of domestic rubbing, causes the boy to achieve orgasm "in the father's place, as it were". Whether or not one is persuaded by the ingenuity of Abraham and Torok's reading is not finally the point; the example is intended to illustrate how absolutely the event – the early scene of child abuse – has taken on phonic and graphic substance. *Tieret* and *rtut* are both "defunct", semantically, at least in terms of the scene they finally address, and yet because of that occluded site elements of each term remain semantically over-charged – theirs is, we might say, a forceful opacity. This turn away from language as communication – from the presentation of what we might call a knowable event to an experience of the past as a kind of indeterminable force – encapsulates that need to conceal which characterizes the discourse of trauma. The event is repressed at the level of direct expression and can only make itself felt again in what Abraham and Torok call the "antisemantic" features of language.[2] Yet in what ways can such textual items be read when they aggressively occlude those elements which are normally read, replacing them with elements which customarily do not carry semantic burdens?

One way to approach this set of questions is to consider the degree to which a particular linguistic opacity articulates or denies access to the origi-nating event against which it provides a preliminary psychic defense. The kinds of opacity or linguistic dysfunction which result from what may be called the traumatic event should not be perceived as simply a stylistic option. Opacity here signifies a condition of language which is not a trans-historical and epistemological linguistic given but rather registers the deform-ing effect of a specific historical event. Unless, at some level, that event is "recognized", opacity features will amount to no more than a stylistic device which might properly be called a kind of decadence. "Recognition" is potentially available through those features described by Abraham and Torok as antisemantic. Each element of their term is operative because the force released by the initial event is itself divided, seeking semanticization in communicative language, even as it enacts its own occlusion through the deformation of that medium. This double movement inscribes a form of temporal play which in Freud's analysis of trauma has become known as "deferred action" or "retroaction".[3] Deferred action is a product of the exces-sive character of the first event which requires a second event of re-narration to release its traumatic force. John Forrester neatly defines this movement as "the articulation of two *moments* with a time of delay".[4] Articulation in such circumstances involves not simply the recovery of an original site but a

restructuring and reworking of that site; the work in question as most typically explored within the psychoanalytic tradition involves a particular species of talk characterized by often extreme forms of condensation and displacement which assert the continuing force of the original traumatic moment but not its complete recoverability. The talking cure so expressed proposes readability without delivering a transparently readable first event. For Freud, the act of memory requires a deliberate and interminable "working through" of the closed forms of temporal and linguistic order on which modernity has been based.[5] Jean-François Lyotard's understanding of the interminability of such work is useful here since he gives particular attention to *anamnesis* as a type of memory which would exceed a narrative or discursive ordering of past "facts" in sequence.[6] "Working through" ostensibly releases us from argument, dialectic and the hegemony of the will, relying instead on mechanisms of association which produce an unpredictable and ultimately therapeutic cross-weave of times and images. The linguistic extension of this cross-weaving is what is meant here by "opacity", entailing in its necessary tensions a radical unsettling of what Foucault terms the "philosophy of representation – of the original, the first time, resemblance, imitation, faithfulness" (Foucault 1977:172).

With the loss of any unproblematic notion of resemblance and imitation comes a necessary materialization of the sign. The first event seems both crucial to referentiality yet unavailable to the act of reference: out of this stand-off between the event and its signification comes an exorbitation of the sign. Caught in the vector of the event which it articulates, the sign becomes excessive because under the contradictory pressure to reveal what finally cannot be revealed, an unavailable first event "which cannot be assimilated into the continuity of psychic life" (Rand 1986:21). A particular kind of semantics results from such circumstances, a semantics which should not be reduced to the simple absence of that which is being addressed because the event remains somehow "encrypted" within a language which is wried from the norm by its apparent refusal to refer. Abraham and Torok speak of a process of "designifying" by which words even as they signify normally are felt more importantly to refer to some event which is inadmissible.[7] What is difficult here and what marks the force of the *de* or *anti* in "designifying" and "antisemantics" is the fact that the second reference puts a new and troubling angle on the first, while appearing to leave it intact. Hence the first or normative reference is made to encrypt the second reference, where "encrypts" means both "to bury" and "to render cryptic".

This set of terms belongs to a broader vocabulary of cryptonymy, central to which is the notion of incorporation as opposed to introjection. Whereas introjection responds to traumatic loss by assimilating to the self what is lost (and getting on with life), incorporation perpetuates the existence of the lost object as something alive and foreign within the self (effectively, getting on with death). The dead person is thus not an object of identification but a

phantasmatic presence within the self which gives rise to a topography which Abraham and Torok call the "crypt":

> Grief that cannot be expressed builds a *secret vault* within the subject. In the crypt reposes – alive, reconstituted from the memories of words, images, and feelings – the objective counterpart of the loss, as a complete person with its own topography, as well as the traumatic incidents – real or imagined – that had made introjection impossible (Abraham and Torok 1980:8).

Language is essential to the design of the crypt; indeed, there can be no crypt without a peculiar kind of word, the cryptonym. The cryptonym is opaque not because it does not refer but because it refers to too much, part of which is unacknowledged. What is unacknowledged is the dead event incorporated in the living event, the dead referent encrypted in the living referent. Derrida in his forward to Abraham and Torok's *The Wolf Man's Magic Word* argues that:

> Anasemia creates an angle. Within the word itself. While preserving the old word in order to submit it to its singular conversion, the anasemic operation does not result in a growing explicitness, in the uninterrupted development of a virtual significance, in a regression toward the original meaning . . . (Derrida 1986:xxxiv).

What Abraham and Torok mean by *anasemia* is thus "a constant movement 'back up toward' (from the Greek *ana*) successively earlier sources of signification (*semia*) that lie beyond perception" (Rashkin 1988:50). This kind of semantics occurs, as Derrida might put it, because the angled term carries "a past that has never been present" (Derrida 1989:58). For Derrida, the past or, we might say, the traumatic event, is both ever immanent and never present. In the remainder of this chapter I want to look more closely at this double condition which produces a writing strongly marked by contradictory desires, turning, as it does, towards opacity and the satisfactions of concealment even as it offers a cryptic promise of readability.

What might it mean for a poetics to found itself on a certain unreadability? As Derrida has observed, unreadability

> does not arrest reading, does not leave it paralyzed in the face of an opaque surface: rather, it starts reading and writing and translation moving again. The unreadable is not the opposite of the readable but rather the ridge (*arêt*) that also gives it momentum, movement, sets it in motion (Derrida 1979:116).

Just such a generative unreadability characterizes a tendency in recent American poetics which has come to be known as Language poetry and

which is represented by writers such as Charles Bernstein, Susan Howe, Lyn Hejinian, Bob Perelman and Barrett Watten. What began as a small vanguard tendency has become, over the last decade, a complex and variegated phenomenon which far exceeds the Language label it continues to attract. Some principles are still widely shared, though, and few would dissent from Charles Bernstein's description of this writing as a "writing centred on its wordness" (Bernstein 1986:32), writing which cultivates forms of diminished reference in order to foreground linguistic operations. This writing is difficult, partly because it sets its face against the more conventional registers of personal experience cultivated by the mainstream lyric. The speaker-situation model of discourse is largely dismantled, and in its place we find often extreme forms of syntactical fragmentation and linguistic opacity. We might summarize by noting that three main sets of conventions are called into question in such writing: "narrative conventions, the grammatical and syntactical conventions governing the sentence, and the convention of lyric univocality" (Golding 1995:149).

How might we explain the emergence of a poetics of such opacity and unreadability? One answer lies in a new distrust of linguistic transparency. Lyn Hejinian, for example, recalls of the group of writers associated with language that "We discovered each other in the intense aftermath of the Vietnam era, having had intense experience of institutions and disguised rationality. And by some coincidence, we all individually had begun to consider language itself as an institution of sorts, determining reasons, and we had individually begun to explore the implications of that"[8]. Hejinian's location of this understanding of language in the moment immediately following the Vietnam war makes a strong association between forms of linguistic transparency and the "closed" rhetoric of political propaganda. Fellow language poet Bruce Andrews makes the equation even more explicit: "Clarity as transparency. Transparency as authority. Formal order, and civil order" (Andrews 1986:526).

The important point here is the association constantly made by these writers between linguistic transparency, common sense, and oppressive forms of authority. Hejinian again: "The open text, by definition, is open to the world and particularly to the reader. It invites participation, rejects the authority of the writer over the reader and thus, by analogy, the authority implicit in other (social, economic, cultural) hierarchies" (Hejinian 1985:272). Somewhat paradoxically, the "openness" of a text and its modes of readability will depend upon the work's resistance to meaning. As Hejinian puts it, in terms which recall the formalist theories of Roman Jokobsom, "where once one sought a vocabulary for ideas, now one seeks ideas for vocabularies" (Hejinian 1984:29). "Thought", then, is not something to be articulated as "content" but is rather something that is encountered in the making of the poem. Just as the writer finds her thought by writing, so the aim is to keep "the reader's attention at or very close to the level of language".[9] The result

of this double objective is a writing which strives to prevent the integration of linguistic items into higher grammatical levels, a writing which, as Bernstein puts it, "refuse[s] . . . the syntactic ideality of the complete sentence, in which each part of speech operates in its definable place so that a grammatic paradigm is superimposed on the actual unfolding of semantic strings" (Bernstein 1992:60). The refusal of "syntactic ideality", as Bernstein suggests, produces a writing which ostentatiously parades its constituent elements, phonetic and graphic, at times reducing words to a rubble of morphemes. This extreme emphasis on "wordness" disrupts forms of narrative and dialectic, substituting for the temporal closure of the sentence a verbal matrix of cross-connected time schemes.

I want to look at two products of this way of thinking about language and time. The first, by Lyn Hejinian, hinges on the unavailability of the past to direct presentation; the second, by Susan Howe, more clearly aligns the sense of the past with traumatic experience. Each in different ways works at the margin between opacity and readability, producing exactly that form of "unreadability" which Derrida defines as the "ridge" which sets reading in motion. Take the following passage from Hejinian's writing *Writing is an Aid to Memory*, published in 1978:

> here and there regularly in a diary
> ruse views
> gulls puff
> yon door for which shape
> fragment
> a desperate with a deeper
> only a good and repeat key-struck and then destroy
> it
> isolating more prominence than previousness
> even trying dinner
> detour in such detail
> "under the fingers" in good measure
> directly responsible
> I absent myself for a rest
> in the minor, an athletic can engage immediately
> picked in attracted but pronounced
> by putting a tiny object into it
> a syllable is a suggestion
> is the beginning of inclusion
> his imitation on the other
> a flourish and a struggle in the same house
> (genre find two of gence object screen object ble) (Hejinian 1978).[10]

This writing is difficult, though not in the sense that, say, Ezra Pound's *Cantos* are. It is not a matter of being able to clarify Hejinian's text by adducing contexts for particular references and allusions; what makes the work difficult is the sense it gives of something at once radically reduced and self-sufficient and at the same time incomplete. This double effect is closer to what I have called "opacity" than to Poundian "difficulty", for the sense of something lost or incomplete which is foregrounded in Hejinian's detached syllables ("yon", "ble" and so on) relates directly to her main theme, which is writing's relation to what is remembered, and the whole problem of the past's representation in the present. In contrast to Pound, for whom the past can be known as an assemblage of verifiable "facts", for Hejinian our historical knowledge is always mediated by the process of writing in which we give it form. This is not simply a matter of narrative structure; more fundamentally, Hejinian attributes to writing a level of resistance to readability, observing, for example that "If language induces a yearning for comprehension, for perfect and complete expression, it also guards against it. Hence the title of my poem 'The Guard'" (Hejinian 1985:284). Writing, in this sense, functions as Freud's second scene, reminding us that the experience it now remembers is, to use Derrida's formulation again, "a past that has never been present"; as Andrew Benjamin explains in another context: "The original event is thus no longer the same as itself. The effect of the present on the past is to cause a repetition of the 'event' within which something new is taking place" (Benjamin 1992:30).

If we now look more closely at the passage from *Writing is an Aid to Memory* (Hejinian 1978), we can see how this complex repetition produces a particular kind of opacity. For as language moves toward articulation so its elements create a profusion of meanings which drag against a directive syntax. There is a parallel here between the bits and pieces of language, on the one hand, and the momentary bric-a-brac of time, on the other. Hejinian's conception of memory – a theme announced in her first jocosely systematic reference to the diary – is a "differential" one in the sense that Derrida speaks of "a series of temporal differences without any central present" (Derrida 1981:210). So there is no worry here about uncoordinated fragments – quite the reverse, in fact, since "a syllable is a suggestion/is the beginning of inclusion", lines which indicate that the isolated syllable is to be seen not as something torn from its full context but rather as an opening to a shared production of meaning – this is what Hejinian terms "generative" as opposed to "directive" writing: "Reader and writer engage in a collaboration from which ideas and meanings are permitted to evolve" (Hejinian 1985:272). Our reading swings through a sequence of phrases, constantly weighing new perspectives ("detour in such detail") and tracing the "good measure" which is the curve of memory.

But memory here is a place of contradiction, where texts and times intersect – Hejinian's lines suggest that while it is permissible in a diary to reduce "here

and there" to "regularly", the poem must exploit the gap between experience and its inscription, opening up the tension between the random unfolding of a life and the "regular" partitioning of the diary. So the word "ruse", which rhymes in several ironic ways with "views", seems to imply that these slices of one's life are merely a trick or artifice by which we create a consistent narrative of our selves. Perhaps an arrogant one at that, one which attributes design to mere contingency ("ruse views" rhythmically parallels "gulls puff" – themselves up, presumably?). Actually there *are* only fragments, as Hejinian says, and it may be that we confuse a "desperate" desire for coherence with a "deeper" knowledge gained in retrospect. Or is it only a "good" time that we get from repeating the past in memory; are we "key-struck", by analogy with "love-struck", and is our obsession with writing diaries a way of actually destroying a real sense of the past rather than of making it present again? But we cannot do that anyway: we can make it appear "prominent" but we cannot restore "previousness". Past events cannot be the object of present perception, and where the old Platonic theory of reminiscence promises to restore what is absent, Hejinian assumes that the relations between past and present experience exist only as traces, imperfectly present, caught in the differential play which is the condition of language. The repeat is enmeshed in the "key-struck" present (the poet at her machine), a praxis of writing rather than of metaphysics, of parallelism rather than of narrativity, of relationship rather than of code (Hejinian 1989b:118).

We may conclude, then, that writing is an aid to memory (its necessary supplement) in a complex sense for Hejinian; not because it perfects recall, providing a second-order articulation of the things we remember, but for quite the opposite reason, that it brings a necessary disunity and opacity to the narrative tendency of memory. As Hejinian puts it in *My Life*, "To speak of the 'self'" is to "improve it from memory" (Hejinian 1987:89), whereas to *write* about it entails a dissolution of presence, exposing it, too, to the play of difference.

I turn now to the poetry of Susan Howe, for whom writing is also an aid to memory, in the sense that writing allows a deconstruction of the metaphysical presumption of memory. Like Hejinian, Howe reckons with the belatedness of historical memory, exploring the way in which the collision of two times activates a rewriting, but one which eschews modernist fantasies of mastery. This alternative history, or "counter-memory", as Howe calls it, somehow resists successful assimilation to the order of discourse; it will not become what Lyotard calls "memorial history", or allow us to *forget* the original traumatic event by erecting the psychic defense of a normalizing narrative. "One forgets", says Lyotard, "as soon as one believes, draws conclusions, and holds for certain" (Lyotard 1988:10).[11]

The thrust of Howe's poetics is firmly against cognitive and narrative modes of historical understanding, against any secure position of knowledge from which we might view the past. As in Freud's model of deferred action, the past for Howe comes back, *nachträglich*, belatedly, with a kind of traumatic

force, *possessing* the subject. So, when an interviewer asks her, "How are poems related to history?", Howe replies: "You open yourself and let language enter" (Foster 1990:23). History is always language for Howe, never "facts" or data; "In my poetry", she says, "time and again, questions of assigning *the cause* of history dictate the sound of what is thought" (Howe 1990a:13). That emphasis on sound tears open the surface of discourse; as Howe writes of "a wilderness of language" in her book on Emily Dickinson (Howe 1985:70), so elsewhere she speaks of "breaks in world-historical reason where forms of wildness brought up by memory become desire and multiply" (Beckett 1989:20).

Like Hejinian's idea of the "guard", Howe's writing always courts disaster, in the sense that she says of Peter Inman's *Platin* that "Meaning self-destructs. Nonsense. The work teeters at the edge, remains rooted in the shape of time, stops short of gibberish" (Howe 1986:555). If dialectical history secures clarity by "continuously link[ing] meaning up to itself", as Derrida puts it (Derrida 1978:275), then Howe plunges into the dark night of an alternative history, where, as she says in Section 6 of *Speeches at the Barriers*, "Transgression links remembering/Dark spell", and where the quest to know and "interpret the world" produces only the *"illusory* sanctuary of memory" (Howe 1990:109). This night is, as she observes in the preceding section of the poem, "monadical and anti-intellectual"; it is the domain of the "unintelligible" in which the force of some primal trauma returns. As with Freud's model of reme-moration, our knowledge of this past depends on an act of renarration, but one which is conditioned by chance and accident rather than by rational design. In an interview, Howe explains that poetry differs from conventional history because "It depends on chance, on randomness" (Foster 1990:23), and this is what she admires in Dickinson's way of "breaking the law just short of breaking off communication with the reader", of opening herself to "the chance meeting of words" (Howe 1985:11,24).

Again we have the idea that history is a force which invades the poet, and, as in Freud, there is always the tension in Howe's writing between this memory of a past which, as she puts it in *Pythagorean Silence*, "never stops hurting" (Howe 1990a:26), and its belated inscription in a language somehow disfigured by it. "This tradition that I hope I am part of", she writes in one essay, "has involved a breaking of boundaries of all sorts. It involves a fracturing of discourse, a stammering even. Interruption and hesitation used as a force. A recognition that there is another voice, an attempt to hear and speak it. It is this brokenness that interests me" (Howe 1990b:192).

Much is contained for Howe in that idea of hesitation, a word, as she notes, "from the Latin, meaning to stick. Stammer. Hold back in doubt, have difficulty in speaking" (Howe 1985:21). The failure to speak fluently thus becomes a sort of strength as it sets up a resistance to conceptuality and dialectic, embedding a kind of violence at the heart of poetic language. Stammering keeps us on the verge of intelligibility, and in her own work Howe's

emphasis on *sound* is coupled with an habitual shattering of language into bits and pieces. "The other of meaning", she tells us, "is indecipherable variation" (Howe 1993:148), thus gesturing toward a writing which constantly courts the non-cognitive in its preoccupation with graphic and phonic elements.

This type of opacity far exceeds what we usually think of when we talk about "the materiality of the signifier". For Howe, the "blasting" of a segment of the past out of the "continuum" of history produces a condition of language which is in a particular sense anti-metaphorical: words do not become figures for things but remain stubbornly themselves. Howe goes so far as to remark that "I've never really lost the sense that words, even single letters, are images" (Keller 1995:6), an observation which may remind us of Abraham and Torok's talk of the encrypted element as "nothing but a word translated into an image".[12]

If poetic language has become cryptic, in Abraham and Torok's sense, it is perhaps because history, if not felt as literally traumatic, appears partly unreadable in the wake of modernism. Where Pound could find the key to past iniquities in, say, the manipulation of Byzantine interest rates, history for Howe is registered less as a phalanx of facts than as an indeterminate force which produces opacities and distortions within our means of expression. History, in this sense, is what Howe calls a kind of ghost writing which perpetually refuses to become transparent, a writing of gaps and traces which keeps us poised between opacity and readability. As ever, the events which haunt us do so because they lie beyond our reach; as Maurice Blanchot puts it, "The act of haunting is not the unreal visitation of the ideal: what haunts is the inaccessible which one cannot rid oneself of, what one does not find, and what, because of that, does not allow one to escape it. The ungraspable is what one does not escape" (Blanchot 1981:84).

History keeps its hold on us, even though its texts remain somehow "ungraspable", inciting us to a labour of cryptonymy which may yield only more signs rather than clarifying meanings. The opacity of such writing, its habitual conversion of concepts to material signs, produces something like the anasemia described by Abraham and Torok. As Howe herself remarks, "Each word is a cipher, through its sensible sign another sign is hidden"; and again, "Words open to the names inside them, course through thought in precarious play of double-enchantment, distance" (Howe 1985:51,82). For Howe, then, language itself contains a kind of cryptic history, sometimes readable, often opaque, but above all insistent as a force that promises even as it eludes cognitive capture.

Acknowledgements

The first section of this chapter was co-written with Richard Godden and presented as a part of a joint paper at the Neo-Formalist Circle's Conference at Mansfield College,

Oxford in September 1996. I am grateful to Richard Godden for his permission to publish it here.

Notes

1. For abbreviated accounts of the narrative, see Abraham & Torok 1994, p. 132–4 (where the Russian word is spelt *teret*) and Abraham & Torok 1986:16–19.
2. See for example, *The Shell and the Kernel*, p. 85 where Abraham and Torok speak of psychoanalysis as "this scandalous antisemantics of concepts dignified".
3. For literary applications of Freud's concept of deferred action, see Godden 1993:31–66 and Nicholls 1996:50–74. See also the discussion of deferred action in Tina Papoulias, Chapter 7 in this volume.
4. See John Forrester, 1990:206 (his emphasis). Cf. Tina Papoulias, Chapter 7, p. 151. "This delay constitutes the fundamental dimension of trauma: it makes the interpretation of the event, as opposed to the event in itself, pathogenic."
5. On "working through" see Peter Nicholls 1991:4–5.
6. See, for example, Lyotard 1988: 1990.
7. See for example Abraham & Torok 1994:84.
8. Interview with Tyrus Miller, *Paper Air* 4, 2 1989:34. Cf. Hejinian, interview with Manuel Brito, in Brito, 1992:84, on the Vietnam War as "a war that was never declared to be such in the United States. A major component of my poetics, or let's say of my poetic impulse, is a result of that war and the meaning of its never being named." See also Barrett Watten, 1995:197, "The central problem of reference in this writing may be seen in context as directly related to the administration of information about the War on the part of the government and media that elicited, from intellectuals-in-the-making, a radical denial of consent for the conduct of the War."
9. See R. Silliman 1987:63–93.
10. Hejinian may take her title from Francis Bacon's *Novum Organum* – see the passage quoted in her essay "Strangeness".

> After having collected and prepared an abundance and store of natural history, and of the experience required for the operation of the understanding or philosophy, still the understanding is as incapable of acting on such materials of itself, with the aid of memory alone, as any person would be of retaining and achieving, by memory, the computation of an almanac. Yet meditation has hitherto (been) more (employed in) discovery than writing, and no experiments have been committed to paper. We cannot, however, approve of any mode of discovery without writing, and when that comes into more general use, we may have further hopes (Hejinian 1989a:40–1).

11. For a more extended discussion of Howe's approach to "history", see Peter Nicholls 1996:586–601.
12 Abraham and Torok 1986:22. Cf. p. 46: "It is a word that operates from the Unconscious, that is, as a *word-thing*." See also, 1994:131–2 for an account of the relation of the incorporation to "demetaphorization".

References

Abraham, N. 1995. *Rhythms: on the Work, Translation, and Psychoanalysis*, B. Thigpen & N. Rand (trans.). Stanford, California: Stanford University Press.

Abraham, N. & M. Torok 1980. "Introjection– incorporation: *mourning* or *melancholia*". In Lebovici, S & D. Widlocher (eds). *Psychoanalysis in France*. New York: International University Press.

Abraham, N. & M. Torok 1986. *The Wolf Man's Magic Word: a Cryptonymy*. N. Rand (trans.), foreword by J. Derrida. Minneapolis, Minnesota: University of Minnesota Press.

Abraham, N. & M. Torok 1994. *The Shell and the Kernel: vol. 1*, N. Rand, (ed. and trans.). Chicago, Illinois: University of Chicago Press.

Andrews, B. 1986. "Misrepresentation: a text for *The tennis court oath* of John Ashbury". In *In the American Tree*, R. Silliman (ed.). Orono, Maine: National Poetry Foundation.

Beckett, T. 1989. The *Difficulties* interview. *The Difficulties* **3**. (2); 20.

Benjamin, A. 1992. "Translating origins: psychoanalysis and philosophy". In *Translation: Discourse, Ideology, Subjectivity*, L. Venturi (ed.). London: Routledge.

Bernstein, C. 1986. *Content's Dream: Essays 1975–1984*. Los Angeles, California: Sun and Moon Press.

Bernstein, C. 1992. *A Poetics*. Cambridge, Massachusetts: Harvard University Press.

Blanchot, M. 1981. *The Gaze of Orpheus*. L. Davis (trans.). Barrytown, New York: Station Hill Press.

Brito, M. 1992. *A Suite of Poetic Voices*. Santa Brigada: Kadle Books.

Derrida, J. 1978. *Writing and Difference*, Alan Bass (trans.). London: Routledge.

Derrida, J. 1979. Living on: borderlines. In *Deconstruction and Criticism*, Harold Bloom (ed.). J. Hulbert (trans.). New York: Seabury Press.

Derrida, J. 1981. *Dissemination*, B. Johnson (trans.). Chicago, Illinois: University of Chicago Press.

Derrida, J. 1986. Foreword to *The Wolf Man's Magic Word: a Cryptonymy*. N. Rand (trans.). Minneapolis, Minnesota: University of Minnesota Press.

Derrida, J. 1989. *Memoires for Paul de Man* (rev. edn.), C. Lindsay et al. (trans.). New York: Columbia University Press.

Forrester, J. 1990. *The Seductions of Psychoanalysis: Freud, Lacan, and Derrida*. Cambridge: Cambridge University Press.

Foster, E. 1990. An interview with Susan Howe. *Talisman*, Spring.

Foucault, M. 1977. *Language, Counter-memory, Practice: Selected Essays and Interviews*, D.F. Bouchard (ed.). Ithaca, New York: Cornell University Press.

Godden, R. 1993. Absalom, Absalom! and Rosa Coldfield: Or, What Is in the Dark House. *The Faulkner Journal* **VIII**, (2) Spring, 31–66.

Golding, A. 1995. *From Outlaw to Classic: Canons in American Poetry*. Madison, Wisconsin: University of Wisconsin Press.

Hejinian, L. 1978. *Writing as an Aid to Memory*. Berkeley, California: The Figures.

Hejinian, L. 1984. "If written is writing". In *The L=A=N=G=U=A=G=E Book*, B. Andrews & C. Bernstein (eds). Carbondale and Edwardsville, Illinois: Southern Illinois University Press.

Hejinian, L. 1985. "The rejection of closure". In *Writing/Talks*, B. Perelman (ed.). Carbondale and Edwardsville, Illinois: Southern University Press.

Hejinian, L. 1987. *My Life*. Los Angeles, California: Sun and Moon Press.

Hejinian, L. 1989a. Strangeness, *Poetics Journal* 8.

Hejinian, L. 1989b. Two Stein talks. *Revista Canaria de Estudios Ingleses*, 18.

Howe, S. 1985. *My Emily Dickinson*. Berkeley, California: North Atlantic Books.

Howe, S. 1986. P. Inman, *Platin*, In *In the American Tree*, R. Silliman (ed.). Orono, Maine: National Poetry Foundation.

Howe, S. 1990a. *The Europe of Trusts*. Los Angeles, California: Sun and Moon Press.

Howe, S. 1990b. Encloser. In *The Politics of Poetic Form: Poetry and Public Policy*, C. Bernstein (ed.). New York: Roof Books.

Howe, S. 1993). *The Birth-mark: Unsettling the Wilderness in American Literary History*. Hanover, New Hampshire and London: Wesleyan University Press, University Press of New England.

Keller, L. 1995. An interview with Susan Howe. *Contemporary Literature* 36, (1).

Lebovici, S. and Widlocher, D. (eds) 1980. *Psychoanalysis in France*. New York: International University Press.

Lyotard, J. 1988. *L'inhumain: Causeries sur le Temps*. Paris, Editions Galilee.

Lyotard, J. 1990. *Heidegger and "the Jews"*, A. Michel & M. Roberts (trans.). Minneapolis, Minnesota: University of Minnesota Press.

Miller, T. 1989. Interview with Lyn Hejinian *Paper Air* 4 (2).

Nicholls, P. 1991. Divergences: modernism, postmodernism, Jameson and Lyotard, *Critical Quarterly* 33, 3.

Nicholls, P. 1996a. "The belated postmodern: history, phantoms, and Toni Morrison". In *Psychoanalytic Criticism: a Reader*, S. Vice (ed.). Oxford: Polity Press, 50–74.

Nicholls, P. 1996b. Unsettling the wilderness: Susan Howe and American history. *Contemporary Literature* 37, 4 Winter.

Rand, N. 1986. Introduction: renewals of psychoanalysis. In *The Wolf Man's Magic Word: a Cryptonymy*, N. Rand (trans.). Minneapolis, Minnesota: University of Minnesota Press.

Rashkin, E. 1988. Tools for a new psychoanalytic literary criticism: the work of Abraham and Torok. *Diacritics*, Winter.

Silliman, R. (ed.) 1986. *In the American Tree*. Orono, Maine: National Poetry Foundation.

Silliman, R. 1987. *The New Sentence*. New York: Roof Books.

Watten, B. 1995. Interview with Andrew Ross. *Aerial* 8, 197.

Part v

Corporeality

9

Identification's edge: dreams, bodies and the butcher's wife

Janet Harbord

The matter of bodies has in the past been the Baby Jane of cultural theory. "Only very recently", writes Elizabeth Grosz, "has the body been understood as more than an impediment to our humanity" (Grosz 1995:2). Certainly cultural theorists have for some time regarded the body with suspicion in the spirit of anti-essentialist combat. This dismissal has been compounded through the discourses of both structuralism and psychoanalysis, where a linguistic account of subjectivity theorizes the repression of corporeality as an effect of language; in the Lacanian account, the body is as inaccessible as the real. Yet as the psychoanalytic account of subjecthood has been increasingly perceived as an account of dominant forms of identity, its failure to articulate marginal and diverse forms of subjectivity has indicated the limits to the explanatory and discursive powers of psychoanalysis. The reversal in the fortunes of the body has developed in league with a by now familiar problematization of the universalism of psychoanalysis. This critique has brought with it an insistence on differences of identity which extend beyond sexual difference as an anchor of identity, differences that fundamentally tie the psyche to the body in a dialogical relationship. Interest in the body has emerged also as a shared attempt in feminism, postcolonialism and queer theory to escape the gridlock of binary thought, to undo what has become shorthand for all socio-cultural difference, but which ironically erases the multiplicity of identities, the infamous opposition "subject/other". What these discourses share, without erasing their individual genealogies, is the search for a way of framing the relations of social and historical intermixing, as well as the mechanisms of social reproduction. Feminism, postcolonialism and queer theory seek a way of understanding the contingent and fluid nature of identity, a contingency that characterizes not only the present pull on identity, but for many, has long characterized the decentred and displaced history of their subjecthood. Discourses

of the body propose to reorientate a universal psychoanalysis by offering a threshold between models of the psyche and history, interfacing those troublingly rigid oppositions of mind–body, interior–exterior, subject–other, and experience–knowledge.

The story of psychoanalysis begins with bodies, hysterical bodies that refuse control, that rail against the confines of social respectability and rational behaviour. The problems of diagnosis, or the difficulty of reading bodies, produce the perplexing questions that open Freud's text. These questions ask whether neuropathological conditions, such as hysteria, are an imaginary or a physical condition. Freud's work was of course to begin the slow task of unravelling this time-worn opposition of mind/body. When, at the end of the nineteenth century hysteria seemed to suggest to the medical establishment the failure of a rational mind over an uncontrollable body (or culture over nature), Freud located the irrational within and as a condition of the psyche itself. Yet the pressures that came to bear on psychoanalysis as a science continued to insist on the distinctions of mind and body, reality and fantasy, not least because their own professional legitimacy and authority depended upon them. The controversy of the seduction theory near the beginning of Freud's work was to present the same opposition in a different way, asking whether hysteria is caused by an actual event, converting trauma into a symptom, or whether it is the product of fantasy.[1] Freud's subsequent denouncement of any necessarily "real" occurrence as an origin of trauma seemed to tip the scales towards fantasy, an effect that must certainly have contributed to the many testimonies to, and anxiety towards, scientific methodology in Freud's work. Consequently psychoanalysis has been dismissed by the scientific institution and within the humanities charged with colluding in a veiling over of sexual abuse by placing the processes of fantasy at the centre of analysis. It is important to understand the very real threat that Freud's project posed to the disciplines of science and the humanities; the displacement of a clear division between fantasy and reality, the mind and the body, indicated the limits to epistemology in the failure of reason's ability to rationally know itself.

If, at the beginning of the psychoanalytic project, hysterical bodies point to the way in which the social and the psyche are enmeshed in the imaginary mappings of corporeality, Lacan's model of the mirror stage indicates a similar process. The subject's mis-recognition of the self in the reflection of the mirror as a unified being, belies the fragmented condition of the psyche. The specular image of the body is the site invested with this cohesion. Although Lacan draws attention to the fictional nature of this imaginary identification, the ongoing disrupting effects of corporeality are less apparent. Certainly the Lacanian model of the subject in bits-and-pieces is presented as a universal condition underlying the fiction of all identity. The specific disruptions that occur in the dialogic relation of the body and psyche, where the body is a threshold between the demands of the social and the fantasy life of the individual, remain under-developed. The ability to psychically imagine or

map our bodies is always a tenuous act of cartography. The production of a coherent self located in a unified corporeality is an ongoing labour, a production that is never complete but demands constant reproduction. The iterative effects of socialization are not always consolidating but can be volatile, reversing direction and oscillating towards a disjunction between identification and bodily image. Thus, there is no necessary correlation between the demands of social inscription and our imaginary corporeal maps, as cross-gender identification illustrates. Embodiment is propelled by a fantasy of our selves, one which represses and sublimates some information, and appropriates, reformulates or fabricates other knowledges. We are, at times, able to make identifications with others, against the grain of our bodily knowledge, across our bodily dissimilarity, through the over-writing of the material marked effects of corporeality. At other moments, the sense of our own corporeality delimits, disturbs and possibly fatally disrupts the operation of the fantasy of self.

The problem of how to develop this model of the body–psyche–social without suggesting either that fantasy has a free rein, or that the body is the direct imprint of social conditioning, is taken up by Elizabeth Grosz. According to Grosz (1995:33) there are, broadly speaking, two main accounts of the body in twentieth century thought; writers as diverse as Nietzsche, Foucault, Deleuze and Turner (1992), have emphasized the political effects of the social sphere upon the individual, imaged in Nietzsche's work through the metaphor of branding. In this account the body is an object produced, constructed and inscribed socially, the notion of branding made more subtle in Foucault's account of the body that knows itself only through these regimes of control. There is no exterior to the social, and no prior moment for the body in some natural state, but the object of the body produced, or brought into being through these discourses. The critique of this constructivist account is that it provides no space for agency on the part of the subject, and implies that bodies are passively acted on in the process of identity formation.

The second approach, which Grosz attributes to psychoanalysis and phenomenology, steers towards a notion of the body as a dynamic site of the interplay of social effects and psychic processes, an approach that informs this essay. What Grosz refers to as the "lived body" describes a more dialectical relation between mind and body, social and psyche. Within this scheme the way in which the sensations and images of the body are internalized, imagined and lived is according to a phantasmatic notion of the self, derived both from bodily sensations, experiences, materials and their social significa-tion. The concept of the lived body describes a form of embodiment whereby the experienced materiality of the self informs and shapes the interior as well as vice versa. Where the legacy of a European rationalism suggests that the body is known and controlled through the privileged realm of the mind, the lived body implies a reversal, that we know ourselves through our bodies.

Self-knowledge is produced through an understanding of corporeality, our experience of bodies, their social worth and cultural meaning.

Bodies and identifications

The common-sense notion and usage of identification smoothes over the radical difficulty of the process that it seeks to describe. For, despite the unity of the mirror image, the act of identification creates nothing less than a schism, a faultline that testifies to the slippage between the terms of subject and object. According to Diana Fuss, against silent presumptions to the contrary, identities and identifications often do not correspond, but are incommensurate (Fuss 1995). Attempts to draw identification into the arena of consciousness and expose it to the light of day have recently been expressed with a sense of political urgency. For example, Joseph Bristow's account of the double demand to identify as gay in the face of homophobia, and the insistence that identity always exceeds this identification (Bristow 1989). The debates and contestations surrounding identification have not played themselves out; rather they have multiplied and connected with other concerns about, to take one instance, the definition of *political*. What is clear is that identifications are part of a fantasy life that cannot be harnessed or controlled in any direct way, but are likely, under pressure, to double back against that force in refusal. The volatile workings of identification are, in Judith Butler's account, "constantly marshaled, consolidated, retrenched, contested, and, on occasion, compelled to give way" (Butler 1993:105).[2] Identifications are not conscious, nor do they take place as an event, but are rather the fantasy of staging and becoming, a fantasy that is not co-terminus with a centred, coherent identity, nor with an alignment of psyche and body. The multiple and dispersed effects of identification are rather "phantasmatic efforts of alignment, loyalty, ambiguous and cross-corporeal cohabitation; they unsettle the 'I'" (1993:105). Far more complex than the common-sense understanding of identification as the claim of similitude between subject and object, identificatory practices in fact disrupt identity as much as they constitute, iteratively, its existence.

My concern here is to read into the disjunction of identities and identifications, a disjunction that can be read through the corporeal to unravel the conditions of fantasy life as they are mediated by the social. The argument is that bodies are not simply socially inscribed objects organized hierarchically, for example by race, gender and age. These modes of corporeality condition the mobility of the identifications that are made, or circumscribe the limits of identificatory practices. In modes of subjectivity where the body is already greatly accented, for example, black subjectivity and female subjectivity, the body anchors identification, and therefore to a certain extent fantasy life, by continually insisting on the material/corporeal as "reality". So, for example, for the black subject to pass as white, the corporeal gets in the way, pronounces

theatrically the distance between the identification and the identity. Whereas for the white man, "passing" is possible precisely because of the invisibility of the white body; the fantasy is achieved because the materiality of the corporeal is not pronounced socio-culturally. Thus, fantasy dissimulates materiality for certain subject categories, while foregrounding it for others.

This is suggestive of the way in which identifications can be part of a colonial enterprise of incorporation, a pillaging of positions of alterity, as the master subject introjects and incorporates the alterity that he seeks to expel. What is at the level of consciousness is a repression at the level of the unconscious production. The fantasy of otherness, whether racial or sexual, is incorporated in the white man's narcissistic imaginary as a position that can be taken up and discarded in the acts of passing and performing. Other bodies are, after all, a variation of the phallic model, but are in relation to this body lacking, incomplete. However, the subject of this essay is not the narcissistic imaginary of the white subject whose conceptual supremacy, parading as rationality, disguises the particular manifestations of corporeality, but the marginal subjects who are forced to recognize the limits of identity through the constant negotiation of corporeality, fantasy and the social. Thus, the argument reverses the normative Oedipal account of subjectivity whereby "others" are located child-like or as primitives in the pre-Oedipal unconscious, unable to take up the position of desiring subject. Rather, this reworking of fantasy as embodiment shows the position of the master subject to be caught in its own enclosed narcissistic space, continually transgressing the boundaries of its own constitution in attempts to shore it up. This leads to a radically different interpretation of psychic development, that boundaries and limits are precisely the matter of marginalized others, who are continually presented with the confining perimeter of the symbolic and their place within it. Far from not knowing their limits, of finding themselves in the chaotic merged space of the pre-Oedipal, for these subjects Oedipalization is the brutalizing experience of identity clearly circumscribed.[3] The possibilities of fantasy are caught in this reflexive return to the body and the difficulties of moving and crossing.

The butcher's wife: distinguishing bodies

In order to unravel the complexity of identifications and corporeality I return to a narrative from the literature of psychoanalysis that has attracted comment from many quarters. It is the story of the butcher's wife, a subject who features somewhat briefly in the cast of characters in Freud's *The Interpretation of Dreams* (1900), and whose dream provides Freud with two mutually compatible interpretations, leading him somewhat coyly to remark that dreams "regularly have more than one meaning". The astuteness of this comment Freud was never to know. This particular dream is a text later taken up by Lacan (1977) and reinterpreted, and later still, by feminist theorists Catherine

Clement (1983) and Cynthia Chase (1987); also by Mikhail Borche-Jacobsen (1988), and most recently Diana Fuss (Fuss 1995:27).[4] The critical celebration of the "witty" butcher's wife, as she is described by Freud, is possibly due as much to her notoriety as a rebellious analysand as the fecundity of her dream. The butcher's wife provocatively recounts her dream in order to disprove Freud's theory that every dream is a wish fulfilment, for her narrative is, purportedly, one of self-denial. Freud, of course, manages to trace the wish through the convoluted twists and turns of identification and desire, and seemingly closes the narrative having proved the existence of a wish fulfilled. Yet the proliferation of commentary since testifies to the opposite, that the butcher's wife's story is indeed a story of resistance to theory. As Fuss notes, the story reflects on the practice of interpretation as one of condensation and displacement, ironically, precisely the techniques that structure dreams themselves.

My intention is to enact a further displacement of the butcher's wife's dream in an interpretation that draws attention to the interdependence of bodies and identifications. In order to do so, it is necessary to outline the dream, the interpretation and cover, briefly, some of the critical ground. The narrative of the dream itself is surprisingly short allowing its production here as Freud presents it in the first person:

> I wanted to give a supper party, but I had nothing in the house but a little smoked salmon. I thought I would go out and buy something, but remembered then that it was Sunday afternoon and all the shops would be shut. Next, I tried to ring up some caterers, but the telephone was out of order. So I had to abandon my wish to give a supper party (1900:229).[5]

In order for Freud to pursue his argument for wish-fulfilment, supplementary material, contextual evidence if you like, is offered under the heading of "analysis". What emerges is an intricate triad of identifications and desires that centre around the body. For according to the butcher's wife, the butcher, it appears, fears that he has become stout, wishes to lose weight and vows to forgo the pleasures of dinner parties. The butcher's wife denies herself caviar because of the expense. The third character in the scenario, the wife's friend, much admired by the butcher, is "very skinny" and wishes to grow more stout, and also wishes the butcher's wife will have more dinner parties. From this information Freud is able to make the interpretation that the butcher's wife is jealous that her husband admires her "skinny" friend, but takes solace in the knowledge that her husband prefers "plump" women. In being unable to give a supper party, the dream fulfils a wish that the friend stays skinny and the husband's attention remains with his wife.

But Freud goes on to admit another, subtler interpretation where the crossing of identification and desire begin to admit an entanglement. For according to Freud, one clue remains unaccounted for, and this is the appearance

of the smoked salmon in the dream. We have been told already that this is the "skinny" friend's favourite food, but why should it appear in the wife's house in the dream? The answer lies in cross-identifications, rooted ostensibly in the wife's wish for caviar, which is like the friend's wish to grow stouter. The dream suggests that instead of acting out the denial of food to her friend, thus acting out the unfulfilled wish, that the wife puts herself in her friend's place because her friend has taken her place in her husband's esteem. Finally then, the dream shows the wife take the friend's place in her husband's high regard, and therefore fulfils her wish.

Diana Fuss provides an account of the debates that ensue in the reinterpretations of the dream of the butcher's wife, which I shall touch upon here. For Lacan, the text performs the mechanisms of desire itself, in that desire is always the desire of the other. The wife's substitution of caviar for salmon repositions her as a subject in the fantasized space of otherness. But, as Fuss notes, Lacan stops to ask what it is the butcher wants, and it is here that the figurative nature of language begins to overflow. Is it the choice between meat and fish, the butcher's pound of flesh or the feminine eggs of caviar? Why is the butcher attracted to the skinny friend, "like a fish to water"? In Lacan's account the butcher is the end point in the circuit of desire; the wife identifies with the butcher's desire for the friend, and the salmon is the desire of the other. Thus the logic of the dream returns us to a masculine signifier of desire.

Catherine Clement inflects the story differently again. To summarize her reading, the wife's identification with the butcher's desire of the other is pushed further to argue that the wife's identification must also be a desire for the friend. In Clement's text (1983), the butcher's pound of flesh is usurped by the wife who opens up the circuit of desire onto homosexual object-choice. In Cynthia Chase's work, this argument runs again. Shifting the emphasis, like Clement, from Lacan's heterosexual desire to a homosexual one, Chase argues for the wife's identification to be understood as pre-Oedipal. From here she argues that the story is one of primary identification with the phallic mother; the butcher's desire is like the phallic mother's, whereby the child in its identification with the mother's desire attempts to become the desiring force of the mother.

This positions female desire as desire for the phallus or phallic power, which treads upon another contested area of debate about homosexual desire and questions of inversion. But in addition to these commentaries, Fuss' analysis throws up further contradictions. For what, she asks, does the butcher want to be? Her pursuit of this question leads her to conclude that the butcher's desire to be thin is in fact an identification with the skinny friend, therefore a feminine identification. What is more, Fuss asks whether Freud's reading of sexual jealousy as repressed homosexual desire and defence against it might not provide the explanatory key. Put like this, the desire between women is certainly disguised, but not necessarily male-identified. This allows a different argument to be made, that the butcher's identification with thinness can be

stretched in this direction to suggest his wish (his feminine identification) to be his wife's object of desire in an imitation of the friend.

Yet, all of the interpretations of the dream centre around sexuality and gender as the central axes of explication for the comedy of multiple, or cross identifications. The less treated aspects of the narrative are those of corporeality, the stout, the plump and the skinny bodies of the dream, and the appetite for various foods. Appetite, we have learnt already, doubles in this discourse to signify a taste or capacity for both sexuality and food. But, as we are made aware by Bourdieu, "taste" is never a question of a pure biological faculty; even, or especially, our taste for food positions us within a system of classification marked by social distinction. In Bourdieu's account, taste is "simultaneously 'the faculty of perceiving flavours' and 'the capacity to discern aesthetic values'" (Bourdieu 1979:474), but the first is never outside of social mediation. If appetites express a desire both for food and for bodies as desires constructed within the system of social hierarchy, then the story of the butcher's wife's dream needs to be situated within that structure of distinction. I want to suggest that the narrative of the dream testifies to a particular anxiety about identity which is not only played out through the body, but has emerged in the triadic relation of bodies–class–taste, that further inflects the axes of gender/sexuality. To return to the meaning of bodies in the text is a return to history, not as an invocation of a real dimension that flattens fantasy, but a fleshing out, as it were, of the historical intertexts which are woven into the psychic imaging and reading of corporeality. To follow the vestigial traces that make up the discursive sense of corporeality at the turn of the century is to produce a notion of the body as something of a palimpsest, written and written over yet bearing the faint marks of former writings. The body is a site of conflicting scripts as the meaning and value of corporeality shifts, in turn disrupting the stability of class and gender identifications, and indeed identity.

From accounts of corporeality in numerous disciplines it becomes apparent that certain bodies at specific times never cross the threshold of the symbolic as subjects, but are marked out as abject beings. Abject, neither object nor subject, is matter that is, in the last instance, unclassifiable.[6] Oscillating between object and subject, the abject body is denied subjectivity, or a coherent sense of self. Of course, bodies change status and mode of classification historically, therefore there is no monolithic demarcation of the universal abject. It is rather that these narratives of exclusion are brought to bear on bodies, where the sedimented effects of social processes appear in the traces of abjection as the denial of a coherent subject position. The abject may also be viewed more positively as the "confused" and complex site of multiple identifications (hybridity), and the refusal to subjugate the self to the radically pared down version of subjectivity demanded by the socio-symbolic. In refusing to repudiate certain identifications, the abject body then is at once a more complex and less coherent site, but simultaneously open to an increased economy of visual scrutiny. The abject body is both spectre and spectacle.

My interest here is with the classification, and its concomitant abjection, of bodies according to size, an abjection that I will argue plays a part in Freud's dream text. In glancing back at the shifting paradigm of the meaning of various sized bodies, the structural division of fat/thin is situated at the centre of a changing social and psychic formation at the time of Freud's interpretation of the dream. The corpulent body is a marker on the threshold of abjection, which in the late nineteenth/early twentieth century, is produced through two discourses of taste. First, the discursive production of taste in relation to shifting class relations, where a growing anxiety revolves around the dislocation of economic from cultural capital, and definitions of taste become increasingly significant in the demarcation of classes. The size and colour of bodies are the markers of an individual's history, indicators of breeding and origins, connected to the distinction between bodies that work, and those predominantly used for leisure. They are also the index of cultural capital and paths of social circulation, the sign and evidence of having acquired the knowledge of what constitutes a "tasteful" body, and of having the restraint/effort to (re)produce the self in that fashion. Questions of tasteful bodies tread a path between the opposing ideologies of inheritance (the biological given), and social mobility (the body as changeable object).

The second discourse that places the corpulent body on the threshold of abjection is that of consumer culture. The coupling of femininity with a burgeoning consumerism emerging at the beginning of the twentieth century troubles the relations of gender and sexuality; the corpulent body becomes a sign of excess consumption, devalued through its association with undistinguished mass produced goods, which in turn is elided with the feminine; consumerism as the insatiable appetite of female sexuality. The elision of femininity, excess, mass produced goods and the spectre of the masses is noted by Huyssen as the return of the nature/culture divide; "The fear of the masses in this age of declining liberalism is always also a fear of woman, a fear of nature out of control, a fear of the unconscious, of sexuality, of the loss of identity and stable ego boundaries in the mass" (Huyssen 1986:52). The corpulent female body represents the extremity of, and invokes the horror expressed towards, a nascent consumer culture. This particular mode of corporeality becomes the abject stain of a feared hybridity where class and gender become inextricably interlaced.

"Fatness", according to Eve Sedgwick, is a discourse that is produced through and colludes with naturalized ideas about gender (Sedgwick 1994).[7] For, discussion of corpulence is almost exclusively fixed on the female form. Gallagher, in *The Making of the Modern Body* (Gallagher and Lacqueur 1987) returns to the eighteenth century to trace an earlier shift in the meaning of the corpulent female body, a meaning tied to the metaphor of the body politic. In the eighteenth century, according to Gallagher, the procreative female body was regarded as an index of the health of the work force, acting as an emblem of the nation's well-being and productive capacity. The body-

as-nation is a fairly familiar and well-developed metaphor in British culture historically, the effect of its evocation a call to cohesion under the sign of the nation. Moreover, the body is historically the way in which we conceptualize place, from metaphors of the head of state through to the measurement of land in feet. But in Gallagher's account, the significance of the opulent procreative female form shifts in relation to changes in class formation. By the end of the nineteenth century, the procreative body, specifically working and working class, had become an index of chaos rather than health, a change effected through the process of urbanization. The extreme proximity of working peoples in the newly formed cities, the spectre of the masses, and the prurient speculation about working-class "animal" sexuality, combined to produce an anxiety about over-population. This was, of course, to be contained by the end of the nineteenth century, as Foucault has shown, through the discourses of hygiene and medicine. But the focus of this anxiety became the large female working-class body, representing an excess that was unsightly and offensive, constructed in reverse as a threat to the nation's well-being.

The discourse of taste and the body can be traced further back in European history through the work of Bakhtin (1968, 1981). The concept of carnival is central to the Bakhtinian model of high/low culture, and integral to carnival is the symbolic value of bodies. Carnival is, according to Bakhtin, the inversion of normative social hierarchies, whereby king becomes pauper and vice versa, and where the grotesque feasting body is celebrated over the constrained working or higher classical body. The classical body, represented most often in the authoritative culture of paintings and statues, is the ideal bourgeois body, a figure that embodies the concept of individualism inscribed in the self-contained, muscular, symmetrical figure. Importantly, it is a body sealed, closed and contained, both internally controlled and defended from external threat (closed borders/orifices). In contrast the grotesque body is distinguished by "the gaping mouth, protuberant belly and buttocks", the abject body writ large, signifying excessive consumption or feasting, displaying a lack of self-control and regulation, an obesity that connects excessive consumption with sexual promiscuity. The concept of carnival has in recent years developed as an important model for the analysis of cultural value. Yet it has also drawn the criticism that the inversion of cultural categories is not a transgressive event but the licensed release of social unrest, contained by these rituals. Stallybrass and White are critical of the utopian passages of Bakhtin's work, arguing instead that the transgressive force comes not from inversion in itself but from the notion of hybridity and intermixing, in which "self and other become enmeshed in an inclusive, heterogeneous, dangerously unstable zone" (Stallybrass and White 1986:193). This is an interesting turn in the debate which places a critical emphasis on the psychological fear that carnival invokes rather than on its ability to permanently transform the social structure. It is the process of intermixing in itself that provides an index to the grotesque or abject, a process that threatens the edges of Freud's analysis where the class

position of the butcher and his wife is less than clear. The threat of class mobility and the gender effects of mass consumerism is precisely the danger of crossing boundaries, the confusion of social roles, breeding and money.

In addition to the opposition of grotesque/classical which inform hierarchies of bodies, class and taste, an opposing discourse of scale was also in effect. According to Susan Stewart a counter discourse of miniaturization emerged in the nineteenth century as a metaphor for the interior space and time of the bourgeois subject (Stewart 1993). This was produced through cultural artefacts such as the miniature portrait, souvenirs, the collector's archive and such diminutive models as the doll's house, artefacts that suggested ordering, containment and control in opposition to the lower order of excess, hyperbole and the grotesque. Yet, the miniature represents a metaphor of bourgeois subjectivity that is not neutral but also inflected by gender. For the miniature is located within domestic interior spaces, within the confines of private property, carrying with it a sentiment reserved for women and children. Indeed, it is a discourse synonymous with the developing cult of childhood in the late nineteenth century. The spectre of femininity interestingly cuts across class; it appears in the lower sphere of consumer culture, and within the bourgeois realm of privatized space. Indeed, the interior space of the consulting room can be read through this prism of class and gender signification, where doubt is cast on the masculine integrity of both analysand and analyst in such an encounter.

Freud published *The Interpretation of Dreams* in the millennium year. It could be argued that this work is an archetypal modernist text, a private discourse proposing to deal with the exigencies of an alienated interiority, and the neurosis of a fragmenting subjectivity. Yet such a generalized model of modernity disguises the uneven effects of social transformation, for modernity also reproduced the historical discontinuities that have always limited access to a secure identity. As Huyssen aptly remarks, "the notion of a stable 'self' is historically datable and dated with the bourgeois age", the implication being that the crisis of modernity was a greater loss for some subjects than others (Huyssen 1986:23). For some cultural critics of the period, notably Adorno, the decay of a necessarily strong ego formation was explicitly related to the rise of mass culture. Whatever the reasons of this ontological crisis, the origin of psychoanalysis in this particular moment in time and within the declining imperial space of Europe is not a coincidental development. Freud's work bears the imprint of this transitional moment. Apologias for the narrative form litter the case studies in an attempt to align psychoanalysis with the rational discourse of science over and above entertainment. Thus Freud's own gender identity is also at stake, caught in a paradox. For whereas Freud attempted to align himself with science, the implications of his findings fundamentally undermine epistemological certitude and the discipline of science itself.

How far can we read Freud's story of the abandoned supper party through this prism of early modernism and the concomitant tensions over class

mobility? How does the story signify under duress of a transformative moment when the precise meaning of bodies and their class alignments is changing? What we know of the class status of the characters is of course limited to the abridged version of the dream, and the further edited information of the analysis. In addition to these mediations, the translation of the text adds another layer of interpretation on top of the others. While acknowledging these mediations and limits it is still possible to speculate on common patterns of gender and class (trans)formation that effects of a European modernity.

The butcher and butcher's wife, defined in Freud's description by what they do, are part of the rising trades class at the end of the nineteenth century. Although the butcher's wholesale trade may create a nuance of superiority over an ordinary butcher, he is bound still by the label of manual trades person. The butcher's desire to lose weight can be reconfigured within the shifting social formation of the late nineteenth century as a wish to lose the signs of an excess that increasingly aligns his body with a working-class ethic of pleasure, and with what was to become more pronounced through the century, an undiscriminating consumerism. The butcher's desire is part of a new social aspiration to "slim and rise" as it were. The butcher's wife we know is plump, and although she does not express an explicit desire to slim, she does speak of the contrariness of her desire for caviar and the self-denial that she imposes because she grudges the expense. What might be interpreted as cross-class concerns can be read into the butcher's wife's articulation of two concerns. The first, a financial anxiety, is the fear of her taste exceeding resources; the second, a concern relating to restraint and propriety. Or, to twist the tale again, is it possible to interpret her anxiety as one of epistemology rather than ontology, that the butcher's wife may not *know* how her body should be in order to facilitate the class identification to which she aspires? Similarly, the butcher's anxiety in relation to his figure can be read as a consequence of class insecurity, evidence of a feminization of the working-class man within the broader hierarchical structure. However the anxieties are interpreted, their existence foregrounds the changing and contradictory demands of class position and the limits of social mobility expressed through the body. In both cases, the anxiety is expressed in terms of restraint; in terms of Freud's original framework, the wish that the dream fulfils is the self-restraint necessary to identify with what is perceived to be bourgeois taste, and which has become in this century an institutionalized aesthetic of less-is-more.

In positioning the body as a central constituent in the tale of the butcher's wife's dream, the turmoil pointed out by other critics around the axes of identification and desire is not displaced. Rather, the body is but one constituent in a field of social hierarchy, interdependent with gender, sexuality, class and taste, the recoding of one part impacting on and tugging at the others. The butcher's questionable identifications and desires cut across and disrupt the stability of any one of these terms. Does the butcher, for example, wish to be

slim to fit his wife's aspiring taste for middle-class goods, such as the caviar, or to compete with his wife's slim friend? Does the butcher set up competition for his wife in his covert admiration for her skinny friend? Do we believe the butcher when he says that he prefers plump when he himself desires to be thin? The possible interpretations proliferate; the point here is that identification and desire are bound up with corporeality, and as such are bound up with social distinctions that demarcate and differentiate bodies from each other, and confer status disproportionately. But the story of the butcher's wife is also a story of the difficulty of some identifications, and that in the non-coincidence of class identifications (the over-weight butcher who aspires to be middle class), the gap between fantasy and reality, and the incommensurability of the psyche and the social, opens up. The butcher is not who he wants to be, thus the possible mobility of identification, the ability to cross into other spaces, is circumscribed by the materiality of the body.

Freud uses the instance of this particular dream to say something more about the mobility of identification and hysteria, an insertion that, we are informed by way of a footnote, he later regrets. This extended discussion leads Freud to hypothesis that, first, identification is linked to the mimetic quality of hysteria. Hysterical patients, notes Freud, are able to "suffer on behalf of a whole crowd of people and to act all of the parts in a play single-handed".[8] What is more, the mimetic act of hysterical identification is infectious; Freud goes on to give the example of patients in a ward who will reproduce the symptoms of another patient's hysterical attack as a result of a common element that remains unconscious. If it were to become conscious, speculates Freud, it may result in a fear of such an attack. Hysterical patients, then, act out an unconscious mimesis, which is "not simple imitation but *assimilation*". Hysteria is not only an acting *out* but a taking *in*, an assimilation or introjection of otherness. What is striking about this description of hysterical identification as pathologized, is its similarity to the way that fantasy operates across the boundaries of self/other in a normative account of subjecthood. For example, in the Lacanian account, the fantasy of the self is always seen from the position of other, but an other that is unknowable, therefore always a fabrication, a fantasy of difference which is performed, introjected, assimilated. The other exists paradoxically both as an exterior projection and an interior fantasy. Thus, while hysteria seems to present as an anomaly, an exception to healthy psychic processes, it is in fact the rule. The nuance which distinguishes pathology from health is precisely the fit between identification and identity; hysteria illuminates the seams of its own fabrication, the patching and appropriation are the signs of a radical disjunction of body and psyche, of identity and identification. Whereas identification as assimilation for the healthy normative subject naturalizes its effects, crossing into territories with no trace of fabrication, where fantasy and identity are fully imbricated.[9]

What restrains identification, and what makes it possible? Certainly the body, or our respective bodies, function within a circuit of constraints. Bodies

straddle the divide of what is psychically imaged and socially regulated, what Lefebvre has referred to as the registers of the perceived, the conceived and the lived body (Lefebvre 1974). Bodies cannot reduce the psyche to the social, but they show us something about each term. For some, the body is the mastered object, a neutral background upon which fantasy acts. For others, decentring is a process that occurs in the radical disjunction between fantasy and the social impossibility of its operation across the marked effects of the body.

Instances of magical defiance

I want to finish by way of another dream, a more recent account in Eve Sedgwick's work, *Tendencies*. The dream opens an essay, co-written with Michael Moon, ostensibly about the performer Divine, but more generally about bodies, sexuality and taste. Shopping features in this dream, as it did in the earlier account, but whereas for Freud's patient the shops were closed, for Sedgwick, the interior space of the department store provides the *mis-èn-scene* of this narrative. In search of clothes, but sceptical about whether the shop sells sizes large enough, she is reassured by a saleswoman:

> [she] said they did, adding that rather than being marked by size numbers, each size-group of clothes was gathered under a graphic symbol: over here, she said, were the clothes that would fit me. "Over here" referred to a cluster of luscious-looking clothes, hung on a rack between two curtained dressing rooms. The graphic symbol that surmounted them was a pink triangle.
> I woke up extremely cheerful (Sedgwick 1994:215).

There are of course parallels and connections between this and the earlier dream; a shared anxiety about corporeality, identity and taste linked to consumerism. It is an anxiety that by the end of the twentieth century has become a fully blown phobia of bodily excess, expressed through a discourse of disgust and moral rectitude institutionalized in magazines, health clubs, cartoons and more; that corpulent, and particularly female, bodies are bad taste, lower class, excessive, offensive. In contradistinction to this moral rectitude, the wish fulfilment of this dream is that the abjected corpulent female body enters the symbolic as a desiring subject, a subject for whom there are goods in the shop. The dream exposes the denial of subjectivity that a capitalist economy metes out; it contributes another layer to the Marxist critique of consumerism as false needs, that an analysis of consumerism also exposes the exclusion of certain groups from the circles of symbolic exchange through reasons of corporeal as well as economic difference. Further, that those false needs are produced, and the mechanism of desire activated, precisely through

the exclusion of others to whom the shop offers very little. Consumerism, far from the promise of an ever-deferred pleasure, cuts dead certain fantasies of identity by foregrounding the disjunction between materiality and psychic life; the body effects what Sedgwick evocatively describes as a "cul-de-sac blockage or clot" in the circulation of economic exchange (Sedgwick 1994:217). Whereas the dream of the butcher's wife testifies to a slightly different anxiety specifically focused around class mobility, the factor of the corporeal as a potential blockage to social ascent shares affinities with this dream. Where the butcher's wife has an anxiety that the shops will be closed to her, Sedgwick dreams that they will not only be open but will facilitate her needs. Although the butcher is tailoring his body to fit the socially acceptable mode of middle-class corporeality, Sedgwick dreams her body will fit the clothes in the store. More than this, Sedgwick's dream invokes a performative sense of clothing, with the option of not one but two dressing rooms suggesting perhaps plural options for a semiotics of identity. Not only does the wish represent the possibility of entering the circuits of symbolic exchange, but of a mobility and fluidity within that – wish fulfilment indeed.

The connections between the dreams could be embroidered at greater length, but suffice it to say that the search for clothing in the department store, like the desire for the right kind of food and body, interfaces the psyche and the social, fantasies of the self and their lived possibility. Identifications that draw attention to embodiment, it can be noted, are those that are in the forced practice of negotiating their own contract with the social sphere, rather than those whose embodied identities are naturalized by its economy. This enforced sensitivity towards the possible fantasies of the self does not necessarily obey the limits that the social sphere prescribes. Again, Sedgwick, speaking in a different context: "Shall I call it my identification? Dare I, after this half decade, call it with all a fat *Woman's* defiance, my identity? – as a gay man" (Sedgwick 1994:256). Having learnt what Sedgwick calls the magical defiance of the fat woman to bridge the circumscribed spaces of fantasy and reality, of the perceived, conceived and lived body, crossing into the territory of gay masculinity is one more precarious leap. The ability to recognise, to understand even, the gaps, fissures, fault lines that separate the social and the psyche, fantasy and reality, does not necessarily keep dreams, bodies or even wives, on the right side of the line.

Notes

1. For a fuller account of the controversy of the seduction theory, see Chapter 7 of this book.
2. Judith Butler 1993 draws on the account of fantasy rendered by Laplanche and Pontalis as both the staging of desire and the dispersal of the subject into a number of identificatory positions within that setting. According to Laplanche

and Pontalis, fantasy is a response to the loss of an original object, providing an imaginary recovery through the staging of a scene. This imaginary recovery is the setting within which the subject is located variously as the desiring subject and its object.

3. See for example, Teresa de Lauretis (1994).

4. Diana Fuss, in tracing the concept of identification ("what may be psychoanalysis' most original idea") in Freud's work, notes the paradox of the critical act: "What is finally at stake in these multiple condensations and displacements of a single abridged story of unfulfilled desire is a notion of interpretation *as* condensation and displacement. The critical desire for a readable and concise ending to the story of the butcher's wife – not only to the dream but to Freud's interpretation of the dream – paradoxically defers closure and keeps the story open for further re-reading" (1995:32).

5. Freud's interpretation of the dream, which follows, is of course is far lengthier than this abridged narrative.

6. Notions of the abject stretch the divide of anthropology, sociology and psycho-analysis. See for example, Mary Douglas 1966 and Julia Kristeva 1982.

7. Eve Kosofsky Sedgwick and Michael Moon set out some historical connections between fat women and gay men, in particular, "a certain interface between abjec-tion and defiance . . . [which] produces a divinity-effect in the subject, a compelling belief that one is a god or a vehicle of divinity" (Sedgwick 1994:218).

8. Freud uses this analysis of the butcher's wife's dream to lead into a more general discussion of hysterical identification, the usefulness of which is questioned in a footnote; "I myself regret the insertion into my argument of excerpts from the psychopathology of hysteria. Their fragmentary presentation and detachment from their context cannot fail to detract from their enlightening effect. If, however, they serve to indicate the intimate connection between the topic of dreams and that of psychoneurosis, they will have fulfilled the purpose for which they are inserted" 1900:233–4.

9. Take for example Virginia Woolf's *Orlando*, where the fantasy of transformation, in terms of gender, is effected with little sense of hysteria. Rather it relies on the geo-graphical and historical tenets of imperialism that naturalize the crossing of borders for white European subjects. Materiality, in the particular form of cor-poreality, circumscribes and even pathologizes the realm of fantasy for some, while facilitating mimesis and assimilation for others.

References

Bakhtin, M. 1968. *Rabelais and his World*. Iswolsky, H. (trans.). Cambridge, MA: MIT Press.

Bakhtin, M. 1981. *The Dialogic Imagination*. Emerson, C. (trans.). M. Holquist (ed.). Austin, Texas: University of Texas Press.

Borch-Jacobsen, M. 1988. *The Freudian Subject*. C. Porter (trans.). Stanford, California: Stanford University Press.

Bourdieu, P. 1979. *Distinction: a Social Critique of the Judgement of Taste*. R. Nice (trans.). London: Routledge.

Bristow, J. 1989. Being gay: politics, identity, pleasure. *New Formations*, **9**, Winter.

Butler, J. 1993. *Bodies that Matter: on the Discursive Limits of "Sex"*. New York and London: Routledge.

Chase, C. 1987. The witty butcher's wife: Freud, Lacan, and the conversion of resistance to theory. *MLN* **102**:5 December.

Clement, C. 1983. "No caviar for the butcher". In *The Lives and Legends of Jacques Lacan*. A. Goldhammer (trans.). New York: Columbia University Press.

Douglas, M. 1996. *Purity and Danger: an Analysis of the Concepts of Pollution and Taboo*. London: Routledge.

Freud, S. 1900. *The Interpretation of Dreams*, (1976), **4**. Harmondsworth: Penguin Freud Library.

Fuss, D. 1995. *Identification Papers*. New York and London: Routledge.

Gallagher, C. & T. Lacqueur, (eds) 1987. *The Making of the Modern Body: Sexuality and Society in the Nineteenth Century*. Berkeley, California: University of California Press.

Grosz, E. 1995. *Space, Time and Perversion*. New York and London: Routledge.

Huyssen, A. 1986. *After the Great Divide: Modernism, Mass Culture and Postmodernism*. Macmillan Press.

Kristeva, J. 1982. *Powers of Horror: an Essay on Abjection*. New York: Columbia University Press.

Lacan, J. 1977. "The direction of the treatment and the principles of its power". *Ecrits*. A. Sheridan (trans.). New York and London: W W Norton and Company.

Lauretis, T. de 1994. *The Practice of Love: Lesbian Sexuality and Perverse Desire*. Bloomington, Indiana: Indiana University Press.

Lefebvre, H. 1974. *The Production of Space*. Oxford: Basil Blackwell.

Sedgwick, E.K. 1994. *Tendencies*. London: Routledge.

Stallybrass, P. & White, A. 1986. *The Politics and Poetics of Transgression*. London: Methuen.

Stewart, S. 1993. *On Longing: Narratives of the Miniature, the Gigantic, the Souvenir, the Collection*. Durham, North Carolina and London: Duke University Press.

Turner, B. 1992. *Regulating Bodies: Essays in Medical Sociology*. London and New York: Routledge.

10

Writing the adolescent body

Jo Croft

We may or may not choose to act our age – we may be immature or precocious – but the momentum of our biological chronology seems, self-evidently, to override the more fluid, reversible identifications of postmodern subjectivity. Age is a component of identity which fixes us within a register of absolute universal terms, setting out the limits of what it means to be human. Punctuated by life stages and the rhythms of a finite bodily existence, personal histories are welded firmly to the grand narratives of History (with a capital H) by the concept of age. And just as significant events (wars, legislation, discoveries) seem to stand as immovable points of reference in the past of a particular culture, so each individual history is also bounded by the absolutes of significant *bodily* events: birth, puberty, childbearing, menopause, death. The fragments of a corpse can usually tell us, if nothing else, the sex and age of the person who has died, as well as the approximate date of their death.[1]

Adolescence has a problematic status within this vocabulary of the body's beginnings and endings: typically conceived as a transitional, in-between and conflict-ridden category, its relationship to the unswerving linearity of physical chronologies is apparently uneasy. At one level, adolescence figures as a point of cohesion, cementing the developmental sequence linking childhood and adulthood. At another level, though, adolescence can come to represent a site of rupture or irresolvable crisis which sets on edge this sequential logic and messes up the boundaries dividing up the narratives of our lives. Above all perhaps, adolescence is conceived, paradoxically, both as an epoch of sexual uncertainties and as an anchor for the most normative accounts of sexuality.

This chapter will explore some of the reasons why the adolescent subject remains more or less untouched by the current theoretical impetus towards scrutinizing hybrid, composite or in-between forms of identity. Its starting point will be the contention that adolescence could be said to encompass the extremes of social identifications. For example, delinquent youth often seems to be taken as a kind of marker for the outer edges of community – an alien,

every thing is heightened

alienating social grouping which supposedly is least accessible to law or morality. On the other hand, the adolescent also tends to be aligned with a discourse of private turmoil and introspection, more likely to be found *inside* – in the bedroom or on the pages of a diary – than *outside* in the social terrain of the street. *[handwritten: really good diary quote]*

For many people, it is better to forget about the adolescent body altogether: it is, after all, a body associated with embarrassment, inadequacy and painful self-scrutiny. More than anything, perhaps, adolescence seems to be bound to a body that *doesn't quite fit*, its material surface (outside) somehow both emblematizing and failing to represent the adolescent's psychic realm (inside). It is surely more than coincidence therefore that this body, which conjures up such problems of representation, is insistently linked with writing. According to Kristeva, for example (in her paper, "The adolescent novel") the "open psychic structures" of adolescence "prompt" writing which is narcissistic, masturbatory and solitary (Kristeva 1991:9–11). Above all perhaps, Kristeva suggests that the adolescent's transitional subjectivity allows for a "psychic interiority" which paves the way for "novelistic" writing. *[handwritten: Kristeva] [handwritten: ← Kristeva]*

Adolescence is mythically (and often pejoratively) aligned with the desire to write about "myself". This analysis will take the adolescent diary as a category of writing which raises several key questions about the relationship between literary production, historical narratives and the body. The activity of adolescent writing, and in particular the keeping of a diary, is peculiarly defined and delimited by its relationship to physical chronology. Intriguingly, it is adolescence which is singled out within the normative codes of common-sense as a time when literary production is typical, predictable and developmentally healthy. Above all, perhaps, it is characterized as a "phase we all go through". The adolescent's desire to write, in other words, is inextricably tied up with a stage of growth which is universal *and* transitory. Just as Roland Barthes describes how the rhetoric of "development" reduces the experience of love as "the great imaginary current, the orderless, endless stream" to "a painful morbid crisis" that the subject must "'get over'" (Barthes 1979:7) so the libidinous excess of the adolescent text is only ever a point of departure, something we "put behind us". *[handwritten: really good starting point for essay] [handwritten: desire to write] [handwritten: individual experience]*

Whether adolescent or not, most diaries are of course texts which chronologically record a person's *individual* experience. As historical artifacts they tend to be valued precisely because of their *lack of distance* from the events they narrate – as personal histories underpinned by the concept of a self-reflexive subject. But while – generically – the diarist might be expected to produce a private narrative which offers an inside view of external social events, adolescent diaries are associated with a kind of writing which is somehow excessively private and excessively internal. It is almost as if this most normative, socially acceptable of writerly genres paradoxically represents the social realm itself only as a vanishing point. The outside context of the adolescent's writing is overwhelmed by the proliferating discourses of the self's inside. *[handwritten: diaries cut through straight to the heart of an event they are texts that should not be edited or censored.]*

[handwritten: → writing seen as healthy.]

191

Adolescents are not in full control of their own body - writing helps them centre themselves and take control.

Probably the most famous of adolescent diaries, *The Diary of Anne Frank* (1981) [1947], is classically read as an autobiographical text which through the very *normality* of its evocations of girlhood, and through its author's exclusion from the outside world, emblematizes and gives weight to the historical events underscoring its production. In the same way, the publication in of *Zlata's Diary*, (the diary of a young girl in Sarajevo, Filipovic 1993) was accompanied by publicity emphasizing its value as a narrative of normality, ordinariness in the face of the pathologies of war. What seems to be at stake in the way these adolescent texts function as testimonies is a demand for texts to *embody* the historical event – to give a (written) body to traumas which somehow throw into question the very possibility of historical representation. Amidst claims that the horrors of a real event such as the Holocaust cannot be put into words, the very interiority of the adolescent text's narrative voice is sought out as a key space for readerly identification; the inside conjured by the adolescent diarist's pervasive "I" enables us, as readers, to feel on the inside that which is otherwise outside the realms of imaginable experience.

everything becomes more centered

At one level, then, the adolescent diary is nominated as a text capable of *securing* other identity positions – not only cleaving out the difference between adult and child, but also anchoring the positions of reader and – perhaps most problematically – that of historical witness. However, as I have already suggested, adolescence is a sign which "cuts both ways" in that it encompasses both the most familiar and the most alien structures of identification. My claim in this chapter is that a developmental grammar of the body seems to stake its linearity upon the linearity of other grammars – of history and of writing itself. But the very fact that the adolescent text is a mode of representation which allows for such conflictual readings suggests that the body's storytelling does not necessarily run smoothly. It may be the case, as Peter Brooks argues, that "stories cannot be told without making the body a prime vehicle of narrative significations" (Brooks 1993:xii), but this does not mean that the body's agency guarantees narrative coherence or consistency. Adolescence may be a story which is saturated with the normative rhetoric of developmentalism, but its transitionality persists in troubling the assumption that discourses of sexual, psychic and socio-historical development run along the same parallel lines.

In an article published in *The Psychoanalytic Study of the Child*, entitled "Adolescent sexuality: a body mind continuum", Moses Laufer writes:

> Physical sexual maturity, that is, the beginning of the period of adolescence, means not only a fundamental change in the person's relationship to his body, but it means that from puberty onward psychopathology *requires* the availability of the sexually mature body for its expression (Laufer 1989:281).

For Laufer, it seems, the concept of psychic health or normality is tied to the ability to identify with a genitally centred, reproductive body. The mind, in

other words, must be spoken through a bodily language that is both linear and progressive. Perhaps most crucially, though, Laufer suggests that a pathological realm of bodily identifications exists whereby the the sexually mature body can serve to represent the very opposite of psychic coherence. In the following lines Laufer conjures an acutely condensed constellation of the key terms underpinning this essay as a whole:

> One essential function of pathology in adolescence – or more specifically, of the development to perversion, or of the break with reality and with one's sexual body as in psychosis – is this destruction of genitality, that is, the destruction of a continuum. It is also the ingredient which is always present in the transference and which faces the adolescent and the analyst with seemingly insurmountable problems during the treatment of these seriously disturbed people (Laufer 1989:282).

Here, the adolescent's pathology registers, above all, as a breakdown in *continuity*. Just as the adolescent breaks his or her relationship to "genitality" (sexuality which "progresses" away from polymorphous perversity), so the relationship between adolescent and analyst also breaks down. Laufer presents the "destruction of genitality" as being both equivalent to the "destruction of a continuum" (Laufer 1989), and as the factor which generates "seemingly insurmountable problems" within the analytic process. In other words, the adolescent's failure to establish genitality apparently bears a contingent relation to the adolescent's failure to enter into transference. Above all, therefore, what emerges from Laufer's formulations is a concept of the adolescent as a developmental category which is called in to guarantee both the stability of adult, genitally centred heterosexuality and the stability of certain formal conditions necessary to successful psychoanalytic treatment.

The next part of this chapter will focus upon a relatively obscure paper published in 1946, entitled "Diaries of adolescent schizophrenics (hebephrenics)" (Hoffer 1946).[2] Its author – Willie Hoffer – was associated with Anna Freud's group of Vienna child analysts.[3] Perhaps most significantly, Hoffer was centrally involved in some of the earliest attempts to use psychoanalytic techniques in broadly pedagogic settings, particularly in the treatment of juvenile delinquents. In 1919 he helped Siegfried Bernfeld to set up a residential home in Vienna (the Kinderheim Baumgarten) for Jewish orphans who were deemed to be "running wild as victims of the First World War" (Freud 1968) and during the Second World War he worked alongside Anna Freud in the Hampstead Nurseries.

Hoffer raises certain explicit objections to the treatment of adolescent schizophrenia through the formal workings of analysis. First, he suggests that the technical process of psychoanalysis would nullify any potential insight which might otherwise be gained into the etiology of hebephrenia. Secondly, he

argues that analytic treatment might well actually precipitate the further development of psychosis:

> For the interview necessarily leads to an increase of self-observation which according to Schilder interferes with the usual course of schizophrenic mental activity. Analytic treatment of incipient hebephrenia for instance may have a precipitating effect; this none will deny (Hoffer 1946:294).

This conforms to the standard (developmental) analytic view that psychosis is untreatable within the analytic transference because of the inability of the patient to receive analytic interpretations (the language of the analyst). The schizophrenic receives the interpretation literally, not metaphorically: for example, the couch is not *like* the mother's lap, it *is* the mother's lap. This means that any interpretation the analyst is liable to make is intrusive and impinging, driving the patient back further into psychosis and fragmentation. However, Lacanian clinical practice shows how psychosis can be treated analytically if the language of the patient (rather than the analyst) is focused on as meaningful.

Hoffer, who is arguing from a developmental position, argues that diaries can offer unique insights into the onset and development of psychosis in adolescents. Far from being an index to developmental normality, then, the adolescent diary is put forward by Hoffer as a text here which is more likely to reveal or portend madness than to articulate normality in the face of insane historical events.

[handwritten margin note: psychological aspect of diaries.]

With Willie Hoffer's 1946 paper, we are witness to the drawing up of a borderline within a borderline: first, in so far as the adolescent typically signifies as a borderline stage within normal psychic and physical growth and yet Hoffer's hebephrenic effectively falls beyond the classification of normal adolescence; secondly, in so far as the hebephrenic's psychosis is characterized as typically adolescent rather than as typical of other forms of psychosis ("hebephrenia ... is more characteristic of adolescence than the catatonic or paranoid forms of schizophrenia") (Hoffer 1946:293). Hebephrenia seems to function here as a sign of excessive transitionality, even to the extent that Hoffer appeals to Mayer-Gross' concept of adolescent schizophrenic activities as being "a discharge of surplus impulse" (Hoffer 1946:293). In other words, the adolescent schizophrenic resides at the boundaries of both normal psychosis and psychic normality, somehow both typical and excessive – above all, a problem of definition: "While the psychotic with delusions and hallucinations may display a rich inner life, the delusions becoming highly systematized, the content of the hebephrenic's mental processes appears to be fluctuating and incoherent and is difficult to define" (Hoffer 1946:293). Willie Hoffer nominates the diary as a unique repository of psychical data on adolescents in general, and on hebephrenics in particular.

[handwritten note: a text of psychical data.]

According to C. Bühler adolescents begin to keep diaries at the age of fourteen to eighteen and stop between seventeen and twenty-one, twice as many writing only for a half to one year compared with those who continue to write for two to three years. There is therefore a probability that diaries could be used to elucidate the initial stages of psychotic processes just as for any other psychopathological state in adolescence. This would be especially desirable where the nature of the mental illness makes verbal communication difficult or impossible (e.g. mutism) (Hoffer 1946:296).

For Hoffer, diaries provide a possible point of entry into an otherwise inaccessible form of psychopathology (adolescent schizophrenia). What I hope to draw out in my reading of Hoffer's 1946 paper is the way in which writing (and, more specifically, the diary) is set in play as the key site of entry into both psychosis and adolescence. Perhaps most crucially, the process of diagnosing hebephrenia seems to be inextricably bound up with an implicit assumption that adolescent writing itself constitutes a developmental stage. But at the same time, psychosis can only be understood through the language and writing of the adolescent body, thus reversing a key supposition in developmental frameworks that language (and the external world) is a stage of normality that the regressed schizophrenic has failed to reach.

Having so specifically identified the diary as a key object, it is noteworthy that Hoffer chooses first to cite not a diary but a letter written by one of the two adolescent schizophrenic diarists – "George" and "Richard" – he bases the paper around. In effect, he represents the diary and the letter as equivalent /indistinguishable writerly forms – he subsumes them into the same textual product.[4] Hoffer introduces the letter itself by stressing it was written at the same time as the diary – for example "during the middle period of diary writing" (Hoffer 1946:297). By the same token, therefore, it seems to be the moment at which the writing takes place rather than its intended object of address which is crucial for Hoffer. In other words, writing signifies here as a developmental phase, irrespective of its generic status.

However, the adolescent's writing also seems to be a stage or position which explains, or renders meaningful the adolescent's body and madness. Rather than a separate relationship to the other (and the recognition of reality) which makes writing and language possible, it is the writing and language of the so-called mad body that enables a connection and communication between self and other to take place. It is through the writing of the body or madness that the "I" can connect and distinguish itself from the "you". The language of the psychotic body is therefore the key to establishing a subject position. This is at odds with the conventional, developmental understanding of psychosis, where identity, normality and cure are seen to reside with the analyst's Oedipal and reality bearing position.

The letter in question, as Hoffer reproduces it, reads as follows:

Dear sister, When I write you I feel happy because when I meet you in my imagination I feel myself a complete unity and therefore I can give you a clear, unified picture of myself. In writing to you just now I give way to a momentary impulse and I have to control myself continually so as not to write too much nonsense. I am completely overwhelmed by my feelings. I can really give way to feeling. My relations with reality are childish, I can hardly grasp material things. You must not take my letter literally, I write phrases which are just reproduced from memory. I have to stop now, my thoughts have become unbridled and I shall try to continue later when reason returns... [Continuing] I shall try to give you an idea of the position here, naturally in quite a subjective way, as far as I can see it. Family life is at the moment cold. Father behaves with tact, he has, so to speak, an expectant attitude towards me and mother, I appreciate this really as far as I can, considering my weak personality. Mother is unable to add anything of value to the family atmosphere. Although she cannot fulfill such expectations she seems to be content with herself and is able to devote herself to work she likes. This is certainly a noble characteristic. I thought so today when I looked at the street from the window and saw mother coming home from the shop. It is Saturday today and she was certainly very tired as she had worked the whole day in the shop. She walked slowly step by step. Her eyes did not wander like those of other people in the street. She walked quietly and as if she were proud of herself. She has a strong personality. I will not suggest that you should take things I write too seriously, there may be an error here and there when I write to you, and that is due to the fact that I cannot be measured by common standards. Naturally father and mother expect me to make conversation, but that has always been my weak spot, that I cannot chatter. I have always been like this since childhood. But I believe that when my mind grows stronger this intrinsic deficiency will be compensated. My reason must help me, otherwise if I still remain a stupid day-dreamer I shall never achieve anything in life – as a materialist. I should be quite capable of creating a world of my own, but that is utopia (Hoffer 1946:297–8).

When Richard writes to his sister he makes his motives plain. Or at least that is how he begins: he starts his letter with the words, "When I write you I feel happy...", which is perhaps another way of saying that the act of writing the word "you" confirms the writer's ability to say "I". Of course, there is a question here as to whether it matters, whether it is significant that Richard does not write "When I write to you". After all, it might be an error in translation, or it might simply be that the original text has been translated using American syntax, though the latter seems less likely as the rest of the letter contains instances ("In writing to you" and "When I write to you") which do not fit this syntactical pattern. In any case, whether or not the relationship

between the "I" and the "you" is mediated by an implicit preposition, the point still stands – that here the "I" strives to assert its textual coherence through emphatically asserting its anticipated site of address.

In the first part of his letter Richard quite explicitly communicates his own conception of the narrative position he holds and of his relation to the reader – his sister. It is almost as if, in the very act of "putting pen to paper" he sees himself taking up a wished for (clear and unified) subject position. There is a strong sense in which this first section of the letter signifies as the absolute inverse of uncommunication. After all, Richard puts himself into words before the reader's very eyes. Yet, such a reading contains an uncomfortable paradox in so far as the letter functions as a narrative, a document of Richard's entry into psychosis. Even the break in the flow of writing (marked by Hoffer's interjection, "Continuing") seems to fit our readerly, and our diagnostic, expectations.

The letter's narrative seems to gravitate towards maintaining control, towards managing (as much as anything) the desire to write ("In writing to you now I give way to a momentary impulse"). It is almost as if the act of writing takes on a double-edged function, because Richard does not simply associate writing with acquiescing to "a momentary impulse", he completes his statement with the clause "and I have to control myself continually so as not to write too much nonsense". Thus, writing seems to signal a loss of control – to indicate the ascendancy of impulsiveness, yet it also articulates and in doing so manages the effort invested in preserving control. In other words, the writer "writes out" his equivocal relation to writing as communication. It is worth noting that the other adolescent diarist discussed in the paper – "George" – also self-consciously expresses this equivocal relation between writing and control; for example, he is cited as writing "I thought words could master everything, but I had not even enough courage for words" (Hoffer 1946:309).

Richard comments that he lets his parents down because he "cannot chatter". While he suggests throughout the letter that his writing is somehow "subjective", unreal, lacking materiality, unliteral, and in error, it is "conversation" which he emphatically identifies as a gap in his communication. Talking, and more specifically "chattering" with his parents, signals a real (social) failure whereas writing is aligned not with absolute failure but with a failure to be real. Read as self-analysis, therefore, the letter shapes the narrator's relationship to reality according to a developmentalist trajectory – from the "stupid daydreamer" (who writes) to the "materialist" (who converses). Nevertheless, although non-realist literary production seems to characterize the immature ("childish") end of this spectrum, it is not the place where words fail. In fact, we might paradoxically argue that it is the Oedipal scene which, for Richard figures as psychotic reality, "where communication by words is ... Lost" (Hoffer 1946:295); the scene of writing on the other hand is the place where such a "mad" reality is kept at bay.

[handwritten margin note: control when writing]

Meanwhile, out in the street (and inside the text), history returns...

In turning to the pages of adolescent diaries, Hoffer seems to be turning away from another, more insistent realm of interpretation. As readers of this 1946 paper we are presented with what already amounts to a biographical reading: the hebephrenics' writings form part of Hoffer's text – we do not read them as autonomous artifacts but as fragments of documents which have been appropriated to function as components of a single reading, a single piece of writing. In one sense, then, this invoking of the literary by Hoffer serves as an effacement of certain critical historical elements, most notably that of anti-semitism.

The diary is set in place as an axis for the case studies, around which the biographical reading revolves. Of course, it by no means follows that this focusing upon diary writing necessarily constitutes an evasion of history. However, in Hoffer's account, the activity of writing itself is taken to stand as a symptom, as an hallucination. In this way, certain revelations made by Richard and George within the framework of their own writing are not taken as symptoms in themselves, but instead only signify as constituents of a single symptom.

Bearing in mind the historical context of both the case histories in this paper (Czechoslovakia in the late 1920s), and in particular the references to Palestine, it seems that there is a conspicuous disavowal of the subjects' Jewish status. For instance, Hoffer describes one of Richard's central adolescent fantasies as being based upon "life in Palestine with other boys who felt like himself" (Hoffer 1946:301). Moreover,

> According to his diary he first became fully aware of his social self when he was eleven: "When I spent my first holiday with Czech people I awakened and my struggles started. For there I had company and for the first time I felt the difference between life at home and with other people, but I do not think I realised this up till now. How obviously inferior my home was, even compared with this place. Since then my youth has been a restless hunting, a striving to get on with my arms stretched forward." Here again I draw attention to his emphasis on the need for something to hold on to (Hoffer 1946:300).

Hoffer reads Richard's narrative of his feelings towards the social sphere simply as a reflection of Richard's failure to acquire "a proper object relationship" (Hoffer 1946:299). Richard's sense of his social difference therefore only registers within Hoffer's interpretation at the point it explicitly coincides with a psychical paradigm of object relations. I am not trying to argue here that Hoffer, in a spirit of conspiracy, deliberately covers over another more compelling agenda of historical events underlining the adolescent schizophrenic

writings. Rather, what seems to be at stake is a failure, on Hoffer's part to address the complex relation between psychic process, historical event and representation.

A recurrent theme within Richard's case history is his attitude towards "running about in the street". For instance, Richard writes,

> I have been spoiled. With every spoonful of soup she put into my mouth she took me on her lap. Father scolded us and I cried and felt that Father wanted me to be different ... Mother said I should run about in the street. I said I would only if I had a hoop. I got it but did not run about. (Hoffer 1946:299–300).

Similarly, when Hoffer describes the moment in Richard's life at which he had to leave school, and was sent to a psychiatrist, he stresses that, "Richard soon became very restless, ran about in the streets, and finally became dirty" (Hoffer 1946:298).

It would be misleading to suggest that Hoffer simply glosses over these references in Richard's case history altogether. In a section headed "Impoverishment of the social self", Hoffer states,

> Considering the role of the street and also of distance and separation in his life, speculation tends to lead to the assumption that he always felt a longing for something which was still outside him and of which he had never take possession: a proper object relationship with his mother based on his experiences with the objects of early childhood. (Hoffer 1946:299).

Here, the very acknowledgment of "the role of the street" nevertheless indicates the kind of effacement enacted by Hoffer in this paper. Hoffer traces the formation of Richard's psychosis to a "regression" caused by the "withdrawal of the libido ... into a more narcissistic stage of ego organisation" (Hoffer 1946:298). He goes on to say that "Richard's type of reaction when considered from outside appears as the slow retreat of a constantly frustrated social life" (Hoffer 1946:298-9). Significantly, the phrase "when considered from the outside" is also used by Hoffer when he makes the following assertion about differences in the "psychotically disposed adolescent's" response to the crises wrought by group life:

> His capacity for adaptation to changing social conditions is usually limited, although this may not easily become apparent; withdrawal from and repression of unpleasant experiences may not be different from the non-psychotic when considered from outside (Hoffer 1946:298).

Hoffer's use of the term "outside" in these instances appears to cast doubt upon any interpretation which might seek to legitimate/rationalize Richard's sense of social isolation. In other words, for Hoffer, an account of the

199

psychotic's "inside" (based upon object cathexes) effectively precludes certain registers of the social – the "outside". Critically, Hoffer's syntax suggests that a view "from outside" collapses the division between normal and pathological. This is perhaps a major reason why Hoffer so emphatically adheres to a normative, developmental paradigm of the psyche in his conclusion.

Outside of psychoanalysis ("the interview"), Hoffer looks for – and finds – the adolescent schizophrenic inside the pages of diaries, between the lines of letters, within the ellipses of aphorisms (c.f. Hoffer 1946:309–10). These written specimens are reproduced by Hoffer as historical documents. Yet this sort of history is firmly identified as personal history: these are narratives borne of a psychical reality which Hoffer sets implicitly against an external history, a "social self" (Hoffer 1946:298). An appeal is made by Hoffer to adolescent writing as a literary reality – either anchoring a developmentalist trajectory, or signalling its disintegration. After all, if writing constitutes a normal developmental stage within adolescence (cf. Hoffer 1946:295–6), then, according to Hoffer's thesis, the adolescent diary signifies as psychic (arti)fact. Paradoxically, though, it is this very process of diagnostic representation of pieces of text as pieces of reality which allows social history to return as a constitutive factor of the hebephrenic's symptom.

In Chapter 6 of *The Haunting of Sylvia Plath*, Jacqueline Rose explores the problematic relation between historical event, identification and representation with reference to the Holocaust. She writes, "Wherever it is that subjects find themselves historically, this will not produce any one, unequivocal, identification as its logical effect (Rose 1991:210). There is always more than one way of reading a narrative, and identity does not consist, either psychically or socially, of only one register of meaning. The lines below from George's diary give the lie to any possibility that questions of social and intellectual identification, Jewishness and self-disgust can have been anything other than painfully enmeshed at the time he was writing. "As regards snobbishness: I shall try to do as the school requires. I shall banish Jewish vanity and boasting of my disgusting cleverness. I shall castigate myself in the diary" (Hoffer 1946:308). George is trying to do "as the school requires". Through the activity of writing he sets out to "banish" his Jewishness, and his "cleverness". Crucially, the diary is nominated as the repository of these socially undesirable components of his identity – a place for castigation, "punishment with words". Thus, to meet institutional demands (to "fit in"), George designates the diary as an outside (of both of himself and of the institution) into which he can evacuate, through representation, things inside himself which do not "fit in".

For Hoffer (like George), it seems, the adolescent schizophrenic diary conjures an interface between inside and outside, representation and the unrepresentable. Writing in 1946 – from within a psychoanalytic institution which is fraught with ever-widening splits[5] – Hoffer takes as his object a category of psychopathology which is itself a gap, a problem for prevailing theories of the psyche. For Hoffer, as for George, adolescent writing becomes a scene

within which resolutions to such cleavages are sought. Strikingly, though, for Hoffer, as for George, adolescent writing also becomes a scene where excess shows itself, where words are seen both to fail and to say too much.

Hoffer's analysis seems to confuse and displace the psychoanalytic, developmental model of object relations thinking with a scene between writing and the body, which undoes any clear distinction between inside and outside, madness and reality, the psyche and the socio-historical realm of representation and culture. The adolescent's body becomes a site where the very meaning of the relationship between the psyche and the social is played out in terms of language. The body in Hoffer's work seems to offer both an explanation of the linear development from the body to language and a displacement of that linearity, where instead of the body acceding to language as some more mature developmental stage, it is the writing or language of that body that shows historical reality, not as some unreached goal of a sick and regressed psyche, but as a constituting factor which breaks down any absolute distinction between inside and outside. The adolescent body becomes the space where so-called interior, self-encapsulated narratives of psychic development become eternally displaced into more external narratives of the social. However, the writing of the adolescent body is also where so-called external historical events are placed as the crucial narrative underpinning of psychic processes, moved to the very heart of bodily and psychic identity.

Notes

1. See Judith Butler's comments about the "discursive limits" of identity in the introduction to *Bodies that Matter* (1993), pp.1–23.
2. Hebephrenia is defined in *Chambers Twentieth Century Dictionary* as "a form of insanity beginning in late childhood, arresting intellectual development, and ending in complete dementia".
3. For a detailed account of the debates about child analysis between Anna Freud and Melanie Klein see "War in the nursery" (Rose 1993).
4. CF. Blos' discussion adolescent writing in *On Adolescence*, 1962. Like Hoffer, Blos tends to subsume different categories such as novels, autobiographies and case histories into a single field of adolescent represetation.
5. See for instance Juliette Mitchell's introduction to *Feminine Sexuality: Jacques Lacan and the Ecole Freudienne* (Mitchell and Rose 1987:3–4 and 21).

References:

Barthes, R. 1979. *A Lover's Discourse: Fragments*. Richard Howard (trans.). London: Jonathan Cape.
Blos, P. 1962. *On Adolescence*. New York: Free Press.
Brooks, P. 1993. *Body Work: Objects of Desire in Modern Narrative*. London: Harvard University Press.

Butler, J. 1993. *Bodies that Matter: on the Discursive Limits of "Sex"*. London: Routledge.

Filipovic, Z. 1994. *Zlata's Diary: a Child's Life in Sarajevo*. Christina Pribichevich-Zoric (trans.). London: Viking.

Frank, A. 1981. [1947]. *The Diary of Anne Frank*. London: Pan.

Freud, A. 1968. Willie Hoffer, MD, Ph.D. *The Psychoanalytic Study of the Child* 23, 7–11.

Hoffer, W. 1946. Diaries of adolescent schizophrenics (hebephrenics), *The Psychoanalytic Study of the Child* 2, 293–312.

Kristeva, J. 1990. The adolescent novel. In *Abjection, Melancholia and Love: the work of Julia Kristeva*, J. Fletcher & A. Benjamin (eds). London: Routledge.

Laufer, M. 1989. Adolescent sexuality: a body/mind continuum. *The Psychoanalytic Study of the Child* 44, 281–94.

Mitchell, J. & J. Rose, (eds) 1987. *Feminine Sexuality: Jacques Lacan and the Ecole Freudienne*, J. Rose (trans.). London: Macmillan.

Rose, J. 1991. *The Haunting of Sylvia Plath*. London: Virago.

Rose, J. 1993. "War in the Nursery". *Why War?* Oxford: Blackwell.

Roskies, D.G. 1994. "The library of Jewish catastrophe". In *Holocaust Remembrance: The Shapes of Memory*. Geoffrey Hartman (ed.). Oxford: Blackwell.

Part VI

Auto/biography

11

Backward glances

Jonathan Rutherford

father when he passed on,
left dust (Ramanujan 1976).

After my visit, my father drove me back to the local train station. As we turned into the approach road, the lights of the level crossing began to flash and the barriers descended. My father accelerated, mounted the pavement to avoid the queue of cars and turned into the station car park just as the train drew to a halt. I jumped out of the car and ran for the station bridge to cross the tracks. Before my foot was on the second step, the train pulled out of the station. My father was reversing his car. I lifted my hand to wave him to stop; to say goodbye; perhaps to sit in his car for 30 minutes until the next train. But I hesitated – not wanting the discomfort of the silence between us – and he drove out of the car park without a backward glance. Or perhaps he gave a backward glance and decided to pretend he had not seen me standing there and the train leaving. For a brief moment our lives together were measured in this surreptitious economy of glances; an economy in which language, the prelude to feelings, had failed to take root.

In the post-feminist era of the 1990s, autobiography has become a popular genre amongst middle-class men searching for a language of emotion. Nick Hornby *Fever Pitch* (1992); Blake Morrison *And When Did You Last See Your Father?* (1993); Paul Watkins, *Stand Before Your God* (1993); Richard Rayner *The Blue Suit* (1995) follow the American example of Paul Auster, *The Invention of Solitude* (1982) and Tobias Wolff, *This Boy's Life* (1989). They are stories which eschew the traditional male territory of public events and heroic deeds and concern themselves with the private details and mundanities of everyday life. Their language grasps at the intricate detail of relationships and the emotional fabric of identity: a reflexive search for the self. They are confessions of male fallibility: Hornby's adolescent depression and obsession with football as a surrogate male role model; Rayner's compulsion to steal and lie; Watkins self-deceiving fantasies as he conjures up a Hemingwayesque boyhood in the

emotionally and culturally barren English public school system; Morrison, in the aftermath of his father's death, making obtuse sexual advances to a woman who years before had been his family's housekeeper and his first sexual experience. At the centre of each story is the death, duplicity or absence of a father. "Autobiography", wrote John Berger, "begins with a sense of being alone." The filial language of these autobiographies – loss, fear, shame, betrayal, disappointment, resentment, misunderstanding – resonates with that aloneness.

In the midst of confusion about male roles and masculine identities, impending middle age and philosophic doubt, the promise of certitude for these men, their hope of belonging, lies with their fathers. "Even before his death he had been absent..." writes Paul Auster (1982:7). "If, while he was alive, I kept looking for him, kept trying to find the father who was not there, now that he is dead I still feel as though I must go on looking for him." Nick Hornby, aged 11, devastated by the divorce of his parents and the subsequent absence of his father, invents a reliable emotional and cultural patrimony in the space of the football stadium and its "overwhelming *maleness*" (1992:19). Blake Morrison recounts his childhood daydream in which his father is called up to fight in a war and hides in the family attic. "And if they send someone looking for him and ask me do I know where he is, when did I last see him, could they just look round, I'll not give him away, I'll keep his secret safe" (1993:205). Preoccupied with paternal absence, these autobiographies covet the father with symbolic substitutions for him and fantastical longings for his continuous presence. They desire to immobilize his transient, slippery always-just-beyond-reachness, puzzle over his enigma and discover the place where he hid his love. These men have written for their fathers and in recompense for exposing themselves, they request that he acknowledges that like their own ever strenuous, ever failing effort to match up to his expectations, he too similarly failed to win the approval of his own father: a mutual humbling, a mutual love, an agreement to redesign the old male agenda on relationships and find a place to begin speaking.

In the inauspicious culture of masculine evasion and self-denial, the obstacles appear insurmountable. "The point is" writes Paul Auster about his father, "his life was not centred around the place where he lived. His house was just one of many stopping places in a restless, unmoored existence, and this lack of centre had the effect of turning him into a perpetual outsider, a tourist of his own life. You never had the feeling that he could be located" (1982:9). The disappointment is palpable. At the age of 7 Paul Watkins was driven to his English prep school by his father, told he was going to a party and deposited on the doorstep. When he asked a teacher where his father had gone he was told to address members of staff as "sir". When he asked: "When can I go home?" (1993:2) the man told him; "You can go home in about three months." When Watkins' father dies years later, the deception and evasion is repeated. The last time Watkins sees him alive, his father is boarding a plane.

He turns and gives Watkins a brief wave: "For me he was already dead and he knew it, but he never said a word" (1993:99). Richard Rayner presented his father with a copy of his completed manuscript – "He never told me what he thought about it, and I never asked" – and fled England. Two weeks later his father was dead of a heart attack: "I came to fear, to be certain, that I'd killed him with my book" (1995:204). In this stultified, disassociated language of masculinity, where emotional honesty can appear fatal, this searching for origins begins with the death of the father. A literal death, but also a metaphorical expression for the ordinariness and failures of paternal love in the face of grandiose expectations; an indefinable sense of hopelessness. A recognition, as Auster writes, that right from the start "the essence of this project is failure" (1982:20).

Perhaps in the end there is no secret place to discover. For men brought up in the 1940s there was no expressive language of domesticity; feelings were repressed or directed into their capacities to serve their families, to cope and to do their duty. The emotional reticence of this generation of fathers is the psychodynamic structure of their masculinities. There is no hidden, magical reservoir of love, only a romanticized patina constructed by their children out of contemporary expectations of intimacy. The private dramas portrayed in these autobiographies of men seeking the approval and love of their fathers is a product of larger social forces, of an epochal way of life, of a form of paternity that is historically ending. Suddenly everything about and between men has become uncertain: men's connection to their homes and families, the nature of men's love and sexuality, their relationship to children and work, ideals of manliness. As the gendered ideologies of the nuclear family become discredited, the changing consciousness of the post-sixties generation of men clashed with the old ways of their fathers leaving them without a sense of continuity and location. This alienation from their fathers provokes an intense desire to "find" him and to regain a sense of historical connectedness and belonging. Of all the writers it is Morrison who has an understanding of this paradox and the wider sense that the private language of autobiography is speaking of broader structural forces of change: "The days of fathers and sons are over: they've run the heredity business for themselves, have invested all their names and money in it, and now the fathers are dying and the sons not taking over and the whole shebang's in ruins" (1993:51).

My childhood was similar to thousands of English, middle-class, white boys growing up in the suburbs in the 1960s. We were the products of families constituted in the gendered relations of the 1950s, of a clearly defined separation of the feminized, domestic world of mothers and the masculine public world of work to which our fathers belonged. At home my mother was the central figure in family life; the housekeeper, manager of relationships, steward of our schooling, buyer of clothes, birthday cards, food; organizer of holidays; cook and entertainer. Her work produced the family – myself, my two sisters, my brother – as a discursive entity. My father on the other hand was a relatively

peripheral figure in family life. He left home each morning at 7.05 for the City of London and returned at 7pm in the evening. Every Saturday morning he took us to the sweet shop, then went to the pub at lunchtime. In the afternoon he worked in the garden if he did not watch sport on the television. On Sunday he worked in the garden and went to the pub in the evening. Our family culture was overwhelmingly maternal. The language of emotions; of need, pleasure and pain were profoundly feminized. At the same time the self-denials and emotional mendacities necessary to sustain the charade of bourgeois domestic respectability were also associated with femininity and my mother. My father's detachment from the messy, always unfinished emotional business of domestic life — we were never allowed into the bathroom in the mornings while he was "shaving", his body remained hidden — gave him an aura of mystery, a representation of authority, potency and money that appeared to bear no direct connection to our lives, yet held us all in a benign state of deference. His role of father and head of household was grounded in, could only survive on the basis of, his not being known.

I grew up in an England which had briefly galvanized itself and embraced modernity: my father, usually indifferent to popular culture, brought home The Beatles single *I Want to Hold Your Hand*. We were in the front line of the new consumerism; a car, Tupperware, nylon sheets, washing machine, coffee, Coca Cola. There was sufficient money for my mother to pursue the new fashions, to bring into our home the styles, designs and decor which signified modern living. Yet we lived in a familial culture which was almost feudal in its ascription of gendered roles and behaviours. At the heart of post-war consumer capitalism and its impetuous rush into the future, its transmogrification of social and economic relations, its commodifying of new hitherto unthought of areas of social life was a world where nature still appeared to determine one's destiny. My family was fashioned on the ideological template of the mid- and late-Victorian bourgeois family. My mother sustained the home, my father's full-time, tenured employment, dependent upon my mother's unpaid labour, underpinned our household and its 25-year mortgage. It was a regressive social form integral to the maintenance of modernity; a counter-modernity which had been formed with the emergence of industrial society in the nineteenth century and had underpinned the middle-class way of life and the capitalist market. But by the 1960s it was beginning to break apart.

The capitalist market had begun to undermine the social form it depended on for its social stability. The process of modernization ignored the niceties of bourgeois propriety and swept through the front doors of our suburban homes weakening women's feudal status as homemakers and mothers. The expanding market in domestic technologies displaced women's traditional homemaking skills; consumerism encouraged more individualized, aspirational femininities. At the same time participation in education was equalized, new liberal divorce laws were introduced and contraception became widely

available. These changes radically undermined women's fate as wives and mothers and provided new languages of female identity. For women the new capitalist ideologies exacerbated the existing tension between the structures of gender inequality and the growing consciousness of female autonomy. It was expected that my two sisters would do well at school and make good careers for themselves. Equally it was expected that they would marry and become mothers and housewives. By the end of the 1960s the gendered relations of many middle-class families were beset by an intense, unacknowledged ambivalence over the role of women and the nature of femininity. It was an ambivalence which centred on the mother who underpinned a system that was designed to pass her by, abandoning her to a post-parental redundancy. It was her predicament and her ambivalence which fuelled the revolt of her daughters, both in sympathy with their mothers and in a desire to escape her fate. Out of the mother's ambivalence was conceived the daughters' Women's Liberation Movement. More obliquely it gave impetus to her son's revolt against his father's masculinity and his willingness to share the new ideal of sexual equality.

The invasion of modernity into the family – with its promises of choice and autonomy – precipitated the contradictions in women's lives, but it confirmed men's traditional role. The new icons of masculinity, James Bond and *Playboy* magazine exemplified the man about town who pursued ambition and sexual pleasure. The sexual revolution encouraged the expansion of male heterosexual autonomy and personal status without any accompanying change in the structures of gender inequality; the domestic division of labour remained intact, men continued to monopolize full-time wage labour and the market and institutions privileged them over women. Men's roles remained relatively unaffected. But women's growing consciousness that choice rather than fate could determine their lives delegitimized the ideologies of male authority. Masculine roles and behaviours were increasingly seen as privileged social constructs which men actively chose and defended. For boys, their mother's ambivalence and her perception of his father as a man lacking empathy with her, reinforced the already existing gulf between father and son. The decline of female gender fate enabled girls to acquire a greater degree of independence from the prescribed roles of their mothers, but conversely it had the effect of reinforcing boys' identification with their mothers.

In his short essay, "Family romances" (Freud 1909) Freud wrote that the sexual rivalries initiated by the Oedipus complex ensure that the boy has a far more intense desire to get free from his father than from his mother. The father intrudes upon the infant-mother relationship, initiating the Oedipus complex and sexual differentiation. He brings language, individuation and access to culture; he represents desire and the future while the mother is consigned to the unconscious. At the same time his rivalry with his son for the mother produces a need in the boy to escape his father's dominating presence. Despite my perception of my father as the personification of all I

wanted to escape from, the problems of my independence centred around my mother. It was she, not my father who was the psychologically dominant figure in the family. The Freudian privileging of the father neglects this struggle for independence and downplays the function of the mother in the formation of masculinity. His evasion of her importance colludes with the demonization and idealization of mothers in nineteenth century European culture. When he wrote in "Civilisation and it's discontents" (Freud 1930:260), "I cannot think of any need in childhood as strong as the need for a father's protection," he echoed his anxiety about the mother's influence in shaping men's masculinity. And while he reiterated the special bond between mother and son in several of his essays, his glowing remarks do not disguise the "terrifying impression of helplessness" he felt in the boy's dependency on her. For Freud, it is in a mother's nature to project her thwarted ambitions into men: "even marriage is not made secure until the wife has succeeded in making her husband her child as well as acting as mother to him" (Freud 1933). What propelled Freud's longing for the father was his fear of the father's failure to protect his son from this virulent maternal power: "this helplessness lasts throughout life [and makes it] necessary to cling to the existence of a father" (Freud 1927).

Despite his fear of the maternal and his need for the protection of a father, Freud is ambiguous about who or what the father is. In "The ego and the id" (Freud 1923) he substitutes the term *superego* for *ego ideal* but retains a distinction between them. The ideal can be depicted as the loving good father, while the super ego is the prohibitive, castrating father. He implies that the father is both, but it is the latter figure who predominates in his writing. In his analysis of the little boy Hans (Freud 1909), Freud provides a case history depicting his theory of the Oedipus complex and castration anxiety. While the subject of the analysis is Little Hans and his phobia of horses, it is Hans' father who is the presence most strongly felt in the text. Freud only met the boy on a couple of occasions and much of the case history is a record of the father's conversations with his son. In the correspondence between the two men there is a collusion, centred on the exclusion of Hans' mother. Both men agree that Hans' phobia is a symptom of his fear of his mother's absence and that his cure involves breaking his attachment to his mother. Hans' father writes to Freud; "On April 5th Hans came in to our bedroom again, and was sent back to his own bed. I said to him: 'As long as you come into our room in the mornings, your fear of horses won't get better.' He was defiant, however and replied: 'I shall come in all the same, even if I am afraid.' So he will not let himself be forbidden to visit his mother." Freud notes the father's intolerance toward his wife's affection for their son (1909:190). "[He] accuses her, not without some show of injustice, of being responsible for the outbreak of the child's neurosis, on account of her excessive display of affection for him and her too frequent readiness to take him into her bed" (1909:209). But he makes no reference to his own collusion in excluding and silencing

her. Freud's own anxieties about the power of the mother predisposes him to a father who signifies prohibition, rationality and emotional detachment. What eludes him is the body of the loving father.

It was the psychoanalyst Melanie Klein who corrected the patriarchal bias of Freudianism with her description of masculinity constructed out of the pre-Oedipal processes of separating, distancing and differing from the mother. In his essay, "Female sexuality" (Freud 1931) Freud had dismissed this pre-Oedipal attachment to the mother – "so grey with age and shadowy and almost impossible to revivify" – as beyond the reach of analysis. Contradicting him, Klein argued that in the early stages of the Oedipus complex, the infant conceives the father as a part object inside the mother, not as an already existing, dominant and autonomous third term (Klein 1928). The infant boy can only move toward an identification with the father through the mother. If the mother is a more psychologically potent figure than the father, the son will not be unable to completely relinquish his identification with her. The relative inconclusiveness of the Oedipus complex ensures that the internalized object of the mother remains a significant effect within the boy's ego. Klein's psychoanalysis ascribes to the mother a determining function in the making of subjectivity. It is through the inter-relationship between infant and mother that the mental processes which constitute thought and language are developed. Her work displaces the centrality of the Freudian Law of the Father as the symbolic organizing principle of human society and kinship.

Men's sexual politics in the late 1970s, attempting to narrativize alternative, democratic forms of masculinity, were preoccupied with this same elusive Freudian father. Men Against Sexism was composed of mainly white middle-class and tertiary educated men; a minority in a generation and a half who had experienced the nascent transformations in the post-war labour market and family structures. Amongst this specific class fraction of men, sexual politics was an effort to recover a sense of identity. Despite their loosening identification with traditional roles, these emerging masculine identities were still relatively free of social and economic contradictions. Change came from women's new assertiveness, precipitating personal crises, broken relationships and men's realization of their dependency and emotional reliance on women. Men experienced the central conflicts of modernization through women; in the private realm of parenting, sexuality, emotions and psychological well-being. As men voluntarily took up domestic and caring roles formerly assigned to women, their consciousness-raising groups addressed issues of fatherhood; papers, articles and workshops debated the failures of fathers, role reversal, shared parenting, men's relationship to children and practical issues of child care. By the mid-1980s numerous popular books on fathers and fatherhood had been published. In some ill-defined way the figure of the father was perceived as the answer to the confusions surrounding men's roles and masculinities. The sheer difficulty and personal pain involved in these changes, in leaving behind the vestiges of a past way of life, the stubborn reci-

divism of old habits and attitudes, led increasing numbers of men into therapy. Small groups began using psychotherapeutic techniques to explore the unconscious structures of their masculine identities. Despite the preoccupation with fathers, the significant figure who emerged in men's unconscious was the mother: an impinging, controlling, invasive mother. Like Freud's evasive, fearful pursuit of an authoritative father, men's sexual politics had been skating across the surface of deeper psychological predicaments in their relationship to women.

Nancy Chodorow, the theorist who most influenced the psychoanalytic discourse in 1970s men's sexual politics used Klein's insights (and the work of the post-Freudian object relations school of psychoanalysis) to develop a psycho-sociological description of the mother–son relationship. In her book *The Reproduction of Mothering*, she argues that structured into the father-absent, mother-involved family is the son's experience of a premature separation from his mother. The effect of a boy's unresolved need for his mother is his continuing unconscious dependency on her. His mother assumes an omnipotence because only she can satisfy her son's need. He idealizes her, but he experiences her as a persecutory object of whom he cannot be free. He feels fated, compelled to give up his autonomy in order to attend to her needs and moods. Only when she is enlivened can he feel alive. Misogyny and emotional need alternate in his attempts to be free of his compliant relationship to her. But this state of ambivalence is reactivated in his relationships with other women. His boundaries between self and other can be threatened, confusing the origins of his perceptions, thoughts and feelings: are they mine or are they hers? To which the answer is neither yes nor no. When men need to defend themselves against this confusion they exercise a measure of control over a woman; impress their strong ego boundaries on the pattern and arrangement of their lives together. But if women tip the axis of men's carefully ordered world, the boundaries of self and object are threatened and order is lost. When women shift the gendered relations of power – however imperceptibly – men can experience feelings of persecution and fear of being abandoned. When men are uncertain they cling to the totem of the father.

By the 1990s the massive expansion of part-time jobs for women and the pattern of women divorcing men were destabilizing men's public and private lives. Men's sexual politics in the 1970s had prefigured an emerging more widely dispersed change in men's relationship to the family and the labour market. An era of economic insecurity had been precipitated by globalization, technology driven job losses and economic recession. Middle-class men began to experience a relative loss in their social prestige and economic status. The impact of this new work order threatened to undermine their role of head of household and create a backlash against the ideal of female equality. The first herald of a men's anti-feminist politics was the organization Families Need Fathers which was established in the mid-1980s to campaign for separated and divorced men's rights to custody and access to their

children. In 1992 the journalist Neil Lyndon published the first anti-feminist polemic, *No More Sex War: The Failures of Feminism*, which argued that men's exclusion from their role of father and from access to their children was inspired by the totalitarian ideology of feminism. His grievance was reiterated by David Thomas, whose *Not Guilty: in Defence of the Modern Man* emphasized the injuries and injustices done to divorced and separated fathers: "an absolute minimum of 20 per cent of all fathers ... will be permanently separated from their own flesh and blood". Thomas and Lyndon are not die-hard chauvinists stemming the tide of female transgression. The backlash against feminism originated amongst men who are a part of the middle-class fraction most influenced by the women's movement. The breaking down of ascribed gender roles has revealed men's tenuous psychological, emotional and cultural relationship to family life and domesticity. In 1993, in the UK, two-and-a-half times as many divorces were granted to women as men. Over half the divorces granted to the wife were for their husband's unreasonable behaviour. The most common ground in granting a husband divorce was adultery. Men are being jettisoned from family life and they are the fastest growing category of single householders (predicted to be the largest by the year 2001) with the attendant problems of social isolation and loneliness (Social Trends 1996:48).

Anti-feminism carries with it a threatening edge of male hatred which ignores the continuing institutional discrimination against women and the impoverishment women suffer after divorce. It has much in common with the British New Right which spent the 1980s issuing dire warnings about an emerging fatherless society. Patricia Morgan, in her essay, "Feminist attempts to sack father: A case of unfair dismissal" argued that the principal battle front in the "war over the family" is whether homes need fathers" (Morgan 1986:38). The absence of fathers and exclusive feminine nurture condemns young males to a life of violent crime and underachievement at school. A society without fathers, she argued would degenerate into a state of "rootlessness – where there are no heritage or ties and people have no place or past, but simply wander about the face of the earth". For Morgan, the ideological function of the father is to enforce social discipline and to represent the moral, ethical and social foundations of culture; its symbolic law. It is an opinion she later reiterates in *Farewell to the Family* (1995): "Fatherhood, that 'creation of society', exemplifies the rule-making and rule-following without which no culture is possible" (1986:153). The New Right's apocalyptic vision of social dislocation created by fatherless, mother-headed families has become a central tenet in Conservative Party politics and found favour in the social authoritarianism of New Labour.

In this atmosphere, the 1990s witnessed the birth of the "mytho-poetic" men's movement inspired by Robert Bly's book *Iron John* (1991). The "Wild Men" were the first significant development in men's sexual politics since "Men against Sexism". While the latter had rejected the masculinity of their

fathers to embrace their more "feminine" feelings – the Wild Men were intent upon reclaiming their fathers. For Bly the caring and sharing New Man of the mid-1980s only proved that modern men were mother's boys. The anti-sexist man was a naïve man trapped in compliant relationships with women which left him feeling powerless and manipulated and too frightened to say no. Bly declared that this lack of manly autonomy was a result of the absence of fathers from boy's lives. Abandoned to their mothers, boys failed to acquire the self-preserving aggression which sustains the boundaries of selfhood. The purpose of the Wild Men was to rediscover the father within, tap his power and build these boundaries. Weekend gatherings in the country-side used ritualized dancing, drum banging and male bonding to make cathartic, primeval attempts to harness men's "masculine free spirit". Bly's simple assertion that men had a fundamental problem being men found a ready consti-tuency amongst a middle-class disoriented and demoralized by the new work order. The mytho-poetic movement, focusing on men's feelings of humiliation and shame and seeing these as a consequence of a mother-dominated family, in-evitably fed into the language of women blaming. Both Thomas and Lyndon, in constructing men as victims of feminism, grossly inflate women's political and economic power. Men's resentment of the domestic power of mothers has readily fuelled an element of irrationality and persecution in the rhetoric of anti-feminism. In the *Daily Mail* on the 21 September 1992, Lyndon's wife, Deirdre, described *No More Sex War* as "the book that killed my marriage". In trying to understand her husband's "politics of hatred", she suggested that he had left her because "he needed to shred all the strands of domesticity to write this book". She added: "In some ways I think Neil wants to strip women of motherhood".

In 1992 my mother died. Her life ended between a telephone conversation and the act of replacing the receiver. She was 59 years old and had suffered a sudden heart failure. My father, who had been out at the shops, found her a few hours later, lying on her bed not quite dead. The following day, I went into her bedroom. There were pictures of her mother and father laid beneath a glass top on her bedside table. There were photographs of our family around the room; my sisters together; my brother, my sister and her new baby; me; my son and me. Her clothes – jeans and a blue sweater – lay folded on the chair as she had left them. There was a stain of blood on the carpet, evidence of the attempt by the paramedics to revive her. It was still damp from someone's vain effort to wipe it away. Her bed had been stripped, the sheets bundled and the blankets folded. I lifted one of the sheets, it was stained with blood and urine. I imagined this sheet to be like our relationship, its function as a source of my comfort contradicted by these abject signs of the body. Would one ever say, "and when did you last see your mother?" as if that relationship could ever be defined by the disembodied economy of looking. A man remembers the body of his mother; her feel, smell, touch. It gave him life, but it's uncanniness, the source of his ambivalence, familiar

and terrifying, impels him to escape its omnipotence. Men lack such a body. Men's fathers are without bodies.

Men pursue an imago of the father, a wish for a father, a Name, House, Law of the father. That is why they are always looking: it is impossible to touch him. "One could not believe there was such a man", writes Paul Auster about his father, "who lacked feeling, who wanted so little of others. And if there was not such a man, that means there was another man, a man hidden inside the man who was not there, and the trick of it, then, is to find him. On the condition that he is there to be found" (1982:20). Only, of course there is no essential father to find. There is only the contingency of language, the possibilities of relationships, the pragmatics of life. The search for *the father* is bound to fail; abandoned once again to their mothers, men blame women. The question Blake Morrison asked himself – "And when did you last see your father?" – has a banal, everyday answer (1993:74). It was shortly before his death and they bickered their way through a series of DIY tasks. It was no great illuminating moment, there was no sudden passionate pronouncement of love. In *The Pleasure of the Text*, Roland Barthes asks: "If there is no longer a Father, why tell stories? Doesn't every story lead back to Oedipus? Isn't story telling always a way of searching for one's origin" (1988:47). But story telling can only invent origins, never find them. Men have to relinquish a language which maintains the father as a symbol of transcendence; the truth of themselves; the recurring antimonies of mind and body, culture versus nature, conscious versus unconscious; for one which connects with the pragmatics of life and the body. It will then be possible to move on toward a democracy of gender, to become a father who is no longer divine and transient but who is known by his body: in his feel, his smell and his touch; in the daily minutiae of household tasks; in the never finished business of care; in his fallibility and his ordinariness. When men can begin to write about the bodies of their fathers, his Law will cease to exist. It is not about fatherhood and motherhood, it is somewhere on the cusp of language, waiting to be spoken. What is my father? Only a man I struggle to know.

> I resemble everyone
> but myself, and sometimes see
> in shop-windows,
> despite the well-known laws
> of optics
> the portrait of a stranger,
> date unknown,
> often signed in a corner
> by my father.
> (Self portrait, A.K. Ramanujan 1976)

References

Auster, P. 1982. *The Invention of Solitude*. London: Faber.

Barthes, R. 1988. *The Pleasure of the Text*, R. Miller (trans.). New York: Noonday Press.

Berger, J. 1984. *And Our Faces, my Heart, Brief as Photos*. London: Writers and Readers.

Bly, R. 1991. *Iron John*. Dorset: Element Publishers.

Chodorow, N. 1978. *The Reproduction of Mothering Psychoanalysis and the Sociology of Gender*. Los Angeles: University of California Press.

Freud, S. 1909. Analysis of a phobia in a five-year-old boy ("Little Hans"). *Penguin Freud Library* 8, London: Peguin.

Freud, S. 1909b. Family romances. In *Penguin Freud Library* 7, London: Penguin.

Freud, S. 1927. The future of an illusion. In *Penguin Freud Library*, 12, 212. London: Penguin.

Freud, S. 1923. The ego and the id. In *Penguin Freud Library* 11, 212. London: Penguin.

Freud, S. 1930. Civilization and its discontents. In *Penguin Freud Library* 12, London: Penguin.

Freud, S. 1931. Female sexuality. In *Penguin Freud Library* 7, London: Penguin.

Freud, S. 1927. Femininity. In *Penguin Freud Library* 2, 168. London: Penguin.

Hornby, N. 1992. *Fever Pitch*. London: Gollancz.

Klein, M. 1928. "Early stages of the Oedipus complex". *The Selected Melanie Klein*. Mitchell, J. (ed.). London: Penguin.

Morgan, P. 1986. "Feminist attempts to sack father: a case of unfair dismissal". *Family Portraits* Anderson, D. & Dawson, G. (eds). Social Affairs Unit.

Morgan, P. 1995. "Farewell to the family?" *Public Policy and Family Breakdown in Britain and the USA*, Social Affairs Unit.

Morrison, B. 1993. *And When Did You Last See Your Father?* London: Granta.

Ramanujan, A.K. 1976. *Selected Poems*. Delhi: Oxford University Press.

Raynor, R. 1995. *The Blue Suit*. London: Picador.

Social Trends. 1996. London: HMSO.

Watkins, P. 1993. *Stand Before Your God*. London: Faber.

Wolff, T. 1989. *This Boy's Life*. London: Faber.

12

Creative writing and problems of identity: a Horneyan perspective

Celia Hunt

In the days when the humanist model of the self was in fashion, autobiography was regarded as a referential act par excellence: it was the writing of the truth of the self or at least the discovering of the truth of the self which was there, inside us, waiting to be revealed. In the wake of the poststructuralist deconstruction of the self, autobiography's referential nature has been called into question. If the self is a text created by language and social discourse, and there is nothing outside of the text, where is autobiography's referent? Indeed, can we talk of autobiography at all? Surprisingly, it seems that we can. Large numbers of people still continue to write autobiography, but the emphasis now is on autobiography as a process of self-invention rather than of self-discovery. On this model, autobiography is not the writing of that which is psychologically given, but the writing of that which is written in the psyche by social and cultural narratives. If we do not like the narratives that currently dominate our identity, then we can change them, rewrite them. Autobiography (like poststructuralist psychoanalysis of the type advocated by, say, Adam Phillips) thus becomes not the finding of the truth of the self, but the formulation and reformulation of more or less workable versions of self.

Although the old humanist model of self with its emphasis on self-discovery has been abolished, the view of self as wholly invented by language and society has also come under increasing criticism in recent debate, and it is obvious now that it cannot stand unchallenged. As critics have pointed out, it cannot account for individual or collective change or indeed for individual differences of character, why one person will act differently in a given situation from another (Flax 1993; Mischel 1977, introduction; Worthington 1996). Also, recent work in developmental psychology indicates strongly that there are senses of self which pre-date the acquisition of language and point to the importance of inherited or innate characteristics (Gibson 1995; Neisser 1993;

Stern 1985). Further, recent research on identical twins separated at birth and reunited later in life, seems to indicate a significant role for genetically inherited characteristics in the formation of personality and the development of lifestyle (see, for example, Tellegen et al. 1988). What this work shows is that although language and social discourse are crucial factors in the formation of personal identity, the role of genetic and innate characteristics should not be over-looked. In other words, we should be thinking of a model of self which is both given and created, discovered and invented.

In his paper on writing voice Trevor Pateman (1998) suggests a way out of the either/or of self-discovery and self-invention by arguing for the term *self-enactment*. To make his argument, he uses as a model the way classical rhetoric understood the process of writing a story:

> Classical rhetoric presented three aspects of speaking and writing as if they were temporally ordered. So invention (*inventio* – having ideas) precedes or-ganisation (*dispositio* – beginnings, middles and ends) and that precedes the actual business of speaking or writing well (*elocutio* – phrasing and sentence structure).

This, he says, is misleading.

> A much better picture would have it that invention and organisation go on in the elocution – in the acts of speaking or writing . . . There is no essential temporal ordering (Pateman 1998).

Thus, when we write a fictional story, we find out what we have to say in the process of writing. A similar point applies to the development of personal identity: we find out who we are in the engagement with language and the social world. This way of looking at the process allows us, he says, "to see that self-discovery is not (essentially) about introspection [although it clearly leaves open the question of whether there is something there waiting to be discovered] and that what is often called self-invention is (actually) self-enactment" (Pateman 1998).

This idea of personal development as self-enactment bears a strong similarity to Christopher Bollas' description of the process of becoming a person. According to Bollas, a Winnicottian psychoanalyst, we are born with what he calls our *idiom* or *true self*. It is the core of the self, but not a homunculus or mini-version of the adult. Rather it is a potential self, "a genetically biased set of dispositions" which exists prior to object relating and which needs mother and father to facilitate its expression (Bollas 1989:9). Bollas sees the inherited dispositions that make up the *idiom* or *true self* as "a form of knowledge" which has not yet been thought. This he calls the *unthought known* (Bollas 1987).

The process of becoming a person is effected through the merging with and separating from what Bollas calls *subjective objects*, in the course of which our

idiom is enacted (Bollas 1993:20). Amongst these subjective objects are not only people, but aesthetic experiences, such as immersion in a play or a book. Janet Campbell has discussed the transformative role of reading from this point of view (Campbell 1988). A similar claim could be made for the writing of autobiography. When we write autobiographically, we use language to give shape to knowledge of ourselves which may be felt but is not known until it is enacted symbolically or metaphorically in the text. According to Paul Eakin: "... autobiographical truth is not a fixed but an evolving content in an intricate process of self-discovery and self-creation..." (Eakin 1985:3). This does not mean, however, as Eakin goes on to suggest, that the self is therefore a fiction. Perhaps it would be more useful to suggest that the self is unknowable except through fictions, although it needs to be borne in mind, as Eakin also points out, that the self is "not necessarily consubstantial with the fictions we use to express it" (ibid.:277). Autobiography, on this model, is neither the writing of some pre-existing truth of the self or of what is already written by language, but a much more complex process of bringing into being, through the medium of language, unthought and unformulated aspects of ourselves, both the given and the invented aspects. It is the realizing of a *personal truth* which is a mixture of the real and the imaginary.

Self-enactment, then, could be regarded as the process by which our personal identity comes into being. Under favourable conditions this may well be a fairly straightforward, linear process. We enact our innate potential through language and social discourse, while also being invented and shaped by them. Both sides of the process are equally important. But as we know all too well, for many of us this process goes awry. Conditions are not favourable. Self-enactment is halted or waylaid, sometimes at a very early stage. We become trapped in unsatisfactory narratives or ways of being which preclude further development and we spend large tracks of our lives trying to free ourselves from entrapment and to make sense of who we are. It is here that the term *self-clarification* is a necessary counterpart to self-enactment, when thinking about personal development and the formation of personal identity. By self-clarification I mean the identifying and understanding of aspects of one's personality of which one is not fully aware, and whose existence may be causing or contributing to psychic entrapment.

Over the past six years of teaching a creative writing course[1] which advocates the writing of fictionalized autobiography as a way into the writing of fiction (see Hunt 1995),[2] I have been struck by the extent to which some of my students are prevented from using themselves freely in their fiction writing because of problems of personal identity. My course was devised specifically with the idea in mind that finding a writing voice was very much bound up with the writer's inner life and that if there were psychological problems which were interfering with the creative process, then the writing out of one's own material might go some way towards "clearing the ground", so that the "real" writing could begin (see Hunt 1997). It soon became clear to

*writing
as
therapy*

me that, for some people, the creating of autobiographical fictions helped to identify and clarify problems of personal identity and, in some cases, to bring about a degree of release from psychic entrapment.[3] My research in progress looks in detail at this process. In attempting to understand these problems, I have found the psychoanalytical theory of inner conflicts formulated by Karen Horney (1885–1952) particularly useful (Horney 1937, 1939a, 1942, 1945, 1951).

It is perhaps surprising that the work of Karen Horney has not, so far, been used to consider questions of personal identity within the debates around the relationship between cultural studies and psychoanalysis, as her theory is particularly suited to an understanding of self as both genetically given and created by social and cultural factors. Indeed, Horney was one of the first psychoanalytic thinkers to stress the important role of cultural factors in the formation of personality. Her early papers on the psychology of women, which posed the first serious challenge to Freud's views on female sexuality (see Garrison, 1981), in particular "The flight from womanhood" and "The problem of feminine masochism" (1926 and 1935; both reprinted in Horney 1967), emphasize the extent to which women's psychological problems are exacerbated by male dominated culture, and it is this aspect of her work for which she continues to be best known, particularly in feminist circles. Nancy Chodorow, for example, ascribes to Horney the political and theoretical origins of psychoanalytic feminism, saying that her theories "form the basis, acknowledged or unacknowledged, for most of the recent revisions of psychoanalytic understandings of gender" (Chodorow 1989:203; Paris 1994:65). However, her positing of female instincts in her earliest papers has made her unattractive to current feminist debates, and her later work has been largely ignored.

Another reason for the neglect of Horney is that she moved away fairly early on from her feminist concerns. This was possibly because of the antagonism towards her views in psychoanalytic circles, but possibly also, as Garrison suggests (Garrison 1981:688), because there was in those days no feminist movement to support her views. A better explanation is provided by a hitherto unpublished paper of Horney's called "Woman's fear of action", recently brought to light by Bernard Paris. As Paris says, this paper makes it clear that Horney "was opposed to a continued emphasis on the distinctively feminine because she *was* a feminist and wanted to promote the emancipation of women" (Paris 1994:92). As Horney herself says in the essay, she had come to the conclusion that:

> we should stop bothering about what is feminine and what is not. Such concerns only undermine our energies. Standards of masculinity and femininity are artificial standards. All that we definitely know at present about sex differences is that we do not know what they are. Scientific differences between the two sexes certainly exist, but we shall never be able to

discover what they are until we have first developed our potentialities as human beings. Paradoxical as it may sound, we shall find out about these differences only if we forget about them (ibid.:238).

Whilst moving away from her feminist concerns, Horney continued to emphasize the role of social and cultural factors, arguing, against Freud, that "culture was more important than biology in the generation of psychological characteristics" (Paris 1994:101). For Horney, the Oedipus complex is not a product of instincts but a culturally conditioned phenomenon, nor is there an innate destructive instinct. Indeed, there is no inevitable clash between culture and instincts. Psychological problems are the consequence of unfavourable conditions in the child's environment, whether familial, social or cultural (see ibid. Chap.15).

As with her feminist phase, Horney moved away fairly quickly from her cultural phase, and her later work concentrates much more on intrapsychic processes in personal development. Nevertheless, the role of social and cultural factors in the development of personal identity is implicit throughout her later work. The other factor in personal development, the innate or inherited characteristics, is what Horney calls the *real self*. She was, in fact, the first psychoanalytic thinker to use this term (Horney 1939b:130). Similar terms have subsequently been developed by Christopher Bollas (true self – 1987), Heinz Kohut (nuclear self – 1977), James Masterson (real self – 1985), Alice Miller (true self – 1981) and D.W. Winnicott (true self – 1965).[4] For Horney, as for Bollas, the real self is a "possible self", felt rather than seen (Horney 1951:158). Although it forms the basis of her theory, she did not elaborate on it in great detail. In many of Horney's statements about the real self, it sounds very much like an essentialist notion, an expression of an essential human nature, "common to all human beings and yet unique in each" (ibid.:17). According to Marcia Westkott, however, Horney hedges on whether the real self is discovered or created (Westkott 1986:70). First, Westkott quotes a passage which implies an essentialist perspective:

... there are forces in [the child] which he cannot acquire or even develop by learning. You need not, and in fact cannot, teach an acorn to grow into an oak tree, but when given a chance, its intrinsic potentialities will develop. Similarly, the human individual, given a chance, tends to develop his particular potentialities (Horney 1951:17).

The acorn here is the equivalent of the homunculus which determines what the child will become, given favourable external conditions. On the other hand, Westkott says, "when describing the release of the real self from neurotic conflicts, Horney emphasized that the basis of the real self is choice" and she quotes from an article (1947) in which Horney emphasizes the importance of choice in the development of self. Thus, Westkott concludes that

Horney was of the view that the real self is both an essence to be discovered and a product of creative choice:

> Individuals are born with unique physical and mental faculties that can be tapped and developed. These potentialities and limitations are not rigidly determined; what one does with them is a matter of choice and chance (Westkott 1986:71).

I am not entirely happy with Westkott's emphasis on choice, as this would make the formation of personal identity a much more conscious and rational process than is implied by Horney's theory, and I do not think this is what Horney is saying in her paper "Maturity and the individual" (1947). However, Westkott is right to point out the created aspect of the real self, because Horney stresses that what people do with their innate potentialities is dependent on the relationship they have with the social world within which they are immersed and the extent to which they become determined by the social narratives of that world. Indeed, the main focus of Horney's theory is to elaborate the psychic processes which are set in motion when people lose touch with the real self or become *self-alienated*, as she puts it, when their centre of gravity shifts from themselves onto other people and the outside world.

Horney's theory, then, offers a way of understanding the development of personal identity, taking into account both the given and the created aspects of self. It is a version of interactionism and is therefore extremely relevant to current debates in cultural studies. Also of relevance is the fact that, in trying to understand psychological problems, Horney puts the emphasis on the present structure of the psyche, rather than, as Freud does, on elucidating the origins of the problems. This emphasis makes Horney's theory much more compatible with trends within poststructuralism which stress the importance of *present* narratives or *present* "truths", rather than seeking a return to some ultimate truth of the past. Unlike some forms of poststructuralism, however, she does not lose sight of the role of the past in the present.

According to Horney, character disorder is the consequence, in the first instance, of difficult interpersonal relations in childhood. If the conditions for healthy psychological development are in place within the family, i.e. unconditional positive regard, safety and a sense of belonging, the child will be able, through good object relations, to enact or realize its innate potential, although the forms of self-realization will be influenced by the environment.[5] More often than not, however, those conditions are not sufficiently in place and the child, feeling its individuality threatened, reacts by developing what she calls *basic anxiety* and defences to cope with it.[6] She identifies three main defences, which she calls "moving against people", "moving away from people" or "moving towards people" (the pursuit of power, freedom or love). In the child, the choice of one defence over another may be determined

to a considerable extent by social and cultural factors, e.g. girls will tend to move towards people and to overvalue love, whereas boys will tend to move against people and overvalue power. All of these defences involve a move away from self or *alienation from the real self*.[7]

In the adult, Horney's defensive strategies become fully-blown *life solutions*, of which there are three main kinds: the expansive, the resigned and the self-effacing, with the first sub-dividing into the narcissistic, the perfectionistic and the arrogant-vindictive solutions.[8] Whereas all three tend to be present at any one time, one of these solutions will become dominant, thus providing a sense of identity and a modicum of security. However, the others do not disappear; they are merely repressed into the unconscious, where they continue to generate painful inner conflicts and new difficulties. Although Horney's mature theory is not gender specific and character trends in her view are not biologically predestined by gender (see Symonds 1991), her life solutions are gendered in that our culture encourages expansiveness in males and self-effacement in females, and this gives rise to a greater incidence of these tendencies in men and women accordingly. For example, as Alexandra Symonds says, "If you look at the characteristics of the self-effacing personality, you will recognise a description of what is considered feminine in our culture – indeed in most cultures" (ibid:304).

Horney's theory, then, sees the origins of character disorder in strategies to cope with difficult interpersonal relations in childhood, but once this development is in train, intrapsychic factors become more important in terms of consolidating and integrating the chosen solution. Of central significance here is the development of what Horney calls the *idealized image*. This she describes as "a kind of artistic creation" (Horney 1945:104) which, through imagination, attributes to oneself the characteristics that are glorified by one's dominant solution. For example, the idealized image of a woman who adopts the self-effacing solution is likely to focus on images of goodness and saintliness. In her behaviour she will be dominated by a *self-effacing narrative*: she will be compliant, try to please others, will avoid expressing direct hostility and will be sensitive to the needs of others. She will value love above power or freedom, the latter being the values of the expansive and detached personalities (Symonds 1991:304).

The function of the idealized image is to provide a feeling of identity, as the development of an authentic sense of identity is inhibited by self-alienation and inner conflicts. It also provides substitute self-esteem, which is crucially important, in view of the impossibility of generating genuine self-esteem where there is alienation from self. However, the fact that there are already inner conflicts inherent in the life solutions arising out of the interpersonal strategies means that there will be conflicts within the idealized image, each aspect of the conflict imposing its own different demands, or *shoulds*, as Horney calls them, or as I prefer to say, its own *compulsory narrative*.[9] Not only are these narratives contradictory, they are also largely unrealistic and impossible to achieve. The

failure to fulfill the compulsory narratives results in an inner turning against oneself, or as Horney calls it, the forming of the idealized image's counterpart, the *despised image*. This complex intrapsychic development, of idealized and despised images in conflict with each other, results in a situation where whatever one does is wrong and gives rise to endless self-disapproval.

The *compulsory narrative of shoulds* is just one aspect of what Horney calls the *pride system* which is generated by the idealized image and its *search for glory* (Horney 1951: Chap. 1). Its other aspects are what she calls *neurotic pride* and *neurotic claims*. Because the idealized image is the source of substitute self-esteem, the drive to realize this image in reality, to become the idealized self, is very strong and generates intense pride in the characteristics of the idealized image. This pride, in turn, justifies the need to make claims on others. Neurotic claims are the counterpart of the shoulds – the neurotic demands we make on ourselves. In order to maintain the illusion that we are our idealized self, both we and others have to honour our demands and our claims. Failure to do so is likely to plunge us into our despised image and the accompanying self-hate. For Horney the task of therapy is to dismantle the pride system and to reestablish contact with the real self, thus setting healthy development in motion again.[10]

Horney's theory of identity conflicts makes good sense of the problems which some of my students have experienced in using themselves in their creative writing. These problems may take the form, for example, of the inability to identify with a first person narrator who is derived from oneself (see Hunt 1997) or the inability to find a satisfactory shape for an autobiographical narrative because of the co-existence within the text of incompatible or conflicting versions of self. The case I discuss below is that of Jane, who had difficulties allowing the free flow of imagination in her autobiographically based stories, because of the fear of appearing in a way contrary to an idealized image of herself which was very important to her in her childhood.[11]

Jane is of Anglo-Indian origin and in her early forties. She has been writing since she was six, under the influence of her mother who was a published short story writer, and when she first attended the Creative Writing Certificate had been writing primarily traditional, non-autobiographical stories set in India. Some years earlier she had also written an autobiographical novel based on a trek in Nepal, which was accepted by a literary agent but ultimately not placed with a publisher.

Although Jane's stories were competent, she felt that her characters tended to be rather superficial and that the endings, which were always neat and determined by a fictional device, were "cheating", "a bit pat".[12] She was attracted by writings which were psychologically more complex, such as those of Iris Murdoch, whom she admires for "the obsessiveness of her characters, the obtuseness and stupidity and almost wilful self-destructiveness and destructiveness towards others" (Essay 1:4). Jane's own characters were "pragmatic, down-to-earth and positive about life. They get on with it instead of

anguishing about it" (ibid.). She felt that in order to create more complex and psychologically compelling characters she needed to draw more extensively on her own experience. However, writing autobiographically was a problem for her because she felt she always came over "very unsympathetically". This was particularly the case with her autobiographical novel: "...everybody who read it said it didn't sound like me and that I came over as this monster". Autobiographical material was also harder to manage, less neat.

In spite of her demonstrable ability to produce interesting and readable short stories, she was not confident of her skills and was hampered by serious self criticism, which sometimes brought her efforts to a halt for long periods. She spoke of the powerful critic in her head who was constantly looking over her shoulder and finding fault with everything she did. One of the reasons she gave for wanting to attend the Certificate was to see whether "writing is really what I want to do or whether it is an attempt to fulfil my mother's ambitions" (Essay 1:2). Clearly there was a problem here of drawing confidence from the efforts she was making and the work she produced.

The pieces of autobiographical fiction which she wrote during the course revealed a desire for closeness with significant people in her environment, but at the same time a deep uncertainty about the appropriateness of expressing emotion. In *Yellayah*, which recounts a childhood journey by train from Bombay in the company of the Indian gardener from the block of flats where the family lived, the child narrator, feeling homesick, longs for closeness with the old male servant who is accompanying her, but the threat of sexuality implied in such closeness keeps her at a distance. In *Arrival*, which portrays Jane's pre-arranged stopover at her estranged father's flat in India during her trek across Asia, she longs for some emotional if not physical sign from him that he is pleased to see her after a gap of some years. However, the father's inability to engage with his daughter in this way or even to provide her with the minimum hospitality, confirms the narrator's lifelong experience of failed emotional connection. In a third piece (untitled), which portrays the departure from India by boat of a young girl and her mother and sister, with both her father and her mother's lover on the quay seeing them off, the family's lack of emotion contrasts strongly with the highly emotional scenes of departure going on around them and the girl narrator has to hide herself away in her cabin when her own sadness at leaving the land of her birth eventually breaks through.

Two autobiographically based short stories develop in more detail the theme of failed emotional connection in childhood and demonstrate its consequences. Both *The Birthday Present* and *How Much is that Doggy in the Window?* feature a young, possibly 8-year-old girl as the main protagonist and narrator. In *The Birthday Present* Anuja is a deeply introspective child of busy parents who seem unable to give her the affection or closeness she needs or to take time to satisfy her imaginative quest for knowledge. The action of the story focuses on Anuja's attempts to compensate for this lack by finding a person who will

provide the emotional connection she needs. To her parents' dismay, she announces that for her birthday she would like a picture of Jesus, having in mind the one that hangs on the wall at nursery school, where Jesus is stretching out his hand to the viewer and smiling kindly:

> She had wanted a picture like that on her wall so that she could talk to him at night when she felt lonely because her mother was working in Bombay and only came home at weekends, and her father was often away at sea, and Rose spent all her time looking after her baby sister and no-one ever seemed to have time for her. She could tell by Jesus's face that he would have time, that he would listen and care about how lonely she felt (*The birthday present*:4).

She is disappointed when the picture her parents grudgingly give her is of baby Jesus cradled in the arms of an angel:

> . . . a baby was no good at all. You couldn't talk to a baby. All they did was cry and make a fuss and then you got into trouble for doing something, or not doing something else (ibid.:6).

Anuja knows that people will love her if only she is good, but it is so difficult to know what "being good" means: what seems natural or comforting to her often turns out to be "bad" in the eyes of the grown-ups. When Rose, the ayah, catches her in her evening ritual of pleasuring herself before falling asleep and tells her that Jesus sees her doing it and will be cross with her for being dirty and wicked, Anuja realizes again that she has failed somehow to be the sort of girl whom adults will love. So she becomes disillusioned with Jesus too; he is just another adult who does not understand her. In her quest to obtain love and affection, Anuja moulds herself into the kind of person others want her to be: in Horney's terminology she *moves towards people*, becomes self-effacing.

Self-effacement is central, too, in *How Much is that Doggy in the Window?* where Sita, the main protagonist, also strives to be good, so that she will please her mother, who is portrayed as an irrational, immature woman, with a tendency to fly into a rage at the slightest provocation. When a blind beggar and his daughter sing and play the song of the story's title outside the block of flats where she lives with her mother and brother, Sita sees a prime opportunity for a display of goodness, and begs her mother to give her some money for them. In a magnanimous gesture, her mother gives her ten rupees, and Sita is thrilled by the impression this makes on the beggar's daughter, who smiles so kindly at her, and on the beggar himself, who declares that her mother is an exceedingly kind woman, blessed by Jesus. Not only does this provide Sita with proof of her own goodness, but she has also managed to transform her mother into a good person.

Over the next few weeks the man and his daughter return to play the same song; each time Sita gives them her mother's money and is happy because someone thinks that she and her mother are good, kind people. She would like to be friends with the girl, who is much nicer to her than the girls at school. But as the beggars come more frequently, Sita's mother grows increasingly angry and eventually refuses to give them any more money. Sita is mortified; each time she hears the violin scratching out the familiar song she cringes and hides herself away, and is relieved when the couple eventually cease to visit them. However, her failure to please makes her deeply unhappy and as she grows up, her experience of music is forever tainted by uncomfortable emotions.

The world portrayed in these stories is peopled by unpredictable, ambivalent adults whose love is not spontaneously available. The child narrators are in search of a person who will listen and understand, a person who will love them for themselves. Unrecognized for who they are, Anuja and Sita move towards people in their attempts to be loved. If love is not spontaneously forthcoming, then it must be because Anuja and Sita are doing something wrong, because they are bad. They must find out how to please people, how to do the right thing, and then mould themselves into the kind of being that will gain them approval. But the adopting of a strategy means that they lose touch with their own individuality and authenticity or, in Horneyan terms, that they become alienated from who they are and this, the stories imply, will determine the course of their future lives.

The theme of failed emotional connection in childhood and the attempt to overcome it through self-effacing behaviour is a strong and recurring theme in Jane's autobiographical writings, which indicates the central role this way of being has played, and must continue to play, in her life. Against this background, her discomfort at the portrayal of herself in her autobiographical novel becomes intelligible. At the end of the second term of the Certificate in Creative Writing Jane presented for assessment a revised extract from her novel. *From Yin Yang's to the Bardo Thodol* is set in the early 1980s and opens with the female narrator, Louise, and her American/Nepalese companion, Hari, in Kathmandu, after a lengthy trek through Nepal. Constantly at odds with each other, both of them demonstrating a somewhat aggressive individualism, they head for Yin Yang's bar where Hari engages in deep conversation with another woman and Louise finds herself somewhat isolated on the edge of a group of chatting acquaintances. In spite of her dislike of substances or behaviour which threaten to undermine her normal, rather rigid self-control, she succumbs to pressure to take a powerful drug, psilocybin and, in her drugged state, finds herself dancing wildly and behaving uninhibitedly in public. When Hari takes her back to the hotel, she succumbs to uninhibited lovemaking, which seems to go on for ever.

Louise is very different from the child narrators of the stories discussed above, and a much more successful mimetic characterization than Anuja or

Sita. Also, the writing generally in this story is much more lucid and open-ended; it trusts the imagery it employs to convey subtle changes in Louise's state of mind and is more daring in what it sets out to achieve. However, as I noted above, the representation of herself in the novel Jane found disturbing. Perhaps this is because Louise is more complex, displays aggression and engages in behaviour – wild dancing, drug-taking, ecstatic sex – which would not come under the category of "goodness" or "niceness" in the world of Anuja or Sita. Although Louise cannot be said to be a "monster" in any sense, if the quest for "goodness" is an essential part of the self-effacing solution so important to the writer in her childhood, then her concern about the unsympathetic portrayal of herself in the novel is not unreasonable: from the perspective of an idealized image of goodness, Louise certainly lets the side down.

The presence in Jane's autobiographical writings of contradictory images of herself is clearly very important in understanding her difficulties with using autobiographical material. In the second interview we talked about this and she said:

> I think that was very strong as a child, that thing about always having to be good, that people have to approve of me. And then I went through a period of absolute anguish, I suppose [when I was] about 19 or 20, when I got to university, until I was about 30. I had this terrific conflict where I was trying to be good all the time, but then there would be these outbreaks of really appalling behaviour, because I was obviously trying to suppress everything in my character that didn't conform with the sort of goody-goody image. I found that very confusing and bewildering. And then from about 30 onwards I think I started to allow more of the aggressive/assertive side of me out, but perhaps didn't like myself very much for it, and I think over the last few years there has been more of a coming to terms with that, accepting that . . .

Nevertheless, she still worries that "I am not managing to portray myself as acceptable". It seems possible that, although the conflict has lessened over the years, it is still sufficiently active to interfere with the subtle processes involved in transposing autobiographical material into fiction. I would suggest that Jane still has a deep need to present herself in her writing in accord with the image of goodness which was so important to her in child-hood, and when her writing reveals a more aggressive and complex picture of herself, this creates anxiety. This means that writing autobiographically is dangerous; it is safer to write non-autobiographical stories, where characterization is more superficial, and where the literary devices and neat endings keep control over the material available.

In the current climate where, one sometimes feels, it is almost mandatory for women to be assertive, it seems strange to suggest that some women might

have difficulty portraying themselves on the page in an expansive way. But changes in external conditions do not lead automatically or immediately to individual psychic change. The strong and long-term cultural preference for women to be self-effacing is deeply embedded in the female psyche and change is much more complex. As Alexandra Symonds puts it: "Helping a woman resolve her ... fear of self-assertion, helping her to emerge with a more authentic identity to handle her hostility and the hostility of others, involves an additional layer of anxiety since she will differ from the expectations of the culture" (Symonds 1991:305).

There is a further complicating factor. Within the self-effacing solution, there is a taboo on self-assertion. Self-assertion is a characteristic of the expansive solution, which is diametrically opposed to the ideals of the self-effacing solution and often in conflict with it. To be assertive, the self-effacing personality has to undergo a complete switch to expansiveness, which means that the uncomfortable inner conflict, often heavily repressed, between these two opposing solutions, becomes activated, thus generating anxiety.

It is clear from early morning freewriting exercises in which Jane engaged during the course,[13] that her dominant tendency towards self-effacement is in conflict with expansiveness of the kind Horney describes, which reveals itself here as an arbitrary quest for greatness:

> Funny how I have always thought I'd make it – be exceptional. Life isn't bad now although I have to list things before I can FEEL how OK it is – nice house, lovely kids, happy marriage – but I wouldn't be satisfied with just that. I expect more – accomplishments, fame, riches. Not so much riches as success – Mum's legacy (Essay 1:6).

This powerful drive to be exceptional in life, *the search for glory*, as Horney calls it, is a preoccupation which goes back to Jane's childhood and continues to render real life disappointing: "As children if we did a good drawing we would be 'famous artists', if we wrote a story we would be 'great writers' ... I would rather be an unhappy 'success' than a happy nobody" (ibid.:6–7).

Achievement, to have any significance, has to be on a grand scale, so that Jane's real efforts are undervalued. This may well account for her uncertainty about whether she wants to be a writer and her inability to have confidence in what she has already achieved. It may also account for her desire, which also emerged in the freewriting, to withdraw into a state of inactivity:

> My dreams are rarely exciting ... Sometimes I dream of business meetings – eight businessmen in grey suits sitting around a boardroom table and talking in monotonous voices. I like these dreams. I find them soothing. I don't have to get involved – I don't even listen to the conversation – I don't have to live – just survive. No that's the wrong word – too urgent – just exist. Like an amoeba – that's about the level of challenge I'm comforta-

ble with. And yet when I'm awake I feel this urge to throw myself into things which I feel uncomfortable with (Essay 1:5).

Here there is a clear conflict between the desire to withdraw into an amoeba state, which is comfortable and soothing, where Jane can exist without having to be challenged, and the contrary desire for challenge, which is uncomfortable. Such a withdrawal, Horney's *detached solution*, would put out of action the contradictory tendencies towards self-effacement on the one hand and expansiveness on the other.

What Jane's writings reveal, then, are two powerful idealized images: that of the good child, seeking the affection of emotionally unreliable adults, and that of the great artist who will dazzle the world with her achievements. To put it another way, they reveal the self-effacing solution in conflict with the expansive solution. As these solutions are mutually contradictory and not achieveable in the real world, the only course of action is to withdraw into detachment or, as Jane has in fact done, to write out her contradictory selves in autobiographical fictions.

This work has had a marked effect on Jane. She says that she feels much more able now to recognize "both my ability to write and my own self-generated commitment to be a writer", as a result of which her confidence is much increased (ibid.:8–9). Further, she now feels freer to use herself in different guises in the text. The second interview revealed Jane successfully using herself as narrator of a story told to her by a friend, which she had been struggling for some years to write purely from his point of view. "Suddenly", she says, "it came into my mind that *I* am in the story."

Karen Horney's theory makes good sense of the problems experienced by a talented writer in her attempts to deepen her fiction writing through the use of autobiographical material. The conflicts of identity described here clearly stem from a childhood environment where the basic conditions for healthy development – unconditional positive regard, safety and a sense of belonging – were not sufficiently in place. In order to feel loved and secure, the child had to take emergency measures by moulding herself into the sort of person she thought her environment demanded. This involved a move away from herself and the development of her real potential, and set in motion an intrapsychic process with a dynamic of its own. Because of this loss of contact with real self, self-enactment, the realizing of the self's potential, was hampered, causing entrapment in faulty narratives which interfered with the use of herself in the writing of fiction. The writing of fictionalized autobiography, the creation of fictional stories which embodied aspects of her personal truth, enabled the writer to identify the different parts of herself which were in conflict with each other and causing the entrapment. The resulting clarification of identity has brought about an increased freedom to plumb her own depths in the writing of fiction and will, I hope, allow greater scope for the process of self-enactment to begin again.

Acknowledgement

I would like to thank Jane for permission to quote from her writings and for her collaboration through the interviews and personal discussion.

Notes

1. The term "creative writing" is used here as a definition of imaginative writing, i.e. poetry, prose fiction and drama; there is no implication that other kinds of writing are not creative. I am, however, aware of the arbitrariness of this definition. As Jerzy Kosinski has suggested, all forms of writing, including journalism and non-fiction, can be regarded, to an extent, as a form of fictionalized autobiography or "autofiction", and could therefore fall within the above definition.

2. My course *Autobiography and fiction*, re-named *Autobiography and the imagination*, now forms the first of a three-term Certificate in Creative Writing at the University of Sussex Centre for Continuing Education.

3. See also in this connection Jo Spence's use of "phototherapy" (Spence & Holland 1991).

4. See Paris, 1994:215.

5. Horney's theory is compatible with object–relations theory. See Ingram & Lerner 1992.

6. A similar point would apply to non-environmental problems which interfere with healthy psychological development, such as innate learning difficulties or other gross or subtle disabilities, but Horney does not discuss these.

7. Horney's notion of *alienation* is quite different from that of Lacan, in that for Horney there is no inevitable fragmentation of personal identity. As Bernard Paris says: "from a Horneyan perspective the belief that the self is inevitably derivative, inauthentic, and fragmented is a product of inner conflict and self-alienation, which is then generalised as the human condition" (Paris 1994:215).

8. One of the criticisms levelled against Horney's theory is that her typology is reductive. Horney was, in fact, aware that such a neat classification could be misleading and in her last book she was at pains to emphasize the dangers of seeing her types as hard and fast categories. Her resort to a typology seems rather to have been a heuristic device, which would provide "a means of looking at personalities from certain vantage points". ". . . what we regard as 'types' are actually cross sections of personalities in which the neurotic process has led to rather extreme developments with pronounced characteristics. But there is always an indeterminate range of intermediate structures deriding any precise classification". Thus, she prefers to regard her types as indicating "directions of development" (Horney 1951:191).

9. Each of the *life solutions* contains a powerful narrative of "shoulds" which determines how a person *should* behave, what she *should* be doing with her life, what sort of relationships she *should* be engaging in, etc.

10. See Paris 1994, Part V, for an excellent summary of Horney's mature theory.

11. The following summary of Jane's case arises out of the work she did while attending my creative writing course in autumn 1994 and tape-recorded discussions we

had about it during 1995 and 1996. The text includes extracts from essays and pieces of creative writing which Jane wrote during the course, as well as quotations from and my resumés of our discussions.
12. She later came to revise this view, saying that she felt this was a rather unfair judgement.
13. This exercise combines the idea of *freewriting* put forward by Elbow (1973) with early morning writing suggested by Brande (1934).

References

Bollas, C. 1987. *The Shadow of the Object*. London: Free Association Books.
Bollas, C. 1989. *Forces of Destiny: Psychoanalysis and Human Idiom*. London: Free Association Books.
Bollas, C. 1993. *Being a Character: Psychoanalysis and Self Experience*. London: Routledge.
Brande, D. 1934/1992. *Becoming a Writer*. London: Macmillan.
Campbell, J. 1988. "Transformative Reading". In *The Self on the Page: the Theory and Practice of Creative Writing in Personal Development*, C. Hunt (ed.). London: Jessica Kingsley.
Chodorow, N. 1989. *Feminism and Psychoanalytic Theory*. New Haven, Connecticut: Yale University Press.
Eakin, P.J. 1985. *Fictions of the Self: Studies in the Art of Self-invention*, Princeton, New Jersey: Princeton University Press.
Elbow, P. 1973. *Writing without Teachers*. Oxford: Oxford University Press.
Flax, J. 1993. "Multiples: on the contemporary politics of subjectivity". In *Disputed Subjects*. New York: Routledge.
Garrison, D. 1981. Karen Horney and Feminism, *Signs*, Summer, 672–91.
Gibson, E. 1995. "Are we automata?" In *The Self in Infancy*, P. Rochat (ed.). Amsterdam: Elsevier.
Horney, K. 1937. *The Neurotic Personality of our Times*. New York: Norton.
Horney, K. 1939a. *New Ways in Psychoanalysis*. New York: Norton.
Horney, K. 1939b. Can you take a stand? *Journal of Adult Education* ll, 129–32.
Horney, K. 1942. *Self Analysis*. New York: Norton.
Horney, K. 1945. *Our Inner Conflicts*. New York: Norton.
Horney, K. 1947. Maturity and the individual, *American Journal of Psychoanalysis* 7, 85–7.
Horney, K. 1951. *Neurosis and Human Growth: the Struggle Toward Self-realisation*. New York: Norton.
Horney, K. 1967. *Feminine Psychology*, H. Kelman (ed.). New York: Norton.
Hunt, C. 1995. Autobiography and the imagination, *Writing in Education*, (7), Winter.
Hunt, C. 1997. Finding a voice – exploring the self: autobiography and imagination in a writing apprenticeship, *Auto/biography* 1–3, 169–179.
Hunt, C. & F. Sampson (eds) 1998. *The Self on the Page: Theory and Practice of Creative Writing in Personal Development*. Jessica Kingsley, London (forthcoming).
Ingram, D.H. & J.A. Lerner 1992. Horney theory: an object relations theory, *American Journal of Psychoanalysis* 52, (1), 37–49.
Kohut, H. 1977. *The Restoration of the Self*. New York: International Universities Press.
Masterson, J. 1985. *The Real Self*. New York: Brunner/Mazel.

Miller, A. 1981. *Prisoners of Childhood*. New York: Basic Books.

Mischel, T. (ed.) 1977. *The Self: Psychological and Philosophical Issues*. Oxford: Blackwell.

Neisser, U. 1993. "The self perceived". In *The Perceived Self*, U. Neisser (ed.). Cambridge: Cambridge University Press.

Paris, B. 1994. *Karen Horney: a Psychoanalyst's Search for Self Understanding*. New Haven, Connecticut: Yale University Press.

Pateman, T. 1998. "The empty word and the full word: The emergence of truth in writing". In *The Self on the Page: Theory and Practice of Creative Writing in Personal Development*, C. Hunt & F. Sampson (eds). London: Jessica Kingsley.

Spence, J. & P. Holland 1991. *Family Snaps: the Meaning of Domestic Photography*. London: Virago.

Stern, D. 1985. *The Interpersonal World of the Infant*. New York: Basic Books.

Symonds, A. 1991. Gender issues and Horney theory, *American Journal of Psychoanalysis*, **51**, (3), 301–12.

Tellegen, A. et al. 1988. Personality similarity in twins reared apart and together, *Journal of Personality & Social Psychology* **54**, 1031–9.

Westkott, M. 1986. *The Feminist Legacy of Karen Horney*. New Haven, Connecticut: Yale University Press.

Winnicott, D.W. 1965. Ego distortions in terms of true and false self. In *The Maturational Processes and the Facilitating Environment*. New York: International Universities Press.

Worthington, K. 1996. *Self as Narrative: Subjectivity and Community in Contemporary Fiction*. Oxford: Oxford University Press.

Index